GRAPHIS

THE HUMAN CONDITION

PHOTOJOURNALISM 97

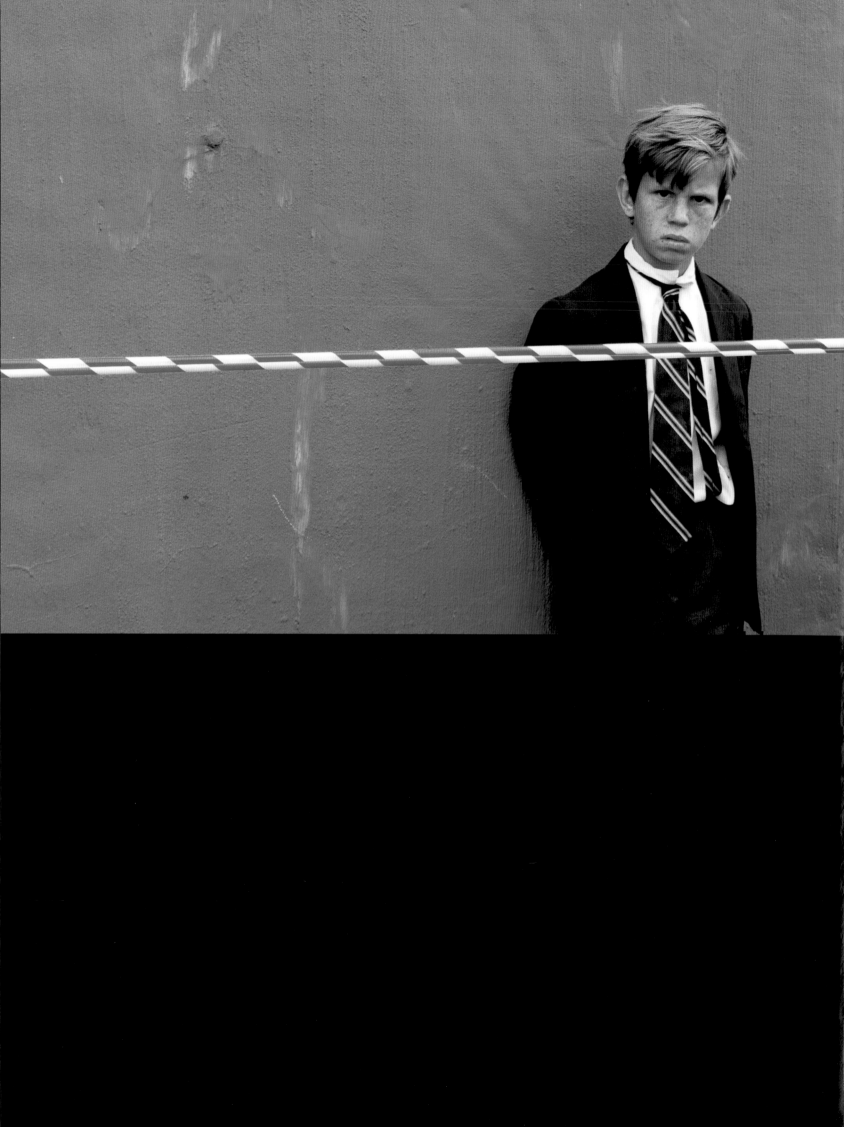

THE HUMAN CONDITION

PHOTOJOURNALISM 97

The International Annual of Photojournalism

Das internationale Jahrbuch über Reportagephotographie

Le Répertoire international du Photoreportage

Publisher/Creative Director: B. Martin Pedersen

Editor: Michael Sand

Associate Editors: Clare Hayden, Peggy Chapman

Art Director: John Jeheber

Designer: Jenny Francis

Graphis Inc.

Cover/Umschlag/Couverture: Photo by Colin H. Finlay
(Opposite) Photograph by Rian Horn. A confused schoolboy arrives home to find his neighbour's property wrapped in police cordon after the brutal murder of his neighbour's domestic worker. This kind of violent crime is becoming a common part of the daily lives of South Africans—Johannesburg, South Africa.

CONTENTS

REMARKS

WE EXTEND OUR HEARTFELT THANKS TO DON STANDING AT SABA, TO CAROLYN HERRARD AT THE ASSOCIATED PRESS, TO KIMBERLEE ACQURARO AT *TIME*, TO KATHY RYAN AT *THE NEW YORK TIMES*, AND TO CONTRIBUTORS THROUGHOUT THE WORLD WHO HAVE MADE IT POSSIBLE TO PUBLISH A WIDE AND INTERNATIONAL SPECTRUM OF THE BEST WORK IN THIS FIELD.

ENTRY INSTRUCTIONS FOR ALL GRAPHIS BOOKS MAY BE REQUESTED FROM:
GRAPHIS INC.
141 LEXINGTON AVENUE
NEW YORK, NY 10016-8193

(OPPOSITE) PHOTOGRAPHY BY DAVID BURNETT, CONTACT PRESS IMAGES.

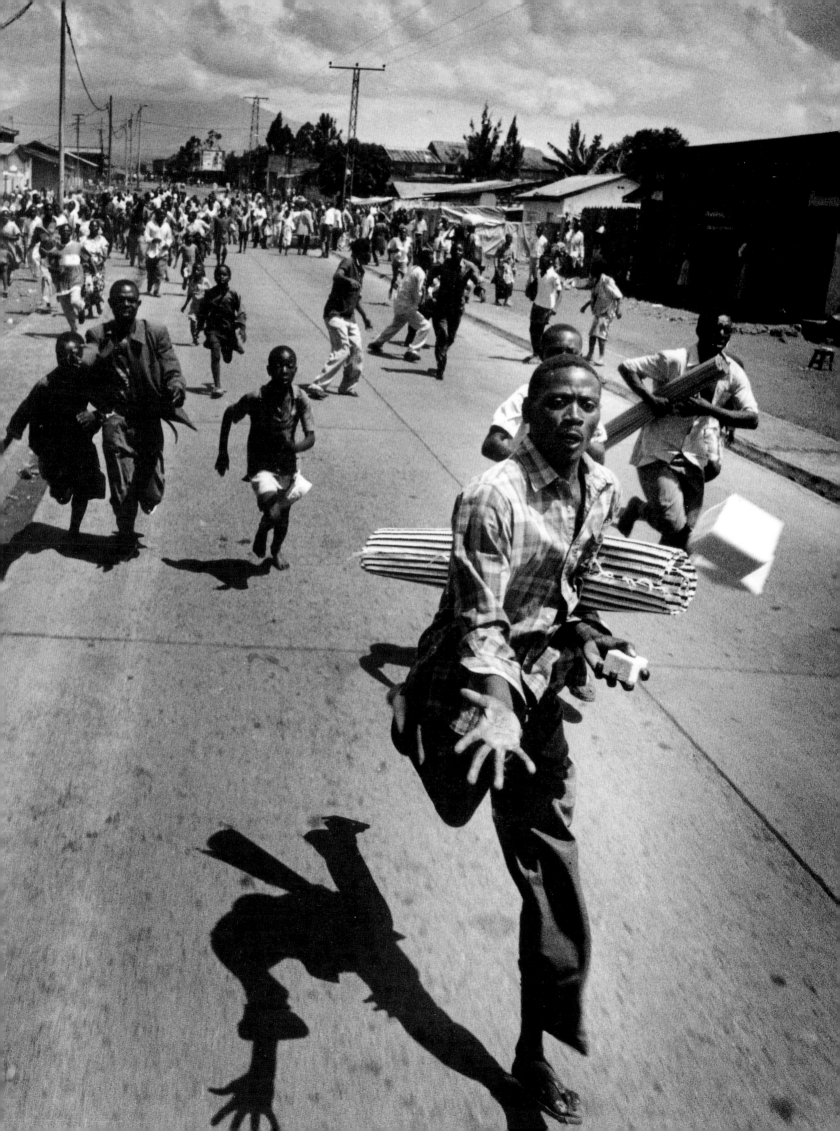

GRAPHIS Do you remember the point at which you decided to become a photojournalist? **YUNGHI KIM** I started with photography in high school and became serious about it at Boston University, where I was heavily influenced by *Boston Globe* photographers Stan Grossfeld and Janet Knott. I remember being very moved by Stan's Ethiopian famine pictures and Janet's Haiti pictures. These were some of my first glimpses into photojournalism, and I was hooked! **GRAPHIS** Can you tell us a little about your personal background? Did you grow up in the U.S.? **YK** I was born in Taegue, South Korea, and came to this country when I was 10. I grew up on Long Island, New York and now live in Washington, D.C., with my husband, Jason Seiken. **GRAPHIS** Have you found there to be special advantages or disadvantages to being a woman in photojournalism? If so, what have they been? **YK** Being a women or man is not important. What's most important is what's inside of you. How you tap into the emotions and instincts within you to translate them into photography. I approach my subjects with sensitivity and emotion, and respect. ● There are advantages to being a women in certain situations, such as photographing a rape victim. But there are certain times when being a woman is a disadvantage, such as when I was held hostage in Bardera, Somalia, in 1992 by rebel soldiers. Being the only female hostage, and the only western woman in town, made me very uncomfortable, as you can imagine. **GRAPHIS** You have devoted a lot of time and energy to covering the plight of the Rwandan refugees. How did you first approach this story, and can you tell us some of your feelings about working in these dire circumstances? **YK** I went to Africa in 1992 for the *Boston Globe* to cover the Somalia famine. I fell in love with Africa. I met some of my heroes there—relief workers who risk their lives to make a difference. When we were taken hostage in Bardera, an Australian Care worker named Bob Allen saved my life. Africa is one of the most beautiful places that I know but it's also one of the most screwed up, due to all the conflicts. I see it [my work in Rwanda] as one continuous story. I was very angered by what was going on there [in Rwanda] in 1994 with the civil war, refugees, and genocide, so I went to Rwanda and Zaire for three weeks. I went back this year when fighting broke out again and the refugees were being threatened. It was very satisfying to photograph everyone going home relatively peacefully. **GRAPHIS** What are some other stories you have done that have been especially meaningful to you? **YK** I'm most proud of my photographic reporting of the "comfort women" of South Korea. These women were forced into sexual slavery by the Japanese army during World War II. A group of them now live together in a small basement apart-

ment in Seoul, and I spent a few weeks with them last year. I also was very moved by the events leading up to the South African election in 1994–the Nelson Mandela rallies, the dancing and music and great energy in the Soweto soccer stadium. But in the end, what matters isn't how big or important the story is. What really matters are the people, the subjects of the story. The people are what make a story meaningful for me. In Rwanda in 1994, I spent a week documenting one family. It's important to me to show that these are not faceless refugees . . . that they are human beings like everyone else. **GRAPHIS** Some documentary photographers complain that there are no longer very many venues in which to publish their work, especially black-and-white photo essays. Is this your experience? **YK** I've been very lucky this year to have my comfort women story published three times. It is harder to publish essays. It's something I'm still figuring out. **GRAPHIS** How important is the role of the agency in your getting assignments and getting recognition for your work? **YK** I think it's a team effort, sort of like a partnership. The photographer has to produce good ideas and pictures, and agencies can nurture the work along or help promote it if the work is good. But ultimately you, as the photographer, have to know what you are about and what photography means to you, and the kind of work that you want to do. That's the most important thing. Contact photographer Frank Fournier once told me that the best assignments are self-generated ones. He's absolutely right. The stories that I'm most proud of are stories that came from my heart. **GRAPHIS** You've just received a World Press Photo Award—first place for the picture story "Deadly Road Home." Is this an important marker for you in your career? **YK** I think contests are subjective, but they can be important in the sense that they can open doors for you and give you exposure. I suppose the World Press Photo Award gives me exposure in the international photo community. But again, the best photography comes from your heart, not from chasing contests. **GRAPHIS** How did the assignment to do a story on the comfort women come about? **YK** As a Korean-American, few issues have hit as close to home as the comfort women issue. In the same way that my mother immigrated from Korea 30 years ago searching for a better life for her family, these women went to Japan after being promised better opportunities. But they lived a nightmare, and were forced into sexual slavery by the Japanese army. ● It was a personal project. I first heard about the comfort women on the radio in 1993 and I still vividly remember feeling angry and sad. How could this have happened and how could it have been kept a secret for 50 years? I was curious about these women. How could they have endured this pain all these years? I wanted to meet them, do an intimate profile of them, and most importantly tell their stories. It

(ABOVE) SCENES FROM YUNGHI KIM'S STORY ON KOREAN "COMFORT WOMEN." (OPPOSITE) DETAIL FROM KIM'S STORY "THE DEADLY ROAD HOME."

was difficult photographically because how do you depict and illustrate emotions of 50 years ago? I'm most proud of this project.

GRAPHIS If you could choose your next three assignments–any topic, anywhere in the world—what would they be? **YK** Continue to cover Africa, continue to cover the comfort women, and continue to do stories about people who have passion and soul, people who are rich in life.

. .

GRAPHIS Erinnern Sie sich, wann Sie beschlossen haben, Reportagephotographin zu werden? **YUNGHI KIM** Ich begann mit Photokursen an der High School, aber ernsthaft habe ich mich mit der Photographie erst an der Boston University befasst, wo mich Stan Grossfeld und Janet Knott, die für den *Boston Globe* photographierten, stark beeinflussten. Ich erinnere mich, dass mich Stans Aufnahmen von der Hungersnot in Äthiopien und Janets Bilder von Haiti ungeheuer beeindruckten. Das war meine erste Berührung mit Photoreportagen, und ich war fasziniert.

GRAPHIS Können Sie uns ein bisschen über sich erzählen? Sind Sie in den USA aufgewachsen? **YK** Ich wurde in Taegue, Südkorea, geboren und kam im Alter von 10 Jahren in dieses Land. Ich wuchs auf Long Island auf und lebe heute mit meinem Mann Jason Seiken in Washington, D.C.

GRAPHIS Gibt es Ihrer Erfahrung nach Vorteile oder Nachteile, wenn man als Frau im Photojournalismus arbeitet? Und wenn ja, welche? **YK** Es ist nicht wichtig, ob man eine Frau oder ein Mann ist. Am wichtigsten ist, was man in sich hat, wie man mit den Emotionen und Instinkten umgeht und sie in Bilder umsetzt. Ich arbeite mit viel Gefühl und Emotionen und mit Respekt vor dem Sujet. ● Es gibt bestimmte Situationen, in denen es ein Vorteil ist, eine Frau zu sein, z.B. wenn man das Opfer einer Vergewaltigung photographiert. Aber manchmal ist es auch ein Nachteil, eine Frau zu sein, z.B. als ich 1992 von Soldaten der Rebellen in Bardera, Somalia, als Geisel festgehalten wurde. Ich war die einzige weibliche Geisel und die einzige westliche Frau in der Stadt, was für mich, wie Sie sich vorstellen können, ziemlich unangenehm war.

GRAPHIS Sie haben viel Zeit und Energie darauf verwandt, das Elend der ruandischen Flüchtlinge zu dokumentieren. Wie gingen Sie dabei vor, und können Sie uns erzählen, was Sie empfanden, als sie unter diesen schrecklichen Umständen arbeiteten? **YK** Ich ging 1992 für den *Boston Globe* nach Afrika, um den Hunger in Somalia zu dokumentieren, ich verliebte mich in diesen Kontinent. Ich habe dort einige der bewundernswertesten Menschen getroffen: Mitarbeiter der Hilfsorganisationen, die ihr Leben riskieren, um etwas zu bewirken. Als wir in Bardera als Geiseln genommen wurden, rettete mir ein Mitarbeiter von Australian Care, Rob Allen, das Leben. Afrika ist einer der schönsten Orte, die ich kenne, aber wegen all der Konflikte auch einer der kaputtesten. Ich sehe meine Arbeit in Ruanda als eine fortlaufende Geschichte. Ich war sehr empört über das, was 1994 dort geschah – der Bürgerkrieg, die Flüchtlinge, der Völkermord –, deshalb ging ich für drei Wochen nach Ruanda und Zaire. Ich flog dieses Jahr wieder hin, nachdem die Kämpfe von neuem ausgebrochen und die Flüchtlinge bedroht waren. Es war sehr beruhigend, Bilder von Menschen machen zu können, die alle relativ friedlich in ihre Heimat zurückkehrten.

GRAPHIS Welche Reportagen waren sonst noch sehr wichtig für Sie? **YK** Ich bin sehr stolz auf meine Photoreportage über die "Comfort Women" von Südkorea. Diese Frauen wurden während des 2. Weltkriegs von der japanischen Armee zu Sex-Sklavinnen gemacht. Einige von ihnen leben jetzt zusammen in einer kleinen Kellerwohnung in Seoul, und ich verbrachte letztes Jahr ein paar Wochen mit ihnen. Ich war ebenfalls sehr bewegt von den Ereignissen, die 1994 zu Wahlen in Südafrika führten: die Nelson- Mandela-Kundgebungen, die Musik, das Tanzen und all die Bewegung im Fussballstadion von Soweto. Was wirklich zählt, sind die Menschen, die Gegenstand der Story sind. Es sind Menschen, die eine Story für mich bedeutsam machen. In Ruanda verbrachte ich 1994 eine Woche bei einer Familie, deren Leben ich dokumentierte. Es ist wichtig für mich zu zeigen, dass es nicht gesichtslose Flüchtlinge sind ... dass es Menschen sind wie alle anderen.

GRAPHIS Einige Reportage-Photographen beklagen den Mangel an Medien, die bereit sind, ihre Arbeiten zu veröffentlichen, besonders wenn es um Photo-Essays in Schwarzweiss geht. Haben Sie ähnliche Erfahrungen gemacht? **YK** Ich hatte dieses Jahr viel Glück, denn meine Geschichte über die "Comfort Women" wurde in drei Publikationen veröffentlicht. Es ist schwerer, Photo-Essays unterzubringen. Das ist etwas, wo ich mich noch zurechtfinden muss.

GRAPHIS Wie wichtig ist eine Agentur, wenn es um Aufträge und Anerkennung Ihrer Arbeit geht? **YK** Ich finde, es ist Teamarbeit, eine Art Partnerschaft. Der Photograph muss gute Ideen und Bilder liefern, und die Agenturen können einen bei der Arbeit unterstützen oder, wenn sie gut ist, helfen, sie unterzubringen. Aber im Endeffekt muss der Photograph selbst wissen, wo er steht und was Photographie ihm bedeutet, welche Arbeit er machen möchte. Das ist das Wichtigste. Der Photograph Frank Fournier sagte einmal zu mir, dass die besten Aufträge die eigenen seien. Er hat absolut Recht. Die Reportagen, auf die ich am stolzesten bin, sind jene, die vom Herzen kamen.

GRAPHIS Sie haben gerade einen World Press Photo Award bekommen – den 1. Preis für die Bildreportage "Deadly Road Home". Ist das ein wichtiger Meilenstein in Ihrer Karriere? **YK** Ich finde, Jurierungen sind subjektiv, aber sie können in dem Sinne wichtig sein, dass sie einem möglicherweise Türen öffnen und den Namen bekannt machen. Ich nehme mal an, dass der World Press Photo Award mir in der internationalen Photobranche zu einem gewissen Ruf verhilft. Aber ich wiederhole, die beste Photographie kommt vom Herzen, nicht durch die ständige Teilnahme an Wettbewerben.

GRAPHIS Wie kam es zu dem Auftrag für die Reportage über die "Comfort Women"? **YK** Als Korea-Amerikanerin haben mich wenige Themen so eng mit meiner Heimat verbunden wie die Geschichte der "Comfort Women". Meine Mutter verliess vor 30 Jahren Korea, in der Hoffnung, in den Vereinigten Staaten ein besseres Leben für ihre Familie zu finden. Ähnlich ging es diesen Frauen, die nach Japan gingen, nachdem man ihnen bessere Chancen versprochen hatte. Aber sie erlebten einen Alptraum, indem sie von der japanischen Armee zu Sex-Sklavinnen gemacht wurden. ● Es war ein persönliches Projekt. Ich hörte 1993 zum ersten Mal im Radio von den "Comfort Women", und ich erinnere mich noch genau daran, wie wütend und traurig ich war. Wie hatte das geschehen können, wie hatte man das 50 Jahre lang verschweigen können? Ich wurde neugierig auf diese Frauen. Wie haben sie das all die Jahre ertragen können? Ich wollte sie kennenlernen und ganz persönliche Bilder machen und vor allem ihre Geschichten erzählen. Es war in photographischer Hinsicht schwierig, denn wie zeigt man Emotionen, die 50 Jahre zurückliegen? Ich bin sehr stolz auf dieses Projekt.

GRAPHIS Wenn Sie die nächsten drei Aufträge auswählen könnten – gleich, welches Thema und welches Land – was würden Sie sich wünschen? **YK** Die Dokumentationen über Afrika und die "Comfort Women" fortsetzen und weiter Reportagen über Leute machen, die ein Herz und eine Seele haben, Menschen, die ein reiches Leben führen.

. .

GRAPHIS Vous souvenez-vous du moment où vous avez décidé de devenir reporter photographe? **YUNGHI KIM** J'ai commencé à prendre des cours de photographie dans une école supérieure, mais je ne m'y suis intéressée sérieusement que lorsque je fréquentais l'Université de Boston où j'ai été très influencée par les photographes Stan Grossfeld et Janet Knott qui travaillaient pour le *Boston Globe*. Les images de Stan sur la famine en Ethiopie et celles de Janet sur Haïti m'avaient beaucoup touchée. C'est là que j'ai véritablement découvert le reportage photo. J'ai été emballée!

GRAPHIS Pouvez-vous nous parler un peu de vous? Avez-vous grandi aux Etats-Unis? **YK** Je suis née à Taegue en Corée du Sud. J'avais dix ans lorsque je suis venue habiter ici. J'ai grandi à Long Island et je vis aujourd'hui avec mon mari Jason Seiken à Washington D.C.

GRAPHIS Selon vous, être une femme reporter photo, est-ce que cela présente des avantages ou des inconvénients? Et lesquels? **YK** Cela n'a aucune importance. Ce qui compte, c'est ce que l'on a en soi, comment on vit, comment on appréhende ses émotions, son instinct et comment on les transpose dans des images. J'aborde mes sujets avec beaucoup de sensibilité, d'émotion et de respect. Parfois, c'est peut-être plus facile d'être une femme, par exemple lorsqu'on photographie la victime d'un viol. Mais parfois, c'est difficile comme lorsque j'ai été retenue en otage en 1992 par des soldats rebelles à Bardera en Somalie. Etre la seule femme prise en otage et, de surcroît, la seule femme occidentale en ville, cela a été très désagréable pour moi comme vous pouvez vous l'imaginer.

GRAPHIS Vous avez consacré beaucoup de temps et d'énergie à documenter la misère des réfugiés rwandais. Quelle a été votre approche et comment avez-vous vécu ces circonstances dramatiques? **YK** En 1992, le *Boston Globe* m'a envoyée en Afrique pour documenter la famine en Somalie. Je suis littéralement tombée amoureuse de ce continent. J'y ai rencontré des personnes extraordinaires que j'admire par-dessus tout: des gens qui travaillent pour des organisations d'aide humanitaire et qui risquent leur vie pour faire changer les choses. Bob Allen, un collaborateur d'Australian Care, m'a d'ailleurs sauvé la vie lorsque nous avons été pris en otages à Bardera. L'Afrique est l'un des plus beaux endroits que je connaisse, mais aussi l'un des plus pourris à cause de tous ces conflits. Je considère mon travail en Afrique comme une seule et même histoire, une histoire continue. Les événements du Rwanda en 1994, la guerre civile, les réfugiés et le génocide m'ont révoltée. Je suis donc allée au Rwanda et au Zaïre pour deux semaines. J'y suis retournée cette année lorsque les combats ont repris et que les réfugiés étaient menacés. C'était plutôt réconfortant de voir les gens rentrer chez eux dans un calme tout relatif.

GRAPHIS Quels autres reportages ont beaucoup compté pour vous? **YK** Je suis très fière du reportage photo sur les «Comfort Women» que j'ai réalisé en Corée du Sud. Durant la Seconde Guerre mondiale, les Japonais ont fait de ces femmes des esclaves du sexe. Quelques-unes d'entre elles partagent aujourd'hui un petit appartement situé dans une cave à Seoul où j'ai passé quelques semaines avec elles l'année passée. J'ai aussi été très touchée par les événements de 1994 en Afrique du Sud qui ont conduit aux élections – les meetings de Nelson Mandela, la danse, la musique et cette incroyable énergie qu'il y avait dans le stade de football de Soweto. Mais ce qui compte le plus en définitive, ce sont les gens. Les gens sont au cœur de l'histoire et ce sont eux qui lui donnent vraiment de l'importance. En 1994, au Rwanda, j'ai vécu une semaine avec une famille dont j'ai documenté la vie. Pour moi, c'est important de montrer que ce ne sont pas des réfugiés sans visage... que ce sont des personnes comme vous et moi.

GRAPHIS Certains photographes se plaignent de la réticence des médias à publier leur travail, en particulier lorsqu'il s'agit d'essais photographiques en noir et blanc. Avez-vous fait les mêmes expériences? **YK** Cette année, j'ai eu beaucoup de chance parce que mon reportage sur les «Comfort Women» a paru dans trois publications. C'est vrai qu'il est plus difficile de faire publier des essais photographiques. Il faudra bien que je m'y fasse.

GRAPHIS Quel rôle joue une agence lorsqu'il s'agit de décrocher des contrats et de faire reconnaître le travail d'un photographe? **YK** Pour moi, c'est un travail d'équipe, une sorte de partenariat. Le photographe doit livrer de bonnes idées et de bonnes images. Quant aux agences, elles peuvent le soutenir dans son travail et contribuer à la promotion de ses photographies si elles sont bonnes. Mais en définitive, c'est au photographe de savoir où il en est, ce que représente la photographie à ses yeux et quel genre de travail il aimerait faire. C'est primordial. Le photographe Frank Fournier m'a dit un jour que les meilleurs travaux sont ceux que l'on s'assigne à soi-même. Et il avait tout à fait raison. Les reportages dont je suis le plus fière sont ceux qui viennent du cœur.

GRAPHIS Vous venez de recevoir un World Press Photo Award – le premier prix pour le reportage photo «Deadly Road Home». Est-ce un tournant décisif dans votre carrière? **YK** Je trouve les concours subjectifs, mais ils sont importants dans la mesure où ils vous ouvrent des portes et font connaître votre nom. Je suppose que le World Press Photo Award va contribuer à ma notoriété dans le monde de la photographie. Mais je me répète, la meilleure photographie, c'est une affaire de cœur, cela n'a rien à voir avec le fait de participer constamment à des concours.

GRAPHIS Comment vous est venue l'idée de faire ce reportage sur les «Comfort Women»? **YK** En tant que Coréenne d'origine et Américaine d'adoption, peu de sujets présentaient des liens aussi forts avec mon pays d'origine que celui des «Comfort Women». Ma mère a quitté la Corée il y a 30 ans dans l'espoir de trouver une vie meilleure pour sa famille aux Etats-Unis. Pour ces femmes qui sont allées tenter leur chance au Japon, c'était la même chose. Mais elles ont vécu un véritable enfer parce que l'armée japonaise les a retenues pour en faire des esclaves du sexe. ● C'était un projet personnel. C'est en 1993 que j'ai entendu pour la première fois parler des «Comfort Women» à la radio et je m'en souviens très bien, j'étais très en colère et très triste aussi. Comment était-ce possible, comment avait-on pu taire cela pendant 50 ans? J'étais curieuse d'en savoir plus sur ces femmes. Comment avaient-elles supporté ça durant toutes ces années? Je voulais faire leur connaissance, prendre des photographies très personnelles et raconter avant tout leur histoire. D'un point de vue photographique, c'était difficile... Comment voulez-vous montrer des émotions qui remontent à 50 ans en arrière? Je suis très fière de ce travail.

GRAPHIS Si vous pouviez choisir vos trois prochains reportages – peu importe le sujet et le pays – qu'aimeriez-vous faire? **YK** Je continuerais à couvrir l'Afrique et les «Comfort Women» et je ferais d'autres reportages sur des gens qui ont un cœur et une âme, des gens dont la vie contient une richesse.

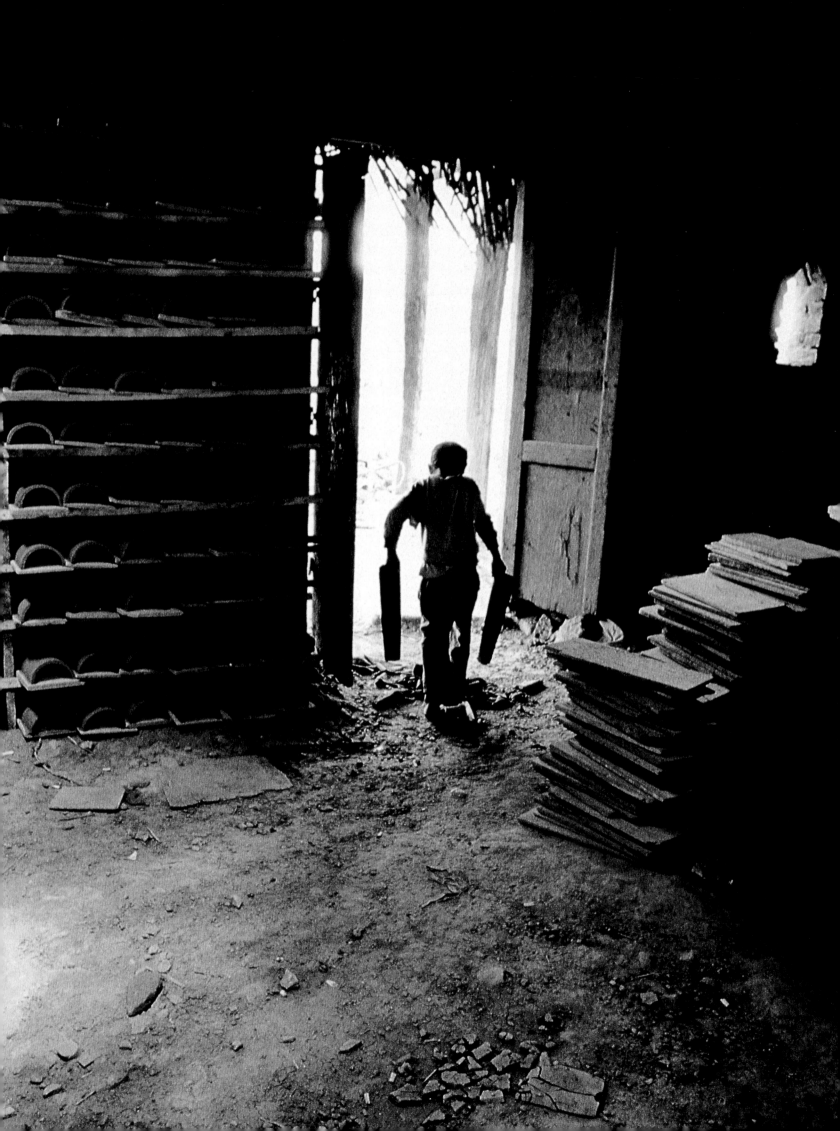

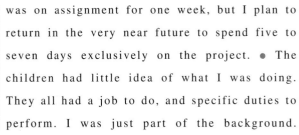

As this book was going to press, we learned that Colin Finlay had won First Prize in the Picture of the Year Awards from the National Press Photographer's Association and the University of Missouri School of Journalism, for his photo essay on child labor in Cairo (see cover, and pp. 70-73). We asked Finlay to describe his experiences on this assignment. ● I was in Egypt doing a story for a travel magazine on Cairo—more specifically, the City of the Dead—a large cemetery that has become home to a number of the living in the overcrowded city. The child labor story came about as an added bonus, when I noticed a terra cotta tile and vase-making factory near the graveyard. They were using the cemetery's children as a workforce. My interpreter was from the City of the Dead, and his father was buried there. Our access, then, was a bit better than usual. Making the images was a challenge, though. I went in with only one camera body, two lenses, and a few rolls of film in my pocket. ● Typically, I get one chance at each location, and my interpreter explains my presence as a sort of "off-beat tourist." It's very difficult to show up and say you are here doing a story on child labor, let alone, "Would you mind if I hung around for a few hours making images?" I

was on assignment for one week, but I plan to return in the very near future to spend five to seven days exclusively on the project. ● The children had little idea of what I was doing. They all had a job to do, and specific duties to perform. I was just part of the background. Conversation with them was superficial, as there was always some type of boss or manager nearby. I was fortunate to come away with a strong series of pictures under the circumstances. ● My viewpoint is based on the ideal of objectivity, but on *mine* versus another photographer's. Two of us standing next to each other would see different realities, shoot with different lenses and films, and each of us would look for different moments. It's amazing to me to see another photographer's edit, when you were both at the same place, with the same subject matter in front of you. ● Photography is a silent language, with a grace of its own. Though silent, our images speak with passion, power, anger, love, joy, sadness, and a multitude of other emotions. It is up to the individual viewers, with the help of a short caption, to absorb the image for themselves—its meaning, its impact, indeed, what it says to them about their own lives.

. .

Kurz bevor dieses Buch in Druck ging, erfuhren wir, dass Colin Finlay für seine Dokumentation über Kinderarbeit in Kairo (s. Umschlag und S. 70-73) mit einem Picture of the Year Award der National Press Photographers Association und der University of Missouri School of Journalism ausgezeichnet wurde. Wir baten Finlay, über seine Erlebnisse bei diesem Auftrag zu berichten. ● Ich war in Ägypten und machte für ein Reisemagazin Aufnahmen von Kairo – oder genauer gesagt, von der Stadt der Toten, einem grossen Friedhof, der auch einigen

Lebenden dieser übervölkerten Stadt Zuflucht bietet. Die Geschichte über die Kinderarbeit ergab sich, nachdem ich neben dem Friedhof eine Fabrik entdeckt hatte, in der Keramikplatten und Vasen hergestellt werden. Sie benutzten die Kinder, die auf dem Friedhof leben, als Arbeitskräfte. Mein Dolmetscher lebte in der Stadt der Toten, und sein Vater war dort begraben. Deshalb war der Zugang für uns etwas leichter als gewöhnlich. Bilder zu machen war jedoch schwierig. Ich nahm nur eine Kamera, zwei Objektive und ein paar Rollen Film mit. ● An jedem

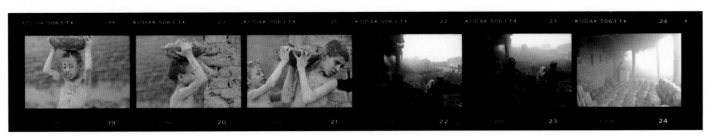

(ABOVE) COLIN FINLAY'S CONTACT STRIP REVEALS A FAST EYE FOR THE TELLING IMAGE. (OPPOSITE) "CARRYING DRIED ROOF TILES."

Ort bekam ich gerade eine Gelegenheit zu photographieren, wobei mein Dolmetscher jeweils erzählte, dass ich ein «etwas verrückter Tourist» sei. Man kann nicht einfach hingehen und sagen, man mache eine Story über Kinderarbeit ...oder gar fragen, «Macht es Ihnen etwas aus, wenn ich ein paar Stunden hierbleibe und photographiere?» Ich war insgesamt eine Woche in Kairo, aber ich habe vor, bald wieder hinzufliegen und fünf bis sieben Tage nur für dieses Projekt zu arbeiten. ● Die Kinder realisierten kaum, was ich machte. Sie hatten ihre Arbeit und bestimmte Pflichten. Ich war nur Teil der Umgebung. Mit ihnen zu sprechen konnte man vergessen, denn es war immer irgendein Boss oder Aufseher in der Nähe. Ich hatte Glück, dass mir unter diesen Umständen einige starke Aufnahmen gelangen. ● Ich bemühe mich immer um Objektivität, aber um meine eigene. Wenn zwei Photographen nebeneinander stehen, sieht jeder eine andere Realität, benutzt verschiedene Objektive und Filme, und jeder wählt einen anderen Moment für seine Aufnahme. Wenn ich mit einem anderen Photographen am selben Ort war und das selbe Thema hatte, staune ich immer, wenn ich die Bilder sehe, die er ausgewählt hat. ● Photographie ist eine stille Sprache, mit einem eigenen Charme. Obgleich sie still sind, sprechen Leidenschaft, Kraft, Zorn, Liebe, Freude, Trauer und unendlich viele andere Empfindungen aus unseren Bildern. Es ist dem einzelnen Betrachter überlassen, mit Hilfe einer kurzen Legende das Bild auf seine Weise in sich aufzunehmen, seine Bedeutung, seine Wirkung und das, was es ihm über das eigene Leben sagt.

...

Peu avant que cet ouvrage ne soit mis sous presse, nous avons appris que la National Press Photographer's Association et l'University of Missouri School for Journalism avaient décerné à Colin Finlay un Picture of the Year Award pour son reportage sur le travail des enfants au Caire (voir couverture et p. 70-73). Nous avons demandé au photographe de nous faire part de ses impressions sur ce travail. ● J'étais en Egypte pour réaliser des prises de vues destinées à une brochure touristique sur le Caire, et plus précisément sur la Cité des Morts, un vaste cimetière où nombre d'habitants de la capitale surpeuplée ont élu domicile. En fait, le reportage sur le travail des enfants est né un peu par hasard, après que j'eus découvert près du cimetière une fabrique où étaient entreposées des tuiles et des poteries en terre cuite. Les enfants du cimetière y travaillaient. Mon interprète venait lui aussi de la Cité des Morts où repose son père. Pour cette raison, nous avons pu accéder plus facilement à cet endroit, mais pour prendre des photos, c'était toute une histoire. Je n'ai emporté avec moi qu'un appareil photo, deux objectifs et quelques pellicules. ● Sur chaque site différent, je ne pouvais prendre qu'une photo, et mon interprète déclarait à qui voulait l'entendre que j'étais un touriste un peu «fou». Bien entendu, il aurait été difficile de justifier ma présence en disant que j'étais là pour réaliser un reportage sur le travail des enfants. Ou de demander: «Cela vous dérange si je passe quelques heures ici à prendre des photos?» En tout, je suis resté une semaine au Caire et j'ai l'intention d'y retourner bientôt afin de consacrer cinq à sept jours à ce projet uniquement. ● Les enfants quant à eux ne réalisaient pas vraiment ce que je faisais. Ils avaient leur travail à accomplir ainsi que diverses autres tâches. Moi, je faisais plutôt partie du décor. Il me fut dès lors impossible de leur parler, d'autant plus qu'un surveillant ou un chef quelconque rôdait toujours dans les parages. Dans ces circonstances, je m'estime heureux d'avoir pu prendre quelques photos saisissantes. ● Je m'efforce toujours d'être objectif, objectif par rapport à moi-même, à mon travail. Imaginons deux photographes côte à côte: chacun d'entre eux a sa propre réalité, utilise des pellicules et des objectifs différents et prend une photo à un moment bien précis. Je suis toujours très étonné de voir les photos que quelqu'un d'autre a prises sur le même sujet et au même endroit que moi. ● La photographie est une forme d'expression silencieuse, avec son charme propre. Mais bien que silencieuses, nos images évoquent la passion, la force, la rage, l'amour, la joie, la tristesse et tant d'autres émotions. Chacun d'entre nous est libre d'interpréter une image à l'aide d'une brève légende, de s'en imprégner à sa guise, d'en saisir le sens à sa façon, de juger de son impact pour finale-ment découvrir ce que cette image nous raconte sur notre propre vie.

THE HUMAN CONDITION

PHOTOJOURNALISM 97

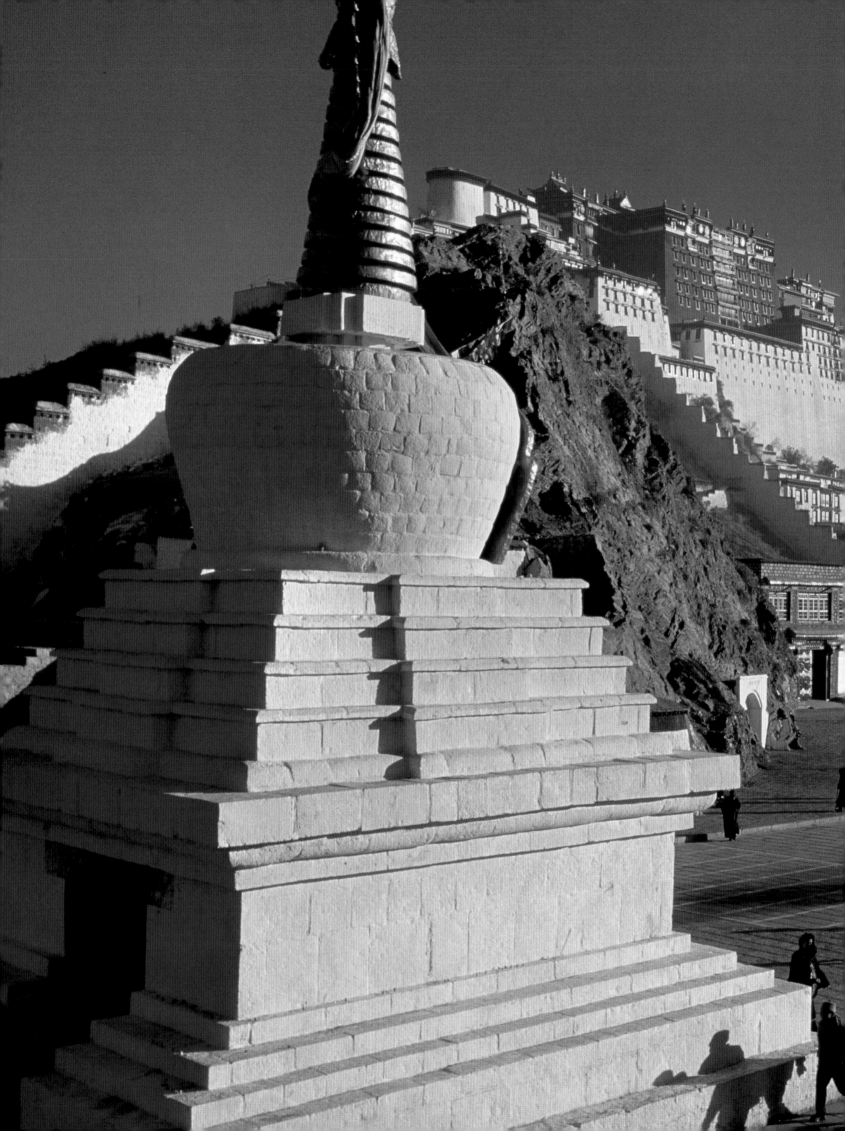

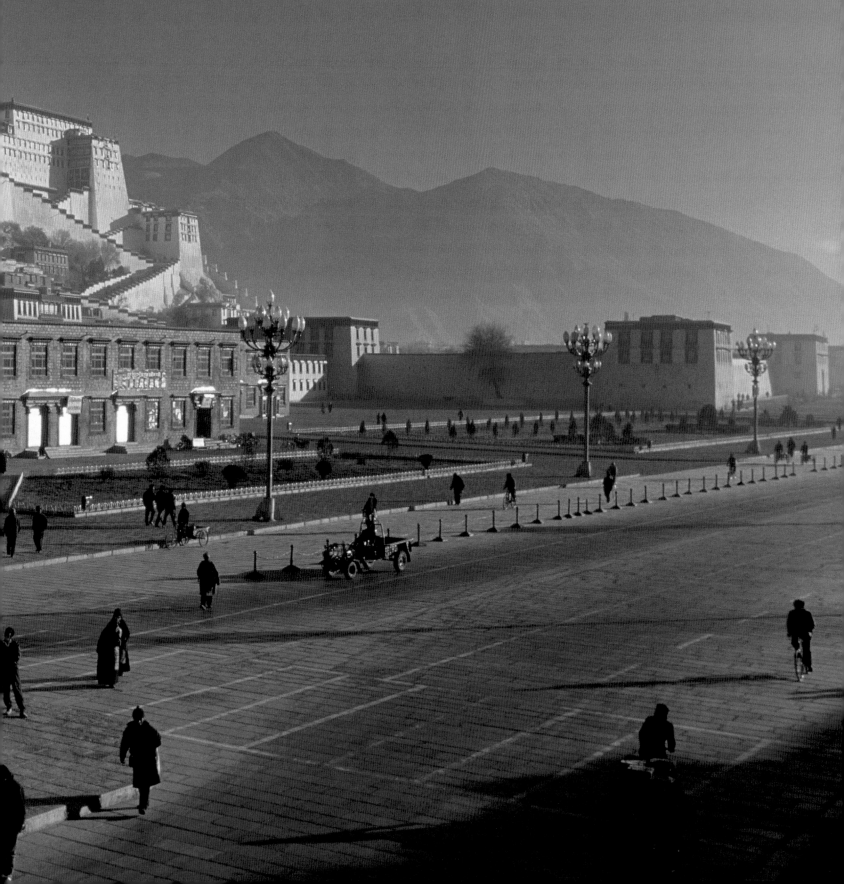

Tibet:
The Enduring Spirit

JEFFREY AARONSON

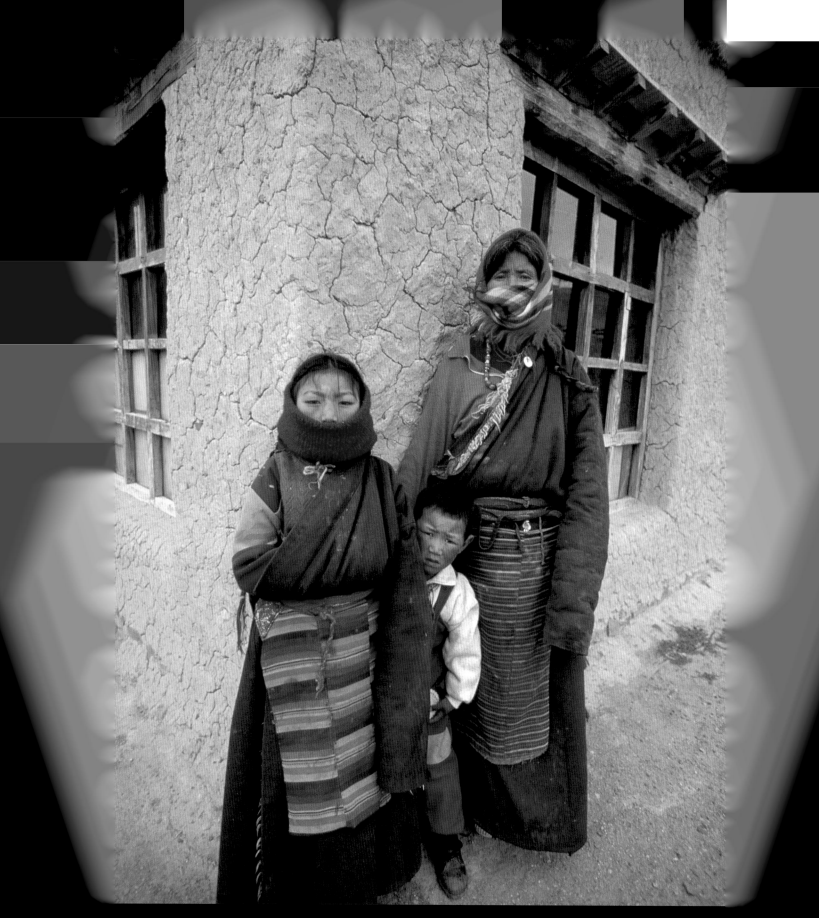

Over the past year I have made three trips to the "Roof of the World" to photograph the spirit and determination of the Tibetan people, who continue to maintain their faith and identity despite years of Chinese oppression. With their spiritual leader the Dalai Lama in exile, the people of Tibet have had to rely on their faith in Buddhism, their family structure, their language, customs, and even their sense of humor to sustain them. The Chinese government has interfered with their religious practice, their education, and their personal freedom, yet they have remained free in their hearts and souls. *Representative: Network Aspen Publisher:* Vanity Fair

PRECEDING SPREAD) LHASA, TIBET. PILGRIMS ARE DWARFED BY THE GIANT *STUPA* AT THE ENTRANCE TO LHASA WITH THE POTALAI BEHIND. ■ *(THIS PAGE* A FAMILY WEARING TRADITIONAL NOMADIC CLOTHING IN A SMALL VILLAGE IN WESTERN TIBET, OUTSIDE NAGCHU.

MONKS PRACTICING THEIR HORNS FOR A RELIGIOUS CEREMONY AT THE JOKHANG TEMPLE, TIBET'S HOLIEST TEMPLE. ■ MONKS PLAY TRADITIONAL DRUMS AT A RARE RELIGIOUS CEREMONY AT THE JOKHANG TEMPLE. ■ NUNS HOLDING A PRAYER ASSEMBLY INSIDE THE COURTYARD OF THE JOKHANG TEMPLE. MONKS AND

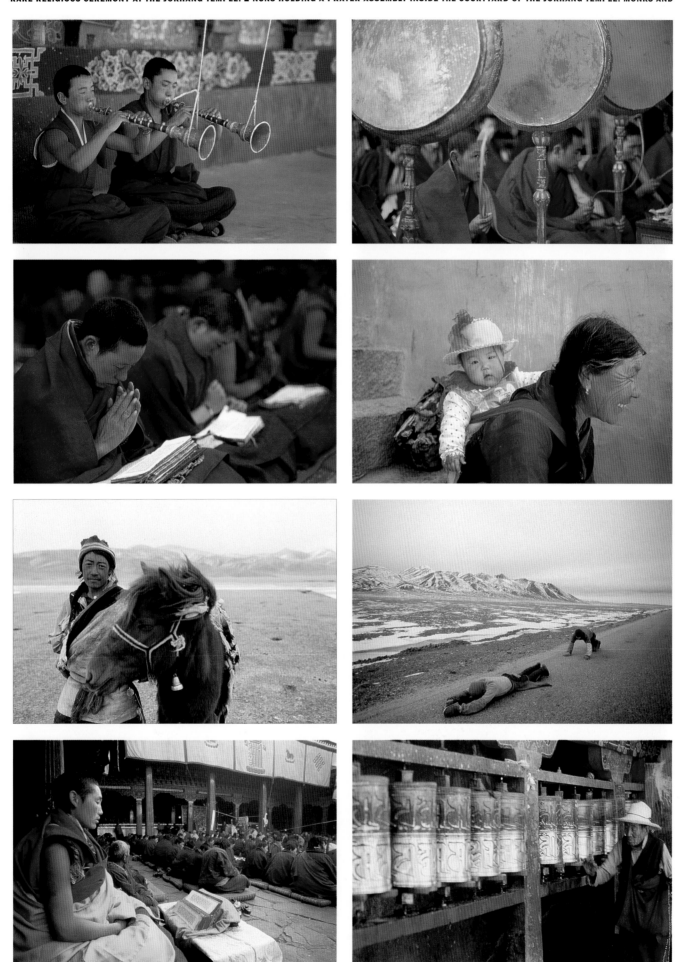

NUNS FROM ALL OVER TIBET ARE GATHERING. ■ A WOMAN WITH HER CHILD, IN LHASA. ■ A NOMAD ON THE ROAD TO NAGCHU. ■ PILGRIMS PROSTRATE THEMSELVES ALONG THE ROAD TO LHASA. ■ MONKS IN PRAYER ASSEMBLY AT THE JOKHANG TEMPLE. ■ PILGRIMS SPINNING PRAYER WHEELS ALONG THE BARKHOR CIRCUIT.

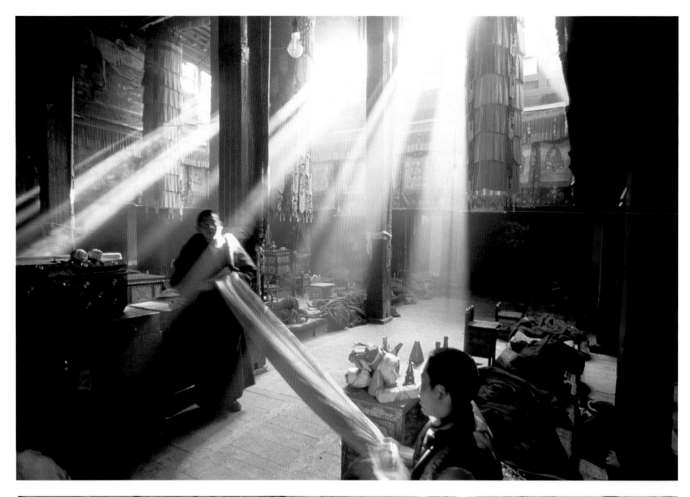

MONKS FOLDING SACRED CLOTH AT TSURPHU MONASTERY, THE TEMPLE OF THE KARMAPA. ■ AT TASHILHUNPO MONASTERY, ELDERLY MONKS ACCEPT AN OFFERING FROM A YOUNG TIBETAN CHILD.

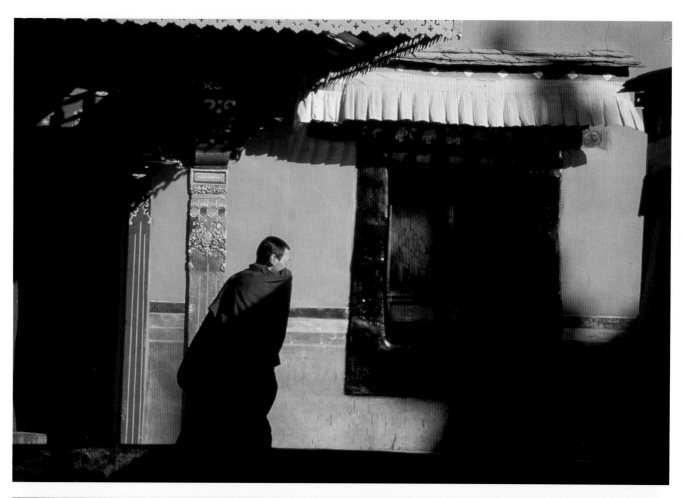

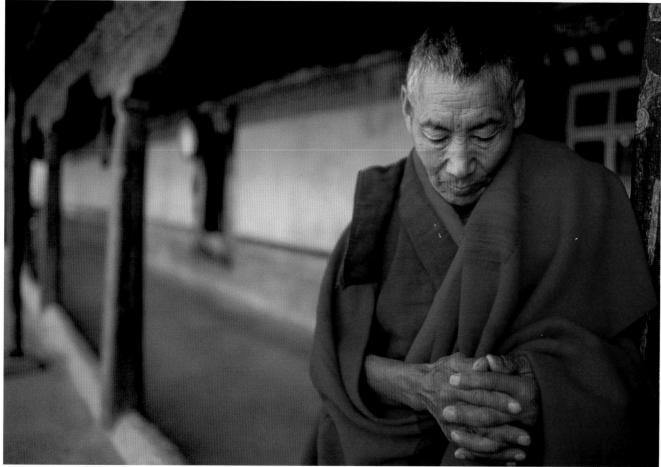

A MONK WALKS ALONG THE ROOF OF THE JOKHANG TEMPLE ON THE WAY TO HIS ROOM. ■ A MONK IN A MOMENT OF REFLECTION ON THE ROOF OF THE JOKHANG TEMPLE.

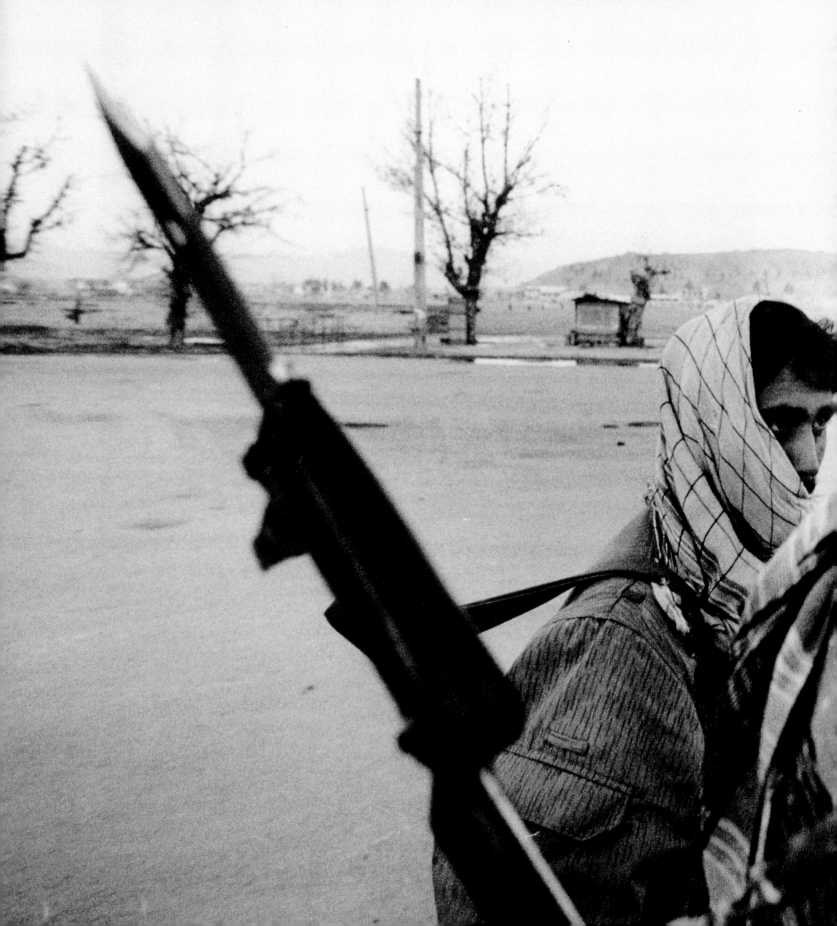

Luigi Baldelli

Afghanistan
in Transition

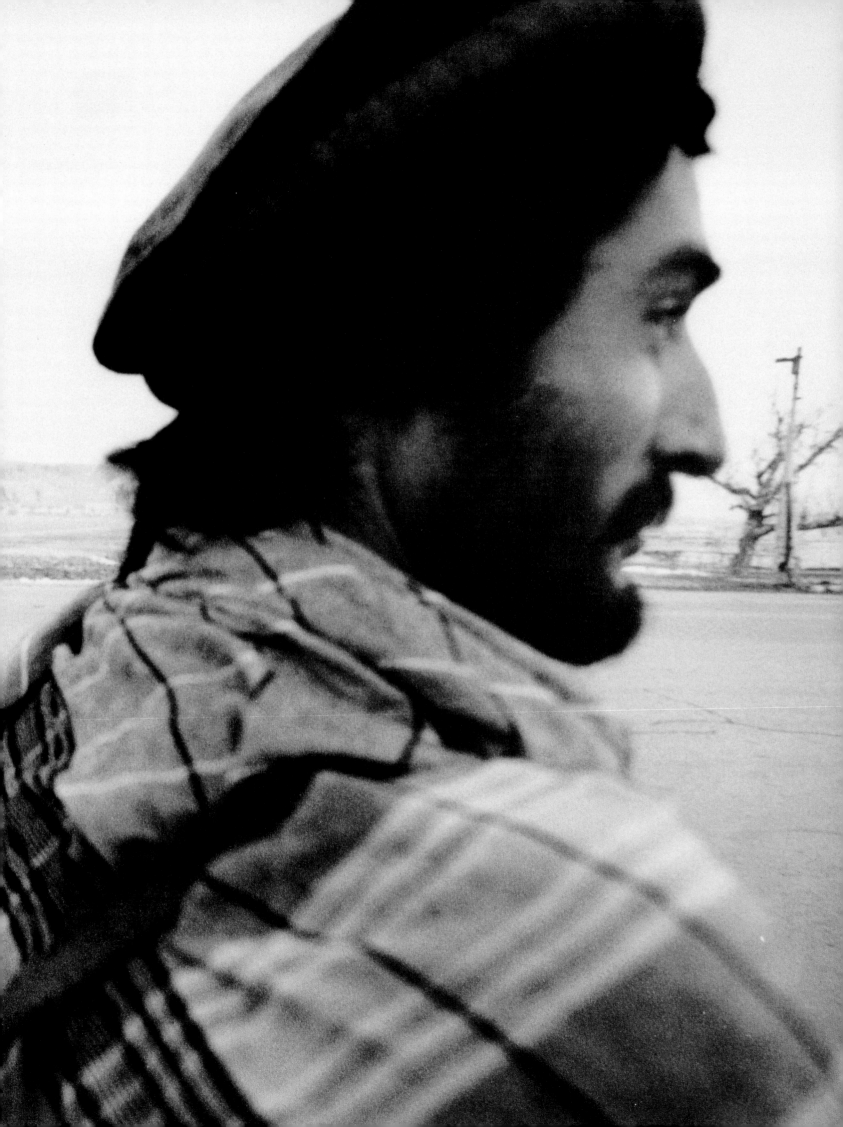

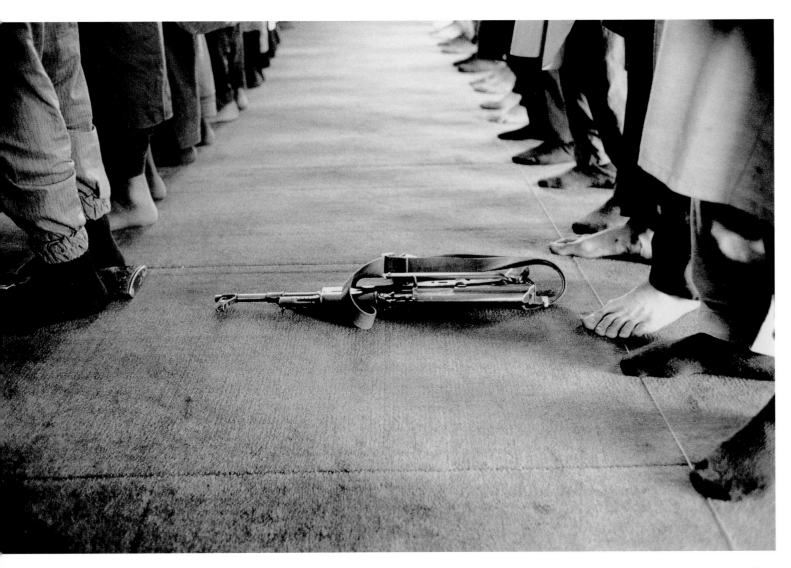

I arrived in Kabul in December 1995, while the city was still being bombed by the Taliban, who were stationed outside of the city. People tried to live their lives as usual: markets were open, even if the prices of goods were high; the women walked the city freely in search of food for their families, while men met and chatted at cafes, or searched for firewood with their children. But at 5:00 p.m. the streets were deserted and the city became a ghost town. As of 10:00 the curfew began and only soldiers remained in the streets. The night was filled with the sounds of machine-gun fire and explosions.

Photojournalism means immediacy, but I try to imbue my images with consistency, strength, and meaning, in order to hold the viewers' attention. We live, as everyone knows, in a world full of images, which the media use to various ends. Many of these images, however, do not possess a strength or character of their own, and leave no lasting imprint. Photographs, and photojournalism in particular, must encourage thought and reflection. A photojournalist has the great opportunity of being in the midst of events, and therefore must attempt to make them live for others as well. Photojournalism bears witness to the social. The challenge is not to fall into easy traps, not to lose the emotional spontaneity and the authenticity of the event. *Representative: Contrasto/Saba Photo Agency*

(PREVIOUS PAGE) MUJAHEDINS, AFGHANISTAN'S ARMED FORCES, KABUL. ■ (THIS PAGE) FRIDAY PRAYER. ■ (OPPOSITE PAGE) FRIDAY PRAYER. ■ GRENADE VICTIM. ■ ROAD BLOCK FOR SENTRY POST AT CITY GATES. ■ SCHOOL FOR ORPHANS. ■ THE OBSEQUIES FOR A GRENADE VICTIM. ■ TWO MUJAHEDINS MEET IN KABUL. ■ MUJAHEDINS AT A CHECK POINT. SIGN DEPICTS DIFFERENT KINDS OF MINES. ■ A MUSLIM WOMAN LEAVING HOME IN THE CITY SUBURBS.

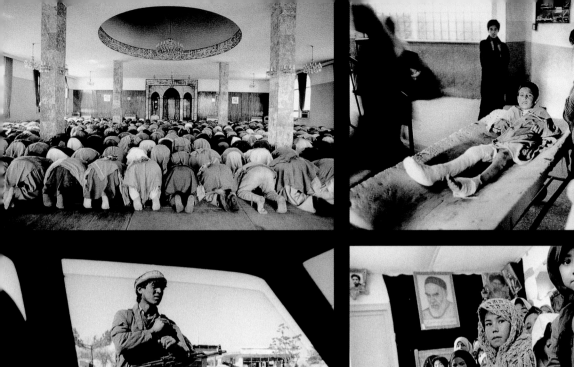
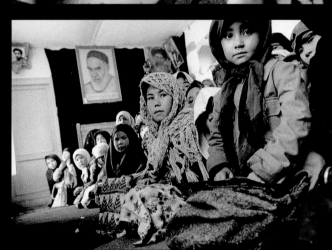
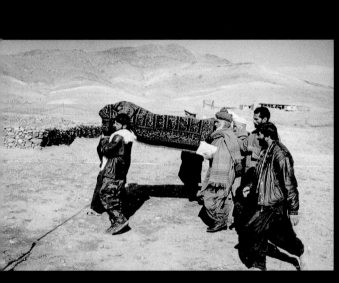
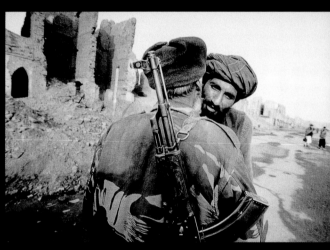
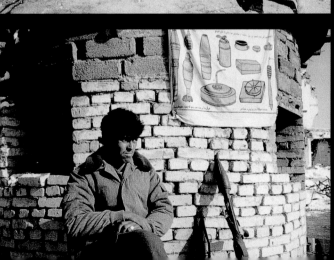
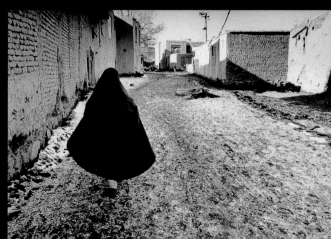

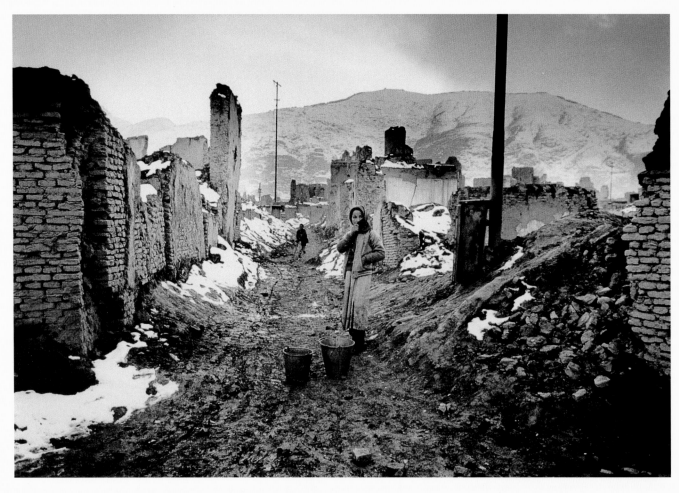

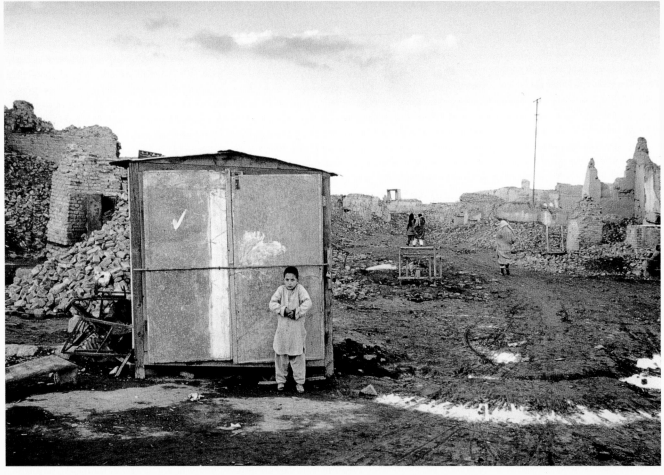

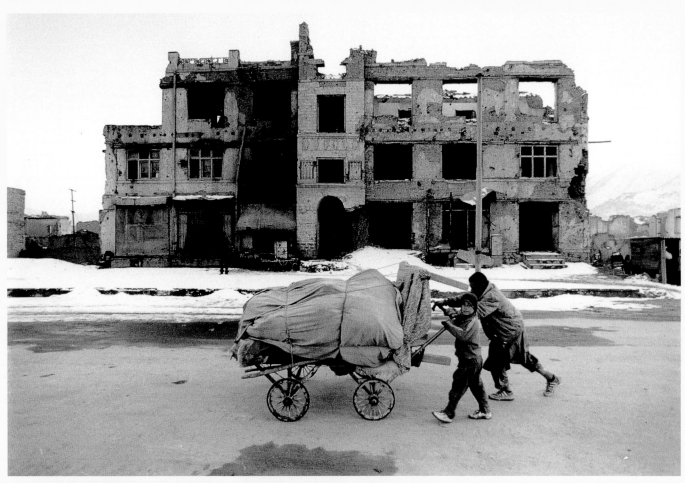

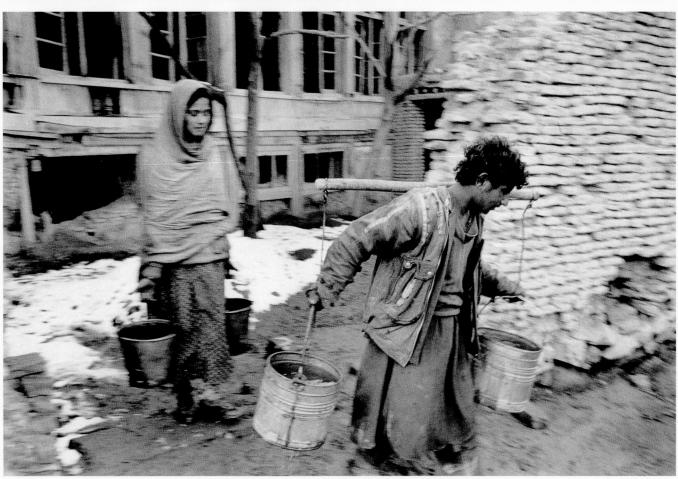

(THIS SPREAD) THE DEVASTATED CITY CENTER, KABUL.

P. F. BENTLEY

Bob Dole:
Behind the Headlines

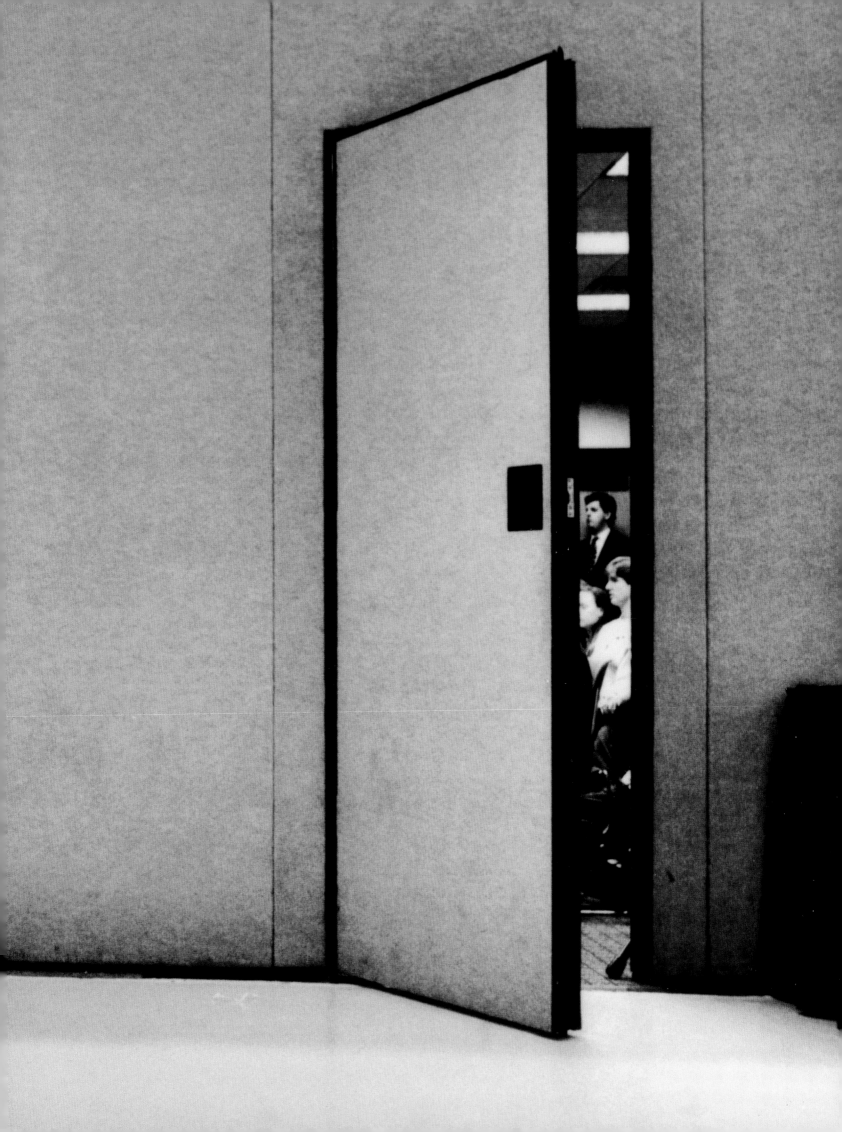

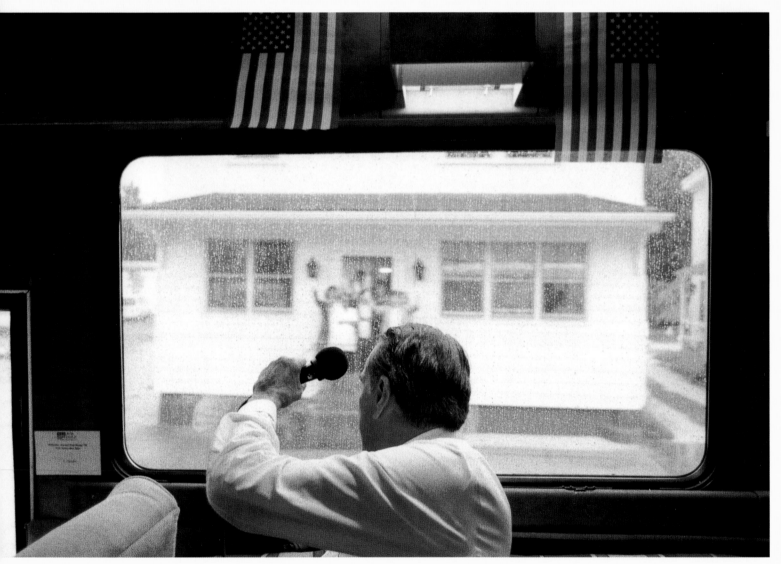

In January of 1996 I set out on an 11-month journey with Senator Bob Dole, who was running against Bill Clinton for the presidency of the United States. My goal was to record what goes on behind the scenes and away from the "photo-ops" of the campaign. Everything that happened was open to me, and no door was locked. The only rule was that I could not talk about any details overheard behind those closed doors.

Mr. Dole started the year as the Senate Majority Leader and ended it out of work for the first time in his life at the age of 73. This is the tale of that year. *Publisher:* Time, *New York*

BUDGET WOES. DOLE LISTENS INTENTLY AS SENATORS, CONGRESSMEN, AND STAFFERS WORK OUT BUDGET NEGOTIATION STRATEGY. ■ THE SOUL OF DOLE. PORTRAIT OF DOLE SITTING POOLSIDE IN TUCSON, ARIZONA. ■ PEEK-A-BOO. DOLE PEEKS AROUND THE CURTAIN TO GET A LOOK AT HIS AUDIENCE JUST BEFORE GOING ON STAGE IN BANGOR, MAINE. ■ DOLE AND LEADER. DOLE CONFIDES IN HIS DOG LEADER ABOUT WHAT DAY HE'LL ANNOUNCE THAT HE IS QUITTING THE

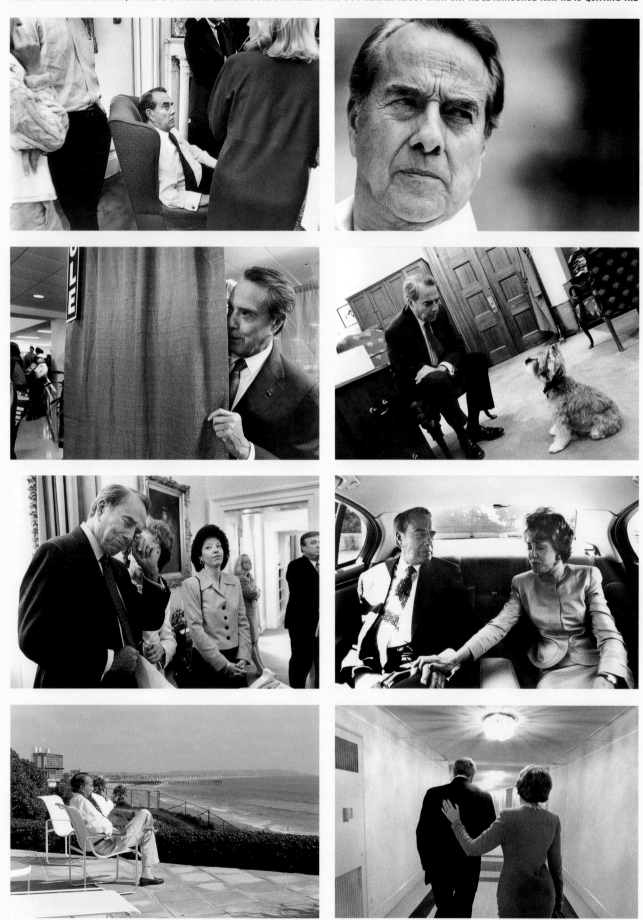

SENATE. ■ HE'S LEAVING. EMOTION OVERCOMES DOLE AFTER A MOVING TRIBUTE FROM SENATOR CONNIE MACK UPON HIS ANNOUNCEMENT THAT HE IS LEAVING THE SENATE. ■ THE LAST RIDE. THE SENATOR AND MRS. DOLE RIDE QUIETLY TOGETHER ON THE WAY TO CAMPAIGN HEADQUARTERS AFTER LEAVING THE SENATE FOR THE LAST TIME. ■ CONVENTION. DOLE PONDERS CHANGES IN HIS NOMINATION ACCEPTANCE SPEECH ON THE PATIO OVERLOOKING THE OCEAN IN LA JOLLA, CALIFORNIA. ■ THE LONG WALK. THE DOLES WALK DOWN THE HALL TO THEIR APARTMENT AFTER HIS SPEECH CONCEDING THE RACE TO CLINTON ON ELECTION NIGHT.

DONNA BINDER

The Burning of
African-American
CHURCHES

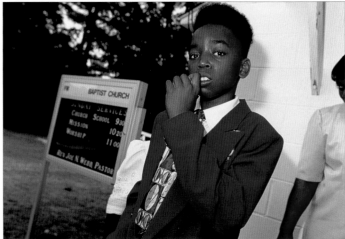

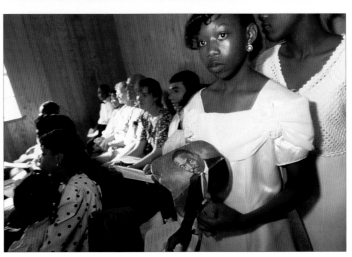

Between January and June of 1996 more than 28 fires occurred in churches in the southern United States. The churches were mostly rural and historically black and multicultural.

In Alabama a fire was set two days before the commemoration of the Selma demonstration that paved the way for the passage of the 1965 Voting Rights Act. Thirteen fires were set in January around the time of the Martin Luther King, Jr. holiday. Amid debates over whether the attacks were racially motivated, it has been mostly young white males (some with Ku Klux Klan ties) who have been charged in connection with the fires. *Representative: Impact Visuals*

(THIS PAGE) REV. AIKEN RUTH AT BURNED ROSEMARY CHURCH, BARNWELL COUNTY, SOUTH CAROLINA. ■ AFTER FIRE DESTROYED LITTLE ZION CHURCH IN BOLIGEE, ALABAMA, SERVICES ARE HELD IN NEARBY FORKLAND. ■ SURVEYING THE DEBRIS AT THE SITE OF A FIREBOMBED CHURCH, SOUTH CAROLINA. ■ WEDDING SERVICE FOR THE SON OF THE DEACON OF LITTLE ZION CHURCH, BOLIGEE, ALABAMA, HELD ACROSS TOWN AFTER THE CHURCH WAS DESTROYED BY FIRE. ■ *(OPPOSITE PAGE)* ROSE JOHNSON OF THE CENTER FOR DEMOCRATIC RENEWAL AND RON DANIELS OF THE CENTER FOR CONSTITUTIONAL RIGHTS AT A GATHERING IN WASHINGTON, D.C., FOR PASTORS OF THE BURNED CHURCHES. ■ ROSEMARY BABTIST CHURCH AFTER FIRE ATTACK, BARNWELL COUNTY, SOUTH CAROLINA.

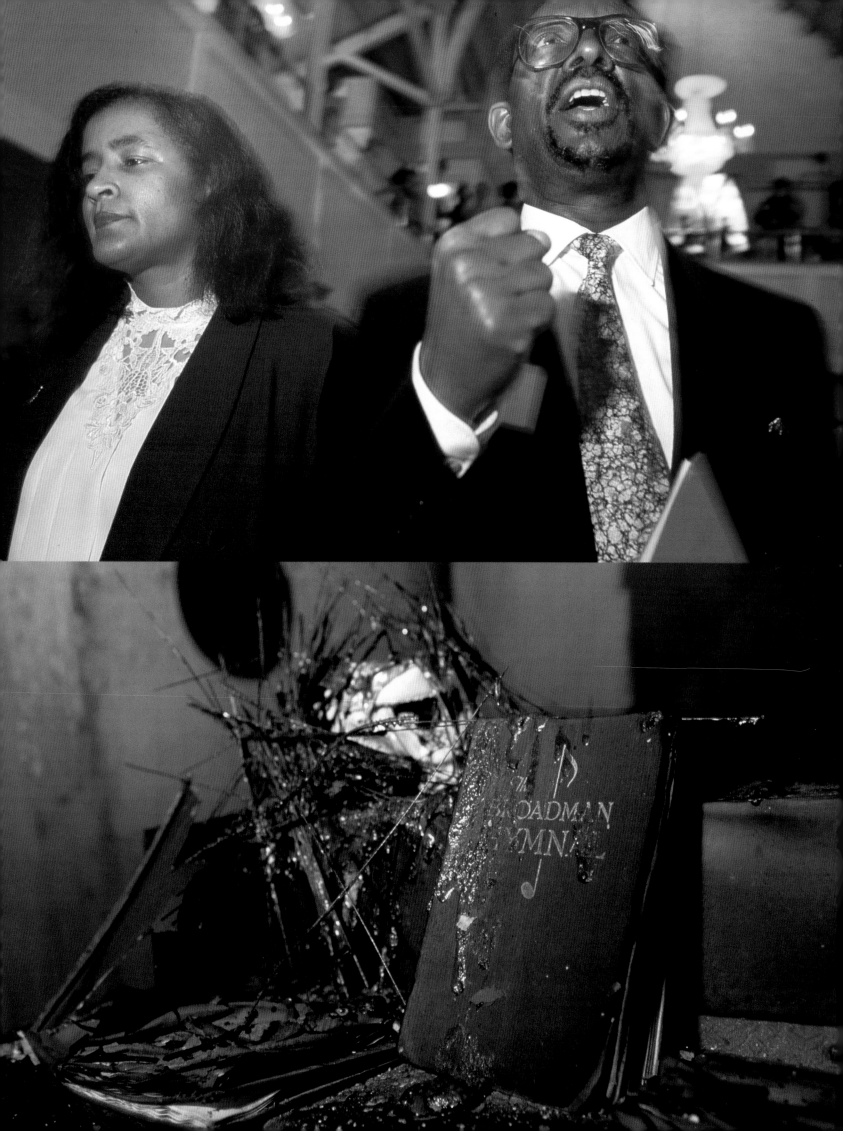

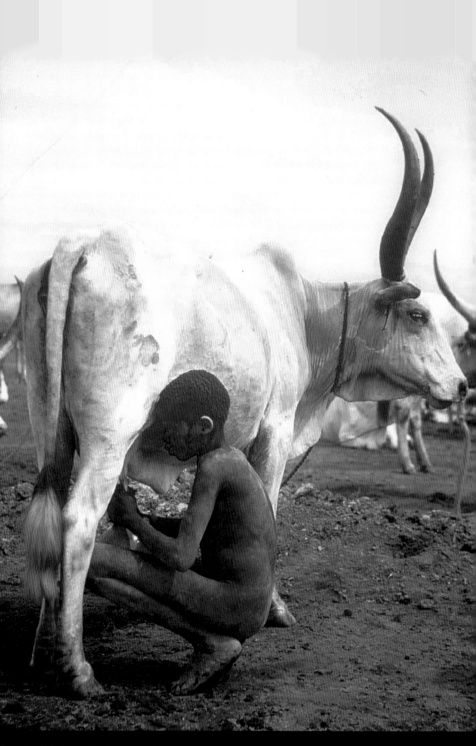

For the Dinkas, the largest tribe in southern Sudan, a herd of cattle is not merely a source of food but a symbol of pride and a measure of wealth. The tribe tends the cattle from dawn till dusk, moving them to the water's edge, burning dung to keep the mosquitoes away, cleaning their coats with ash to discourage ticks, and finally sleeping alongside the herds to ward off predators.

Unmarried Dinka men hold an annual contest, if milk supplies permit, gorging themselves on the cattle's milk daily for up to three months to become as fat as possible. In this way they make themselves attractive to women, showing that their family's herd is large enough to spare the extra milk.

However, due to civil war in Sudan, the herds have been decimated and the contests have disappeared in many Dinka areas. *Representatve: Associated Press*

DINKA GIRL MILKS A COW INTO A GOURD IN A CATTLE CAMP NEAR TWIC, SUDAN. MILK IS AN ESSENTIAL PART OF THE DINKA DIE

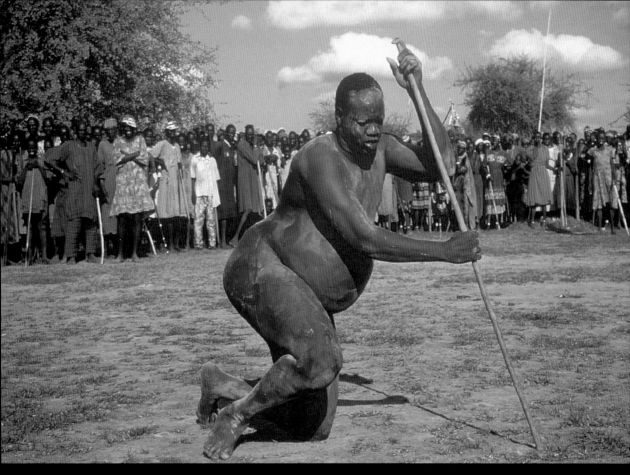

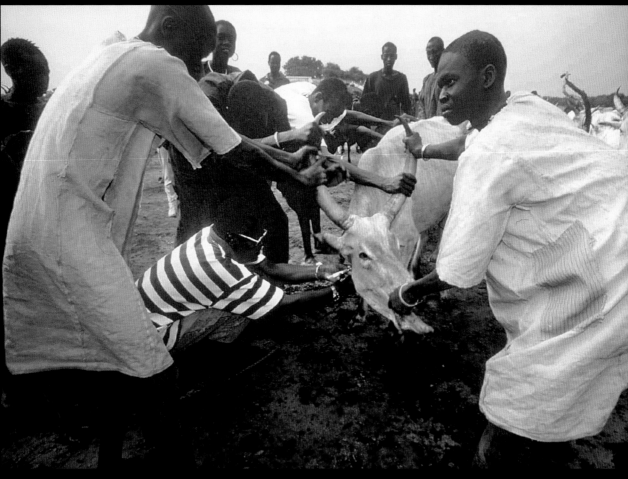

MAYOK MAYEN, 25, LEANS ON A WALKING STICK AS HE STANDS UP AFTER FALLING TO HIS KNEES DURING A CONTEST TO CHOOSE THE FATTEST DINKA MALE IN PIYIIR, SUDAN. THE DINKA FEEL THAT BEING THE FATTEST IS A SIGN OF WEALTH AND ATTRACTS WOMEN. ■ VETERINARIAN GEORGE WERE, WEARING STRIPES, DRAWS BLOOD FROM A COW IN A CATTLE CAMP IN THIET, SUDAN.

JEAN-MARC BOUJU

FEMALE CIRCUMCISION

 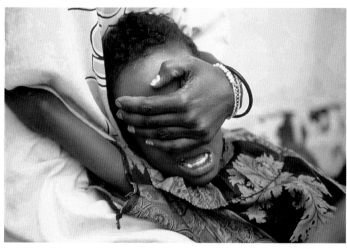

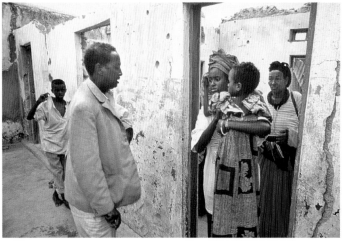 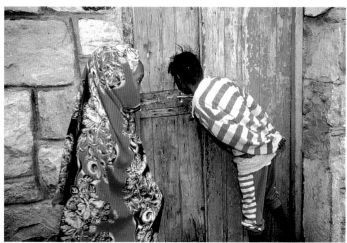

The World Health Organization estimates that up to 120 million females alive today in at least three dozen countries have been circumcised. UNICEF says that most girls are between the ages of four and 10 when they undergo the rite. Six-year-old Hudan Mohammed Ali is no exception. With the aid of Hudan's grandmother and sister, a *gudniin*, or traditional circumciser, struggles to cut the genitals of the writhing and shrieking girl. Earlier Hudan had been asking for the procedure so that she would fit in with other girls and be accepted by society. In the practicing countries of Africa, the Middle East, and Southeast Asia, women who are not circumcised are considered less desirable—the promise of a circumcised virgin brings a higher bride price or dowry. However, the procedure, considered by Westerners as torture, child abuse, and a violation of human rights, often can result in infection, difficult childbirth, or even death. *Representative: Associated Press*

HALIMO MOHAMOUD OBAHLEH, A CIRCUMCISER, ACCOMPANIES A STILL-YAWNING HUDAN MOHAMMED ALI, BEFORE BEGINNING HUDAN'S CIRCUMCISION EARLY IN THE MORNING IN HER HOUSE IN HARGEISA, SOMALIA. HOUDAN'S GRANDMOTHER IS AT LEFT. ■ HUDAN MOHAMMED ALI, AGE SIX, SCREAMS IN PAIN WHILE UNDERGOING CIRCUMCISION IN HARGEISA, SOMALIA. HER SISTER FARHYIA MOHAMMED ALI, 18, HOLDS HER SO SHE CANNOT MOVE. ■ RELATIVES OF HUDAN MOHAMMED ALI GATHER TO SEE HUDAN AFTER THE COMPLETION OF HER CIRCUMCISION. ■ TWO NEIGHBOR GIRLS, ATTRACTED BY HUDAN'S SCREAMS, TRY TO GET A LOOK THROUGH THE DOOR OF HER HOUSE. (OPPOSITE PAGE) CIRCUMCISER HALIMO MOHAMOUD OBAHLEH WASHES HER HANDS AFTER THE CIRCUMCISION. AT LEFT IS HUDAN'S GRANDMOTHER, FATUMA ISMAIL MOHAMOUD, WHO ASSISTED IN THE OPERATION. ■ HUDAN LIES WITH HER LEGS TIED AFTER HER CIRCUMCISION IN HARGEISA, SOMALIA. SHE WILL STAY TIED UP FOR AT LEAST ONE WEEK, EATING ONLY STICKY RICE TO PREVENT HER FROM URINATING.

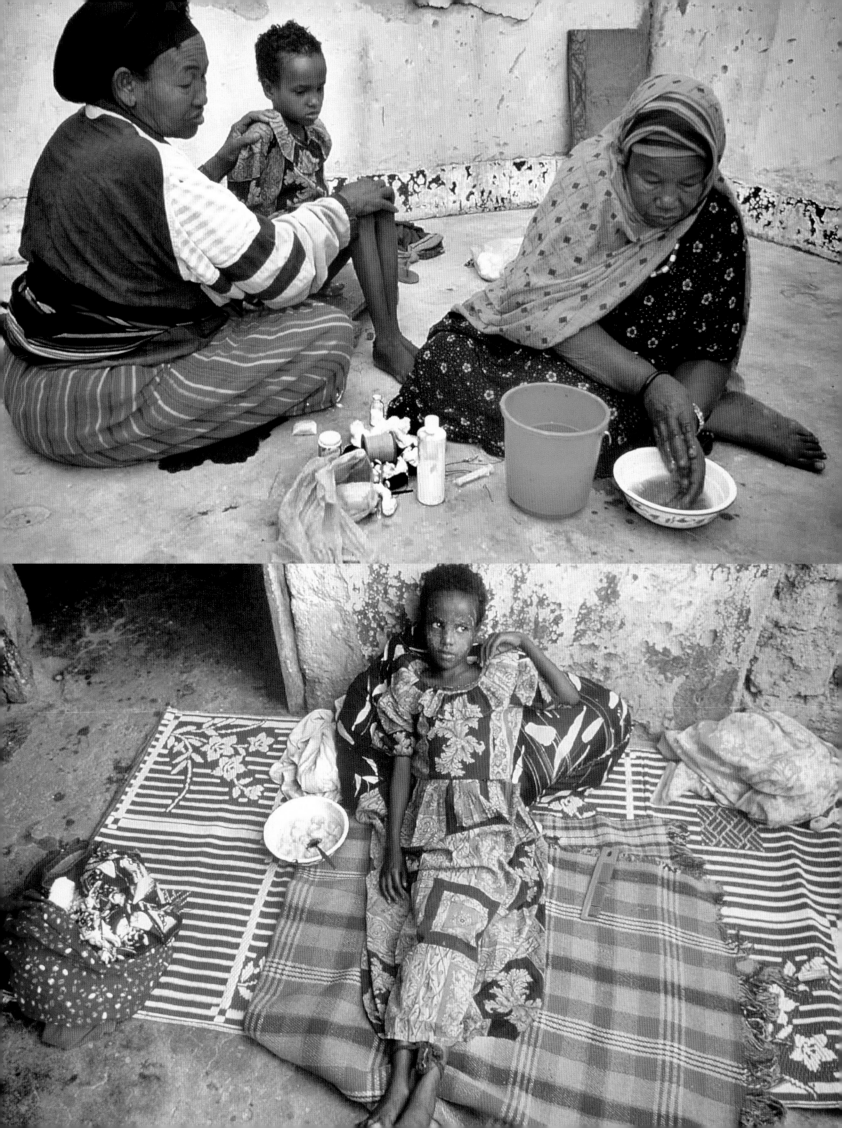

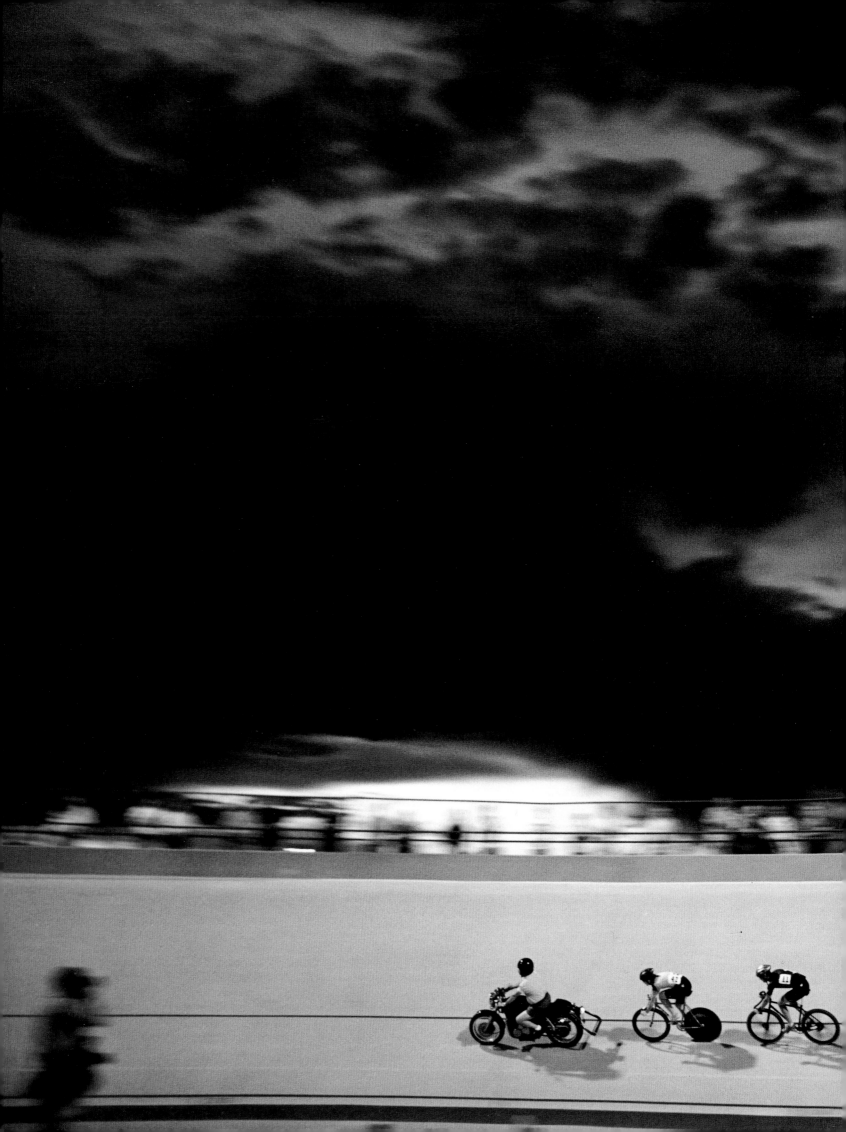

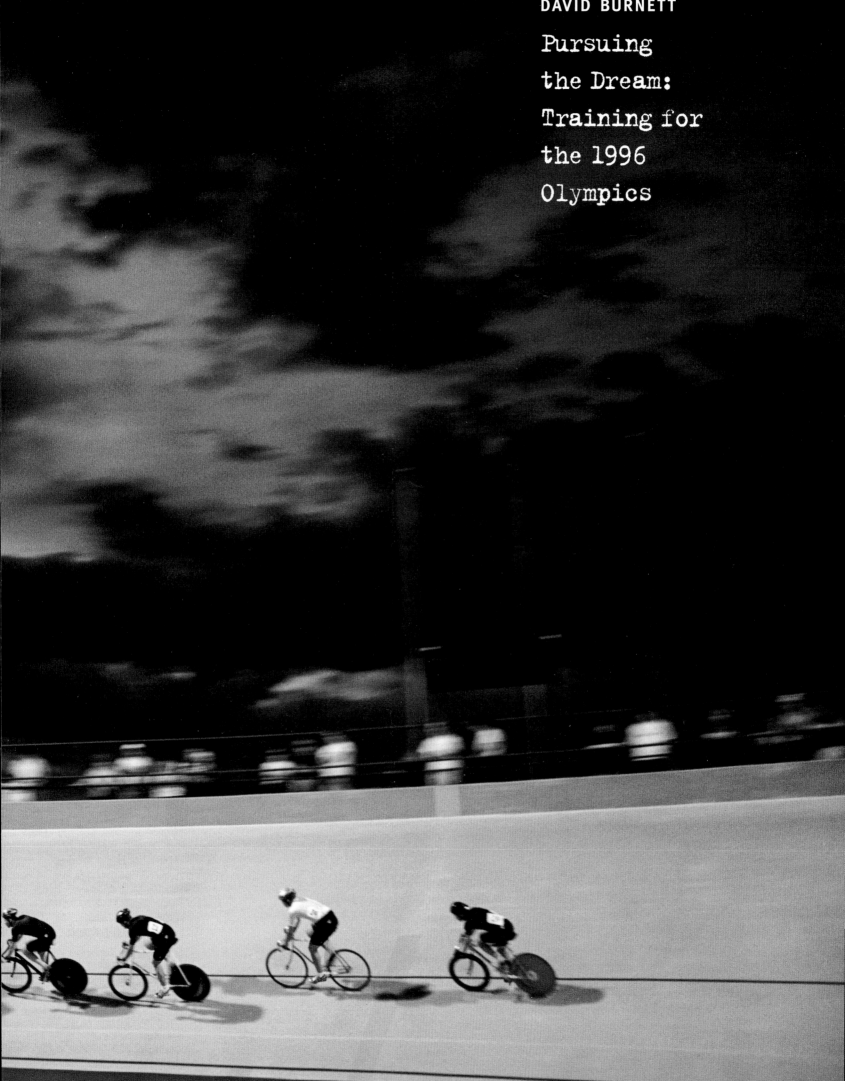

DAVID BURNETT

Pursuing
the Dream:
Training for
the 1996
Olympics

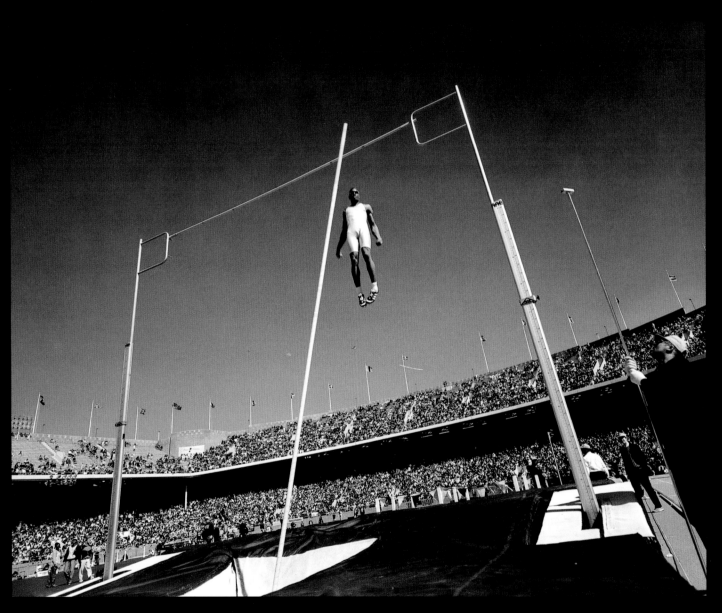

For a year leading up to the Atlanta Olympics, David Burnett photographed numerous events involving Olympic hopefuls in an effort to convey the emotional intensity of preparing for the Games.

His photo essay was featured, along with quotes from former Olympic champions, in *Time* magazine's special Olympic preview issue. *Representative: Contact Press Images/ Publication:* Time, *Summer 1996 Special Issue, New York*

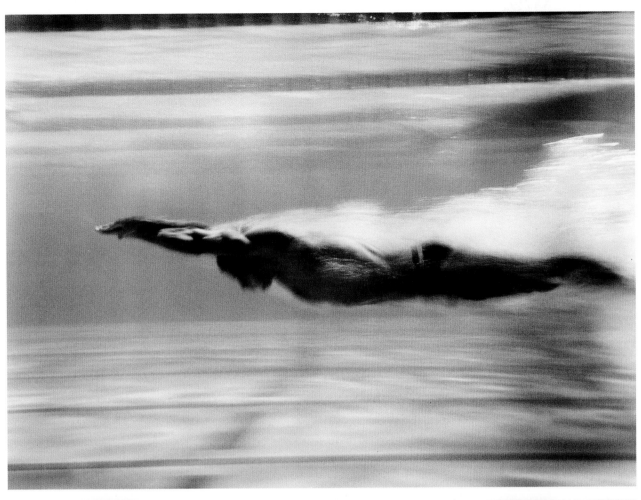

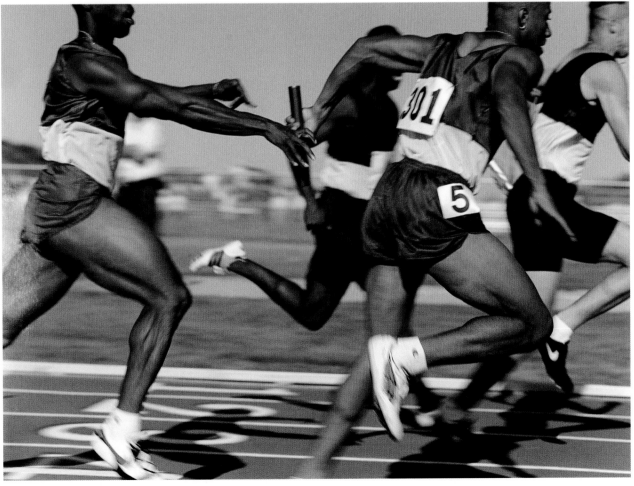

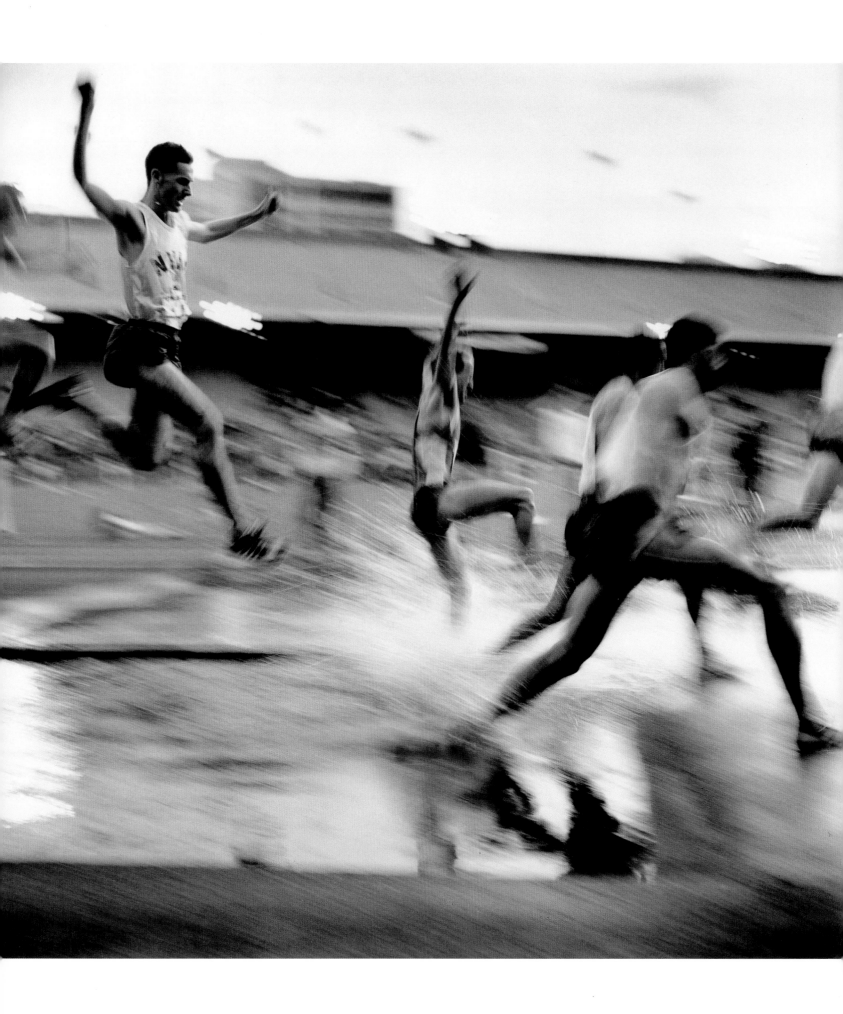

(OPPOSITE PAGE) PHILADELPHIA, PENNSYLVANIA PENN RELAYS. MEN'S STEEPLECHASE COMPETITION. ■ (THIS PAGE) FT. LAUDERDALE, FLORIDA INVITATIONAL DIVING MEET. DIVER DEAN PANARO DIVES FROM THE FIVE-METER PLATFORM. ■ ATLANTA, GEORGIA OLYMPIC GAMES. PHOTOGRAPHERS AND RUNNERS LINE UP AT THE BEGINNING OF THE

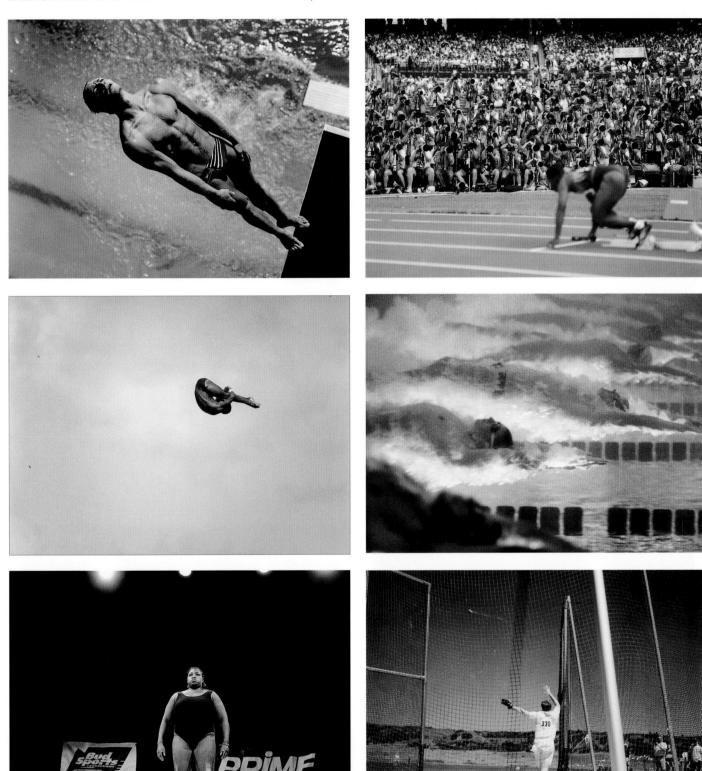

WOMEN'S 4X400. ■ FT. LAUDERDALE, FLORIDA INVITATIONAL DIVING MEET. MALE DIVER TUCKS AS HE LEAVES THE TEN-METER PLATFORM. ■ PHOENIX, ARIZONA SPEEDO INVITATIONAL SWIM MEET. MEN'S FREESTYLE COMPETITION. ■ COLORADO SPRINGS, COLORADO OLYMPIC FESTIVAL. HEAVYWEIGHT-CLASS WEIGHT LIFTER PREPARES FOR HER LIFT. ■ A COLORADO SPRINGS, COLORADO OLYMPIC FESTIVAL. MEN'S HAMMER THROW COMPETITION.

David Butow

Days and Nights on
HOLLYWOOD BOULEVARD

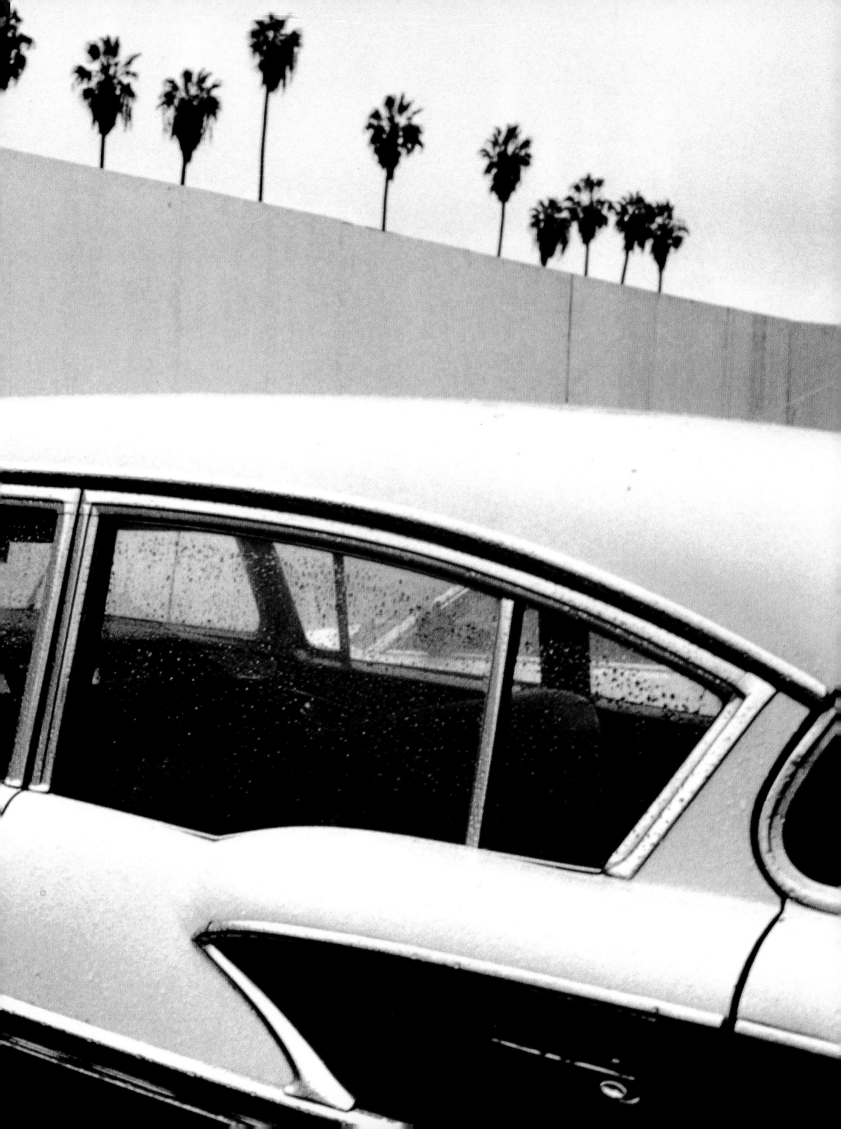

Hollywood Boulevard remains one of the most popular tourist attractions in Los Angeles. Busloads of sightseers from around the world flock to Mann's Chinese Theater to look at the hand and foot imprints of movie stars, past and present. Visitors scan the sidewalk—called the "Walk of Fame"—searching for the names of their favorite actors and celebrities, hoping to touch a bit of Tinsel Town glamour.

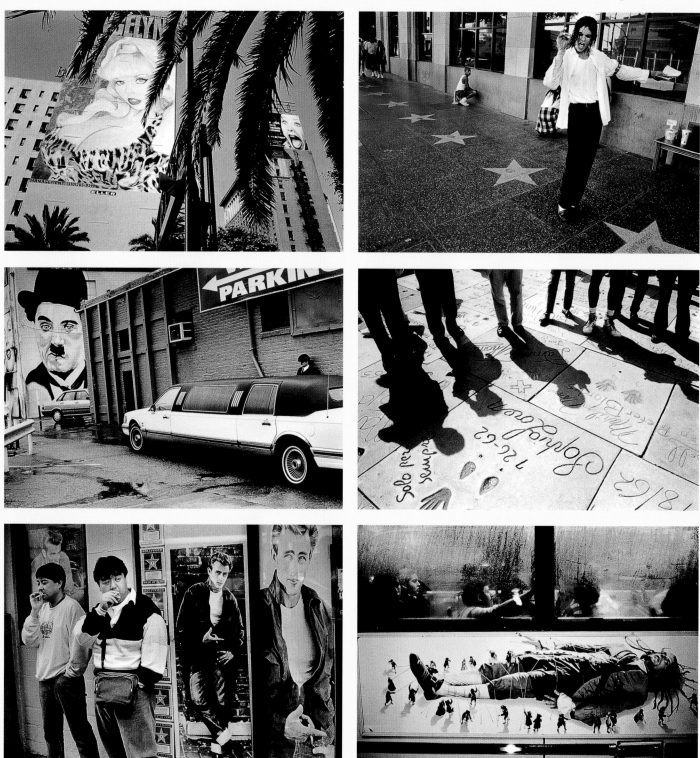

Others come to these streets to live, work, panhandle, or just to hang out. Their dreams are simpler: a good job, a nice apartment, a mate to share these things with. Another group—street performers of all kinds—are here in the hope that they will get their big break in show business. For most of them, this is as likely as a tourist from Des Moines getting to have lunch with Mel Gibson. The glamour of Hollywood today is as two-dimensional as a poster of Marilyn Monroe.

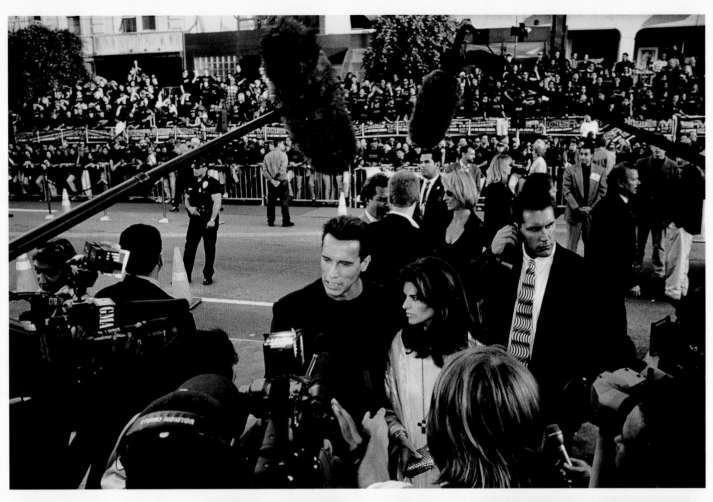

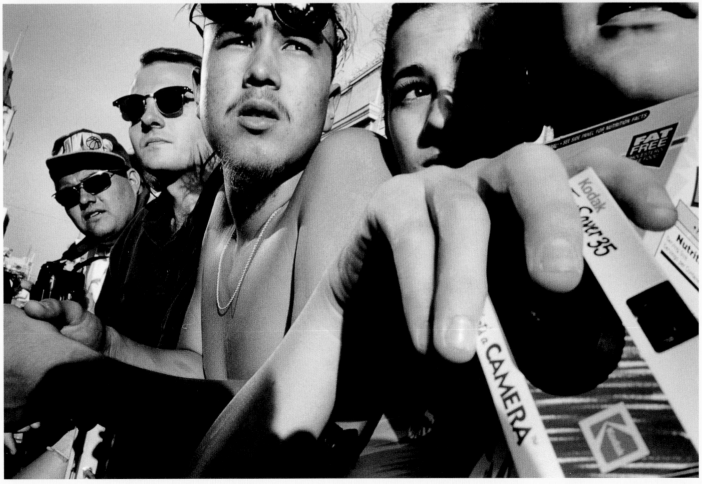

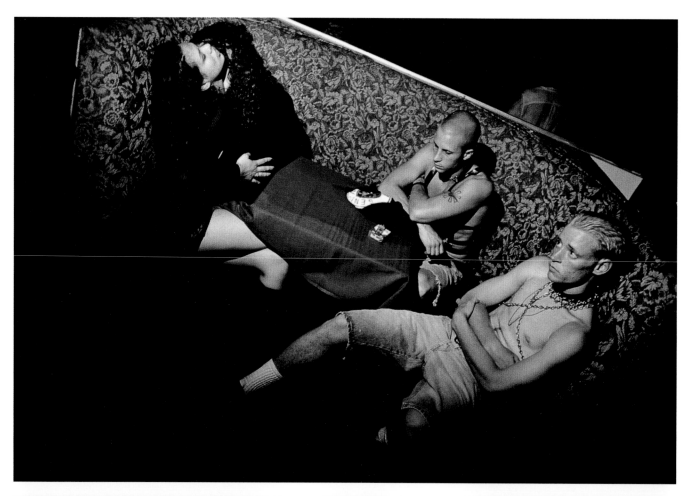

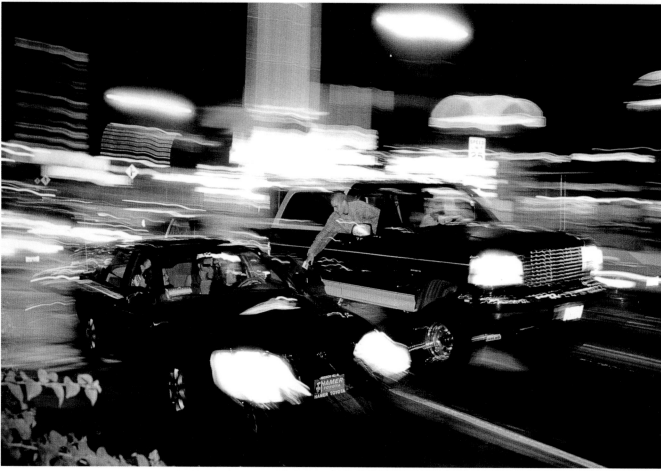

THESE TWO YOUNG MEN BROUGHT THEIR FEMALE DATES TO A CLUB, ONLY TO FIND THAT THE GIRLS WERE MORE INTERESTED IN EACH OTHER. ■ MANY TEENAGERS
CRUISE THE BOULEVARD ON FRIDAY AND SATURDAY NIGHTS, HOPING TO FIND ROMANTIC PARTNERS.

HOLLYWOOD BOULEVARD IS OFTEN A SHOWCASE OF MASS CULTURE: FAST FOOD, ROCK AND ROLL, AND SHOW BUSINESS. ■ WOMAN LIGHTS A CIGARETTE IN A NEAR-EMPTY BAR. ■ SOMETIMES, FOR THOSE WHO ARE UNEMPLOYED AND HAVE NO FAMILY SUPPORT, THE BEST SLEEPING SHELTER IS A CAR. ■ DESPERATE CIRCUMSTANCES OFTEN GET STREET

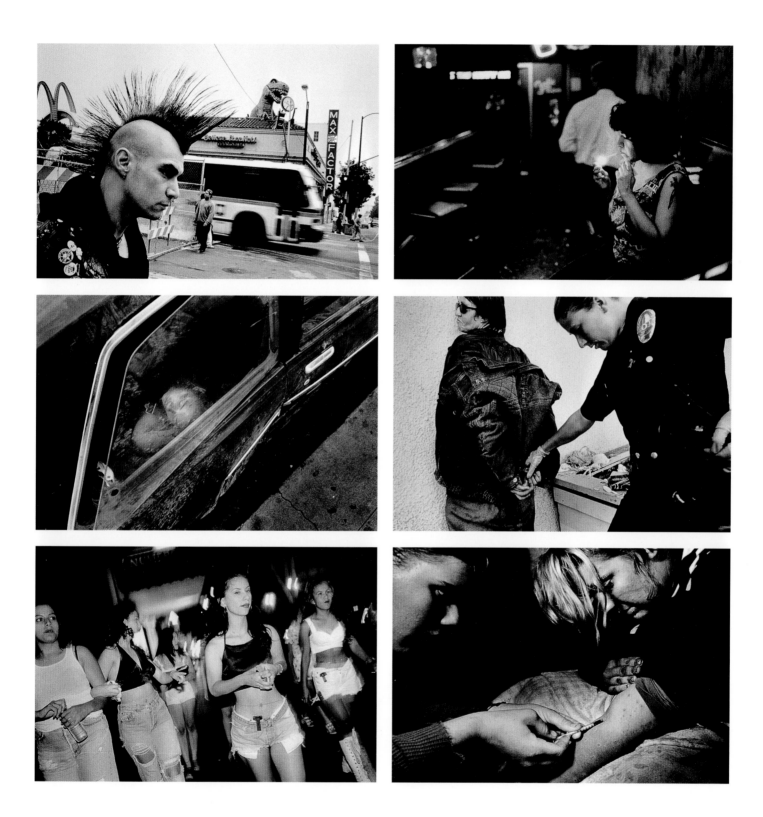

PEOPLE IN TROUBLE WITH THE POLICE. ■ HISPANIC TEENAGE GIRLS WALK THE STREETS WEARING BEEPERS AND REVEALING CLOTHES TO GET ATTENTION FROM BOYS. ■ DRUG ABUSE IS COMMON IN THE COMMUNITY. HERE, A MAN INJECTS SPEED INTO THE VEINS OF HIS FEMALE FRIEND.

WILLIAM CAMPBELL

INDIAN SUMMER

In the summer of 1996 photographer William Campbell spent seven weeks with 40 teenagers and a group of counselors from the Cheyenne River Sioux tribe taking part in a Healthy Nations project called Wolakota Yukini Wicoti—a camp designed to renew the spirit and culture of the Lakota people.

The camp was conceived by and for Native Americans, relying on local resources. Many of the Lakota teenagers were refugees from alcoholic families, foster homes, and the emerging reservation gangs. They were there to help break a grim cycle of abuse and despair by living as their ancestors had—sleeping in teepees, traveling on horse-back, and learning their once-forbidden language, songs and traditions. *Publication:* Time, *New York*

PREVIOUS SPREAD) A DAY ENDS IN PEACE FOR THE CHILDREN OF THE SEVENTH GENERATION AT THE HEALTHY NATIONS CAMP IN BLACKFOOT, SOUTH DAKOTA. THE CAMPERS ARE TAUGHT THAT THEY CARRY THE KEY TO THEIR TRIBE'S FUTURE. THEY MUST UPHOLD THE TRADITIONS AND CARE FOR THE EARTH, NOT JUST FOR THEMSELVES BUT FOR SEVEN GENERATIONS TO COME. ■ (THIS PAGE) LAKOTA TEENAGERS PUT UP THEIR OWN TEEPEE. ■ CHAD WHITE FACE, 11, BUNDLES UP AGAINST THE DAWN CHILL. ■ (OPPOSITE PAGE) SIOUX CHILDREN FROM HEALTHY NATIONS CAMP ON THE CHEYENNE RIVER INDIAN RESERVATION LEARN THE TRADITIONAL WAY OF SETTING UP THE TEEPEES THEY WIL

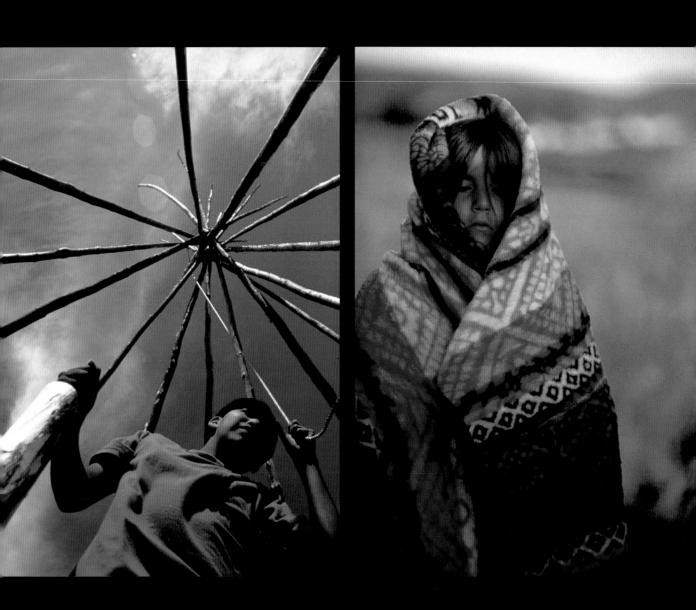

IVE IN DURING THE SUMMER. ■ ALANA MARSHALL, 20, WITH HER ADOPTED HORSE, CODA. ■ LOGAN STENGAL, 16, AIMS A BOW AND ARROW. ■ LESLIE HORN, 15, LEARNS TO RIDE A HORSE FOR THE FIRST TIME. HORN, A CAMPER WHO WAS BORN WITHOUT ARMS, USED SPECIAL REIGNS WRAPPED AROUND HER SHOULDERS TO CONTROL THE HORSE AND GUIDED HIM WITH HER LEGS. ■ AN EAGLE FEATHER BUSTLE AT A POWWOW THE CHILDREN PARTICIPATED IN DURING THE SUMMER. ■ ALANA MARSHALL LEARNS O PREPARE A BISON HIDE IN THE TRADITIONAL WAY. THE CAMPERS LEARN HOW TO USE EACH PART OF THE BISON, AS THEIR FOREFATHERS DID. ■ A HEALTHY NATIONS DER HOLDS SAGE AND A BUNDLE OF SWEETGRASS USED IN A BUFFALO KILL CEREMONY. ■ DAVID ROCKY MOUNTAIN, 12, WATCHES OVER THE HEALTHY NATIONS

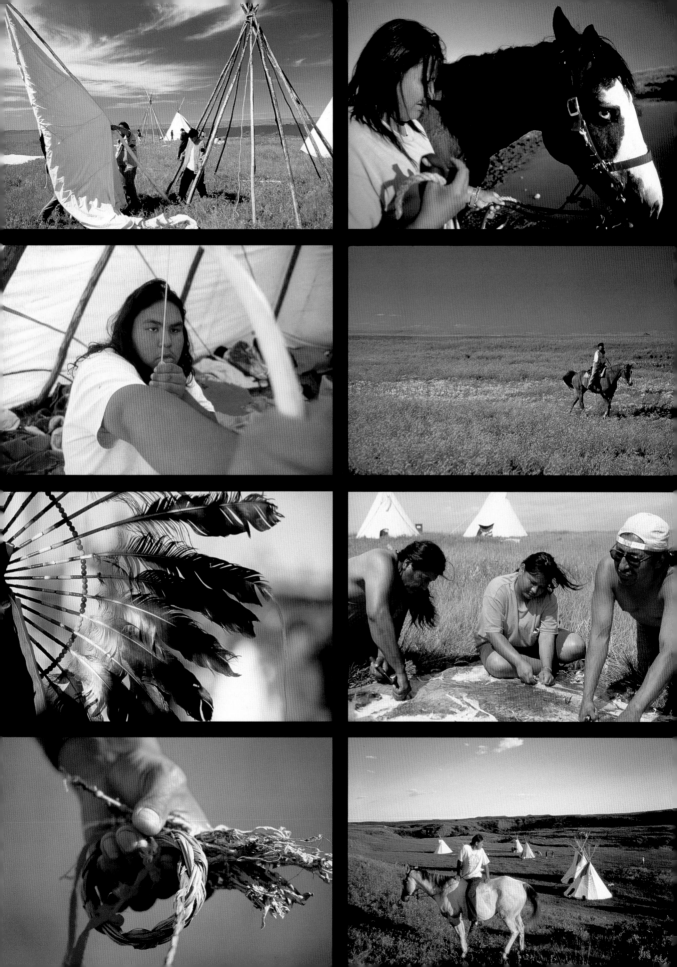

GIGI COHEN

HONG KONG—CHINA BORDER

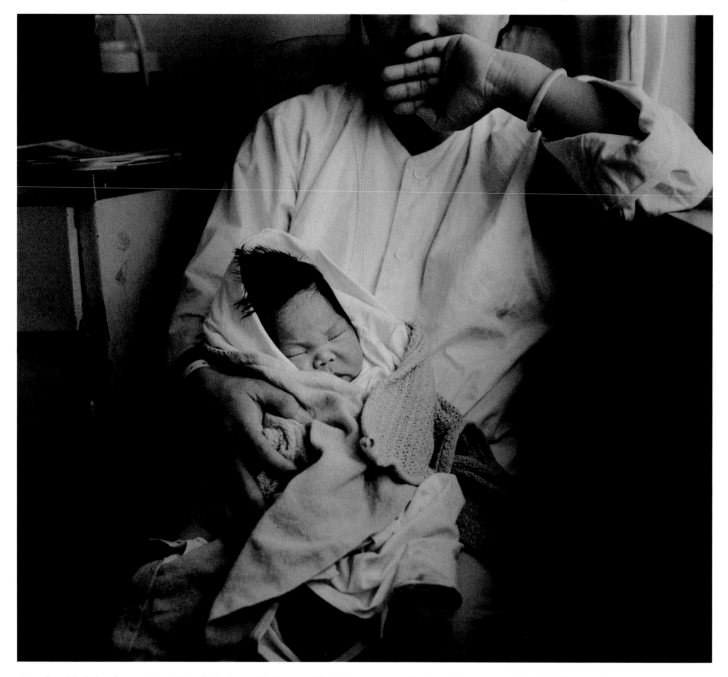

As of midnight June 31, 1997, Britain will have officially handed over Hong Kong to China. The 26-mile border that separates two vastly different ideologies—East and West, Capitalism and Communism—will undoubtedly change.

Currently the Royal Hong Kong Border Police guard the border along with the Gurkha British troops from Nepal. Their main objective is to capture illegal immigrants and send them back to China. Police fear that after the transition mainland Chinese will see it their right to enter Hong Kong freely, but in actuality, the border will remain and most will still need a special permit to enter.

Thousands of business people and tourists are allowed to cross the border every day. Daily work permits are also granted to mainland Chinese who have historically owned farmland along the border.

On the China side, the Special Economic Zone mirrors Hong Kong's capitalist ambitions. The skyline is ever changing, new factories are built, and beggars line the streets. Windows on the World, China's first big modern tourist attraction, sits along the border, and features re-creations of monuments such as the London Bridge, the pyramids of Egypt, and the Statue of Liberty. China has brought in the world, as if to say to its people that there is no need to leave.

Representative: Network Photographers, Ltd./Saba Photo Agency

(THIS PAGE) ILLEGAL IMMIGRANT WITH NEW BABY IN HONG KONG HOSPITAL, WAITING TO BE TRANSPORTED BACK TO CHINA. ■ *(OPPOSITE PAGE)* POLICEMAN DIRECTS DISABLED ILLEGAL IMMIGRANT TOWARD TRUCK GOING BACK TO CHINA. ■ ILLEGAL IMMIGRANT WAITS WITH POLICE AFTER BEING CAPTURED TRYING TO CROSS BACK INTO CHINA. ■ ILLEGAL IMMIGRANT BEING HELD FOR QUESTIONING AFTER BEING CAPTURED AT BORDER IN POSSESSION OF WEAPONS. ■ ILLEGAL IMMIGRANT IN HOLDING CELL AFTER BEING CAPTURED TRYING TO CROSS BACK INTO CHINA. ■ TWENTY-SIX-YEAR-OLD WANG XIAO MEI IN HER DORMITORY AFTER A DAY'S WORK IN A FACTORY PRODUCING HANDBAGS. ■ BORDER CHECK POINT.

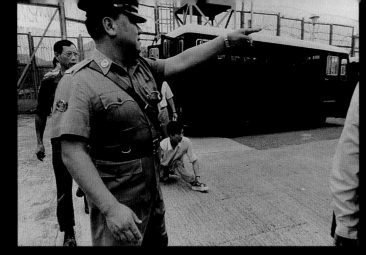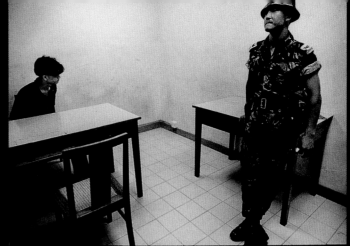
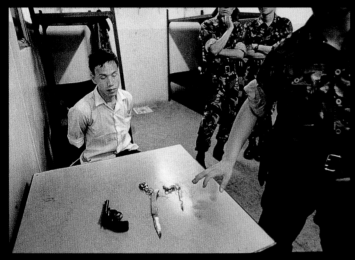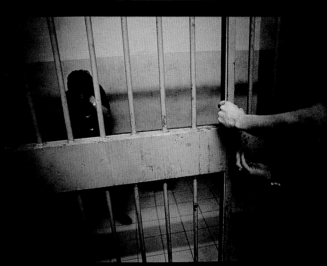
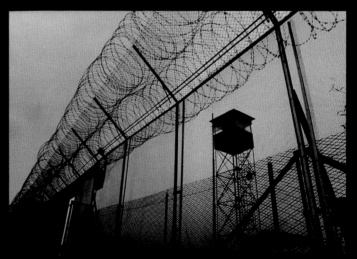

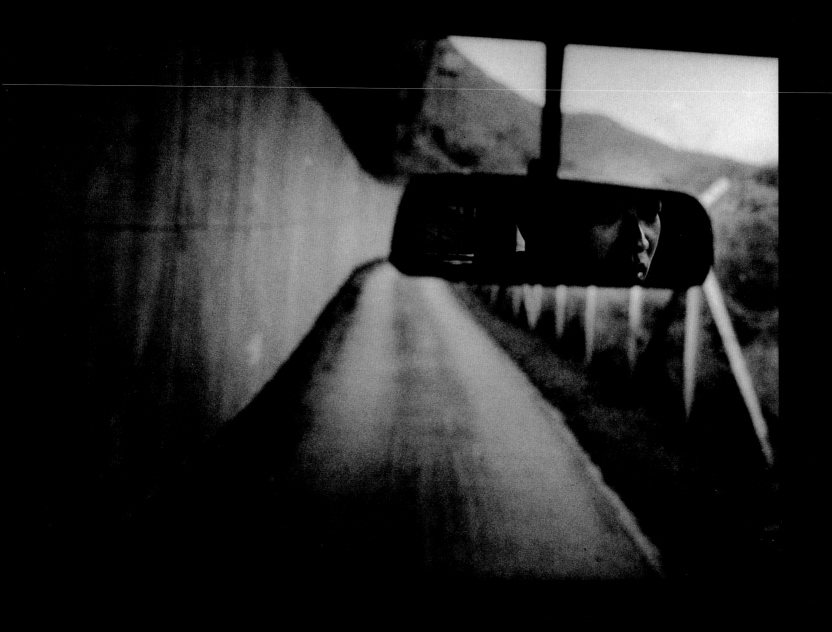

ROYAL HONG KONG BORDER POLICE PATROL THE 26-MILE-LONG HONG KONG-CHINA BORDER.

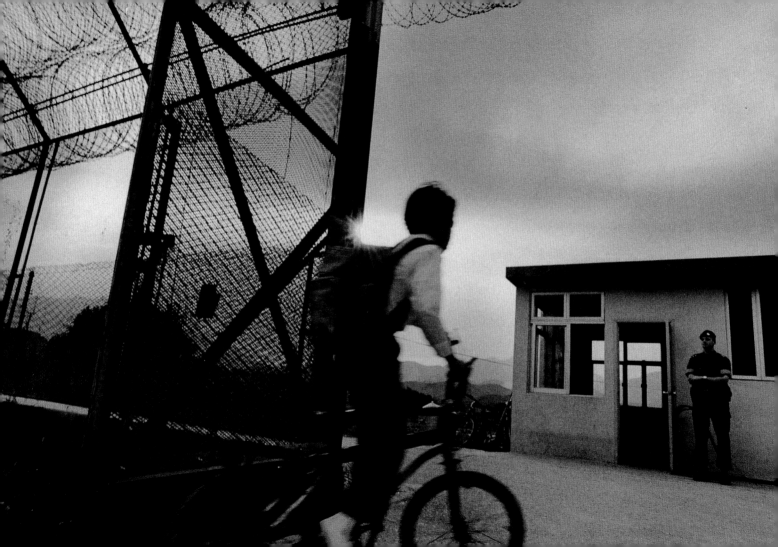

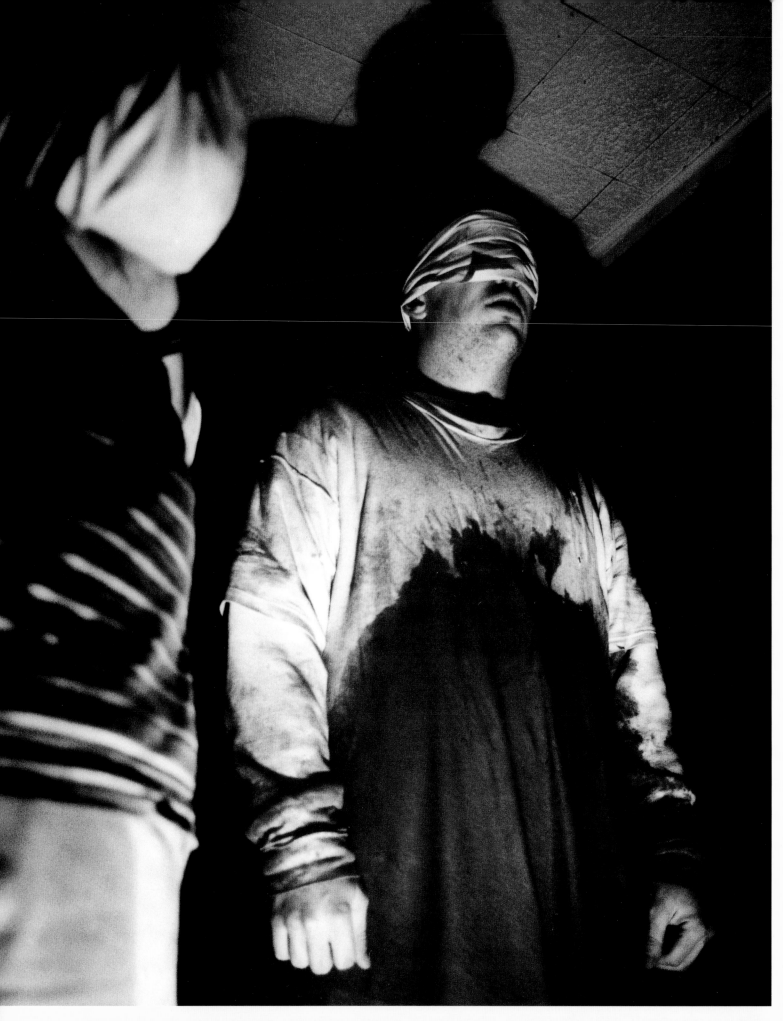

(THIS PAGE) MIND GAMES. IN A CANDLELIT ROOM, A PLEDGE WAITS—HE BELIEVES—TO BE BRANDED WITH A SECRET FRATERNITY SYMBOL. ■ *(OPPOSITE PAGE)* BIG NIGHT. IN A SPARTAN BASEMENT "PARTY ROOM," PLEDGES ACCEPT FORMAL MEMBERSHIP BY CRUSHING BEER CANS AGAINST THEIR FOREHEADS, TOSSING BEER AT THE CEILING, AND SLIDING DOWN STAIRS ON WATERFALLS OF BEER. MANY REVELERS END UP ANKLE-DEEP IN SUDS. ■ LINEUP. TEN WEEKS BEFORE INITIATION, TRAINING FOR HELL WEEK BEGINS. EACH PLEDGE RECEIVES A NUMBER, A NICKNAME, AND A SINGLE T-SHIRT TO BE WORN THROUGHOUT THE PLEDGE PERIOD, NO LAUNDERING ALLOWED. ■ BONDING. BLINDFOLDED WITH VOMIT-DRENCHED T-SHIRTS, SURVIVORS ARE DRENCHED WITH MOLASSES, THEN LED AWAY. OUT OF CROWD VIEW, OTHER MEMBERS WILL CAREFULLY URINATE ON EACH NEW

C. TAYLOR CROTHERS

HAZING DAYS

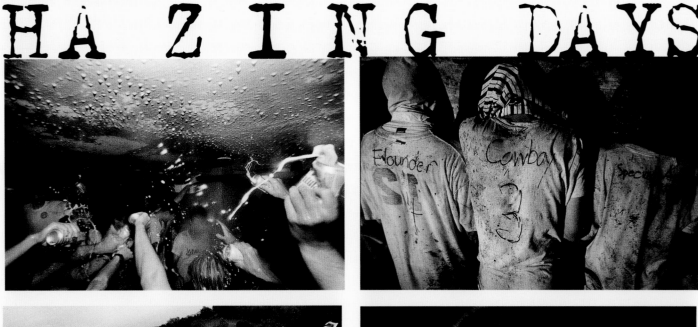

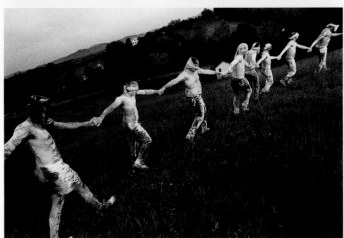

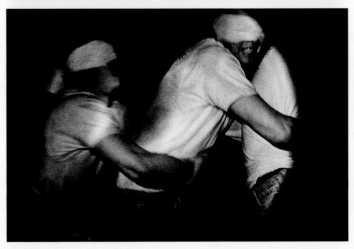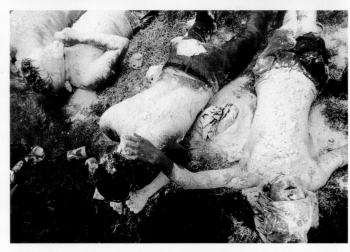

During fraternity pledge week on American campuses, many students come to classes late or not at all. Instead, they try to meet the demands of ritual initiation. They march in silent lockstep to secret meetings. They memorize the Greek alphabet backward. They chug grain alcohol mixed with mayonnaise. They turn up in shopping-mall dumpsters, blindfolded and *au naturel*. They yearn to belong.

Hazing occurs on nearly every campus every fall, and every fall, somewhere, the hazing process goes wrong, resulting in serious injuries and even death. Campus infirmaries and paramedics dread the season, when naked pledges are tied to trees, locked in car trunks, tossed in rivers, sent running through flaming gasoline.

Some pledge but quit during the so-called "Hell Week"; some decide not to buy their friends. Many who stay believe all their lives in the mystic ties of brotherhood... "Hazing is very educational about human nature," one rush chairman told me. "The nicest, politest, most churchgoing people turn out not be so mean and angry. And cruel, if you give them a little power." *Publisher:* The New York Times Magazine/*Text excerpted from accompanying article by Anne Matthews*

BROTHER. ■ ARMPIT SNACKS. HEAD COVERED BY A PILLOWCASE, ARMPITS STILL FILLED WITH PEANUT BUTTER AND GRAPE JELLY AFTER 30 MINUTES OF SIT-UPS, A CANDIDATE WAITS WHILE TWO SLICES OF WHITE BREAD MOVE UP THE PLEDGE LINE. EACH MAN SWIPES HIS SWEATY UNDERARMS WITH THE BREAD; ALL SHARE THE SANDWICH THAT RESULTS. ■ ENDURANCE. IN A DARK OFF-CAMPUS FIELD, SLEEP-DEPRIVED PLEDGES CLING TO FELLOW NEWCOMERS AS THEIR BROTHERS-TO-BE TRY TO BREAK THE HUMAN CHAIN. "OUR RIGHT AND DUTY IS TO INFLICT PAIN," A SOPHOMORE EXPLAINS. ■ FELLOWSHIP. COVERED IN FLOUR, TOO DRUNK TO STAND, CLUB INITIATES FACE A LAST ORDEAL TOGETHER. ONE SOPHOMORE IS MISSING; UNABLE TO THROW UP, HE SUFFERED IMMEDIATE ALCOHOL POISONING AND WAS RUSHED TO THE HOSPITAL FOR AN EMERGENCY STOMACH PUMP.

. NORMAN DIAZ

Home Butchering

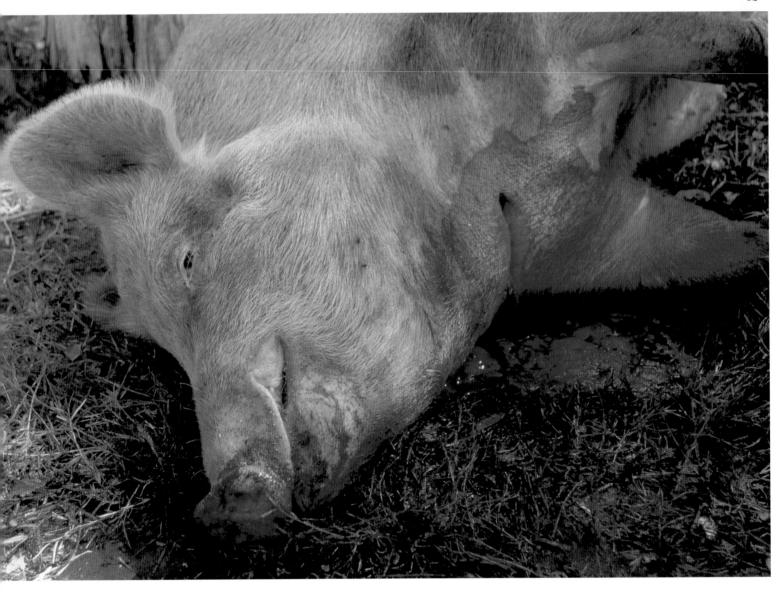

People have been farming meat for family consumption for centuries without the use of high-tech equipment, refrigeration, hormones, or mechanized tools. This manner of raising food leads to less waste of resources, happier and healthier animals, and, if you are accustomed to it, better tasting meat. The aim of these photographs—taken in rural California—is to capture the traditional art of butchering home-grown farm animals.

Most Americans have lost any sense of the connection between the pig or cow on the farm and the roast purchased at a local supermarket. The practice of home butchering is kept alive only by older generations and newer immigrants, who still have the knowledge and motivation to carry out the long process. In a few communities, it is still a neighborhood event for people of all ages.

(THIS PAGE) DEAD PIG WITH THROAT CUT. ■ *(OPPOSITE PAGE)* SCRAPING THE OUTSIDE OF THE PIG TO REMOVE HAIR. ■ SKINNING AND CLEANING THE CARCASS. ■ REMOVING INTESTINES AND ORGANS. ■ SOCIALIZING WHILE THE MEAT COOKS. ■ SEPARATING PARTS OF THE ANIMAL FOR DIFFERENT USES. ■ COOKING AND SOCIALIZING IN THE KITCHEN.

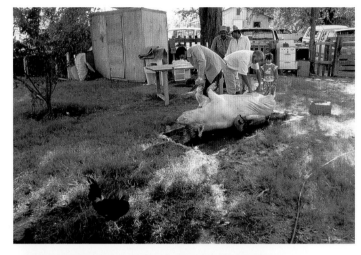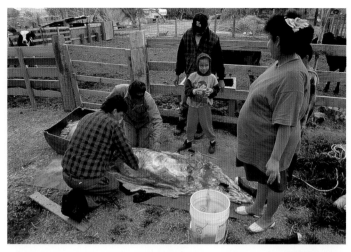

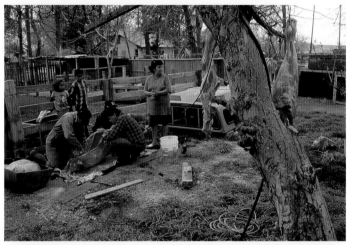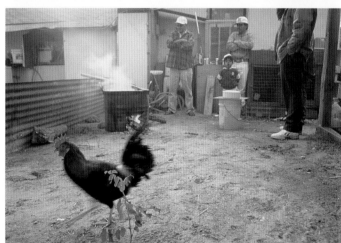

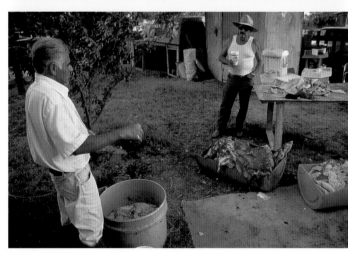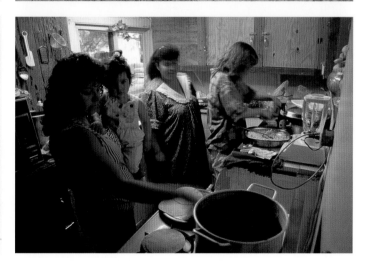

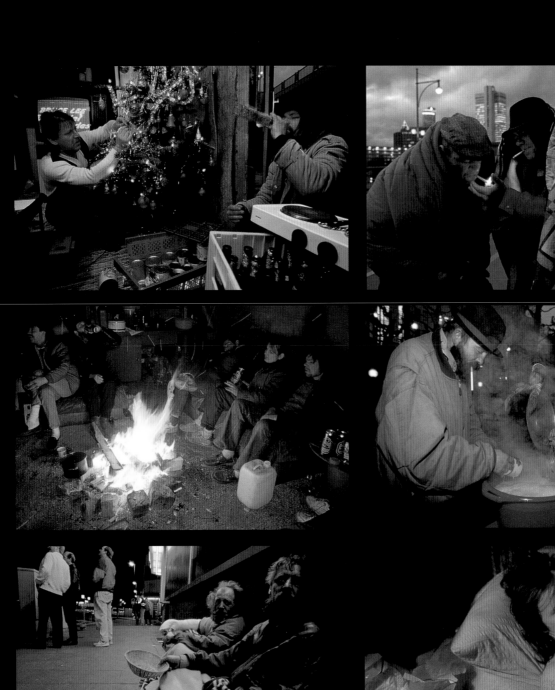

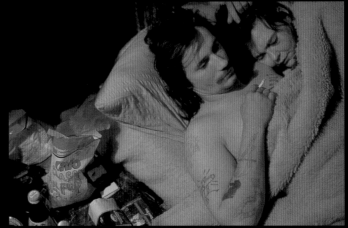

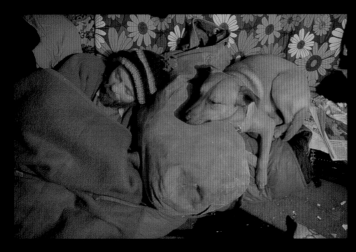

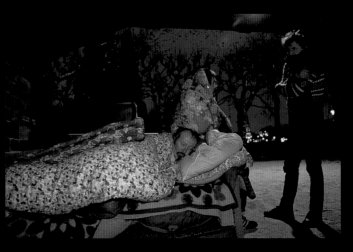

(OPPOSITE PAGE) CHRISTMAS IS NEAR AND FOR THE PAST FEW YEARS A BRIGHT CHRISTMAS TREE HAS BEEN SET UP IN THE SHACK. AT THIS TIME OF THE YEAR, MANY PEO-PLE GIVE MONEY, LIQUOR, FOOD, OR CLOTHES TO THE HOMELESS. ■ KARL-HEINZ AND MANFRED ON A BRIDGE OVER THE RIVER MAIN. ON THEIR WAY TO BEG FOR ALMS, THEY LIGHT A CIGARETTE AGAINST THE COLD. BESIDE THIS BRIDGE, RIGHT NEAR THE RIVER BANK, THEY HAVE BUILT A SHACK AROUND A BENCH IN THE PARK. ■ WHEN IT IS WARM

THOMAS ERNSTING

HOMELESS COMMUNITY, FRANKFURT

In the center of Frankfurt, not far from the high-rise bank buildings, lived a group of homeless people from 1988 until last year. Beside a bridge on the banks of the river Main, they constructed a small wooden shack around a park bench, for which they even had an official acknowledgment of toleration from the city administration.

They lived year round in this hut and under the bridge, and established a somewhat rigid communal hierarchy in which everyone had a task, such as begging, shopping, cooking, or doing the dishes. In winter other homeless people came here and they were either accepted by the group or sent away. In summer, only a few remained, only to return again in the first chilly days of November.

They would beg for alms in the evenings and at night in the Frankfurt red-light district. In winter they could get several hundred marks in a few hours. They also received money from the state, so none of them suffered from terrible deprivation. Most of their money went into a common fund from which they paid for food, drinks, tobacco, and so on. The hut was approximately 10 x 10 meters, and was often occupied by 10 or 11 people. It had electricity, a refrigerator, stove, color TV, and a VCR. Three to four of the homeless would sleep in the hut, and the others on mattresses under the bridge, even in winter.

One day, they were all gone and the hut was torn down. Only the park bench, where it had all begun, remained there for tired strollers. *Publishers:* Stern, Zeit-Magazine.

ENOUGH, THE HOMELESS (WHO PROUDLY CALL THEMSELVES "BERBER" IN GERMANY), SPEND THE WHOLE DAY UNDER THE BRIDGE, WHERE THEY HAVE PUT SOFAS AND CHAIRS AROUND A FIREPLACE. ■ EVERYONE IN THE GROUP HAS A SPECIFIC TASK. THIS EVENING, ROLLI HAS TO DO THE DISHES. AS THE SHACK IS FAR TOO SMALL, HE GOES OUT UNDER THE BRIDGE. ROLLI IS THE ONLY ONE OF THOSE WHO BUILT THE SHACK WHO IS STILL IN THE GROUP. ■ SOME MONTHS AGO, HANS LOST HIS JOB, AND SINCE THEN HE HAS LIVED ON THE STREETS. ON THIS DAY, HE RECEIVED DM 4,000 FROM UNEMPLOYMENT INSURANCE, AND IT WAS STOLEN IMMEDIATELY AS HE HAD BOASTED ABOUT HIS MONEY ON THE FRANKFURT DRUG SCENE. ■ EUGEN IS THE ONLY ONE OF THE GROUP WHO HAS A STEADY GIRLFRIEND—MICHAELA—AND AS CHIEF OF THE HOMELESS HE IS ENTITLED TO A SMALL SEPARATE ROOM, IN WHICH THE THEY BOTH SLEEP. ■ ROLLI SLEEPS IN THE SHACK WITH HIS DOG WRAPPED IN BLANKETS. ■ MOST OF THE HOMELESS OF THIS GROUP SLEEP IN THE OPEN UNDER THE BRIDGE, EVEN IN WINTER. ■ *(THIS PAGE)* THE BENCH WHERE IT ALL BEGAN, NOW JUST A STOPPING PLACE FOR WEARY PASSERS-BY.

DAVID EULITT

The Forgotten
Games

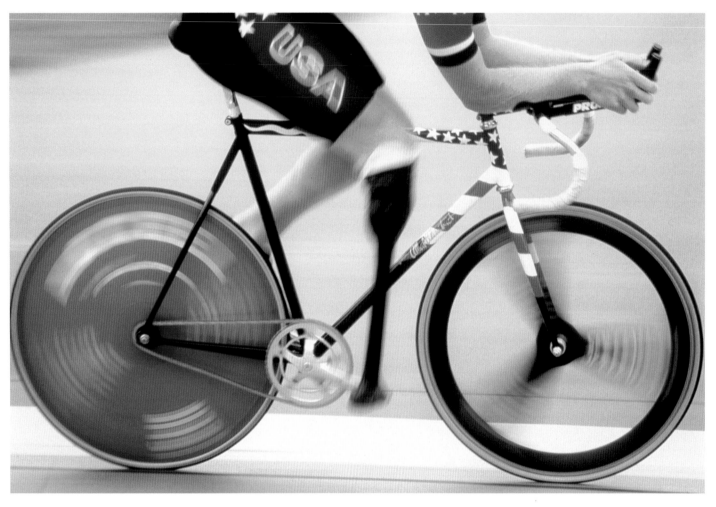

Every four years some of the nation's finest athletes gather for a global competition—their showcase and the payoff for years of training in anonymity. For the disabled athletes at the Tenth Paralympic Games in Atlanta, Georgia, the competition also takes place away from the world's spotlight. Two weeks after the international hype of the Olympic Games in Atlanta, the Paralympics opened amid much less fanfare. The elaborate opening and closing ceremonies did sell out, but the attendance for the competition numbered a few thousand in a stadium that accommodated 80,000 fans a few weeks earlier.

In the Paralympic Games, athletes are classified based on their degree of disability—amputees, athletes in wheelchairs, the blind, and those with cerebral palsy. Athletes are drug tested after their events, just like their counterparts in the Olympic Games.

The small crowd in attendance did witness amazing events. Two hundred and fifty-five world records were broken in the 10 days of competition. The 3,211 athletes proved that the Olympic ideal of the best in amateur competition did indeed take place in Atlanta this summer. It just happened two weeks after most people stopped looking. *Publisher:* The Topeka Capital-Journal, *Kansas*

(THIS PAGE) UNITED STATES TRACK CYCLIST DORY SELINGER RACED AROUND THE STONE MOUNTAIN VELODROME ON HIS WAY TO A NEW WORLD RECORD FOR AMPUTEE CYCLISTS IN ATLANTA DURING THE PARALYMPIC GAMES. SELINGER USES A PROSTHETIC LIMB TO AID HIS CYCLING. ■ *(OPPOSITE PAGE)* CHINESE HIGH JUMPER BIN HOU LEAPED HEAD-FIRST OVER THE HIGH JUMP BAR AT OLYMPIC STADIUM FOR A NEW WORLD RECORD FOR MEN'S F42-44 AMPUTEE HIGH JUMPERS, 1.92 METERS.

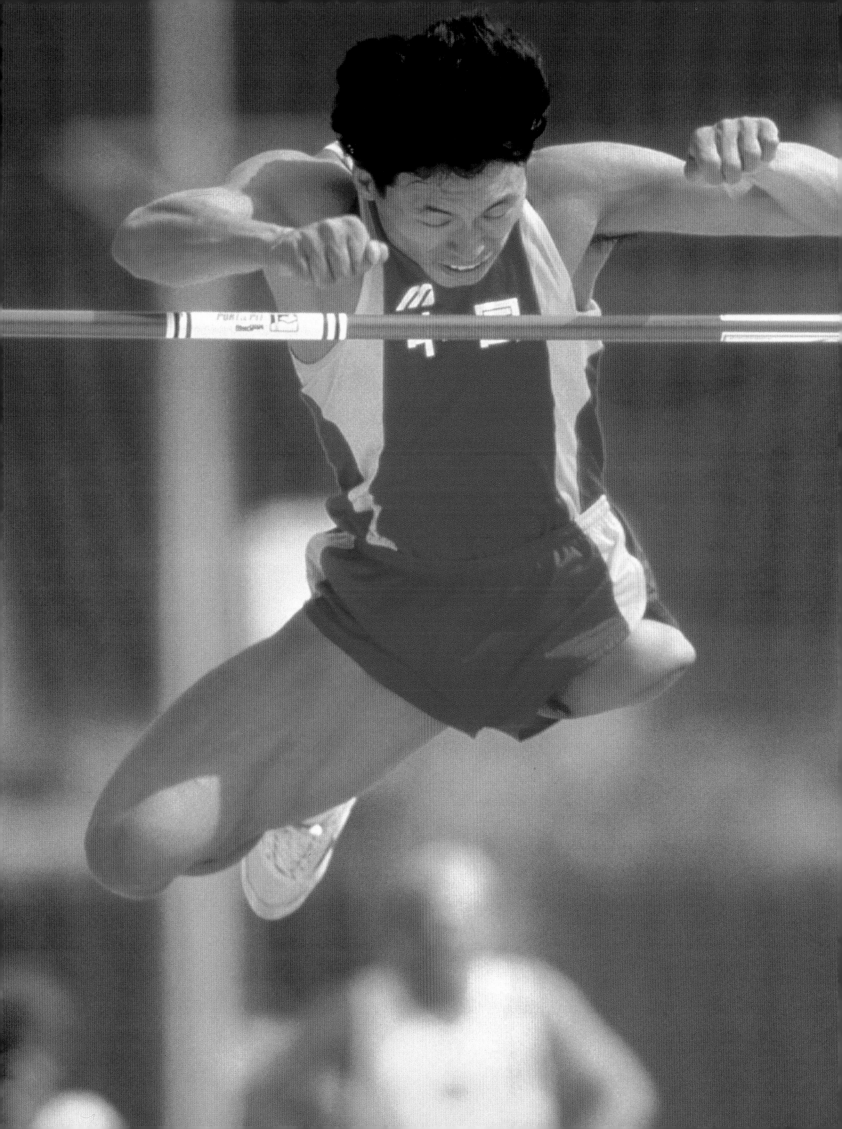

JAMES HALL, A TABLE TENNIS PLAYER FROM SAN BERNARDINO, CALIFORNIA, WAVED TO THE 65,000 FANS AT OLYMPIC STADIUM CHEERING AS THE UNITED STATES TEAM WAS INTRODUCED AT THE OPENING CEREMONIES OF THE TENTH PARALYMPIC GAMES IN ATLANTA. ■ ROBERT FIGL OF GERMANY GOT A COOL SQUIRT OF WATER ON HIS FACE AFTER THE MEN'S 400-METER WHEELCHAIR RACE. THE GEORGIA HEAT AND HUMIDITY TOOK ITS TOLL ON COMPETITORS, ESPECIALLY THOSE NOT USED TO THE CLIMATE.

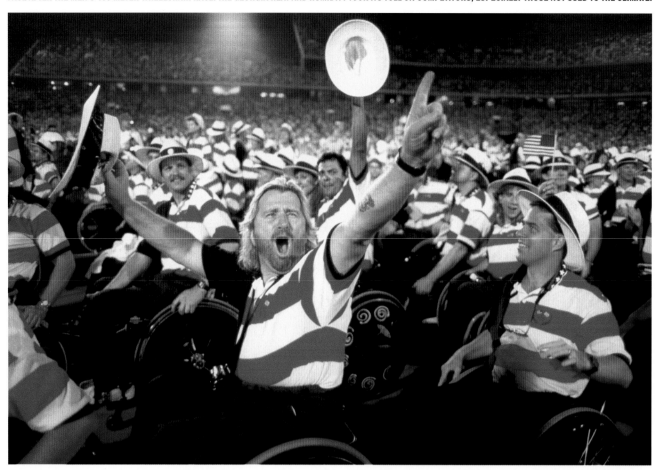

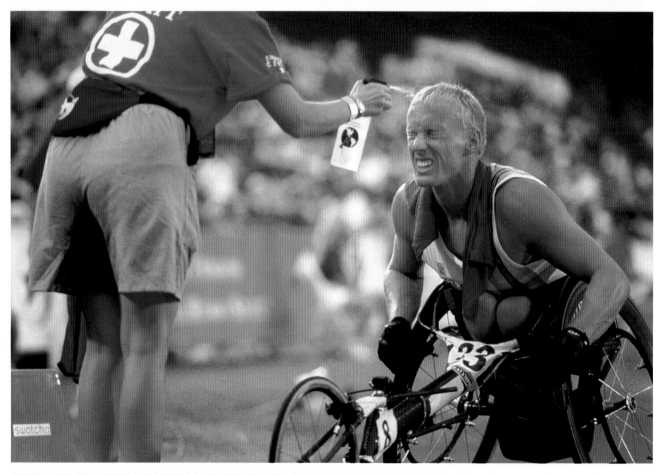

(OPPOSITE PAGE) REGIO COLTON, LEFT, RECEIVED A CONGRATULATORY KISS FROM HIS WIFE, LOTTIE, RIGHT, AFER THE UNITED STATES MEN'S BASKETBALL TEAM DEFEATED THE NETHERLANDS AT THE PARALYMPIC GAMES IN ATLANTA. ■ DU KIM OF KOREA, CROSSING THE FINISH LINE IN THE RAIN, REACTS TO HIS WORLD-RECORD TIME OF 1:00.25 IN THE MEN'S 400-METER T34-35 CEREBRAL PALSY CLASSIFICATION AT OLYMPIC STADIUM.

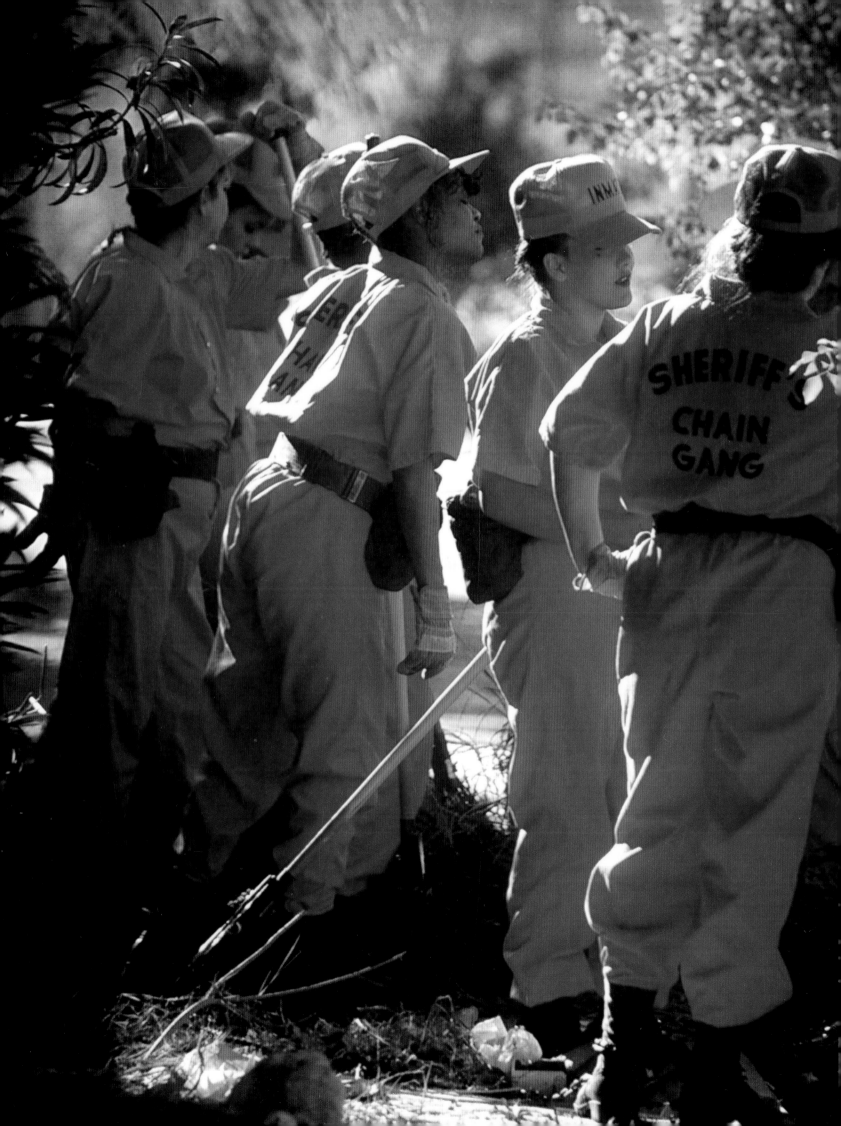

NAJLAH FEANNY

Working on the
CHAIN GANG

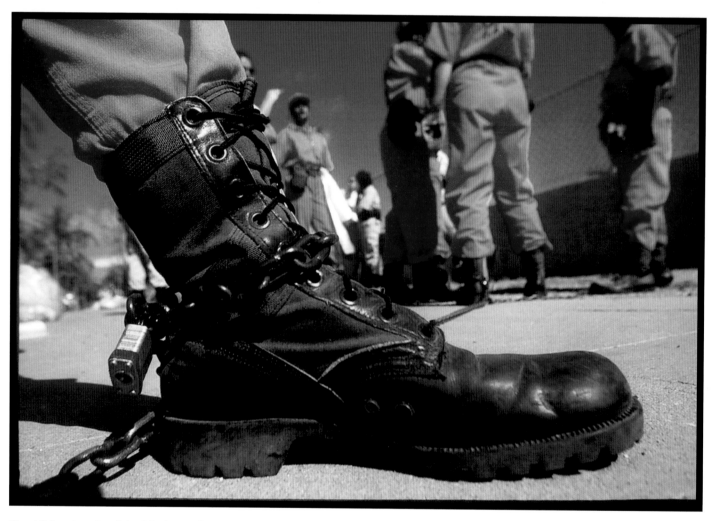

Sheriff Joe Arpaio of the Maricopa County, Arizona, sheriff's office fancies himself an equal-opportunity incarcerator, as he likes to put it. Creating the nation's first female chain gang was a logical step in his unique brand of rehabilitation.

Chained together in groups of five, the women labor eight hours a day, six days a week, under the watchful eye of a detention officer and armed posse members. Their criminal offenses range from petty theft and prostitution to drug possession and armed robbery.

Arpaio's strategy is to offer sentenced inmates, who have had trouble with the system, a way to work themselves out of long-term lockdown and back into the jail's general population. *Representative: Saba Photo Agency*

(OPPOSITE PAGE) EACH MORNING AT SUNRISE INMATES ON CHAIN-GANG DUTY ARE TRANSPORTED FROM THE JAIL TO VARIOUS WORK SITES AROUND THE CITY. THEY ARE TRANSPORTED BY BUS WITH THE WORDS "SHERIFF'S CHAIN GANG" EMBLAZONED ON THE SIDE. ■ **(THIS PAGE)** CHAINS AND PADLOCKS ARE WRAPPED AROUND THEIR ANKLES CONNECTING THE INMATES TO ONE ANOTHER AS THEY CLEAN UP THE CITY.

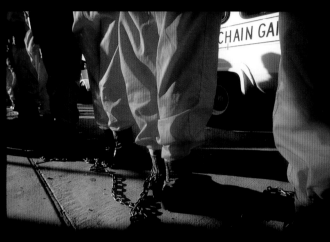

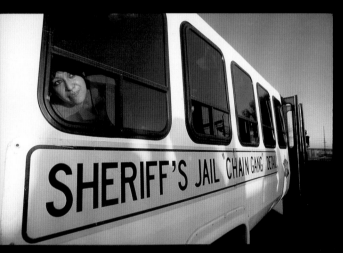

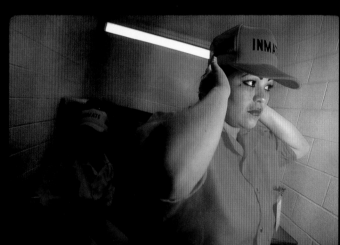

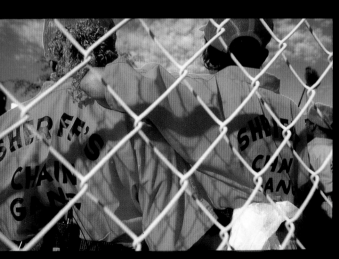

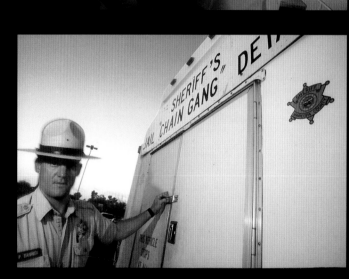

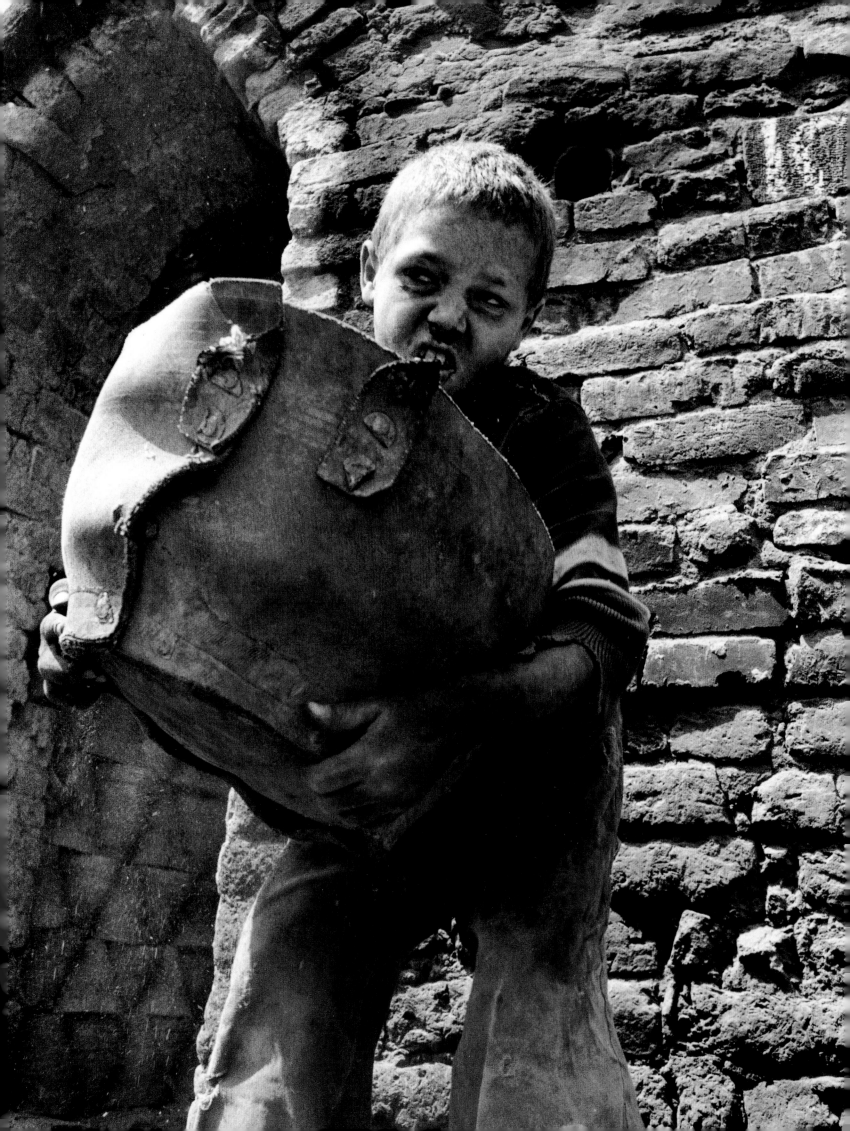

Colin H. Finlay
CAIRO: CHILD LABOR

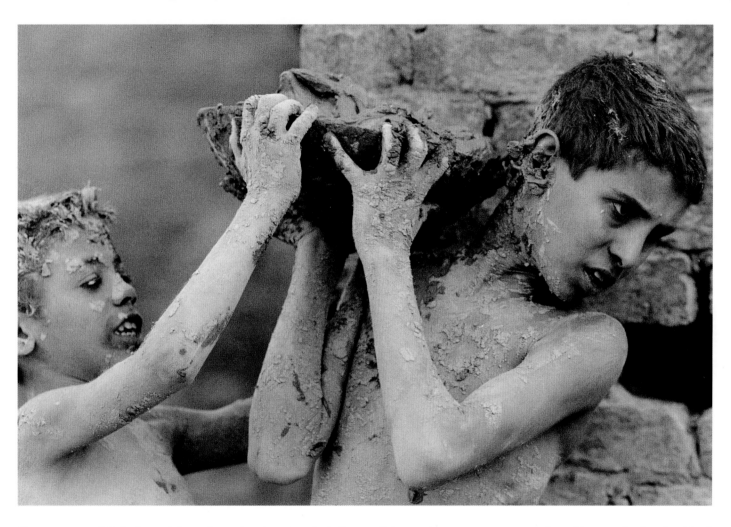

Ten percent of Cairo's workforce is under the age of 14. Some of the workers are as young as four. Overworked and robbed of their childhood, they struggle against a system that accepts and even encourages their plight. *Representative: Saba Photo Agency/Publication:* American Photo, *Campus Edition*

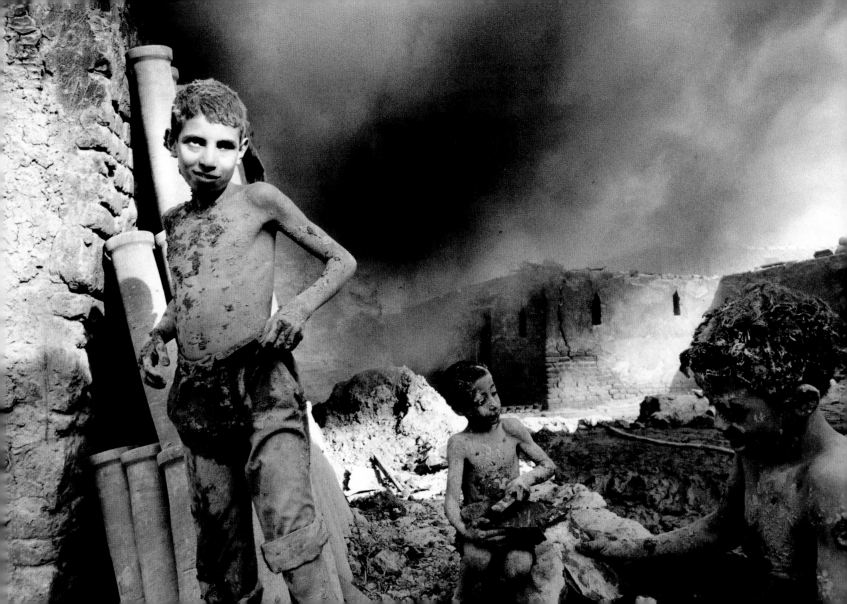

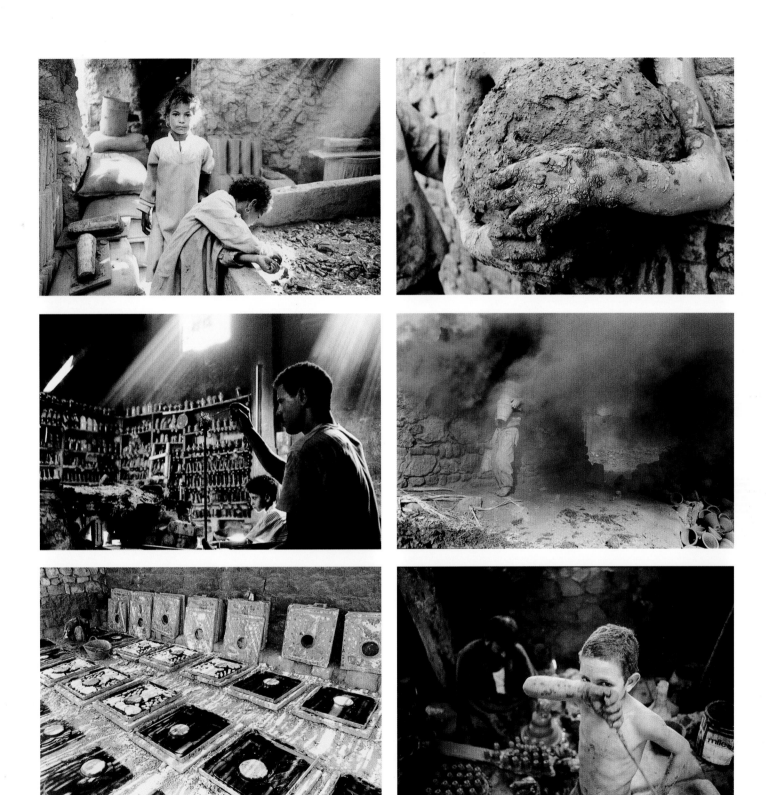

(PRECEDING SPREAD, LEFT) LIFTING A HEAVY BAG OF DIRT AND ROCKS. ■ *(PRECEDING SPREAD, RIGHT)* BOYS TRANSPORT A HEAVY BOWL OF MUD. ■ *(OPPOSITE PAGE)* THESE "MUD BOYS" MAKE BRICKS. *(THIS PAGE)* ■ KNOCKING ROCKS OFF THE CONVEYOR BELT. ■ A BOY CLUTCHES HIS MUD BOWL. ■ A BOY HEATS GLASS. ■ COLLECTING DRIED VASES FROM THE KILN. ■ MAKING TOILET HOLES. ■ WIPING THE SWEAT OFF HIS BROW.

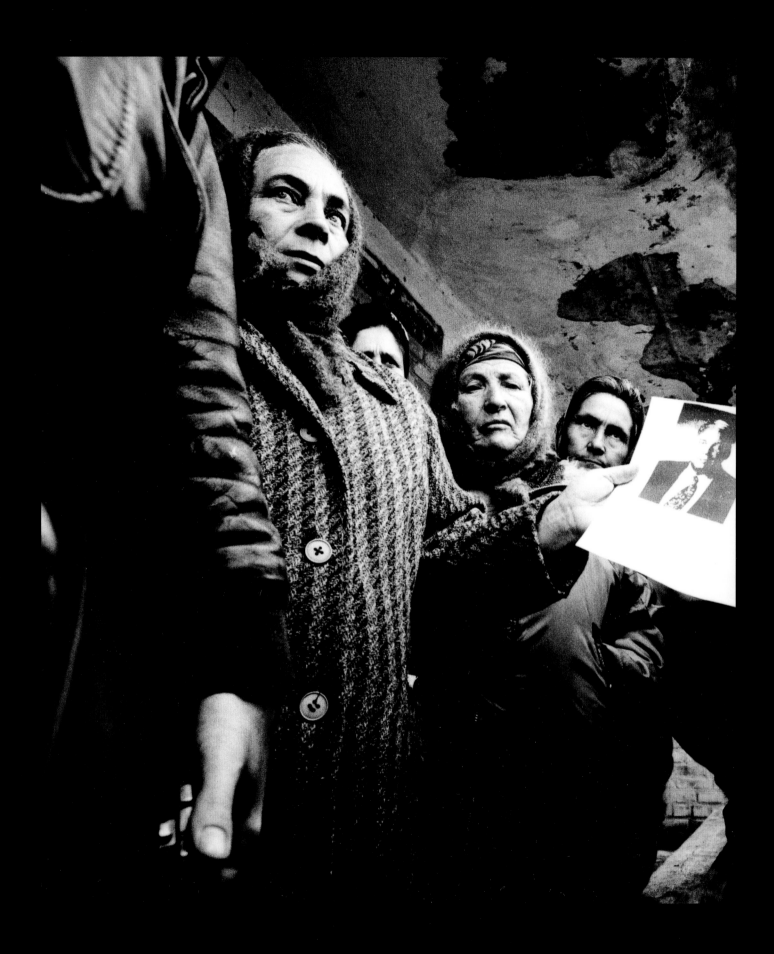

STANLEY GREENE

What Happened to
FRED CUNY?

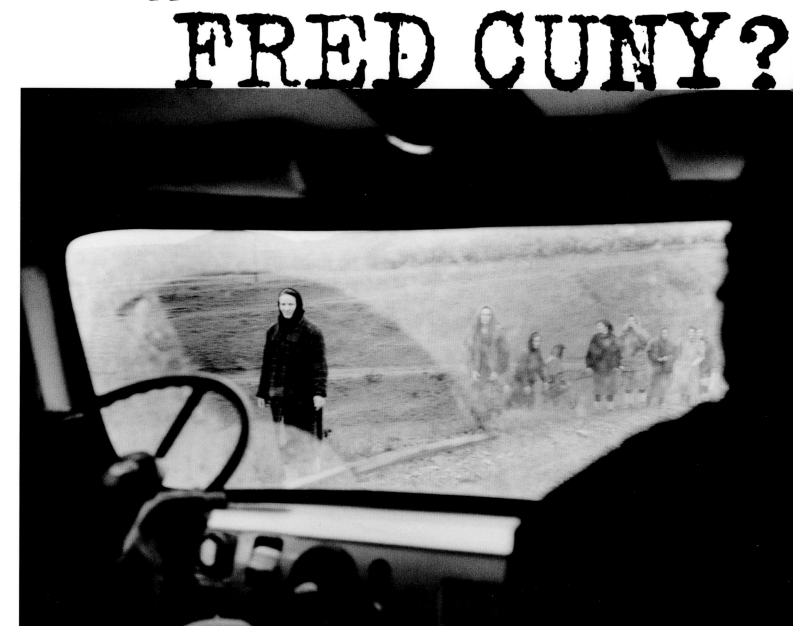

Fred Cuny had been a maverick international relief worker, a Texan who had successfully brokered seemingly impossible solutions in war and famine-stricken corners of the world, from Biafra to Bosnia, and who had the nerve and the know-how to commandeer United States Army helicopters to shuttle Kurdish guerrilla leaders across national frontiers during crisis in Iraq. Journalist Scott Anderson, writing in the *New York Times Magazine*, describes Cuny as "a man working at the murky confluence of humanitarian assistance, diplomacy, military operations, and intelligence."

In March of 1995 Cuny, along with two Russian Red Cross doctors, a Russian interpreter, and a local driver, set out for the heart of Chechnya during the Russian republic's bloody war of secession. They were last reported seen in Samashki, a small agricultural town in western Chechnya, but have never returned or been heard from again. Rumors circulated that the Russians had wanted them eliminated, and simultaneously, that Chechen rebels had seen them as a threat and had assassinated them. One year later, Anderson set out to retrace Cuny's steps, and to pick up the trail of a large-scale but inconclusive investigation conducted by U.S. government and intelligence agents. Photographer Stanley Greene traveled with Anderson and made this series of images that capture powerfully suggestive moments in the effort to uncover the mystery of Fred Cuny's disappearance. *Representative: Agence Vu/Publisher:* The New York Times Magazine

(OPPOSITE PAGE) WIDOWS IN THE CHECHEN TOWN OF SAMASHKI RECOGNIZED A PICTURE OF CUNY AND SAID HE WAS THERE AT THE TIME OF A RUSSIAN ASSAULT IN APRIL 1995. WHO HAD A BETTER MOTIVE TO KILL HIM, THE CHECHEN REBELS OR THE RUSSIAN ARMY? ■ (THIS PAGE) THE ROAD TO SAMASHKI MAY HAVE BEEN THE ROAD TO DEATH FOR THE "GREAT FRIEND OF THE CHECHEN PEOPLE."

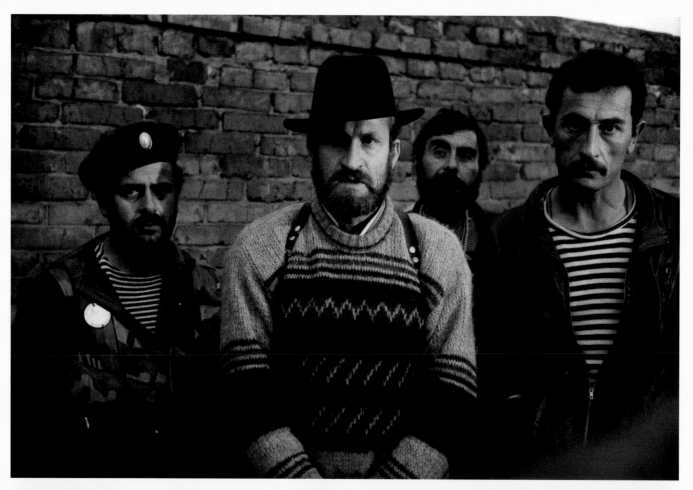

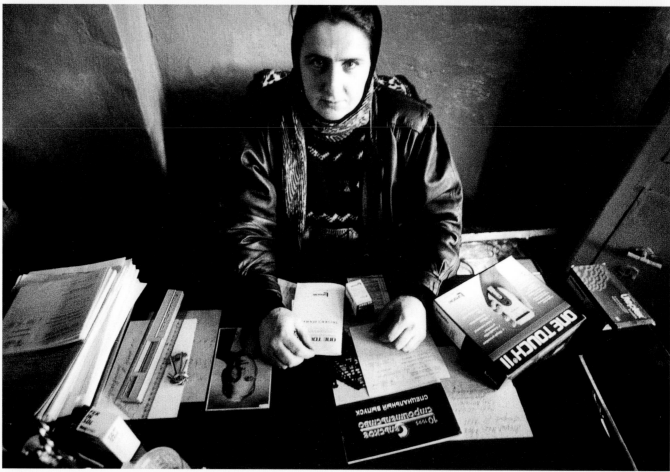

CHECHEN GUERRILLA COMMANDERS, LIKE OMAR HADJI, AND MEMBERS OF DZHOKHAR DUDAYEV'S NEGOTIATING TEAM, MAY HAVE KNOWN ABOUT CUNY'S DEATH. ■ A PHOTOGRAPH OF CUNY DISTRIBUTED BY A SEARCH PARTY STILL REMAINS UNDER THE DESK GLASS OF A SAMASHKI HOSPITAL ADMINISTRATOR.

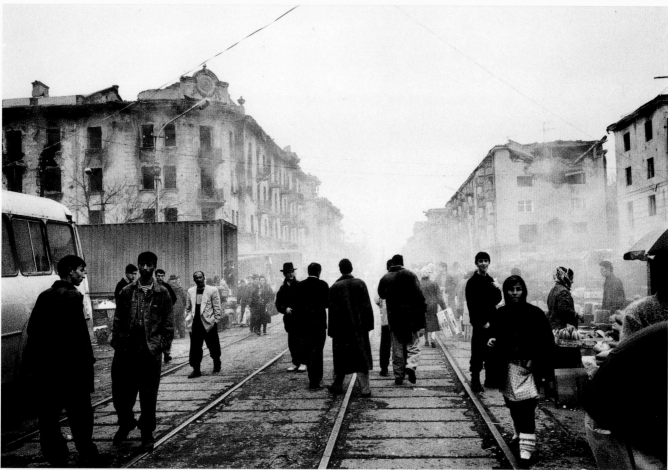

PEOPLE HAVE BEEN KNOWN TO DISAPPEAR ALONG THIS ROAD, WHICH IS HALF CONTROLLED BY THE RUSSIANS, HALF BY THE CHECHENS. ■ THE CENTRAL MARKET IN THE CHECHEN CAPITAL GROZNY, THE CITY THAT IS A BATTLEGROUND. A CHECHEN REBEL HERE CLAIMED TO KNOW WHAT HAD HAPPENED TO CUNY.

Rwandan
Boxers

David Guttenfelder

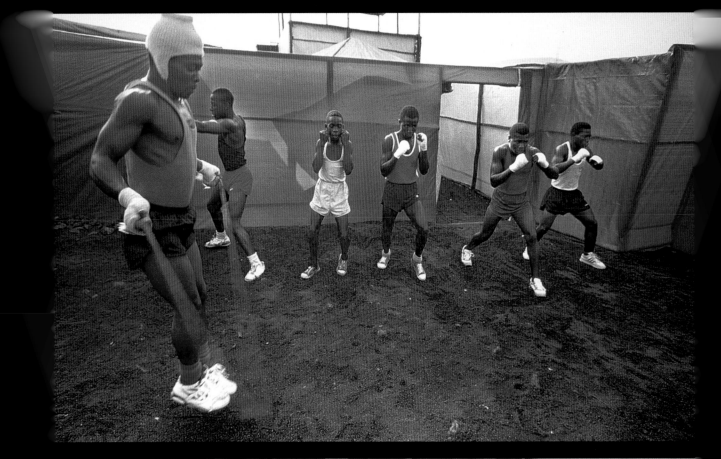

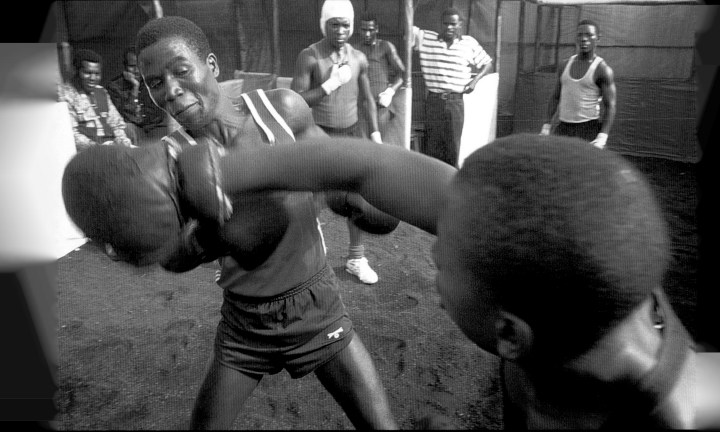

THE CAMPS A YEAR AND A HALF AGO, WHEN EVERYONE WAS DYING OF CHOLERA HERE, MAYBE IT WAS OUR STRENGTH, PHYSICALLY AND MENTALLY, THAT KEPT US ALIVE," HE SAYS. ■ (THIS PAGE) FORMER RWANDAN NATIONAL BOXING CHAMPION JEAN-MARIE UGIRAMAHORO, 26, JUMPS ROPE AS OTHER REFUGEES SHADOW BOX DURING A TRAINING SESSION. ■ AUGUSTIN HARIMANA, LOWER RIGHT, FAILS TO CONNECT A PUNCH AGAINST ESIDRAS DUSENGIMANA DURING A PRACTICE SESSION.

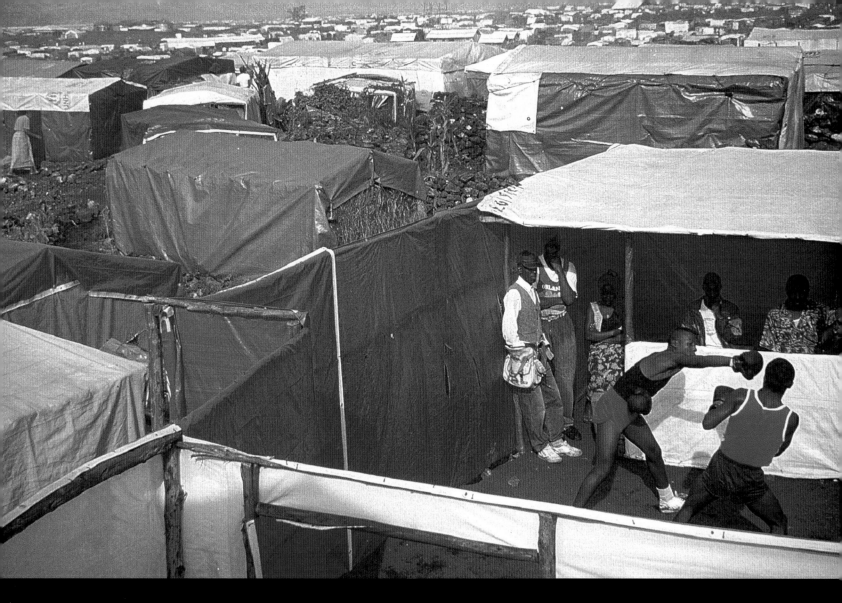

Jean-Marie Ugiramahoro credits boxing with keeping himself and his fellow boxers alive. Ugiramahoro, a former Rwandan national boxing champion, organized the boxing club at the Mugunga refugee camp in Goma, Zaire. "Training in the morning makes us strong," says Ugiramahoro. "And when we start to get hungry, we just train again to forget it." When thousands of ethnic Hutus streamed across the border into Zaire in 1994, Ugiramahoro and his two younger brothers were part of the exodus, carrying boxing gloves, a jump rope, and two hand dumbbells with them. In a hall made of plastic sheeting provided by the United Nations, the club was established with a dirt floor, sisal ropes, and 30 rows of wooden bleachers. Audience members each pay 1,000 Zaires—about four U.S. cents—to watch an afternoon of boxing. *Representative: Associated Press*

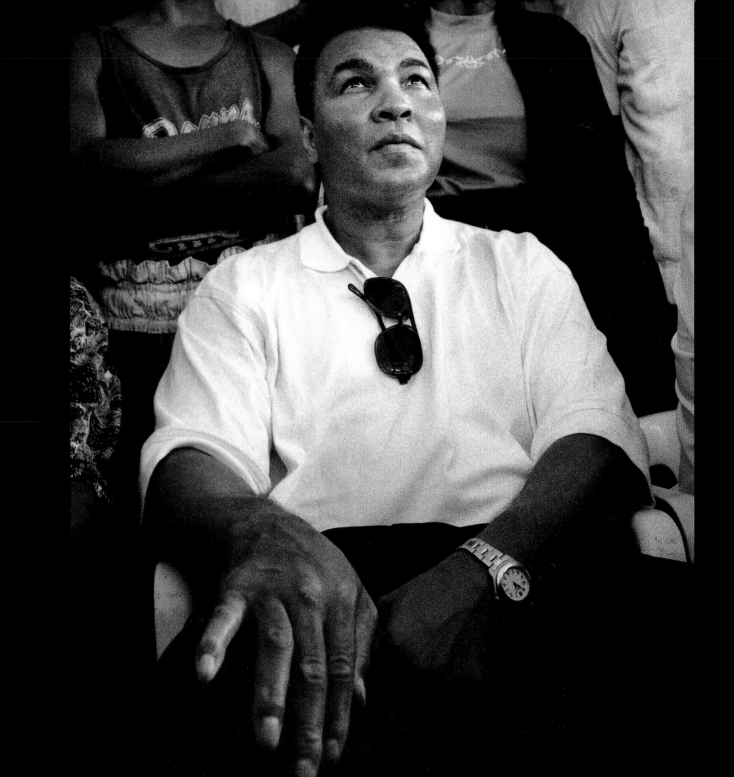

HAZEL HANKIN

Muhammad Ali
IN HAVANA, CUBA

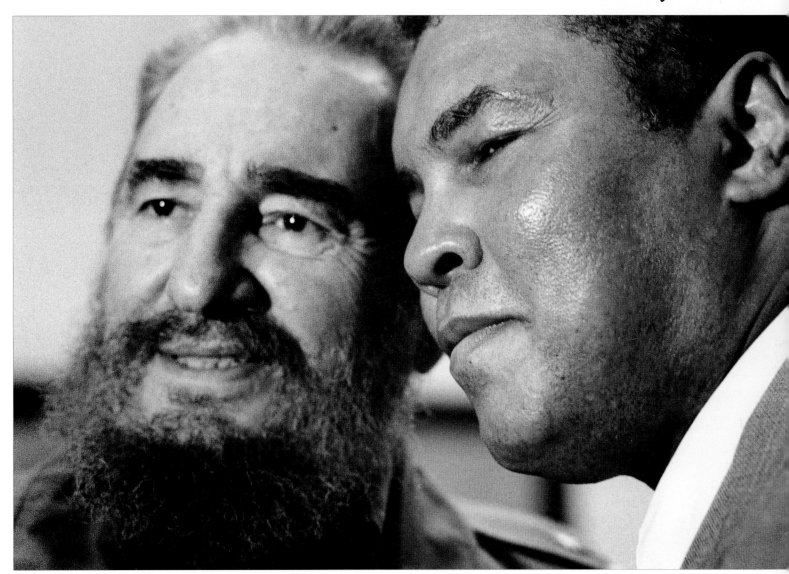

The end of Soviet subsidies and the ever-tightening U.S. embargo have led to dire shortages of medical supplies in Cuba. In January 1996 over half a million dollars' worth of medicine and supplies were delivered to the Cuban Red Cross in Havana by the Disarm Education Fund, a New York-based humanitarian aid organization. It was the largest shipment ever granted a license by the U.S. government and was the first of several to be delivered over a two-year period. Muhammad Ali accompanied the DEF delegation on a five-day tour of Havana. His presence brought world attention to the record humanitarian shipment and the desperate Cuban situation, though the mission was all but ignored by the U.S. media. Ali was joined in Havana by Cuban boxing great and three-time Olympic heavyweight champion Teófilo Stevenson. Crowds turned out at each stop to meet the two champions and to salute Disarm Education's efforts. Fidel Castro received the group at the presidential palace in Havana. *Representative: Impact Visuals*

(OPPOSITE PAGE) MUHAMMAD ALI WATCHES CHILDREN IN THE RING AT A BOXING GYMNASIUM IN HAVANA. ■ *(THIS PAGE)* FIDEL CASTRO WITH MUHAMMAD ALI AT THE PRESIDENTIAL PALACE IN HAVANA.

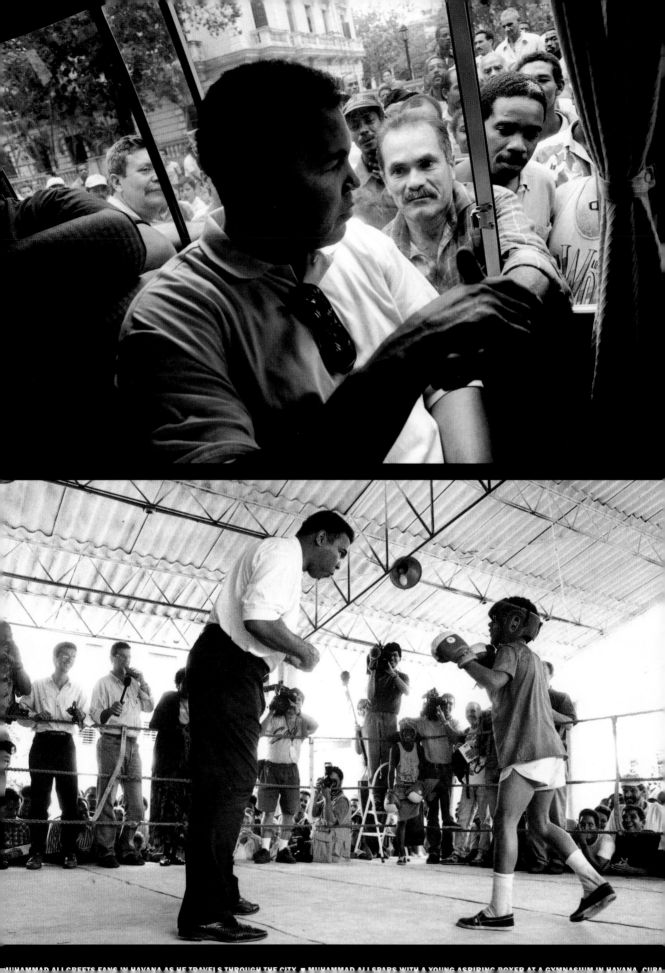

MUHAMMAD ALI GREETS FANS IN HAVANA AS HE TRAVELS THROUGH THE CITY. ■ MUHAMMAD ALI SPARS WITH A YOUNG ASPIRING BOXER AT A GYMNASIUM IN HAVANA, CUBA.

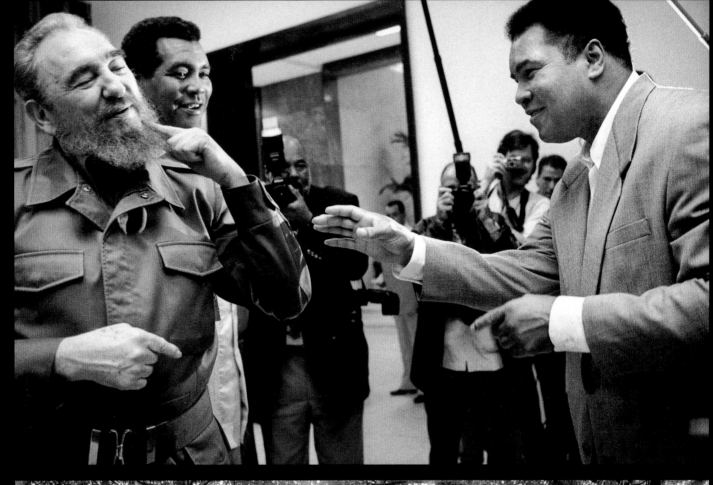

FIDEL CASTRO JOKES WITH MUHAMMAD ALI AT THE PRESIDENTIAL PALACE IN HAVANA. ■ PRIMARY SCHOOL CHILDREN SING A GREETING TO MUHAMMAD ALI AND HIS DELEGATION.

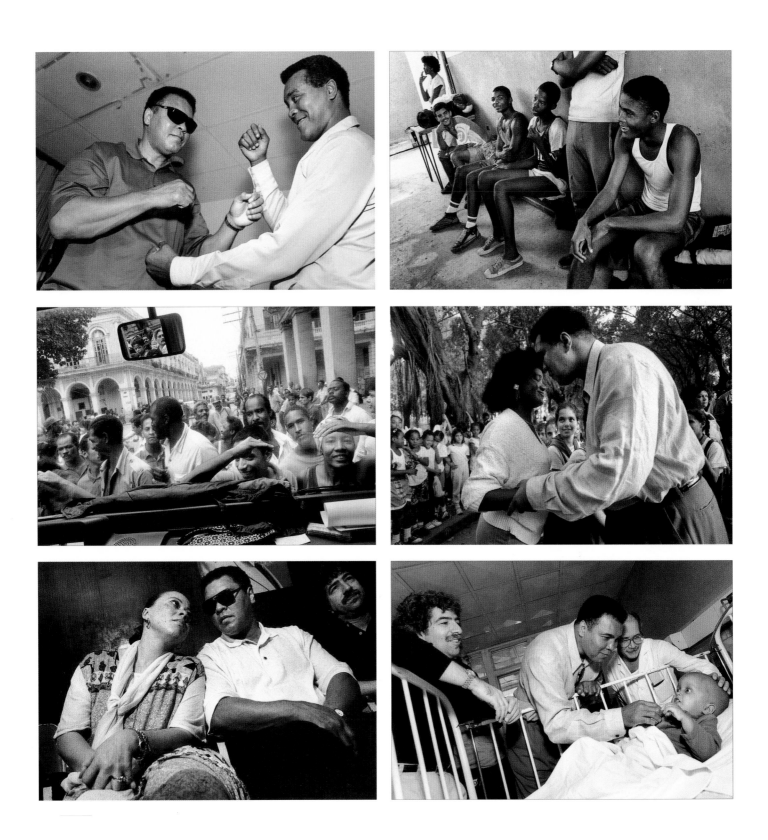

MUHAMMAD ALI WITH CUBAN BOXING CHAMPION TEÓFILO STEVENSON. ■ ASPIRING BOXERS AT A GYMNASIUM IN HAVANA DURING ALI'S VISIT. ■ WELL-WISHERS GATH-
ER AROUND ALI'S BUS AS HE VISITS SITES IN HAVANA. ■ ALI GREETS A TEACHER AT A PRIMARY SCHOOL IN HAVANA. ■ MUHAMMAD ALI AND HIS WIFE LONNIE VISIT A
HEALTH CLINIC IN HAVANA. ■ ALI GREETS A PATIENT AT A PEDIATRIC HOSPITAL. WITH HIM ARE BOB SCHWARTZ, OF THE DISARM EDUCATION FUND, AND THE BOY'S
PHYSICIAN. ■ MUHAMMAD ALI OBSERVES HAVANA STREET LIFE DURING A RIDE THROUGH THE CITY.

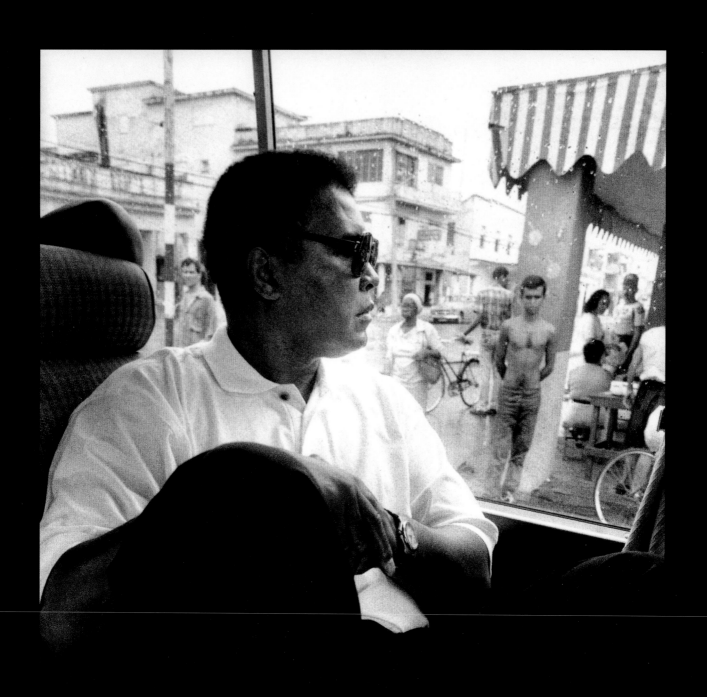

ANDREW HOLBROOKE

The Marching Season

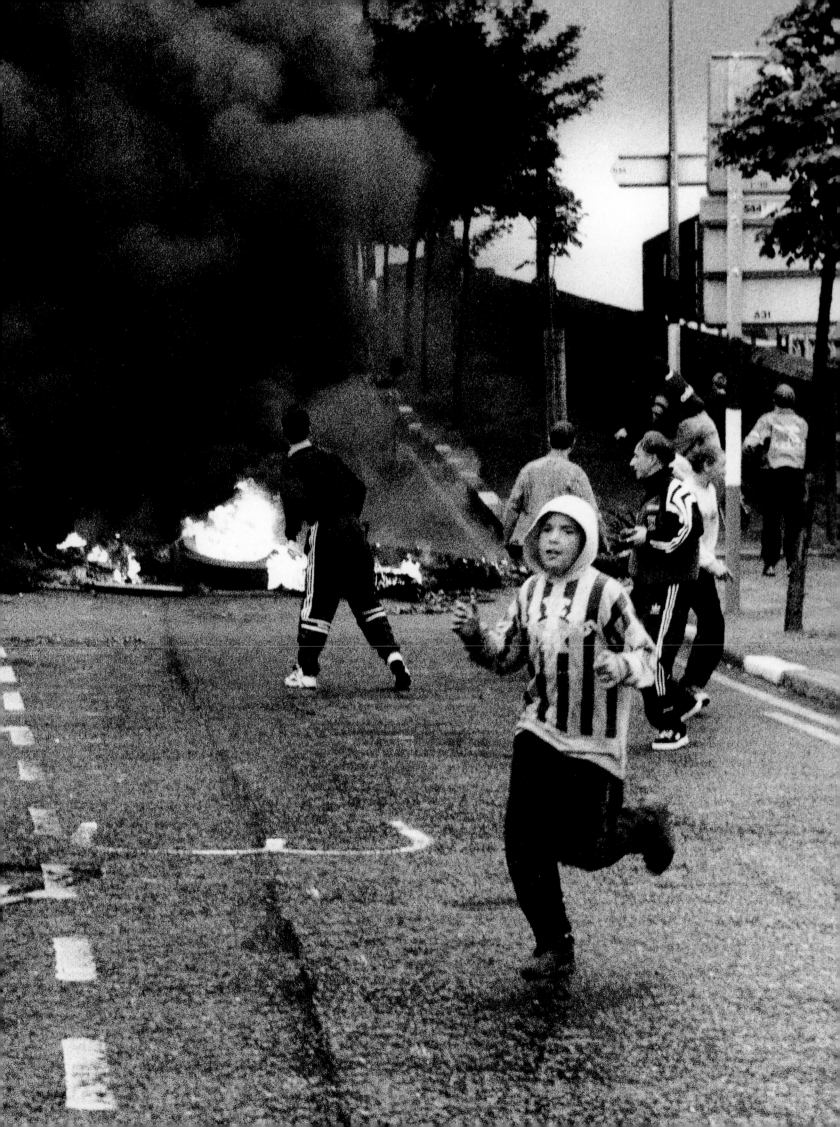

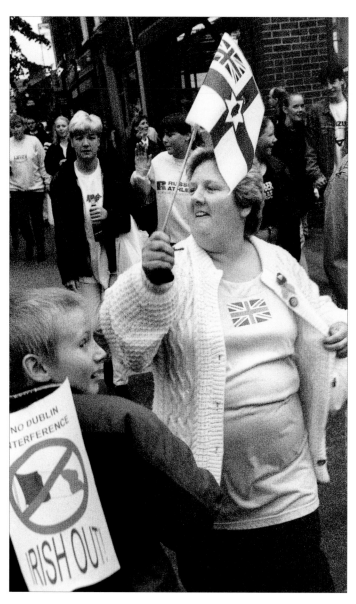

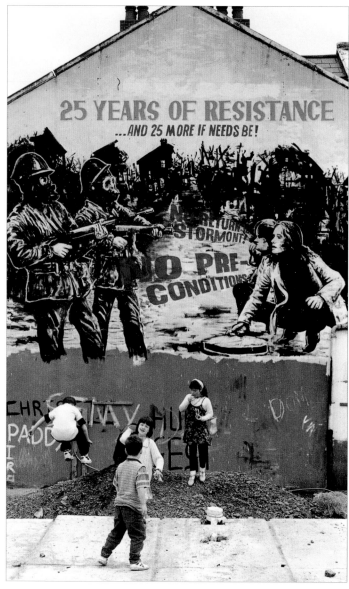

Protestant Loyalists in Northern Ireland are passionate about celebrating what is known as "the marching season." These are contentious marches conducted with fife and drums, and banners flying as they pass through Catholic neighborhoods. They celebrate William of Orange's (Protestant) victory over King James at the Battle of the Boyne in 1690. Their triumphal marching is deeply resented by the Catholic, Nationalist minority.

In July 1996 the police stopped men of the Orange Order from marching back to the town of Portadown by way of a Catholic neighborhood. Loyalist Protestants rioted and tensions mounted until the police gave in and let them march after all.

The Catholic Nationalists, feeling betrayed by the police, rioted in response. With more than a thousand incidents throughout the region in just over a week, the violence was the worst in Northern Ireland for 20 years.

As sectarian violence consumes the people of Northern Ireland, as the cycle of hate is passed from generation to generation, as ten-year-old children take to the streets with bottles and stones and petrol bombs, the "troubles," as they are called, continue.

(PREVIOUS SPREAD) LOYALIST RIOTERS IN THE SANDY ROW SECTION OF BELFAST, NORTHERN IRELAND. ■ *(THIS PAGE)* LOYALISTS DEMONSTRATE THEIR STRONG PRO-BRITISH UNION SENTIMENTS AND THEIR SUPPORT OF THE ORANGE MEN'S RIGHT TO MARCH. ■ ON THE FALLS ROAD IN WEST BELFAST, A CATHOLIC AREA. ■ *(OPPOSITE PAGE)* ORANGE MEN, DETERMINED TO MARCH, PASS A BURNING BARRICADE ERECTED BY PROTESTANT RIOTERS IN THE SANDY ROW SECTION OF BELFAST.

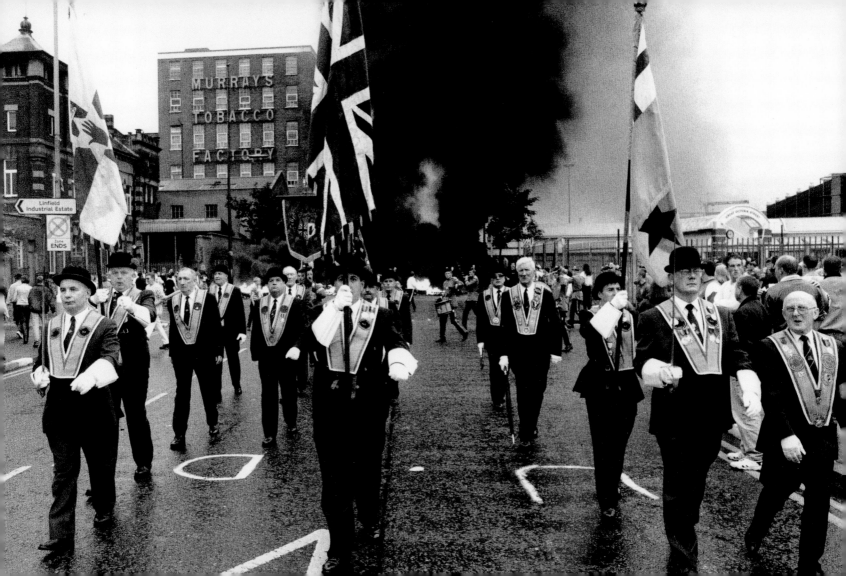

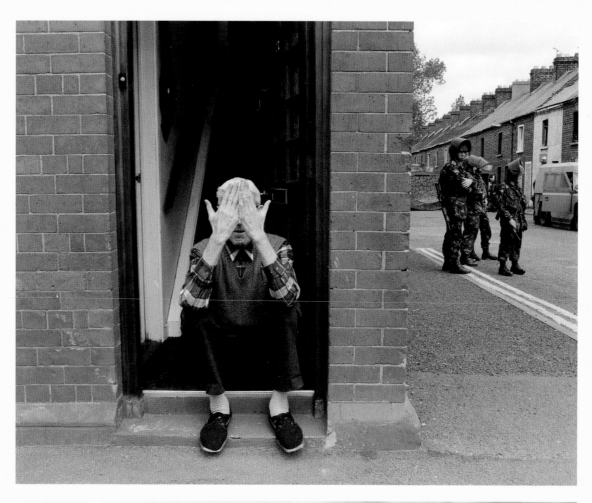

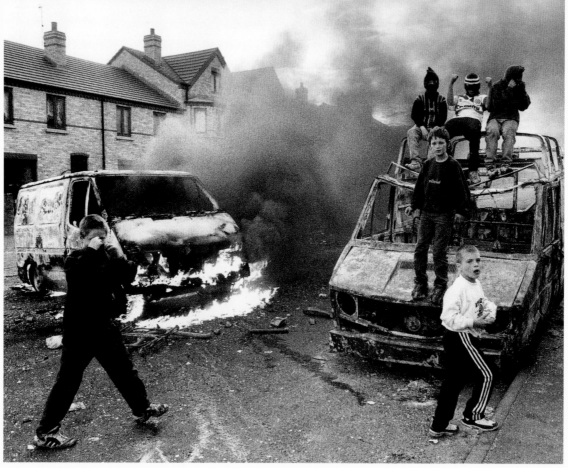

A CATHOLIC MAN DISPLAYS HIS FEELINGS AS BRITISH SOLDIERS IN PORTADOWN SEAL OFF HIS NEIGHBORHOOD FROM RIOTING PROTESTANTS.
■ NATIONALIST CHILDREN TAKING PART IN A RIOT IN THE OLD PARK AREA OF NORTH BELFAST.

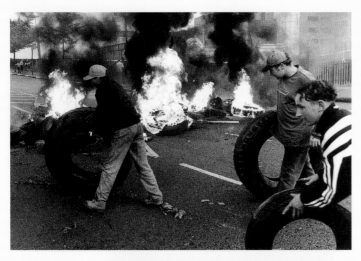

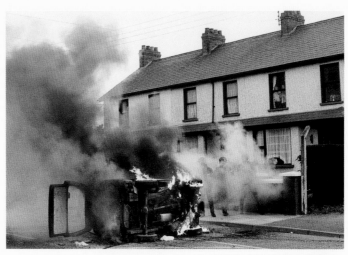

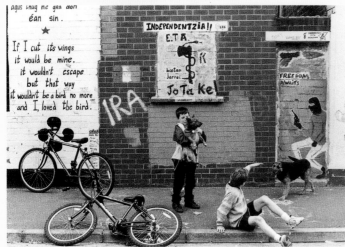

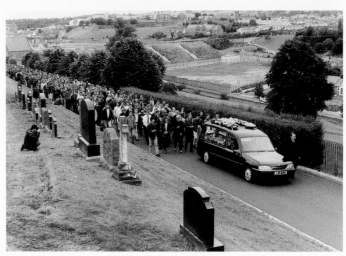

LOYALIST RIOTERS IN THE SANDY ROW SECTION OF BELFAST. ■ CATHOLICS IN PORTADOWN RIOTED AFTER FEELING BETRAYED BY THE GOVERNMENT'S DECISION TO ALLOW PROTESTANT ORANGE MEN TO MARCH THROUGH THEIR NEIGHBORHOOD. ■ THE FALLS ROAD SECTION OF WEST BELFAST, A CATHOLIC AREA. ■ FUNERAL FOR NATIONALIST RIOTER KILLED BY POLICE VEHICLE DURING RIOTING IN LONDONDERRY.

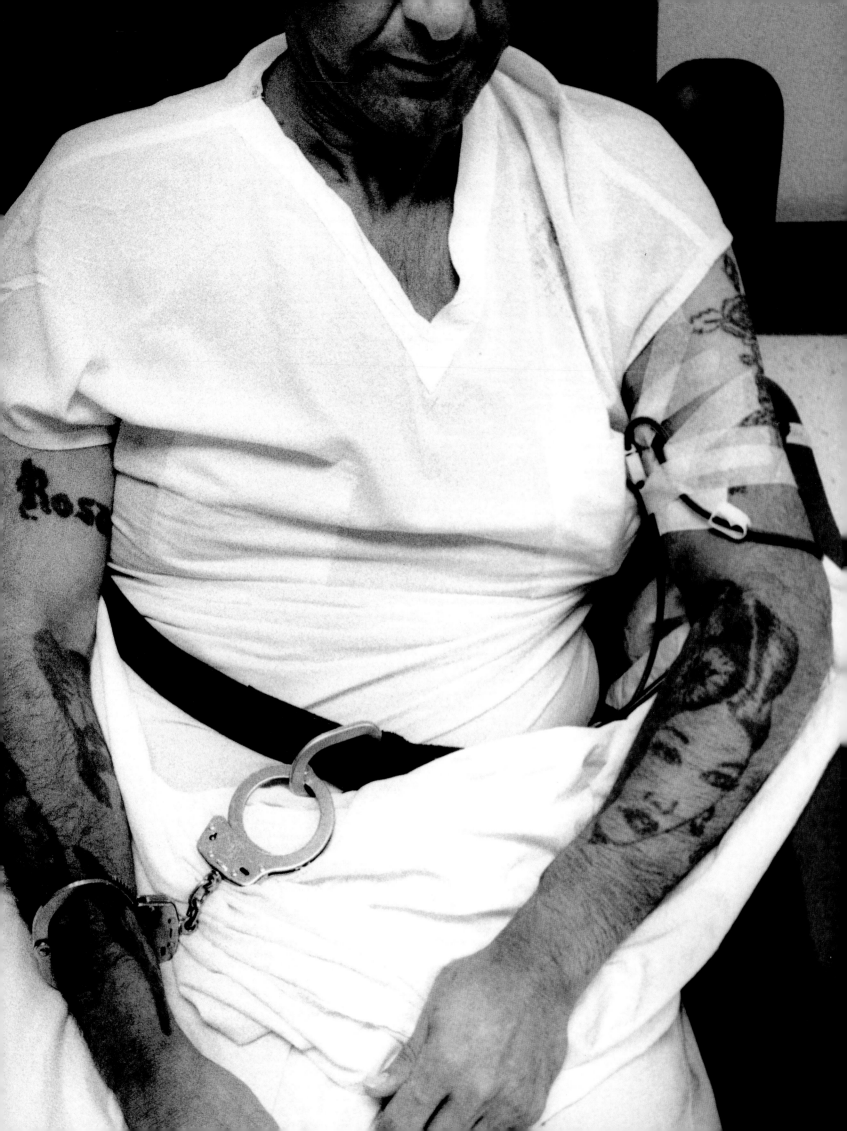

ED KASHI
Growing Old
Behind Bars

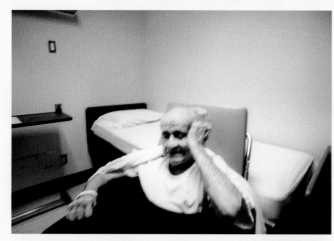
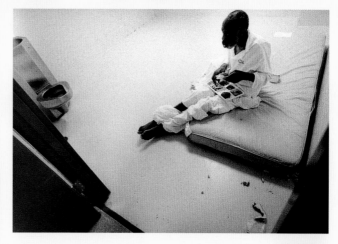
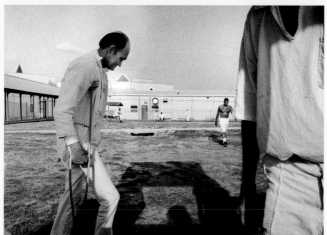
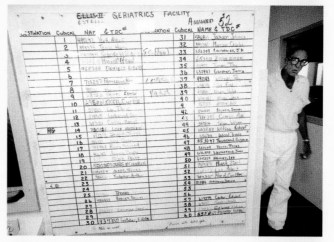
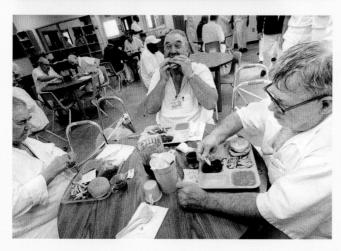
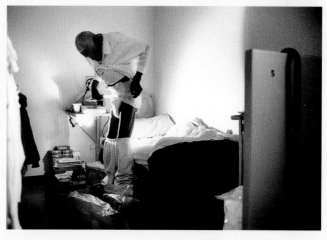

America's state and federal prison systems are suffering from serious overcrowding, and are beginning to confront a costly new problem: elderly convicts. The number of aged prisoners has increased more than 50 percent in the last four years; there are now more than 20,000 prisoners over the age of 55 in the United States.

Prison administrators have had to make adjustments to provide long-term health care for the elderly, new diets, and even prison facilities that can accommodate people who have trouble walking or are in wheelchairs.

This story illustrates the effects of aging in U.S. prisons by focusing on a 60-bed geriatric unit attached to a hospital near Huntsville, Texas. Roughly 100 of the 2,000 inmates in this unit are elderly. All of the men here have been accused of murder or assault.

(OPPOSITE PAGE) A SHACKLED GERIATRIC INMATE RECEIVES KIDNEY DIALYSIS IN THE PRISON HOSPITAL. ■ (THIS PAGE) HERMAN JUNDT, IN AND OUT OF PRISON FOR DECADES, WAS A CHRONIC CHILD MOLESTER. SUFFERING FROM DEMENTIA AND VIOLENT OUTBURSTS, HE IS KEPT IN AN ISOLATION CELL. ■ AN INMATE FOR MORE THAN 30 YEARS, JOHNSON FRANK EATS IN AN ISOLATION CELL. THESE CELLS ARE USED FOR VIOLENT OR DIFFICULT INMATES. ■ GERIATRIC INMATES MIX WITH THE GENERAL POPULATION IN THE RECREATION YARD ONLY. ■ THE GERIATRIC WARD'S ROSTER. ■ INMATES IN THE GERIATRIC WARD DIG INTO ONE OF THEIR THREE DAILY MEALS, WHICH ARE SERVED COMMUNALLY. ■ ROBERT DANIEL, 68, RECOVERING FROM PROSTATE SURGERY, CHANGES HIS DIAPER IN HIS CUBICLE. THERE IS LITTLE PRIVACY IN THE GERIATRIC WARD.

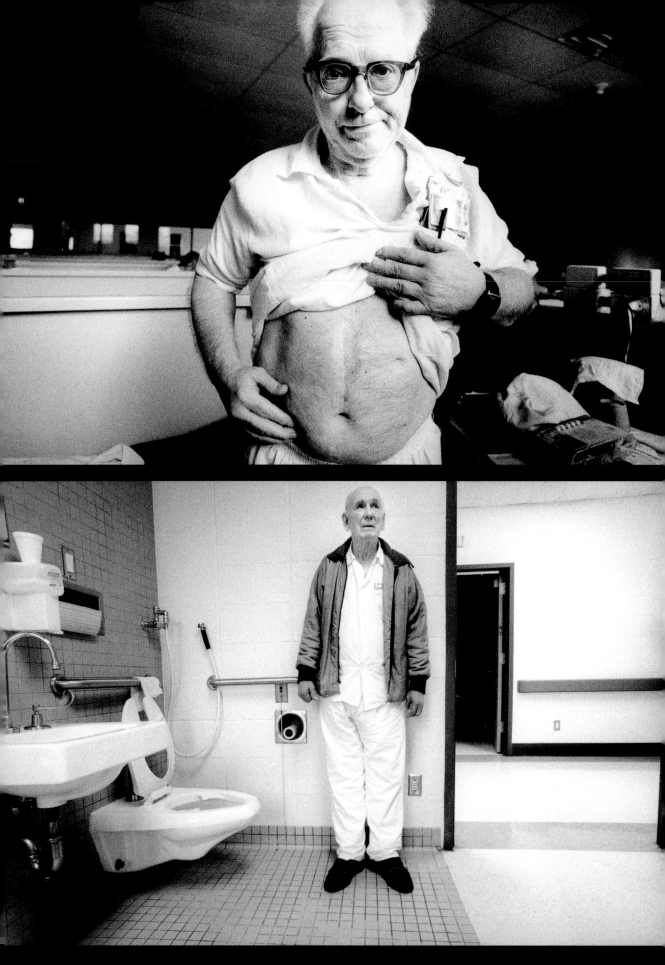

THOMAS CLINTON STODGHILL, 65, SHOWS OFF ONE OF HIS MANY SCARS INCURRED DURING A LIFETIME OF CRIME AND INCARCERATION. ■ A GERIATRIC INMATE SUFFERING FROM ALZHEIMER'S DISEASE, PAUSES BY HIS CELL'S TOILET.

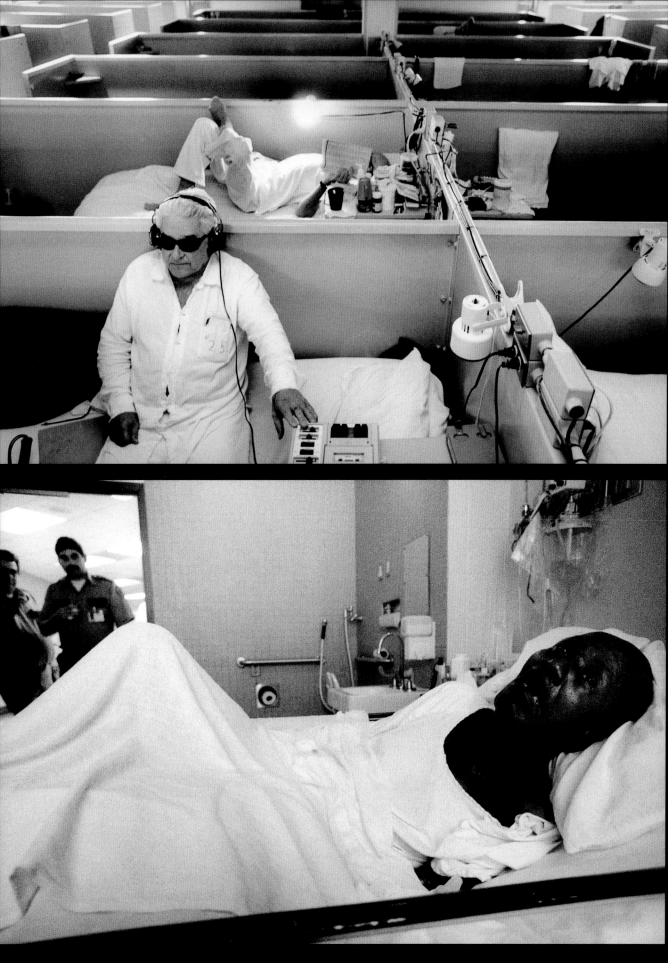

A BLIND GERIATRIC INMATE LISTENS TO STORIES ON TAPE IN ONE OF THE CUBICLES THAT SERVE AS A CELL IN THE GERIATRIC WARD. ■ RICHARD YOUNG, 80 YEARS OLD, DYING OF CANCER IN THE PRISON HOSPITAL.

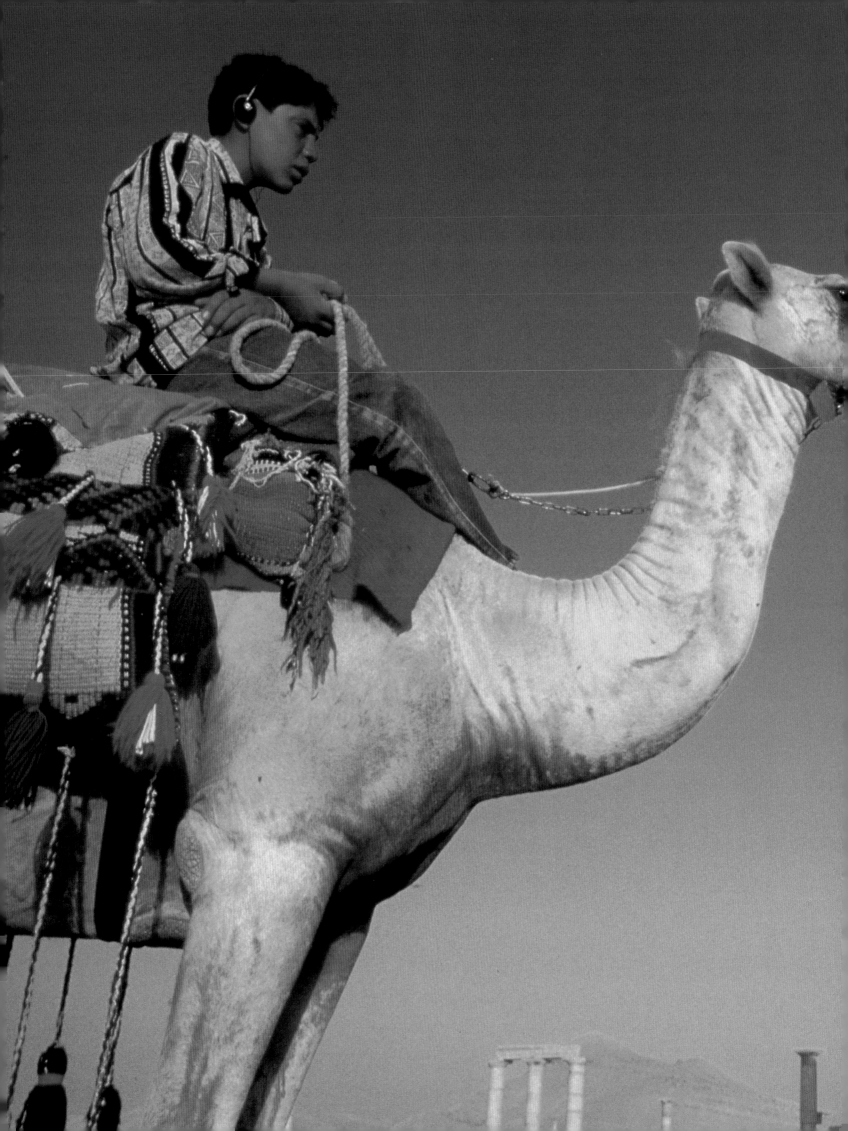

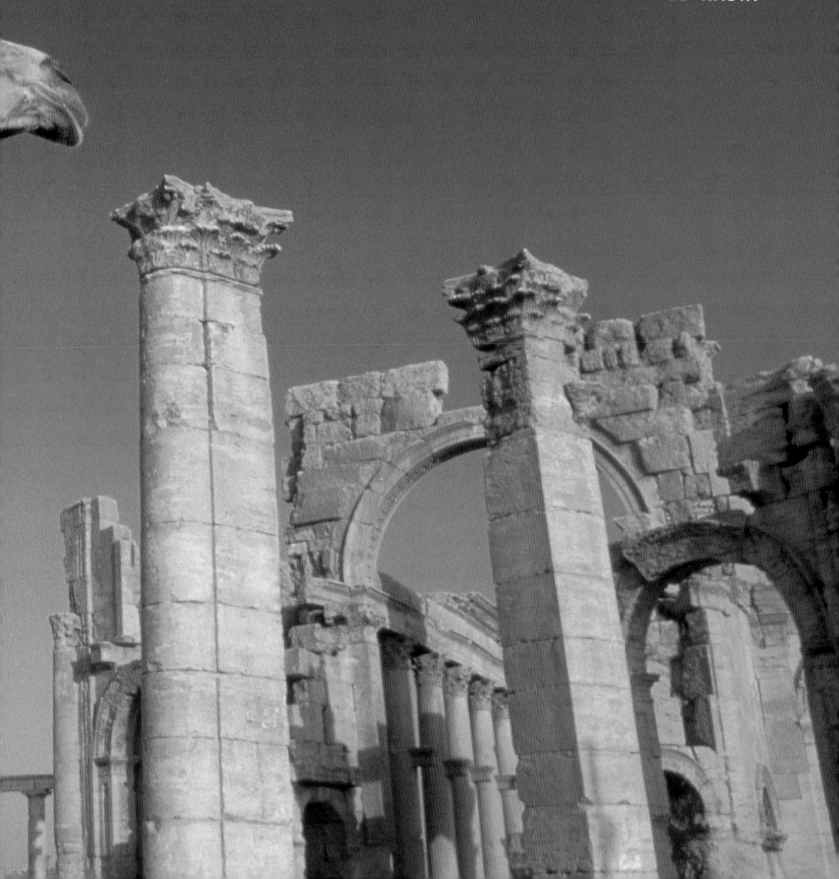

Syria:
Behind the Mask

ED KASHI

(PREVIOUS SPREAD) AT THE MAIN ENTRANCE TO THE RUINS OF PALMYRA, A YOUNG CAMEL DRIVER LISTENS TO HIS WALKMAN AND WAITS FOR WILLING TOURISTS. ■ *(THIS PAGE)* IN THE JARAMANAH CAMP FOR PALESTINIAN REFUGEES, A FAMILY LOOKS OUT FROM BEHIND THEIR WINDOW. THERE ARE 20,000 PALESTINIAN REFUGEES IN SYRIA. ■ *(OPPOSITE PAGE)* A KURDISH *ATAL*, OR CARRIER OF WHEAT, STRAINS UNDER THE LOAD OF THE ABUNDANT WHEAT HARVEST NEAR QAMISHLI. ■ A DRUZE FAMILY YELLS WEEKLY NEWS ACROSS THE GOLAN HEIGHTS "SHOUTING VALLEY," A MINED ZONE SEPARATING ISRAELI-OCCUPIED MAJDAL SHAMS FROM SYRIA'S TERRITORY. ■ A GROUP

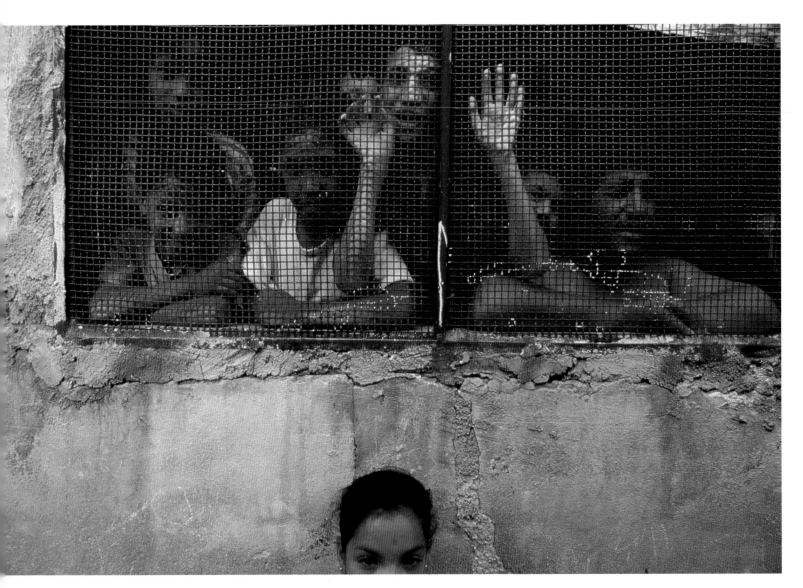

Long viewed in the West as a terrorist state ruled by a ruthless dictator, Syria is today one of the most complex and politically vital countries in the Middle East, with a central role in keeping the peace and controlling the balance of power in the region. This photo essay reveals aspects of life in Syria that are rarely seen by the outside world. Although 25 years of ironfisted rule by President Hafez Al-Assad has left the country with the scars of modern-day regional conflict, traces of the underlying ancient civilization remain apparent. *Publication:* National Geographic, *Washington, D.C.*

OF TRADITIONAL MUSLIM WOMEN ENJOY THE SUMMER SURF AT A BEACH NEAR LATAKIA ALONG THE MEDITERRANEAN COAST. ■ WOMEN TAKE A BREAK FROM THE WHEAT HARVEST NEAR THE SITE OF APAMEA, A GREEK CITY WITH A MILE-LONG MAIN STREET FLANKED BY 40-FOOT-HIGH CORINTHIAN COLUMNS. ■ A BEDOUIN FAMILY WANDERS EACH SPRING TO GRAZE ITS HERD ON THE STUBBLE LEFT BY WHEAT HARVESTS IN THE AL GHAB VALLEY, THE BREADBASKET OF SYRIA. ■ A CITY OF WHEAT RISES FROM THE SYRIAN DESERT NEAR QAMISHLI, WHERE SACKS OF GRAIN AWAIT DISTRIBUTION. DESPITE ITS SURPLUS, SYRIA IS A NET IMPORTER OF AGRICULTURAL PRODUCTS.

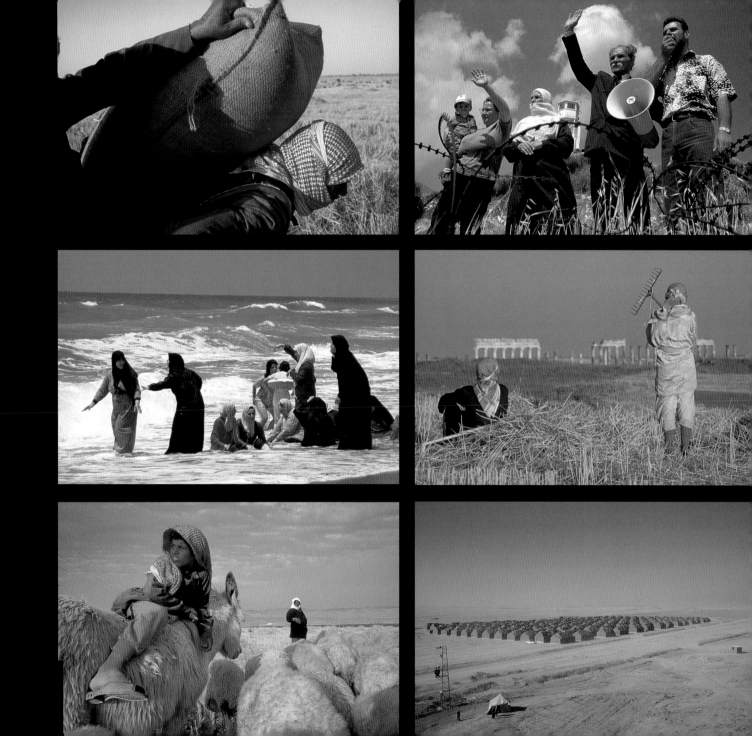

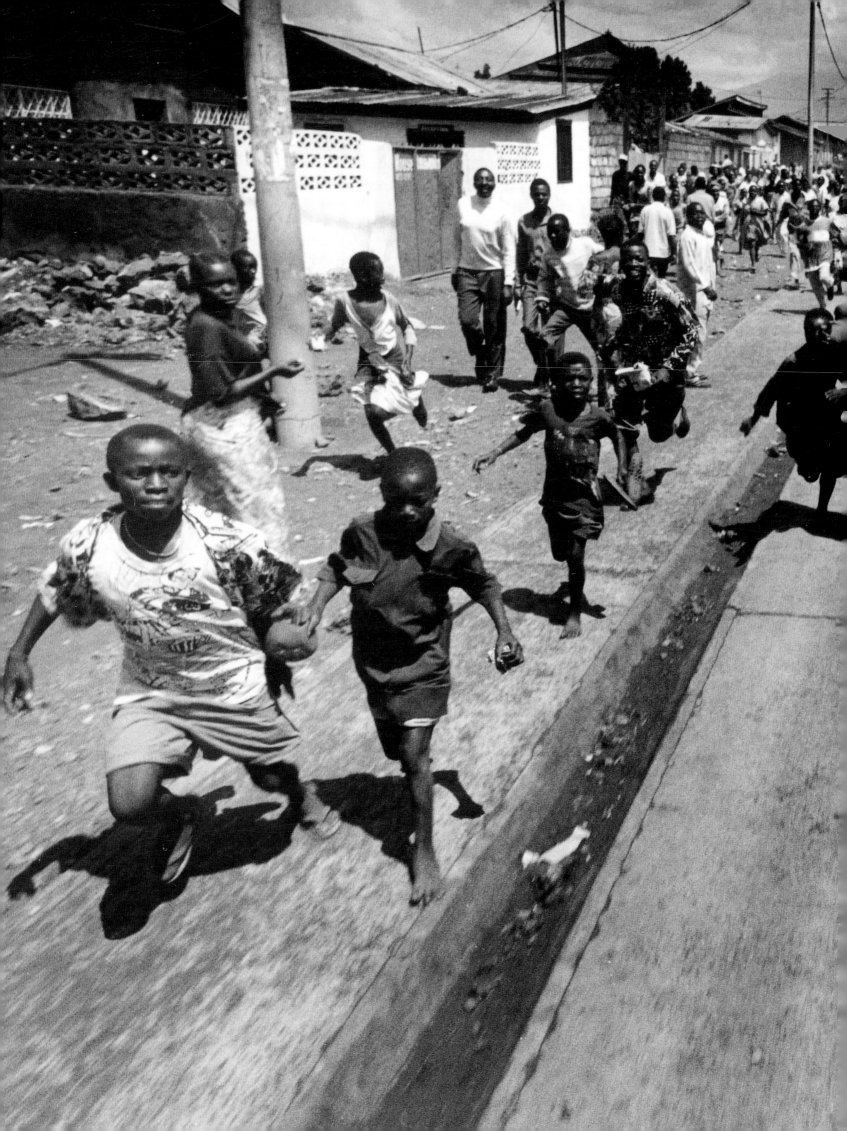

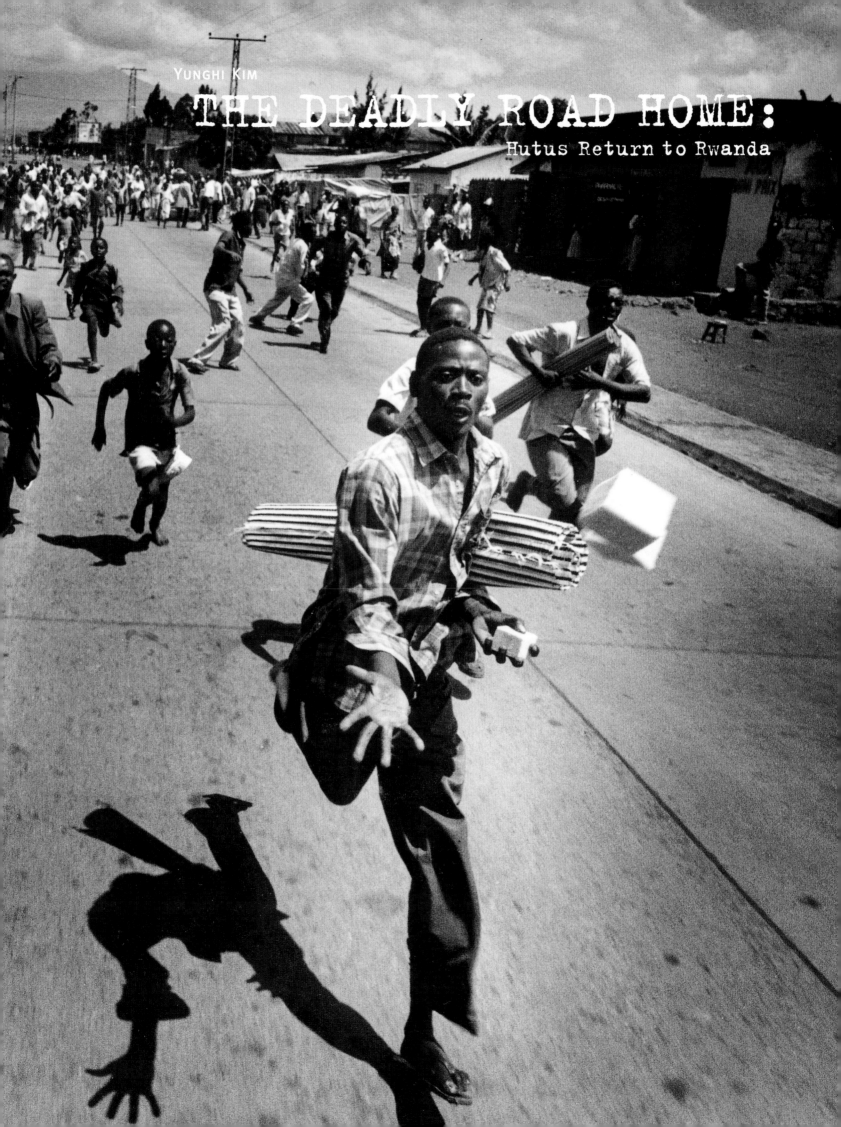

YUNGHI KIM

THE DEADLY ROAD HOME:

Hutus Return to Rwanda

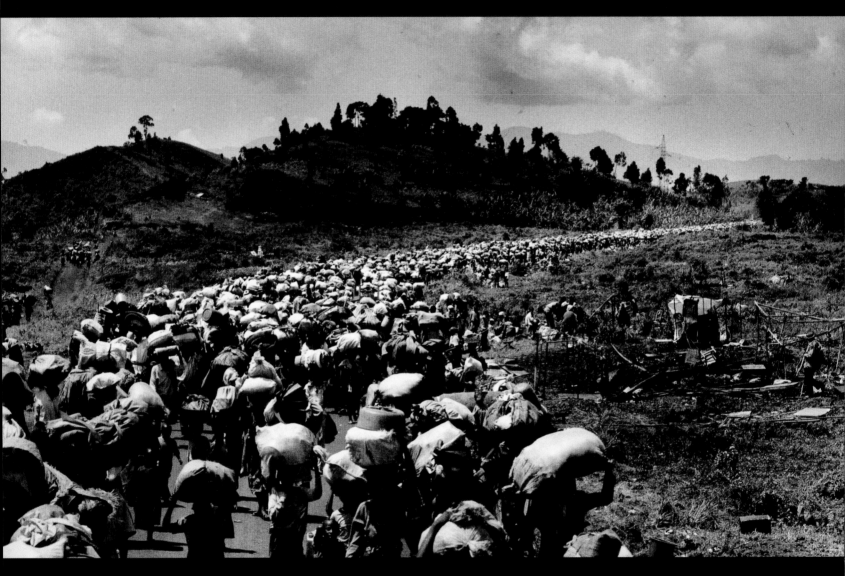

In November 1996 the deadliest refugee crisis in modern history came to an abrupt close as hundreds of thousands of Rwandan Hutus began their journey home from neighboring Zaire. The return followed two years in exile from a genocidal fury that killed half a million Rwandans. Another half million had died of cholera in the refugee camps.

For weeks in the fall of 1996 heavy fighting raged between Zairian rebels and the Zairian government soldiers. Aid workers withdrew from the refugee camps in Goma, Zaire, including Mugunga, the world's largest refugee camp. Amid widespread fear of a massive new cholera epidemic, the United States considered sending in troops.

Then, to everyone's surprise, the Mugunga camp was suddenly on the move. Within four days, some 600,000 refugees had crossed the border back into Rwanda, and families that had been apart for two years were reunited. The crisis was, for the time being, over. *Representative: Contact Press Images*

ON NOVEMBER 15 HUNDREDS OF THOUSANDS OF RWANDANS SUDDENLY LEAVE MUGUNGA FOR THE LONG WALK HOME WHEN FIGHTING BETWEEN ZAIRIAN REBELS AND THE OLD HUTU GOVERNMENT SOLDIERS THREATENED THE CAMP. ■ *(OPPOSITE PAGE)* A SOLDIER'S BODY LIES ON THE ROAD IN THE MUGUNGA CAMP. FORMER HUTU GOVERNMENT SOLDIERS IN THE CAMP ALSO MASSACRED REFUGEES IN ATTEMPTS TO KEEP THEM FROM RETURNING HOME TO TUTSI-CONTROLLED RWANDA.

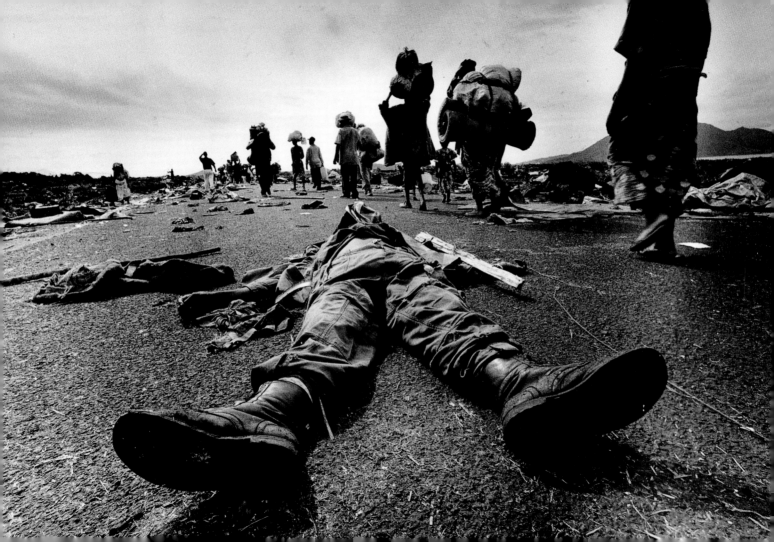

RESIDENTS WHO HAD FLED GOMA, ZAIRE, TO ESCAPE THE FIGHTING HAVE THEIR BAGS SEARCHED UPON RETURNING BY A ZAIRIAN REBEL SOLDIER. BECAUSE OF THE HEAVY FIGHTING AROUND GOMA, IT WAS SAFER TO RETURN BY BOAT THAN BY LAND. ■ AT GOMA CENTRAL HOSPITAL, NO PAINKILLERS WERE AVAILABLE TO RELIEVE THE SUFFERING

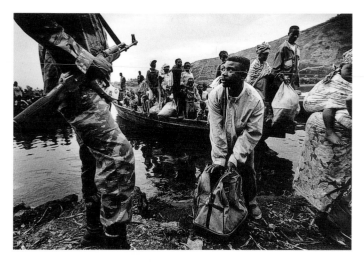 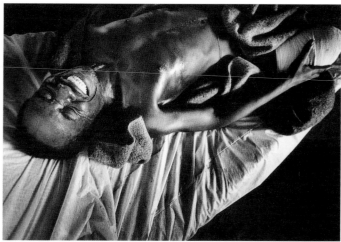

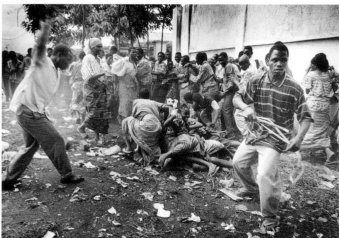 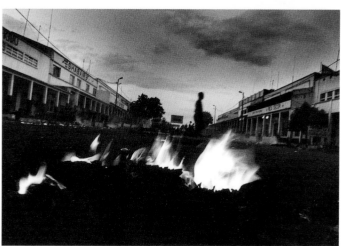

OF THOSE WOUNDED IN THE FIGHTING. THIS MAN'S LEG HAD BEEN AMPUTATED AFTER HE WAS INJURED DURING THE REBEL TAKEOVER. ■ FOOD RIOTS WERE A DAILY OCCURRENCE IN GOMA, AS GUARDS TRIED TO CONTROL THE CROWDS FIGHTING TO GET INSIDE A RELIEF WAREHOUSE. FIGHTING IN THE AREA LEFT GOMA ISOLATED FROM RELIEF AGENCIES AND WITH LITTLE FOOD. ■ AFTER WEEKS OF FIGHTING IN AND AROUND THE CITY, THE GOMA THAT THE REBELS HAD WON WAS A SHELL OF A CITY, ITS STORES LOOTED AND GARBAGE BURNING IN THE STREETS.

AT A TRANSFER STATION SET UP BY THE UNITED NATIONS NEAR KIGALI, RWANDA, THOUSANDS OF RWANDANS SCRAMBLED TO BOARD TRUCKS THAT WOULD TAKE THEM TO THEIR HOMES IN MORE REMOTES AREAS OF RWANDA. ■ AT THE MUGUNGA CAMP, A MAN PLAYS A GUITAR HE FOUND IN AN ABANDONED TRUCK. THE TRUCK HAD BEEN

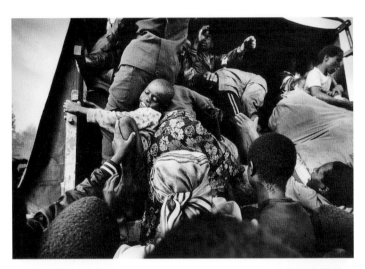
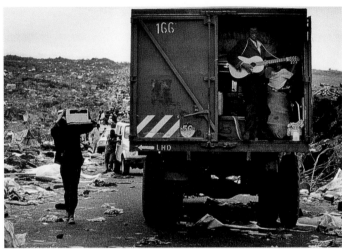
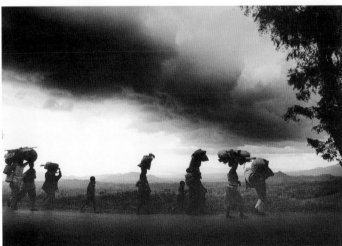
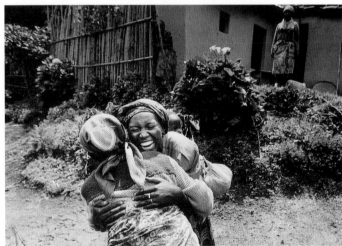

LEFT BEHIND BY THE OLD HUTU GOVERNMENT SOLDIERS WHO HASTILY FLED INTO THE HILLS AS THE ZAIRIAN REBELS APPROACHED. ■ REFUGEES JOURNEY HOME THROUGH THE RWANDAN MOUNTAINS. MANY WOULD WALK FOR WEEKS IN THE EVENINGS AND NIGHT TO AVOID THE HARSH SUN. ■ AFTER A TWO-WEEK JOURNEY ON FOOT FROM THE REFUGEE CAMP, YOLANDA MUGENI HUGS HER MOTHER-IN-LAW, ANGELINE IRADUKUNDA, UPON ARRIVING AT HER HOME IN RHUENGERI, RWANDA.

ZIV KOREN
Russian Immigrant
Strippers

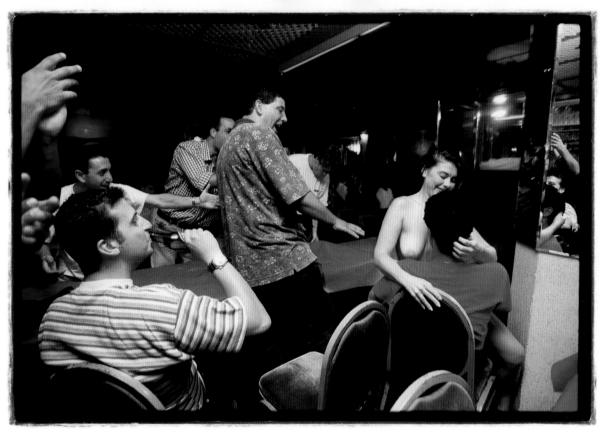

Jessica and Lolita (their stage names) immigrated to Israel last year, as have nearly 700,000 Russians since the new liberal era in the former Soviet Union. Jessica is 19 years old and Lolita is 23. Following the mass immigration, widespread unemployment among Russians led to many young women, like these two, supporting themselves as strippers, launching an adult-entertainment industry in Israel that did not previously exist. The industry is ruled and managed exclusively by Russians. *Representative: Sygma/Publisher:* Yedioth Ahronoth

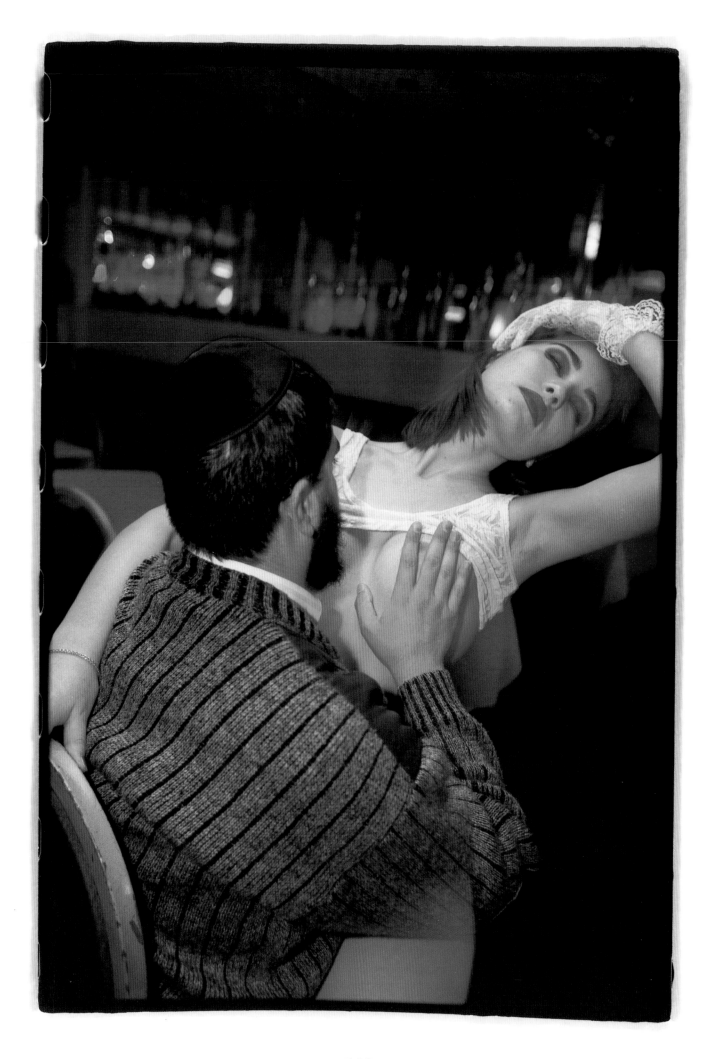

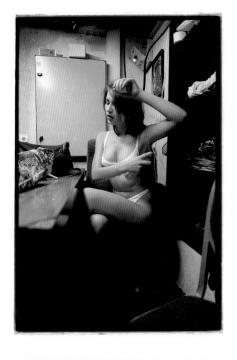 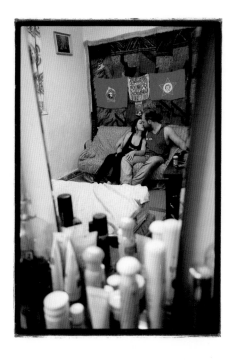 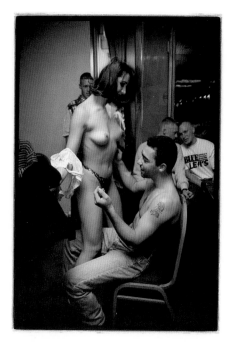

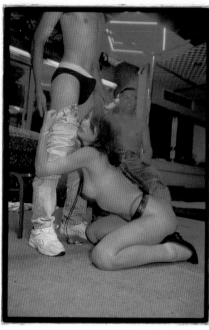 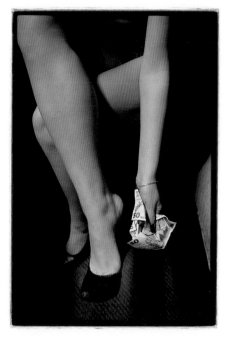 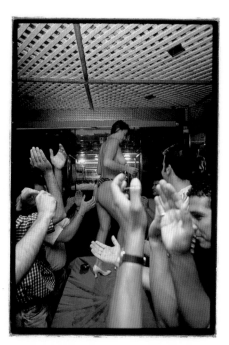

ZIV KOREN

THE RABIN ASSASSINATION, ONE YEAR AFTER

A year after the assassination of Israeli Prime Minister Yitzhak Rabin, people gather to
light candles at the site of the incident. *Representative: Sygma/Publisher: Yedioth Ahronoth*

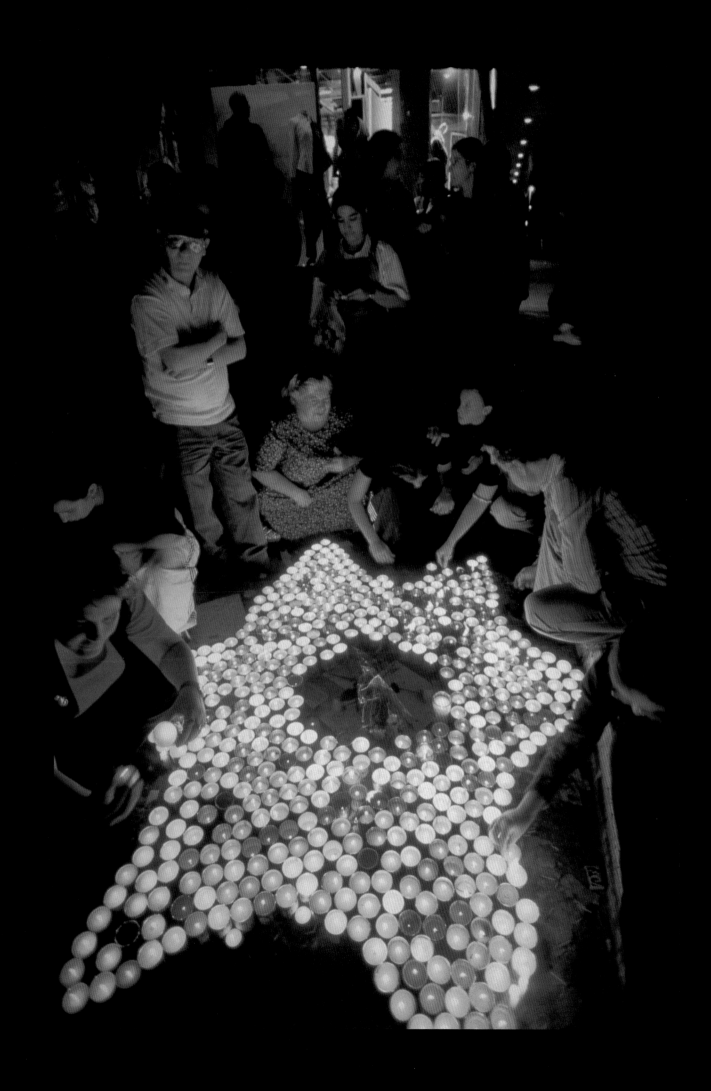

The Feast of
Saint Lazarus

ANTONIN KRATOCHVÍL

 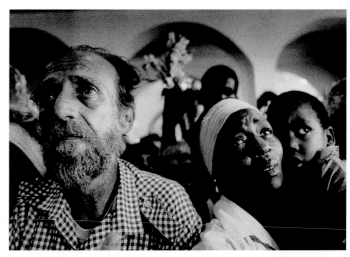

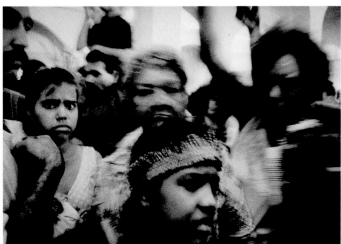 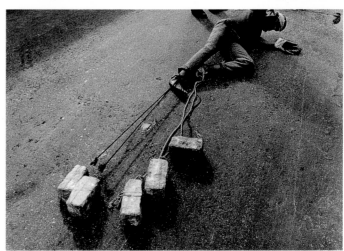

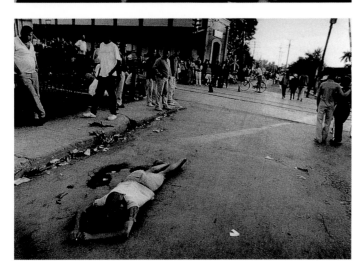 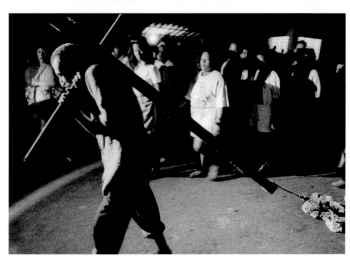

Every year, right before Christmas, in a small town outside of Havana, Cuba, men seeking miracles celebrate the feast of Saint Lazarus.

Crawling on their bellies, boulders strapped to their bodies, these men travel great distances in the hope that their sacrifice and pain will bring them the blessing of Saint Lazarus. From their small villages, these men crawl with their burdens to a church where they pray that their ailing family member or friend will be healed of their particular sicknesss in exchange for their suffering. *Representative: Saba Photo Agency*

(PREVIOUS SPREAD) CHURCH OF ST. LAZARUS IN RINCON, CUBA. ■ *(THIS PAGE)* WOMAN CRAWLS TO THE CHURCH ALONGSIDE A STATUE OF ST. LAZARUS. ■ PILGRIMS PRAY AT THE ALTAR OF ST. LAZARUS. ■ PILGRIMS GIVE OFFERINGS AT THE CHURCH OF ST. LAZARUS. ■ PILGRIM CRAWLS TO THE CHURCH OF ST. LAZARUS. ■ PILGRIMS CRAWLING TO THE CHURCH OF ST. LAZARUS. ■ A PILGRIM COLLAPSES ON THE STEPS OF THE CHURCH.

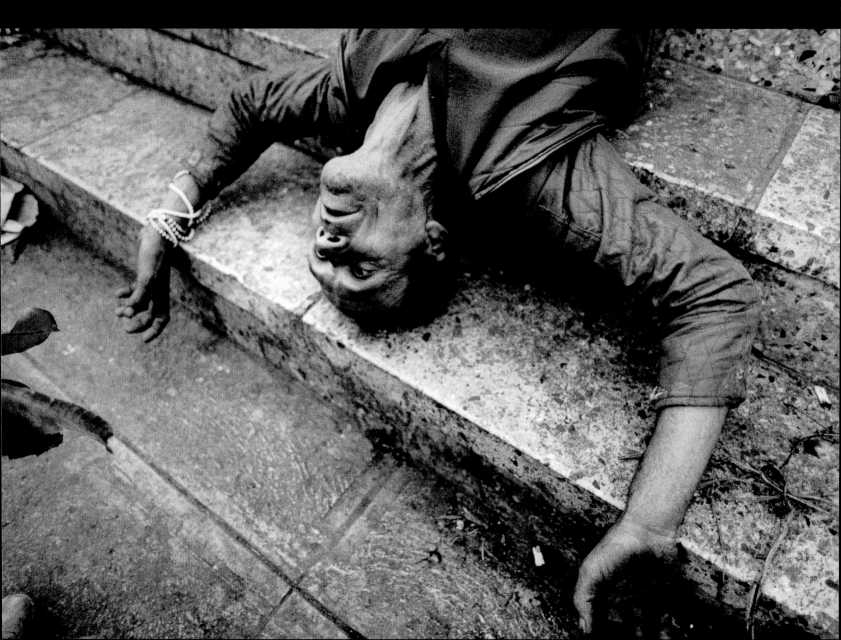

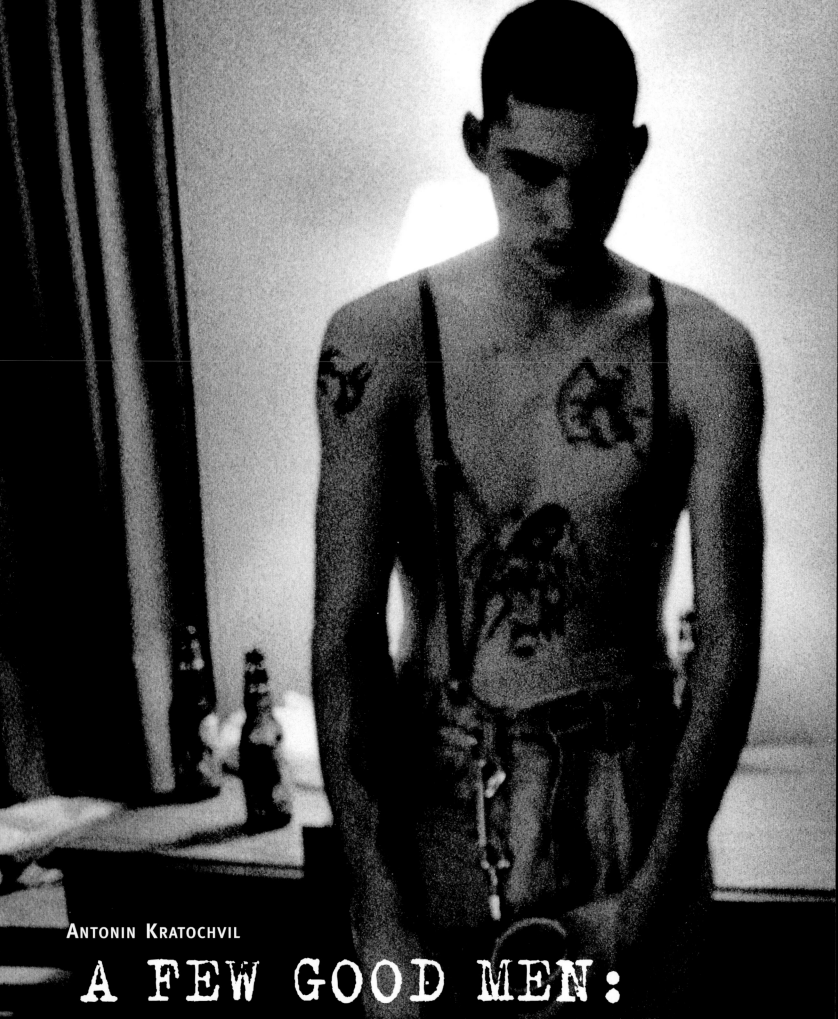

ANTONIN KRATOCHVIL

A FEW GOOD MEN:

White Supremacists in the Military

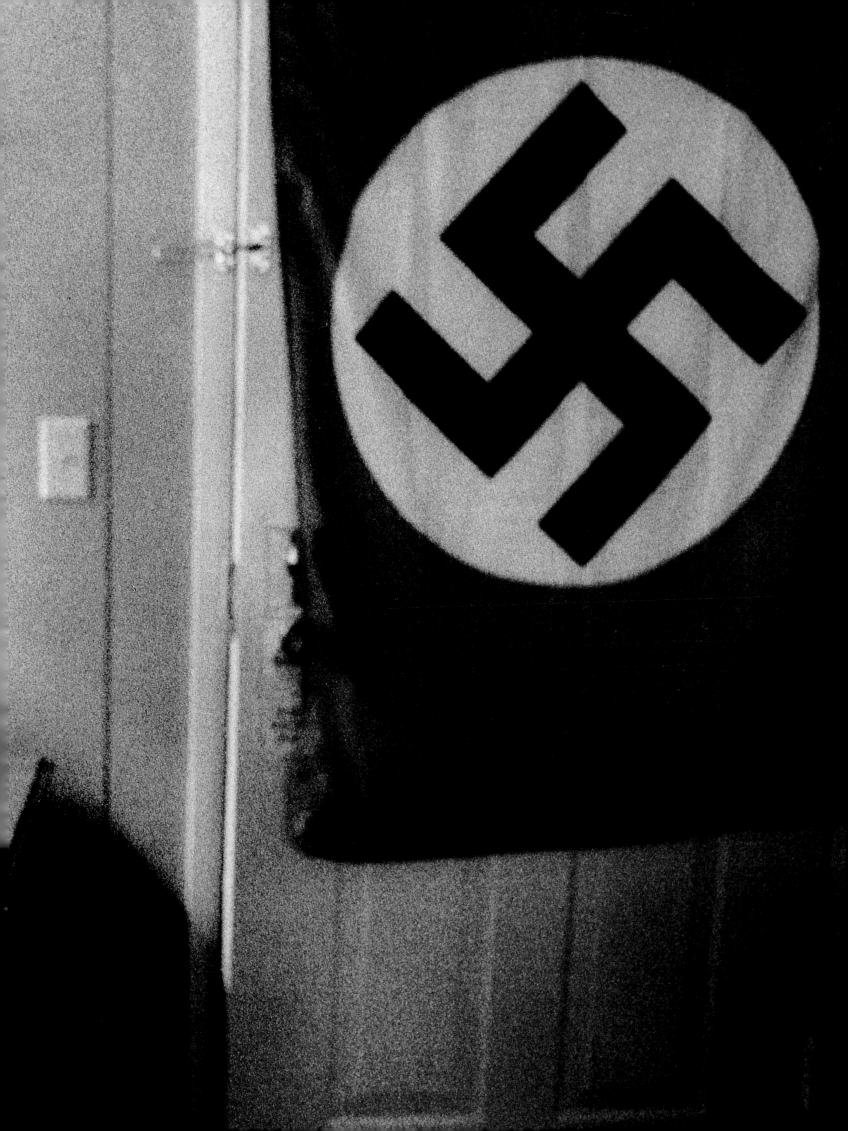

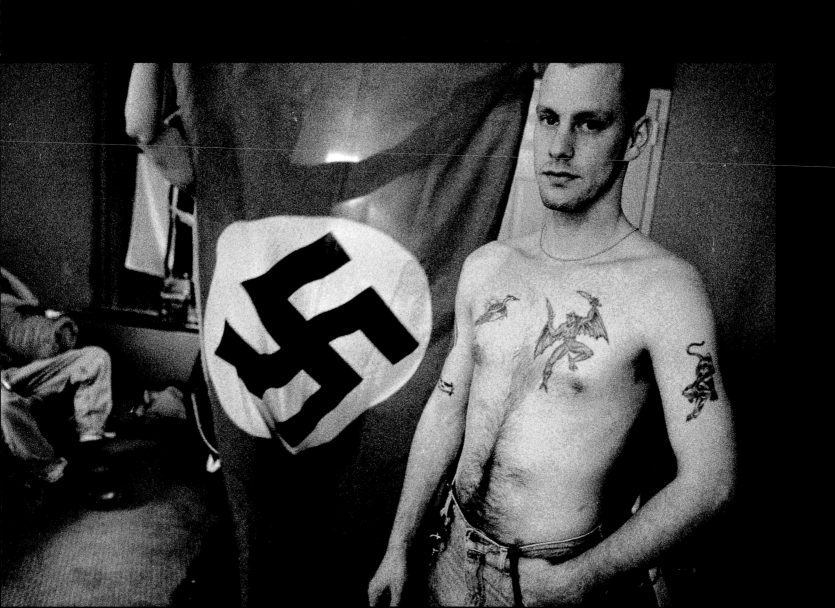

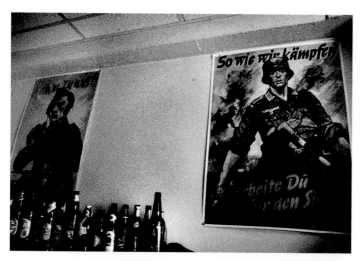
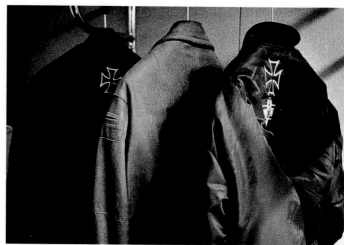
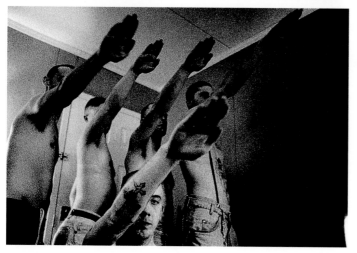
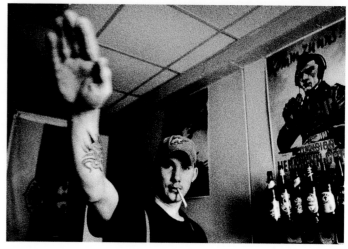

Early in 1996, *Esquire* magazine investigated the story of Private Jim Burmeister and his buddies at Fort Bragg, North Carolina, who proudly displayed swastikas in their barracks and celebrated white supremacism. The Army had apparently tolerated this activity for years, until one day a black couple was murdered in the area, and Burmeister and a buddy, Malcolm Wright, were the prime suspects.

The murder raised unsettling questions. "Just what does it take to get expelled from the Army?" asked *Esquire*. "Had he been openly homosexual, Burmeister would have been chaptered out immediately. But the true beneficiaries of the military's 'Don't ask, don't tell' philosophy seem to be political extremists."

Photographer Antonin Kratochvil covered the story for the magazine. All of the soldiers depicted were, at the time the article ran, being "chaptered out" of the Army, chiefly, *Esquire* reported, for being photographed and not necessarily for past skinhead activities.

(PREVIOUS SPREAD AND THIS SPREAD) NEO-NAZI BEER PARTY AT FORT BRAGG, NORTH CAROLINA. ■ *(THIS PAGE, TOP RIGHT)* JACKETS WITH NAZI EMBLEMS AT A BEER PARTY AT FORT BRAGG. ■ *(THIS PAGE, BOTTOM RIGHT)* NEO-NAZI SALUTES IN THE BARRACKS AT FORT BRAGG.

REGIS LEFEBURE
ALCATRAZ

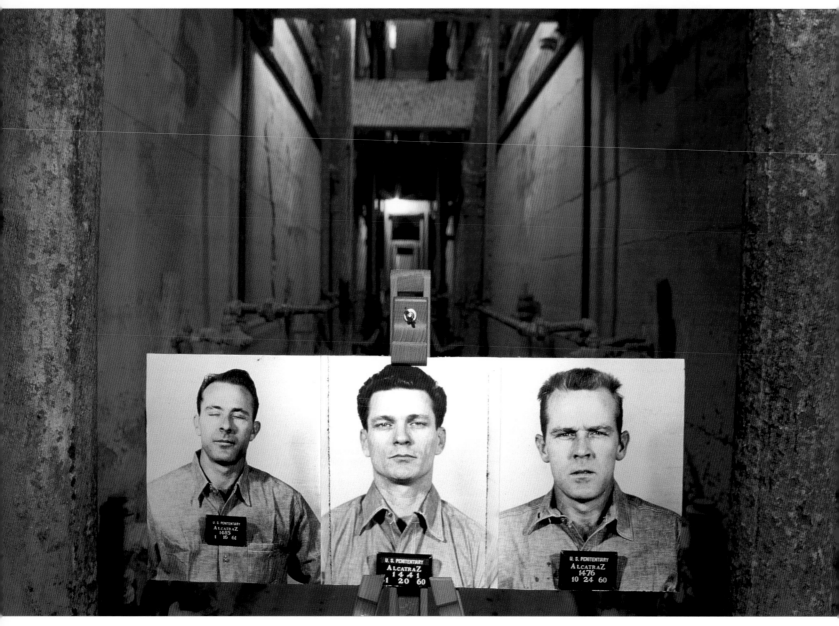

The stories of Alcatraz abound. It was once a Civil War-era fortress and military prison and in 1970 was occupied for 19 months by American Indians in a symbolic fight for rights. The best-known stories began in 1934, when J. Edgar Hoover made Alcatraz the most formidable prison in the U.S. I had been photographing the island since 1989 when Edgar Rich of *Smithsonian* magazine suggested taking along mug shots of Alcatraz's most infamous inmates to help illustrate a story on the former federal prison. *Publisher:* Smithsonian *magazine*

(THIS PAGE) FRANK MORRIS FLANKED BY BROTHERS CLARENCE AND JOHN ANGLIN. WORKED ON ESCAPE FOR SIX MONTHS. MADE PLASTER CASTS OF THEIR HEADS, DUG THROUGH WALLS WITH SPOONS, AND CLIMBED PIPES IN THIS CORRIDOR TO A ROOF VENT. ALL PRESUMED DROWNED. ■ *(OPPOSITE PAGE)* AL CAPONE SMILES WHILE PLAYING CARDS ON THE FIRST TRAIN OF PRISONERS TRANSFERRED TO ALCATRAZ IN 1934. CAPONE WAS THE CELL HOUSE JANITOR ON ALCATRAZ, SWEEPING FLOORS IN THE MAIN BLOCK KNOWN AS "BROADWAY." ■ ALVIN "CREEPY" KARPIS WAS PRESIDENT HOOVER'S ORIGINAL PUBLIC ENEMY NO. 1, AND SPENT TWENTY YEARS ON ALCATRAZ. ■ GEORGE "MACHINE GUN" KELLEY WAS WELL LIKED BY ALMOST ALL IN PRISON, THOUGH MOST THOUGHT HIM NOT VERY BRIGHT. ■ ROBERT STROUD, THE "BIRDMAN OF ALCATRAZ" CUNNING, DEVIOUS, SELF-PROCLAIMED PEDOPHILE WHO SPENT SEVEN ISOLATED YEARS IN A MODIFIED HOSPITAL CELL COMPLAINING OF TRANSPLANT AILMENTS.

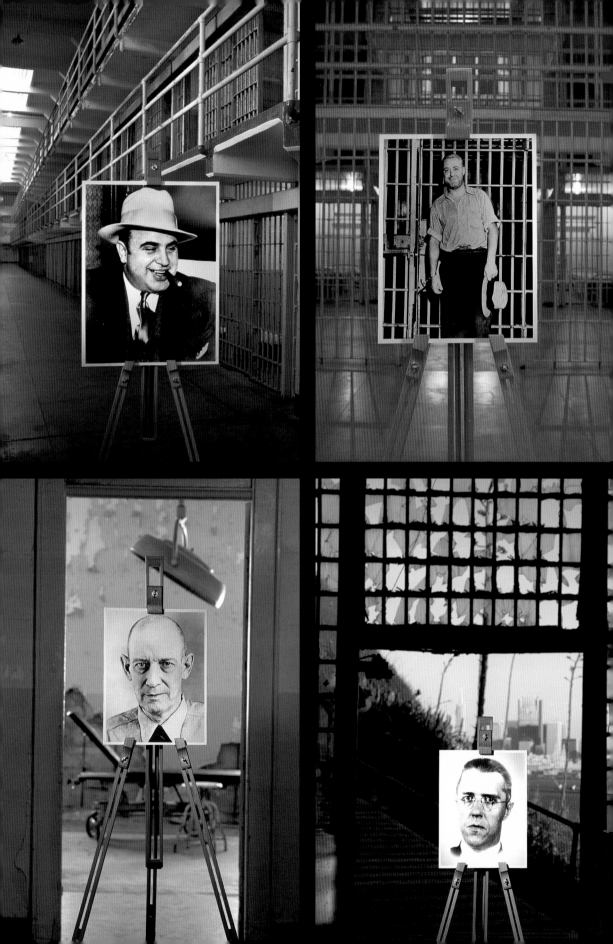

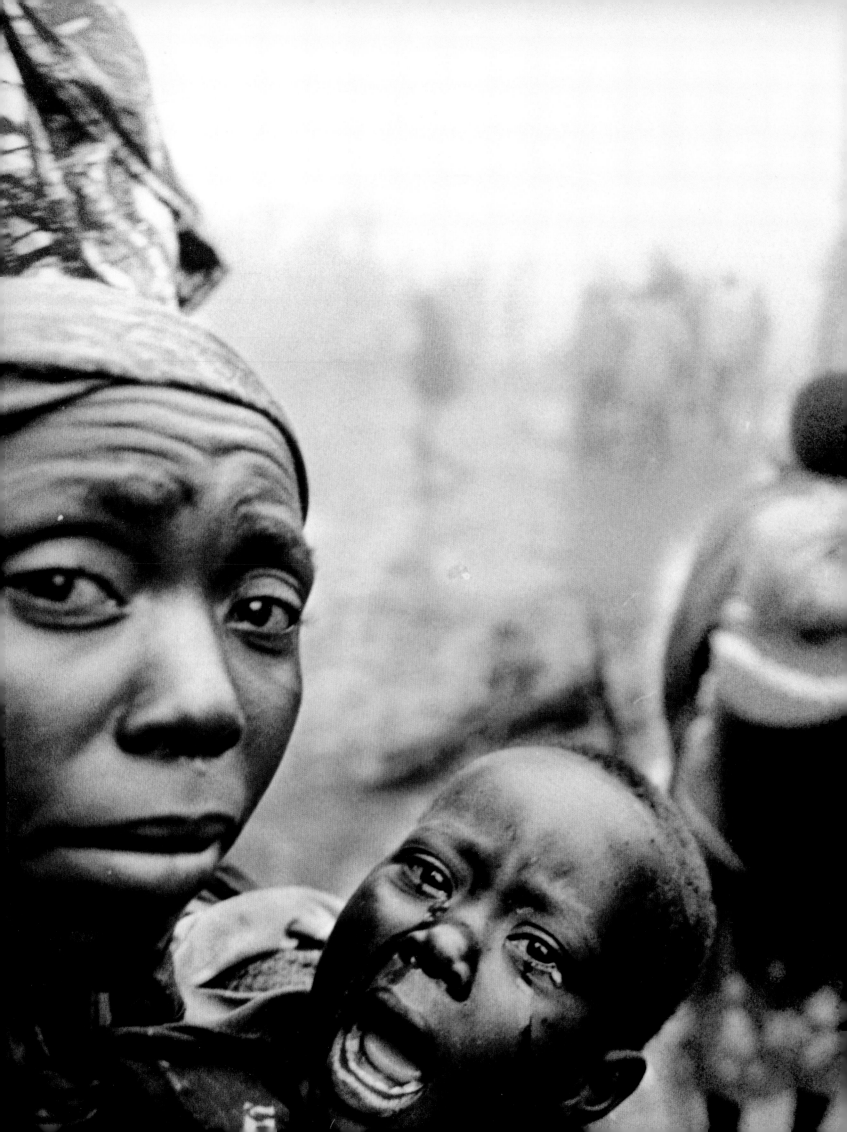

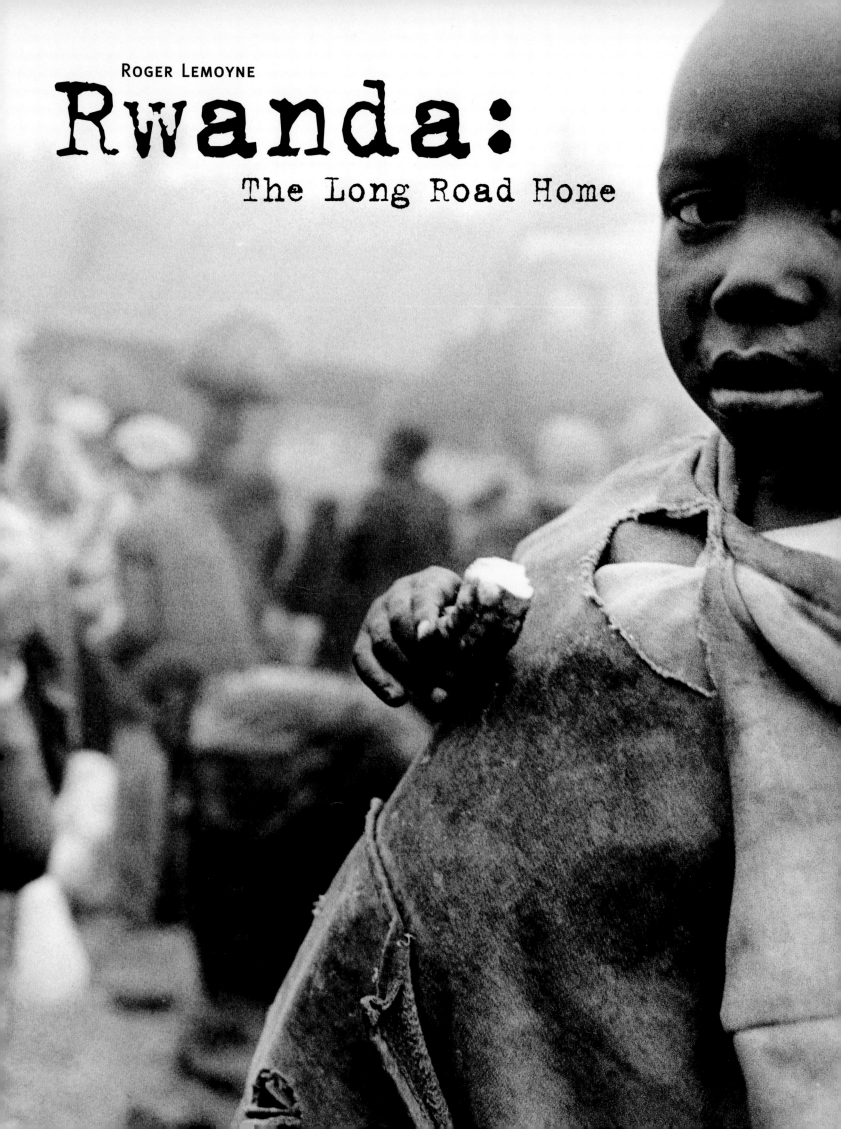

Rwanda:

The Long Road Home

ROGER LEMOYNE

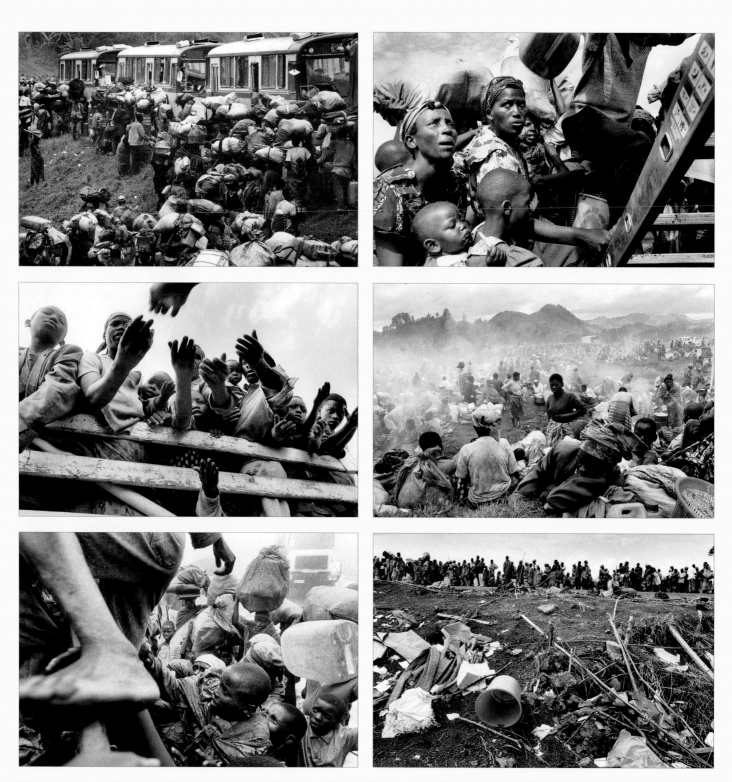

These photographs depict the repatriation of Rwandan Hutu refugees from Mugunga and other refugee camps in Zaire—one of the longest human migrations in history. *Representative: Gamma-Liaison/Publisher: UNICEF and others*

(PREVIOUS SPREAD) MOTHER AND CHILD. ■ *(THIS PAGE)* UNHCR BUSSES. ■ STEPS. ■ BISCUITS. ■ COOKING FIRES. ■ TRUCK NEAR RUHENGERI. ■ LEAVING MUGUNGA.
■ *(OPPOSITE PAGE)* THOSE LEFT BEHIND. ■ TROUBLED CHILD IN MUGUNGA.

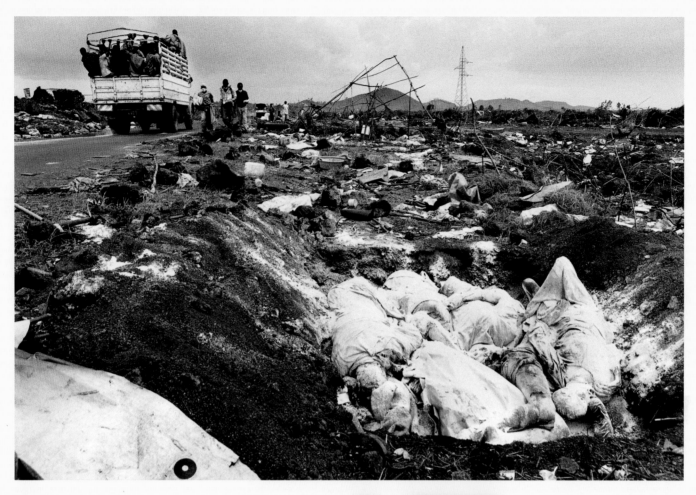

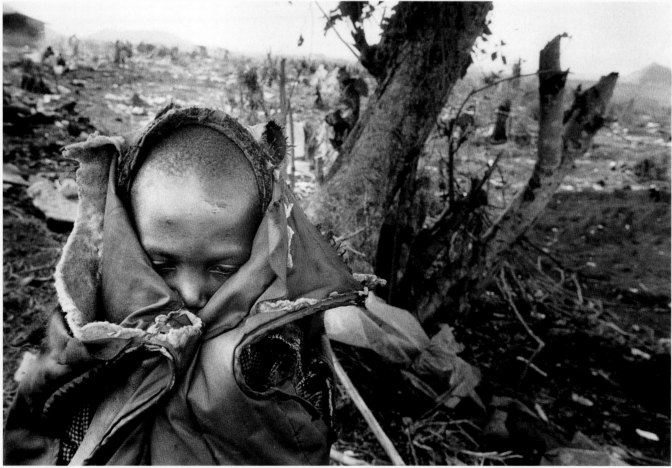

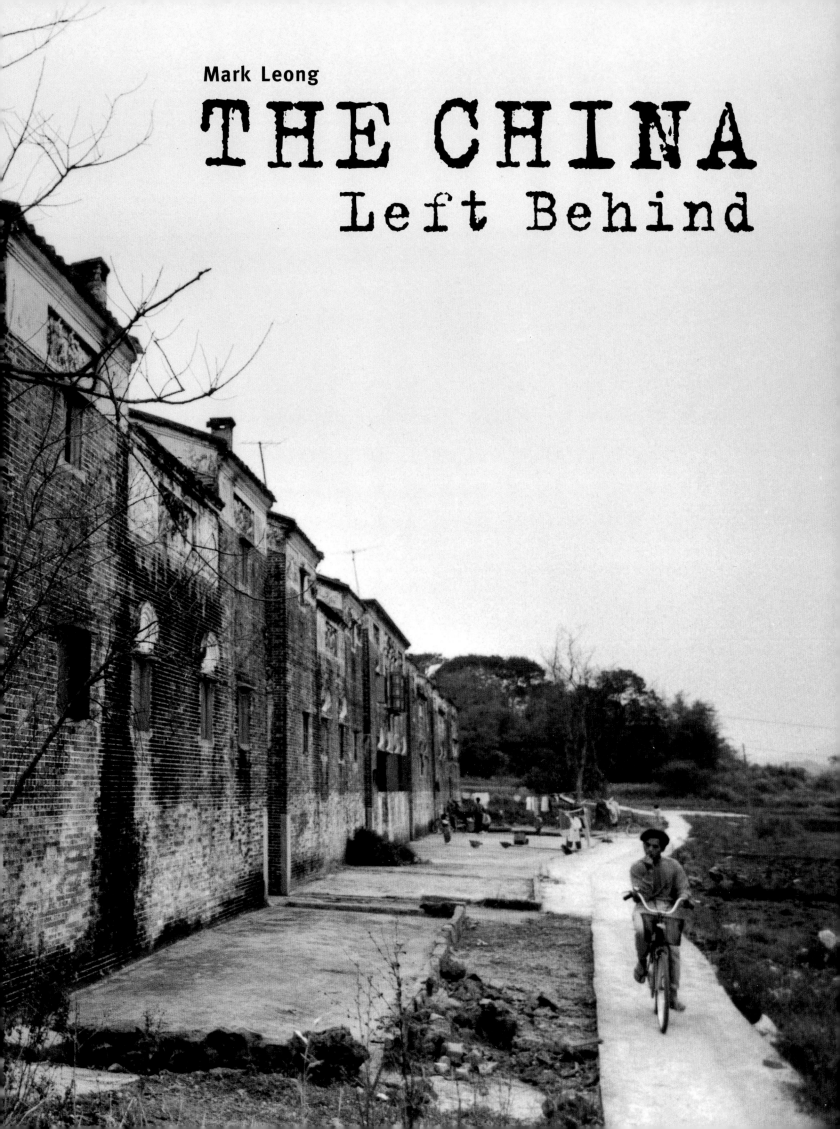

Mark Leong

THE CHINA
Left Behind

(PREVIOUS PAGE) THE VILLAGE OF SOON WALL SITS ALONE ON THE PEARL RIVER DELTA IN CHINA'S SOUTHERN PROVINCE OF GUANGDONG, SEPARATED FROM OTHER VILLAGES BY HILLS, FIELDS, AND STRETCHES OF ROAD. THESE DAYS, MOST OF THE 300-YEAR-OLD FARMING VILLAGE BUILDINGS ARE EMPTY. ■ *(THIS PAGE)* SOON WALL OFFERS LITTLE IN THE WAY OF DIVERSION, SO VILLAGERS PASS THE AFTERNOON WATCHING THE ROAD. YOUNG PEOPLE UNABLE TO GO TO AMERICA HEAD FOR EMPLOYMENT IN CHINA'S BOOMING URBAN CENTERS, AS MUCH TO ESCAPE BOREDOM AS TO EARN MONEY. ■ *(OPPOSITE PAGE)* OVERSEAS RELATIVES PROVIDE ENGLISH ADDRESS LABELS TO MAKE CORRESPONDENCE EASIER. ■ WALLS CRAMMED WITH SNAPSHOTS OF RELATIVES IN THE WEST ARE COMMON IN SOON WALL AND OTHER TOISAN VILLAGES. ■ SEVENTY-YEAR-OLD

In 1923 my grandfather Fong Quong Zon left the southern Chinese village of Soon Wall to seek his fortune in the United States. Sixty-seven years later, I made my way back to this rural hamlet in Toisan County, in the heart of Guangdong's Pearl River Delta. Three generations in America notwithstanding, I was welcomed like a returning brother. Nearly everyone in

and children. The population, which had been gradually dwindling from its 1930s peak of 700, has plummeted from 350 to 120 in the last five years.

Where has everybody gone? A cousin guided me past empty homes, reciting an American litany—San Francisco, Houston, Connecticut—as he touched each silent door.

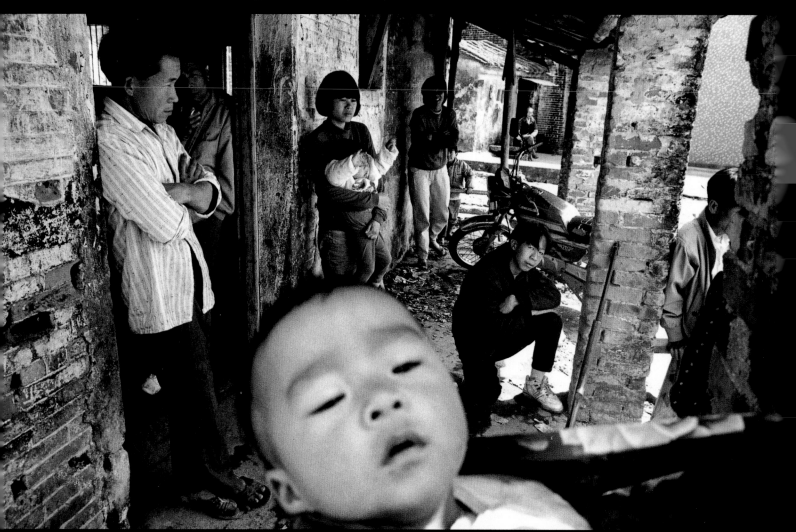

Soon Wall is named Fong. All I had to say was, "I am the grandson of Fong Quong Zon," and doors would open wide.

On a second, more recent visit, however, I was startled to find many of those doors boraded shut. Previously bustling, Soon Wall has become a deteriorating shell of vacant houses and crumbling walls, a hollow demographic of elderly people

In this century, so many have emigrated from villages like Soon Wall that Chinese-Americans with roots in Toisan now outnumber the county's million residents.

A billboard in the county seat once read, "Home of the Overseas Chinese," before it too corroded. *Representative: Matrix/Publisher: The New York Times Magazine*

FONG NY ZONG RUNS THE ONLY SHOP LEFT IN SOON WALL AFTER THE LACK OF CUSTOMERS CLOSED TWO OTHERS. HIS STORE HAS ONE OF THE FEW REFRIGERATORS IN THE VILLAGE; OTHER MODERN CONVENIENCES LIKE TELEPHONES, RUNNING WATER, AND AUTOMOBILES REMAIN SCARCE. ■ THE CHARACTERS "SOON WALL" MEAN "SMOOTH PEACE." ■ SOON WALL HAS BECOME A VILLAGE OF MOSTLY OLD PEOPLE AND CHILDREN AS MOST OF THE YOUNG PEOPLE HAVE GONE AWAY TO WORK IN THE UNITED STATES OR IN CHINA'S BOOMING URBAN CENTERS. ■ SNAPSHOTS OF ELAINE FONG AND HER FAMILY IN SAN FRANCISCO DOMINATE HER MOTHER'S KITCHEN WALL IN SOON WALL. ELAINE (PICTURED AT CENTER WITH HER HUSBAND) HAS JUST RECEIVED HER AMERICAN CITIZENSHIP AND HOPES TO BRING HER MOTHER OVER IN THE NEXT YEAR.

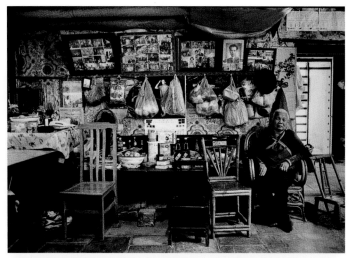

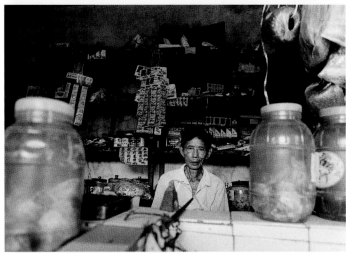

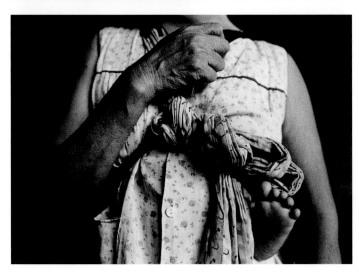

(THIS PAGE) THE FEW YOUNG MEN WHO REMAIN IN THE VILLAGE FIND WORK ON CONSTRUCTION SITES IN NEARBY TOWNS. HERE, THE AVERAGE PAY IS ABOUT US $25.00 PER MONTH, COMPARED TO THE $45.00 PER MONTH AVAILABLE AT FACTORY JOBS IN CITIES LIKE GUANGZHOU AND SHENZHEN. ■ FOR THE GRAVESWEEPING FESTIVAL, VILLAGERS MAKE RITUAL OFFERINGS OF ROASTED GOOSE, RICE WINE, HARD-BOILED EGGS, SUGAR CANE, AND GLUTINOUS RICE CAKES AT THEIR ANCESTRAL PLOTS IN THE HILLS AROUND SOON WALL. THIS FESTIVAL, IN MARCH AND EARLY APRIL, IS THE PRIMARY TIME THAT THOSE WHO HAVE MOVED ELSEWHERE RETURN TO THE VILLAGE. ■ THIS COW WAS PURCHASED FOR PLOWING WITH MONEY SENT BACK FROM A RELATIVE WHO LEFT IN THE 1940S AND NOW OWNS A RESTAURANT IN CHICAGO. ■ VILLAGERS (LEFT) WATCH AS COUSINS FROM CHICAGO (RIGHT) MAKE AN EXTRAVAGANT OFFERING OF A WHOLE ROASTED PIG AT THE GRAVES OF ANCESTORS IN THE

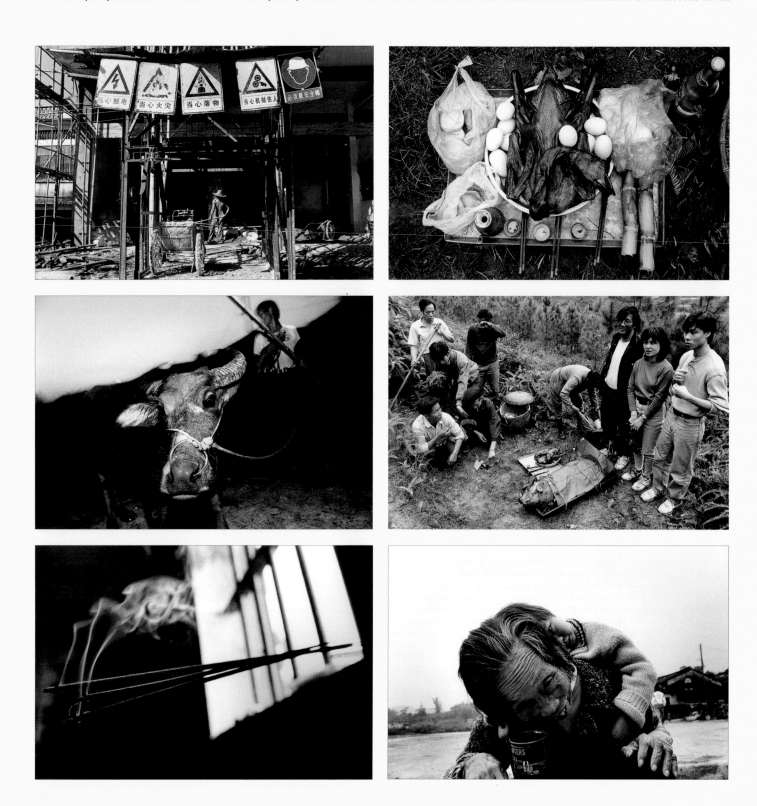

HILLS SURROUNDING SOON WALL. AFTER SOME OF THE PORK IS LEFT ON THE GRAVESITES, THE REST IS SHARED AMONG THE VILLAGERS. ■ BURNING INCENSE LETS THE ANCESTORS KNOW THAT THEIR DESCENDANTS HAVE RETURNED FROM ABROAD TO VISIT THEIR FAMILY HOME. ■ A CHILD AND HER GRANDMOTHER REMAIN IN SOON WALL, WAITING FOR THE CHILD'S FATHER TO STRIKE IT RICH AND SEND FOR THEM FROM THE BIG CITY. ■ *(OPPOSITE PAGE)* IN 1934, MY GRANDFATHER SETTLED IN CHICAGO AND SENT FOR MY GRANDMOTHER. BECAUSE HE WAS NOT YET A CITIZEN, SHE PAID A MAN FROM A NEARBY VILLAGE FOR THE PROPER PAPERS TO ALLOW HER TO TRAVEL AS HIS DAUGHTER, CARRYING A "CRIB SHEET" OF DETAILS ABOUT HER SUPPOSED HOME TO STUDY FOR THE IMMIGRATION INTERVIEW. ■ MY GREAT-GRANDFATHER'S HOUSE HAS STOOD VACANT SINCE THE 1940S, WHEN THE REMAINING FAMILY MEMBERS FLED CHINA TO AVOID THE COMMUNIST TAKEOVER.

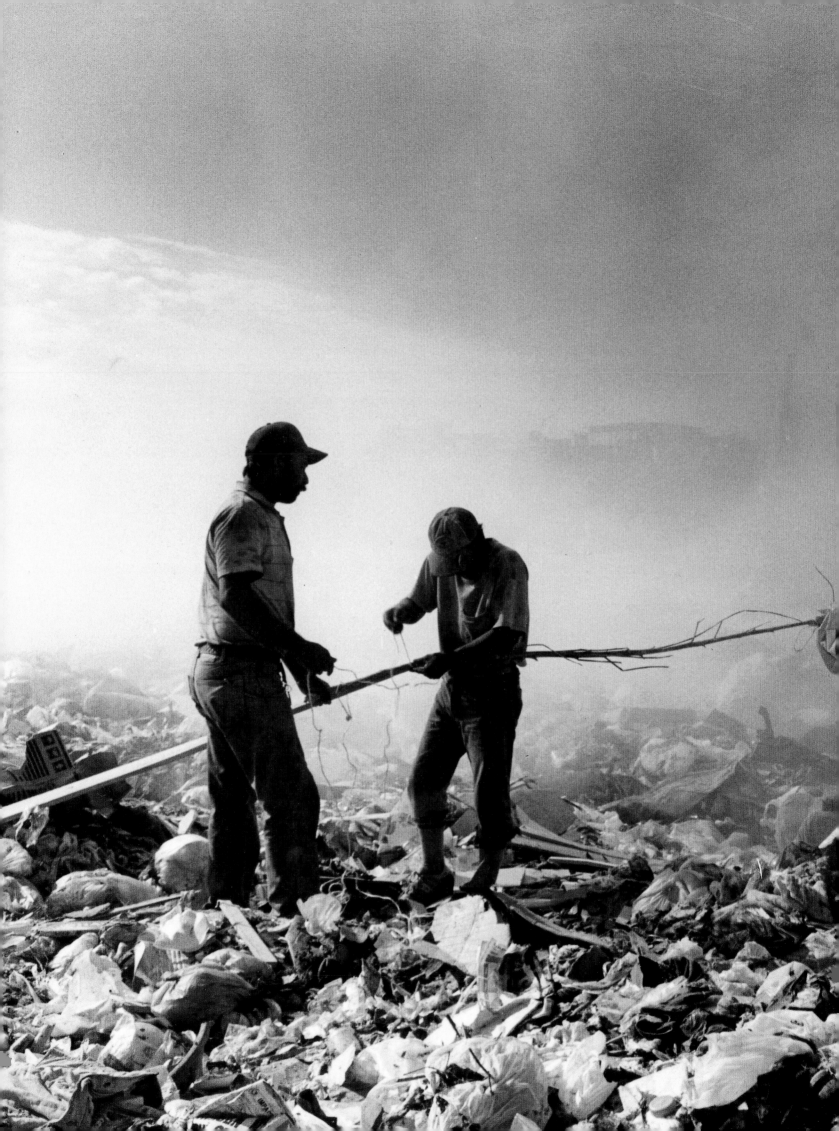

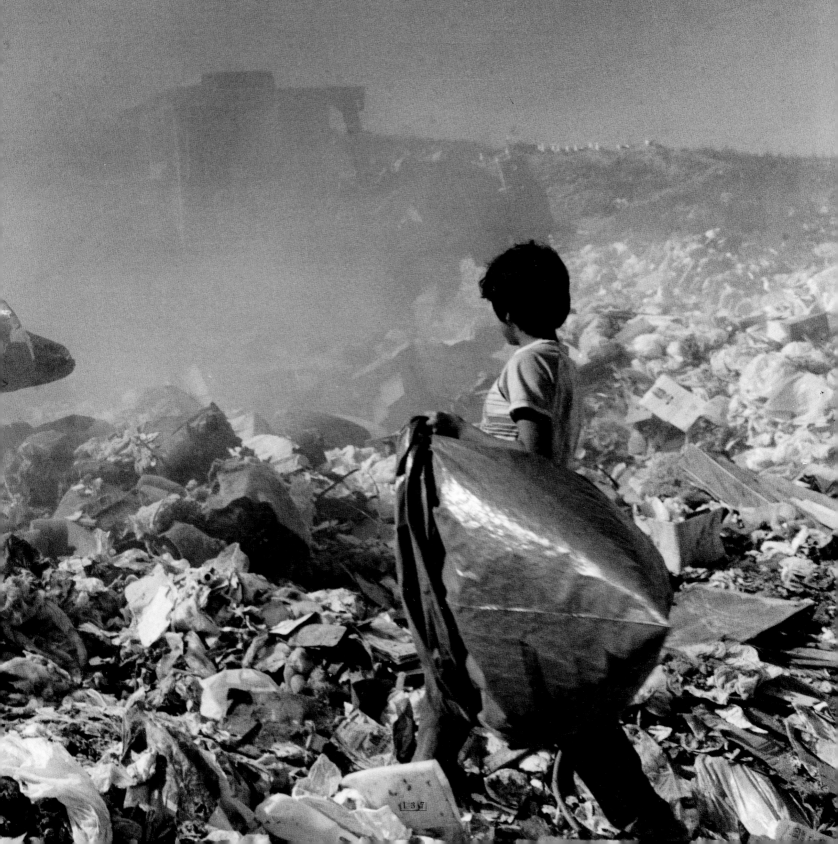

Families Who Live in and Off of the Dumps of

Tijuana

Jack Lueders-Booth

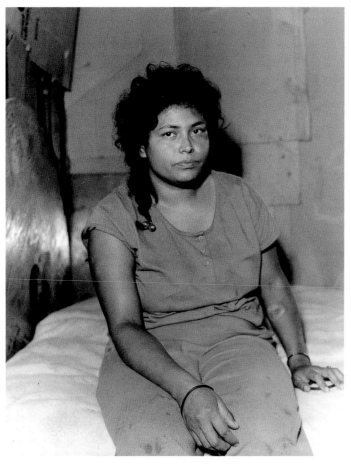

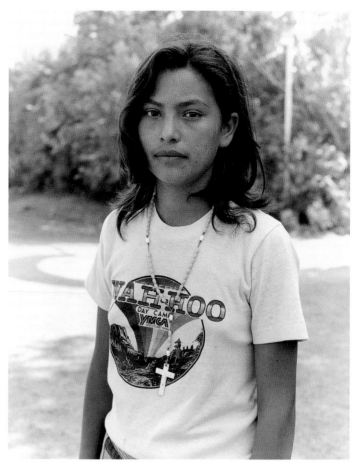

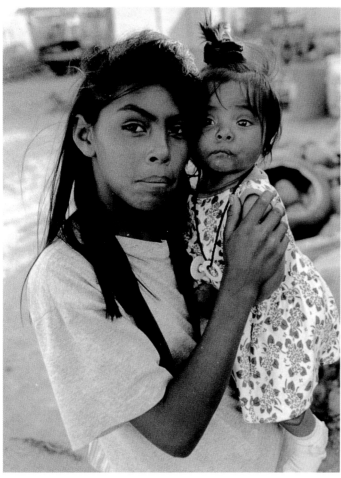

I have been photographing in the dumps and barrios of Tijuana, Mexico, several weeks a year since 1991. I intend to continue and will return again later in 1997.

Through the residents' trust I have gained privileged access to this community, which is not only unknown to most Americans, medical disasters, they have a strong sense of purpose, spirituality, family, and generosity. I was amazed to observe that they had voluntarily set aside an area of the dump in which the elderly and disabled could pick trash without having to compete with the more physically fit, and I am repeatedly struck

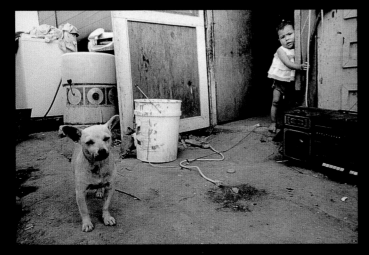 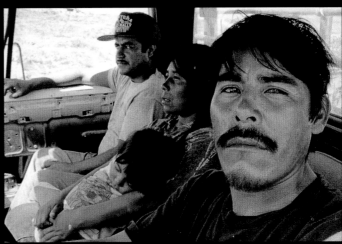

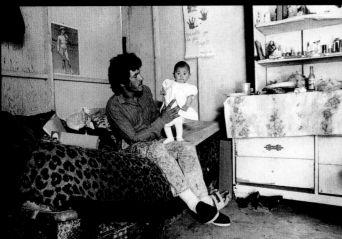 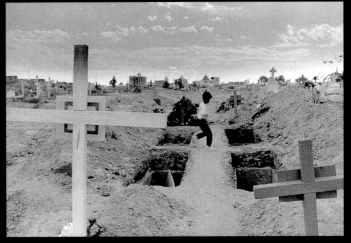

it is also unknown to most Mexicans. These are very resourceful people, who skillfully dig through trash finding cans and bottles that are redeemable for cash, restorable furniture for their homes, repairable toys for their children, and (sometimes), edible food for themselves. In the face of economic and by many other examples of selflessness, community, and optimism in these people, for whom such things as infant mortality, malnutrition, chronic illness, inadequate shelter and clothing, are commonplace. Many of them are now using my photographs to start family albums. I am honored.

(ALL IMAGES) FAMILIES WHO LIVE IN AND OFF OF THE DUMPS OF TIJUANA. WORK-IN-PROGRESS, 1991-1997.

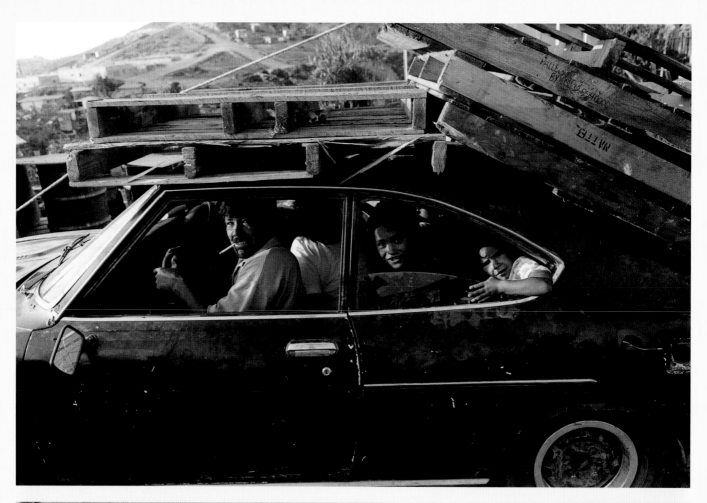

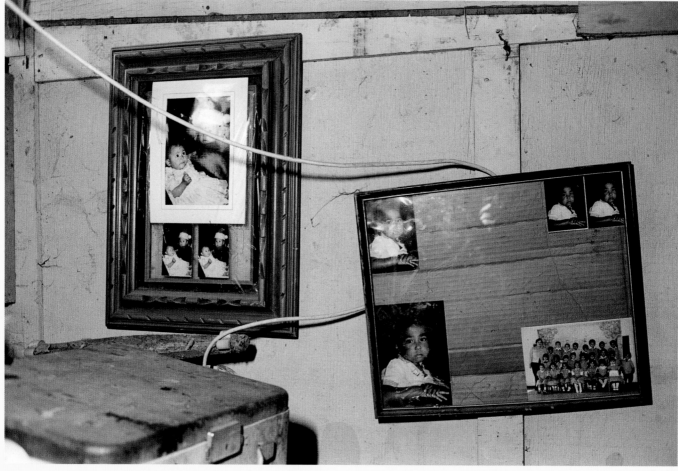

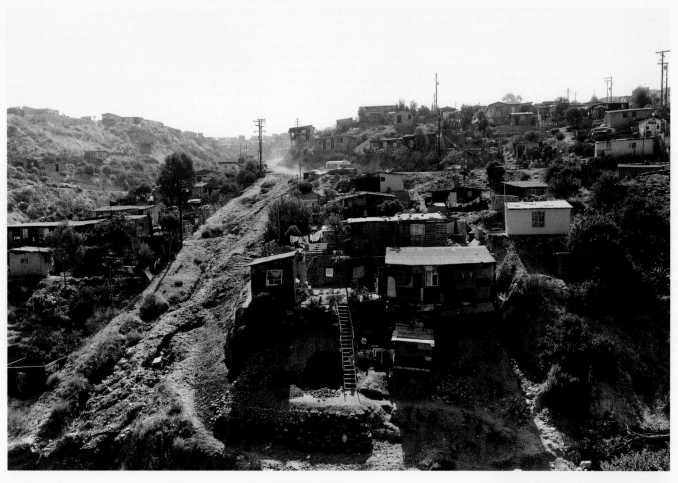

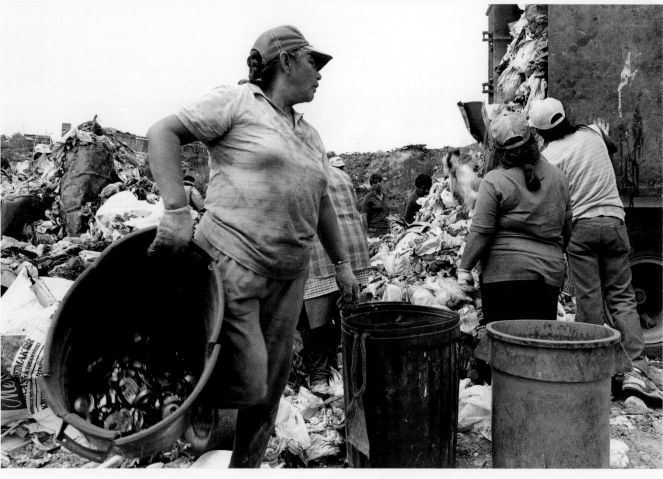

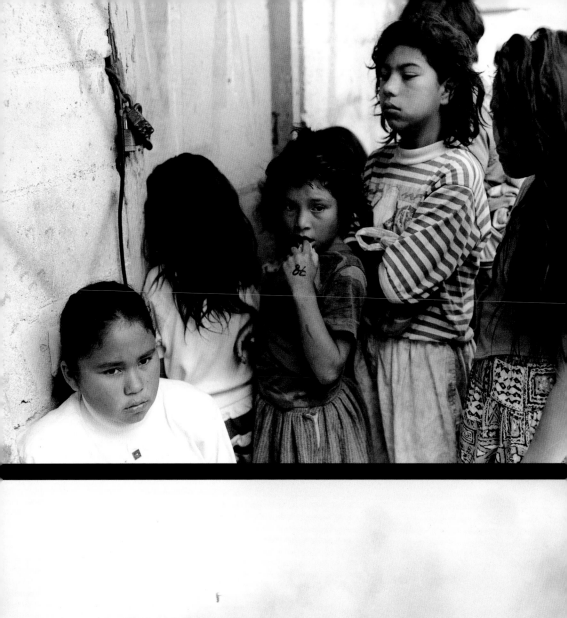
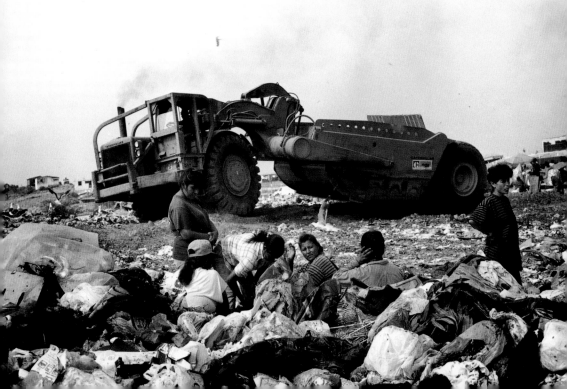

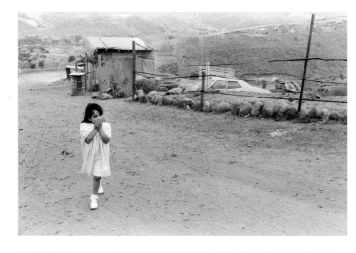 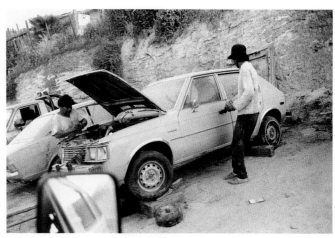

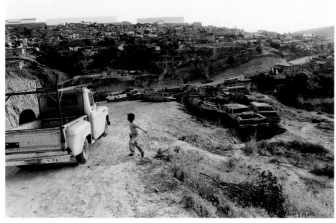 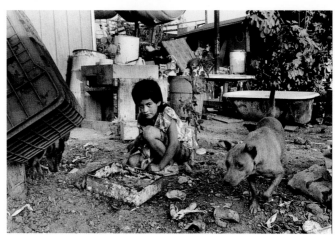

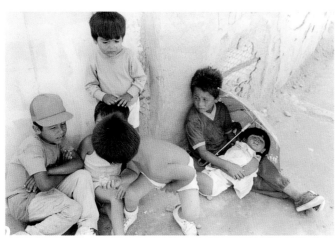 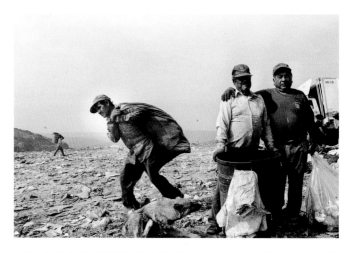

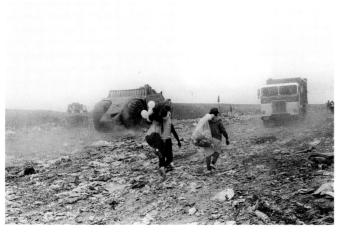 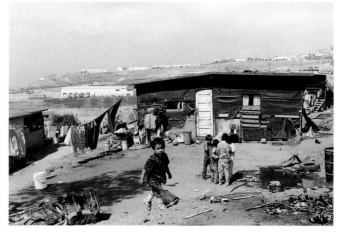

NORMAN MAUSKOPF

A Time Not Here

Originally from Brooklyn, New York, and currently living in Santa Fe, New Mexico, photographer Norman Mauskopf made the first of a series of trips to Mississippi in 1992. He had intended to put together a magazine article on country blues, and country blues musicians, and headed for Oxford, then to Clarksdale and surrounding towns—places once synonymous with Delta blues.

Before long he was drawn to the rhythms of daily life in Mississippi, and found himself photographing out-of-the-way churches—inside and out—as well as church services and gospel music. Three years and a few hundred rolls of film later, he had a rich portrait of this slice of religious and cultural life in rural Mississippi. A large selection of the images was published, along with a stirring narrative by Randal Kennan, in the award-winning book *A Time Not Here* (Twin Palms/Twelve Trees Press).

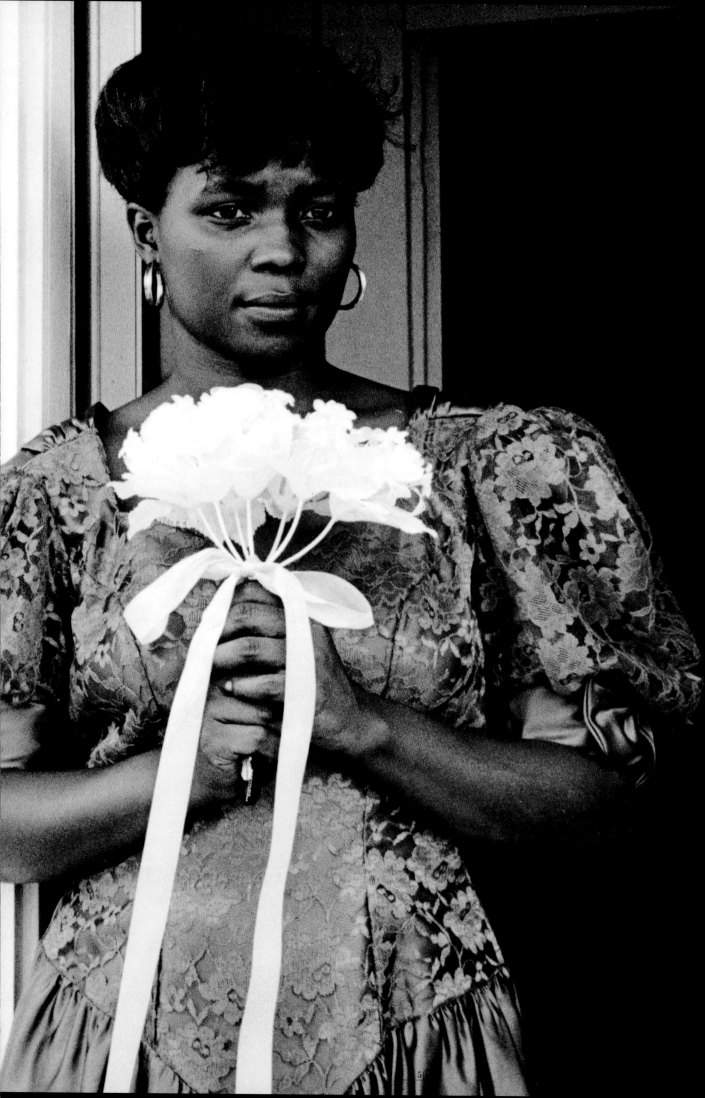

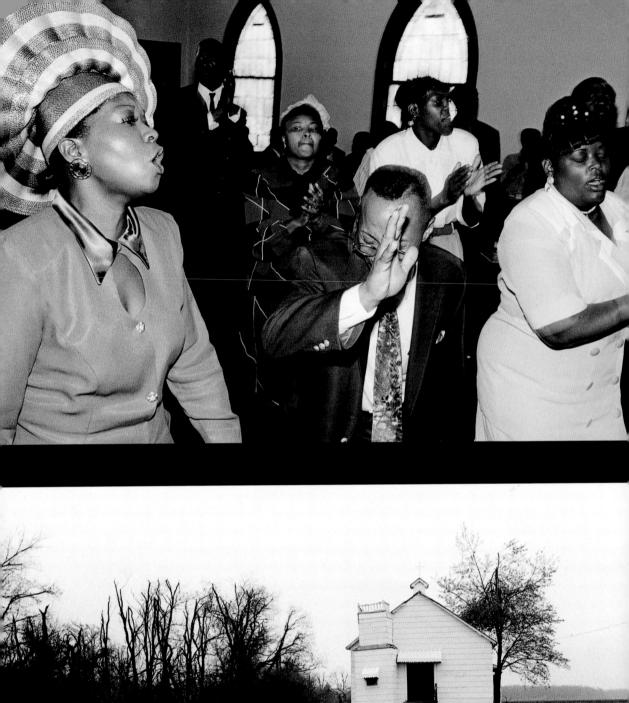

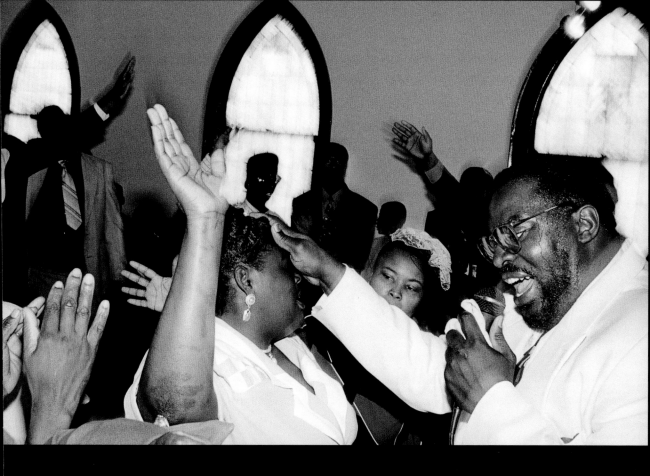

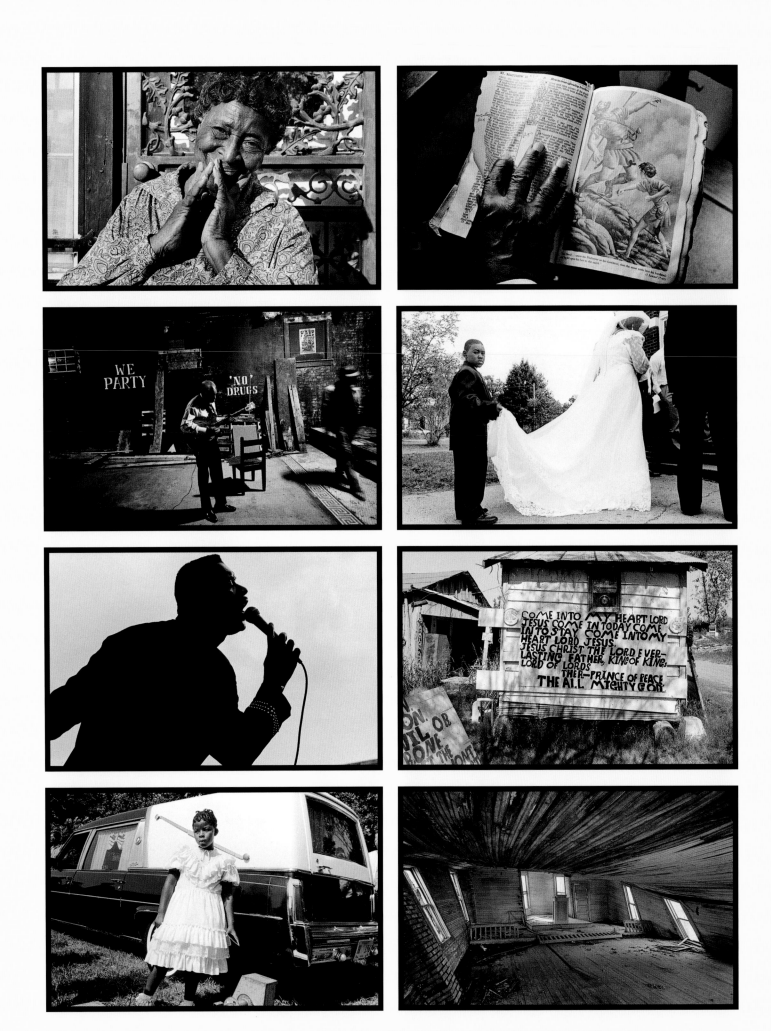

(THIS PAGE) MISS MABEL, SLEDGE, MISSISSIPPI ■ BIBLE CLASS, JONESTOWN, MISSISSIPPI ■ CLARKSDALE, MISSISSIPPI ■ MARKS, MISSISSIPPI ■ CLARKSDALE, MISSISSIPPI ■ MARKS, MISSISSIPPI ■ LELAND, MISSISSIPPI ■ TALLAHATCHIE COUNTY, MISSISSIPPI ■ *(OPPOSITE PAGE)* COANOMA COUNTY, MISSISSIPPI

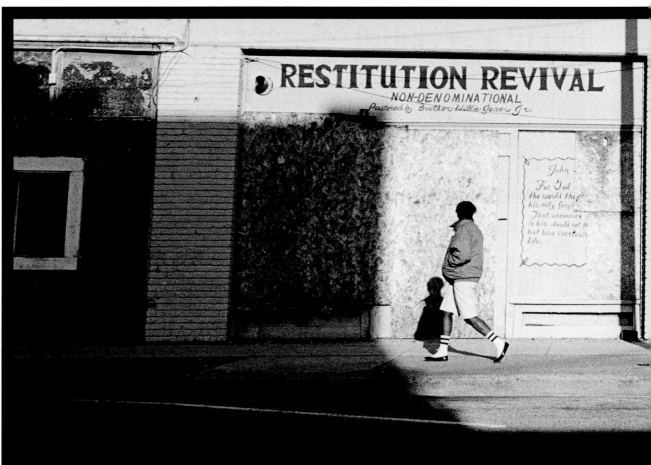

COANOMA COUNTY, MISSISSIPPI ■ CLARKSDALE, MISSISSIPPI

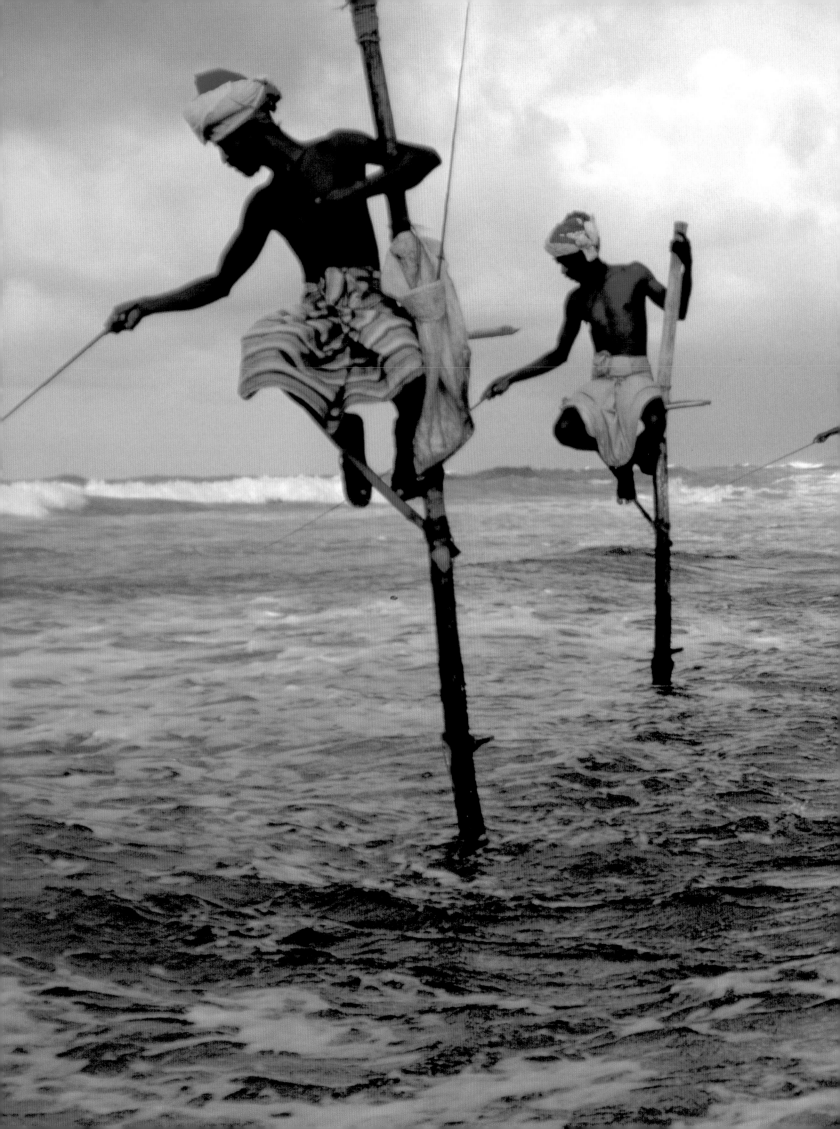

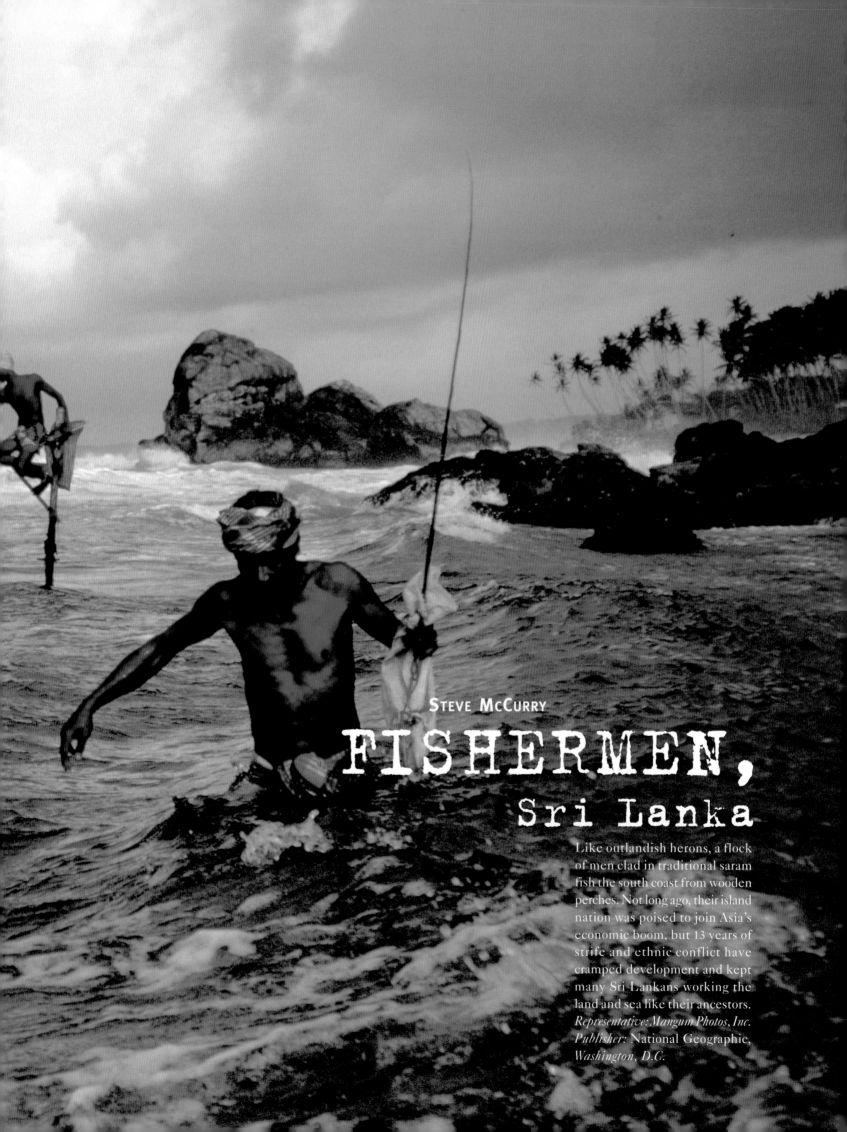

STEVE McCURRY

FISHERMEN,
Sri Lanka

Like outlandish herons, a flock of men clad in traditional saram fish the south coast from wooden perches. Not long ago, their island nation was poised to join Asia's economic boom, but 13 years of strife and ethnic conflict have cramped development and kept many Sri Lankans working the land and sea like their ancestors.
Representative: Mangum Photos, Inc.
Publisher: National Geographic, *Washington, D.C.*

John Moore
LITTLE LAMA

Four-year-old Trulku-la is like any other boy his age in most respects. He is playful—enjoying a ride in a red wagon—and restless, as well, tapping a toy on the head of his nanny as he is being dressed. But that is where most similarities between Trulku-la and other boys end. He is recognized by Tibetan Buddhists as Deshung Rinpoche IV, the reincarnation of a high lama who died in Seattle, Washington, in 1987.

Deshung Rinpoche III told his students before his death that he would be reborn in the Seattle area. Born Sonam Wangdu in that city, the boy was renamed Trulku-la, the Tibetan term for reincarnation. At the age of two he was formally enthroned in a ceremony attended by 4,000 people. He will now study subjects ranging from medicine to the Tibetan language to Buddhism, while under the care of 38 monks in a monastery in Katmandu, Nepal, which he will eventually lead. *Representative: The Associated Press*

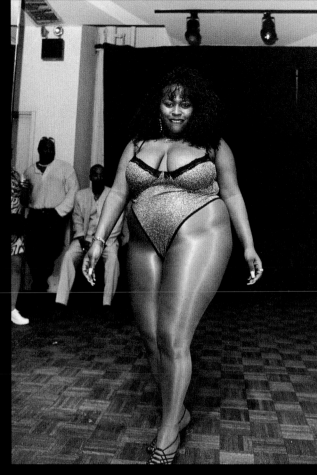

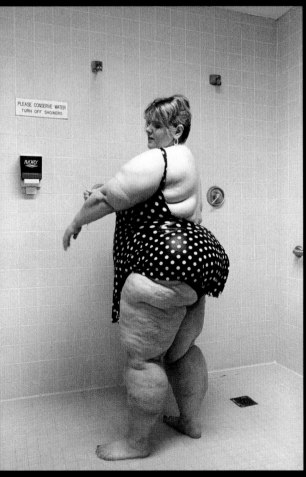

Fat Competition

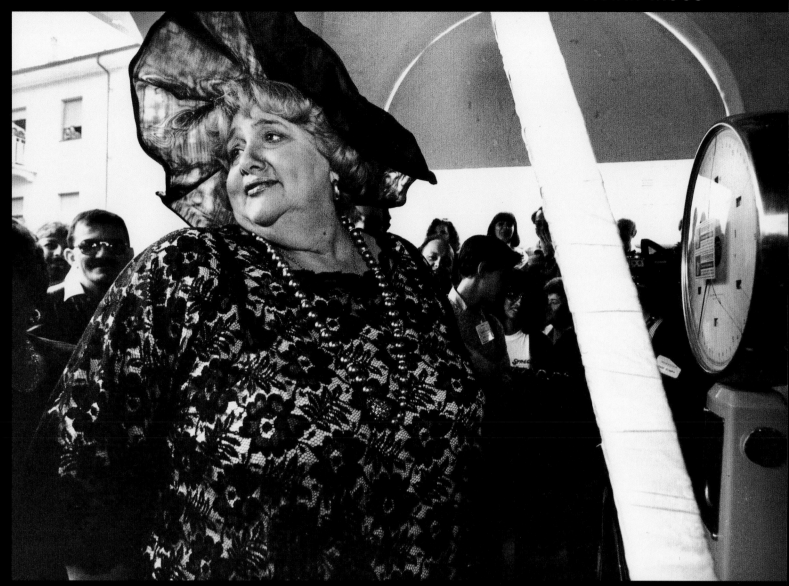

"One should be proud to be fat," was the slogan on Sunday, March 19, 1996 in Cavour, a little village near Turin, Italy. Twenty-four men and five women came together from Italy, Germany, and the United States to compete for the titles of Mister and Miss World Fat. Their combined weight totaled 8,896 pounds (4,044 kg)—an average weight of 307 pounds.

Back in 1948, Giovanni Genovesio, the portly owner of Locanda La Posta, an inn founded in 1720 and known for its excellent food, got some of his fat friends together and decided they should all stop apologizing for being fat. He organized a competition to see who could gain the most weight after eating an enormous lunch. This became such a successful event that every year people came from far and wide to participate. From 1967 to 1970 Margherita Cauda, a woman from Turin won four years in a row by weighing in at an unbeatable 503 pounds (229 kg). Locanda La Posta became known as

the Fat People's Inn, but for some reason the competition stopped being held in 1971.

This year the competition is back, revived by Antonella and Giovanni, Genovesio's granddaughter and grandson, along with their mother and father who have kept the inn's culinary fame alive.

For the first time an American was competing: Forty-one-year-old Nancy Esposito from Queens, New York, won the title of Miss World Fat 1996, at 354.20 pounds (161 kg). She beat Angela Masini, an Italian film and television actress from Alessandria, who holds the regional title of Miss Fat of Italy 1995.

Rennar and Diane, a husband and wife designer team from the United States, put on an elegant fashion show for women over 200 pounds. They strutted their way down a runway that had been set up in the village square that was overflowing with men, women, and children.

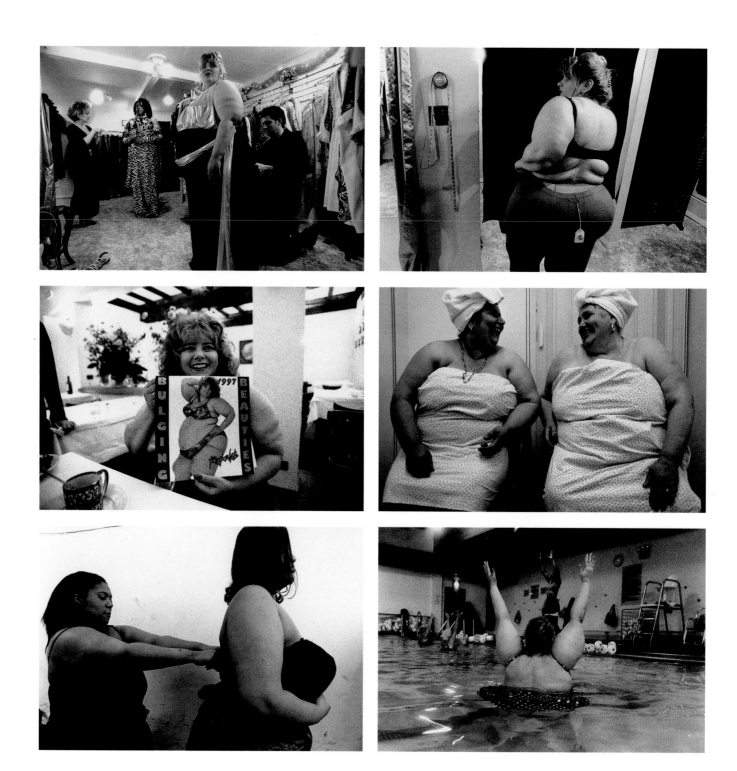

A LINGERIE SHOW AT CAFE 44 IN NEW YORK CITY. ■ NANCY EXERCISING AT THE YMCA IN LONG ISLAND, NEW YORK. ■ *(OPPOSITE PAGE)* NANCY EXERCISING AT THE YMCA IN LONG ISLAND, NEW YORK. ■ EXHAUSTED, NANCY HAS HER FEET MASSAGED BY PAT, A MODEL AND FRIEND.

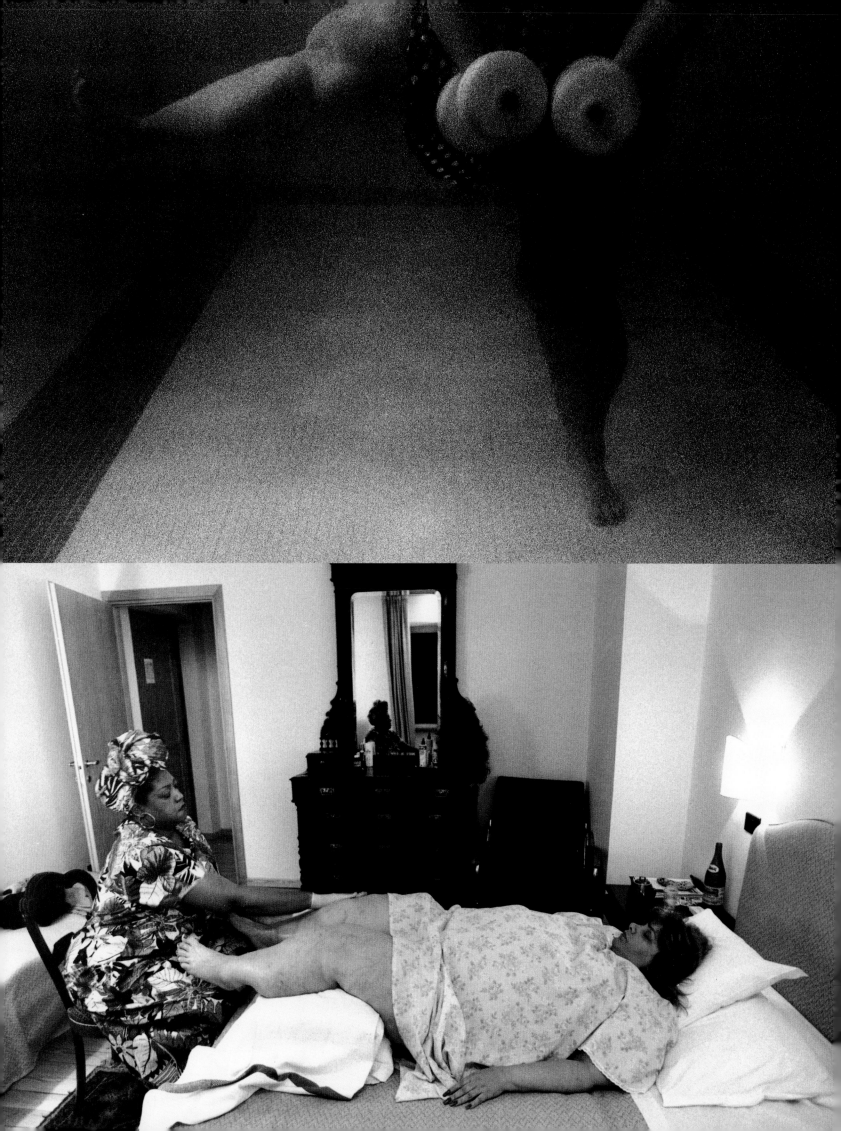

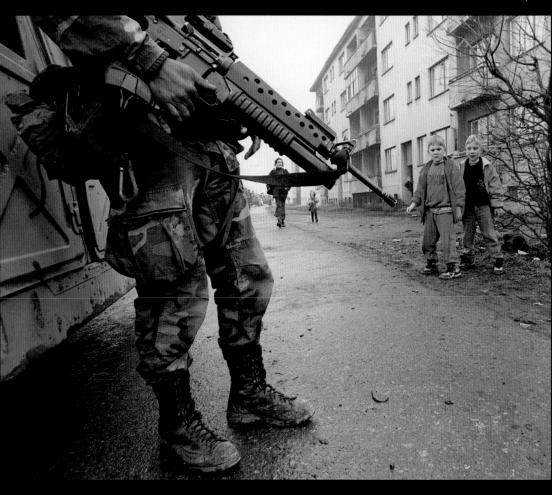

I HAD JUST BEEN RIDING WITH SOLDIERS IN A CONVOY OF HUMVEES THROUGH THE STREETS OF TUZLA. THEIR MISSION WAS TO SCOUT FOR PEO-
PLE WITH WEAPONS AND TO HAND OUT PROPAGANDA. IT WAS ONE OF THE FIRST CONVOYS INTO THE CITY. AS TWO BOYS EYED HIM WARILY, CAPT.

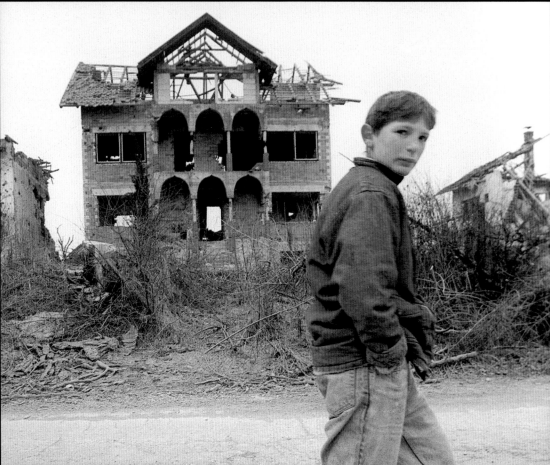

TRACY LUDGOOD, 31, OF ST. LOUIS, JUMPED OUT OF THE VEHICLE WITH HIS M-16 AND STOOD AT ALERT. THE BOYS HESITATED. IS THIS A GOOD
SOLDIER OR A BAD SOLDIER? AN ADULT DECISION. WITHIN SECONDS, THOUGH, THEY WERE BOYS AGAIN, WRESTLING AND CLOWNING AROUND.

JERRY NAUNHEIM, JR.

Bosnia's Little Ones

I'm often chided by other photographers for taking so many pictures of kids. In the mind of the "serious" news photographer, children are an easy target. Even a department-store photographer can get a cute baby picture. In fact, they call my work "Jerry's Kids." It's a title I like.

The first photograph I took for this series shows a young girl viewed through hundreds of feet of razor wire which surrounds the air base in Tuzla, Bosnia. Inside is probably the safest spot in her country—a U.S. military complex filled with some of the world's best trained soldiers, all sworn peacekeepers. But the wire keeps her out in the cold—in harm's way.

If she is typical of many other Muslim refugees in the area, her father, grandfathers, uncles, and older brothers have been killed trying to protect her. They may have died fighting or, as in the case of many thousands of non-combatant men and boys, they may have been herded into detention camps and executed.

But what can I tell you about her that you can't read better with your own eyes? My job as a photojournalist is to help you, the reader, see and feel the things that I have seen and felt— to distill into 1/250th of a second the life of a child living a world away. *Publisher:* St. Louis Post Dispatch

AS THE FIRST AMERICAN ARMOR CROSSED THE SAVA RIVER INTO BOSNIA, THIS BOY SEEMED OBLIVIOUS TO THE FACT THAT A HEAVILY ARMED FOREIGN POWER WAS MARCHING INTO HIS HOMELAND. HE JUST KEPT CLIMBING THE LITTLE HILL AND SLEDDING BACK DOWN. ■ A BOSNIAN GIRL STANDS AMID THE RAZOR WIRE SURROUNDING THE AMERICAN BASE IN TUZLA. ■ AT AN ORPHANAGE IN TUZLA, BOSNIA, ALMA MURATORIC, 1, LIKES TO PEER AT VISITORS THROUGH THE BARS OF HER CRIB AND TO PUSH HER LEGS THROUGH THE BOTTOM. HER MOTHER IS "EMOTIONALLY DESTROYED" AND GAVE HER CHILD TO THE ORPHANAGE. ALMA, HERSELF, HAS SERIOUS EMOTIONAL PROBLEMS. SHE AUDIBLY GRITS HER TEETH AND SLAPS HERSELF IN THE FACE CONTINUALLY. NOTHING IS KNOWN ABOUT HER FATHER. ■ THE TOWN OF GRADACAC WAS ALMOST COMPLETELY DESTROYED DURING THE WAR, BUT SOME FAMILIES HELD OUT OR RETURNED LATER. CHILDREN MAKE THE BEST OF THINGS. WITH FEW NEIGHBORS, THERE'S NO ONE TO YELL AT YOU FOR PLAYING KICK BALL IN THE FRONT YARD—THERE ARE NO FLOWER GARDENS TO TRAMPLE IN THIS NEIGHBORHOOD.

WILL VAN OVERBEEK

Barton Springs

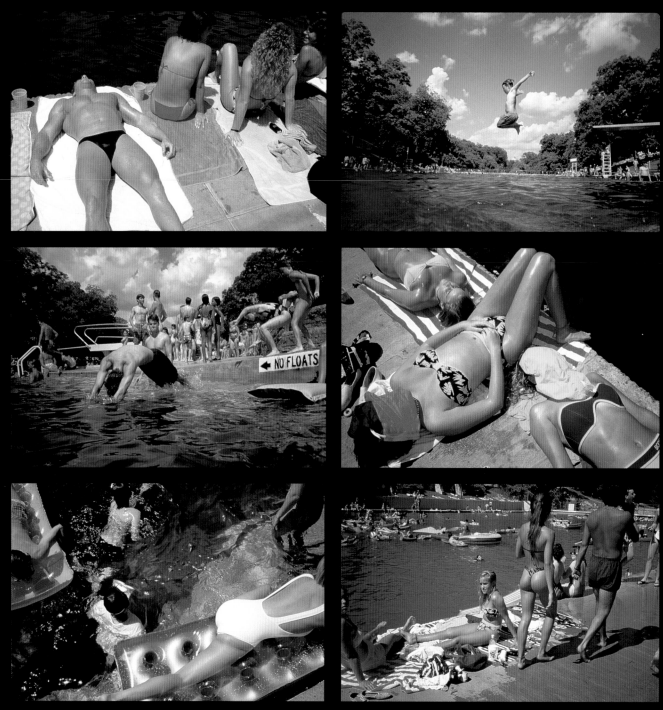

Barton Springs, a natural swimming hole in downtown Austin, Texas, is at the center of an environmental conflict in the region. Conservationists seek to preserve the aquifer that supplies the springs, while economic development and new construction threaten the sensitive recharge zone.

While the ecological struggle takes its course, I am interested in how this site is used today, and have focused on children and teens playing and coming of age in the clear cool water under the hot Texas sun.

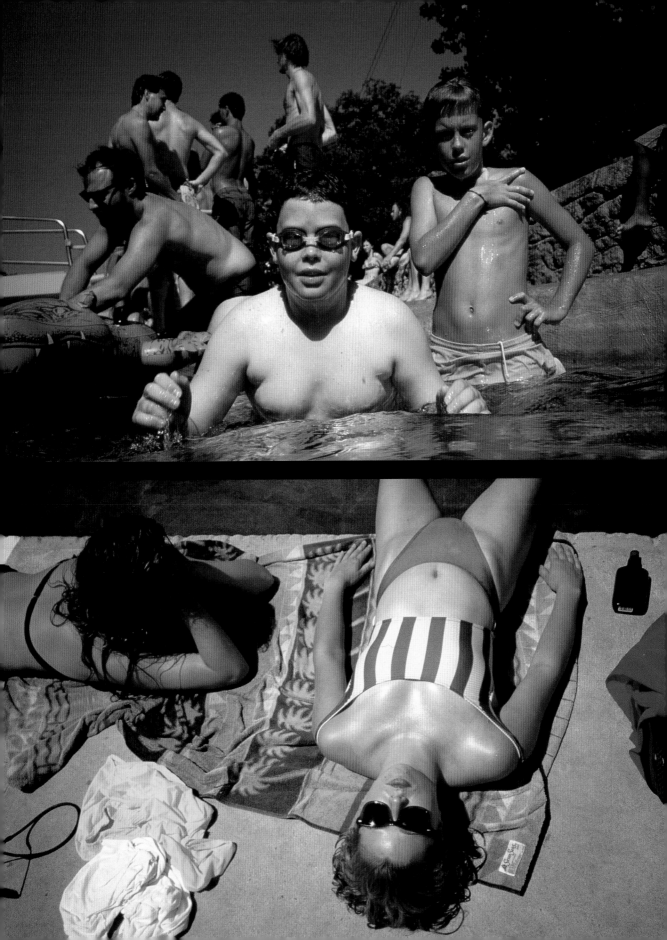

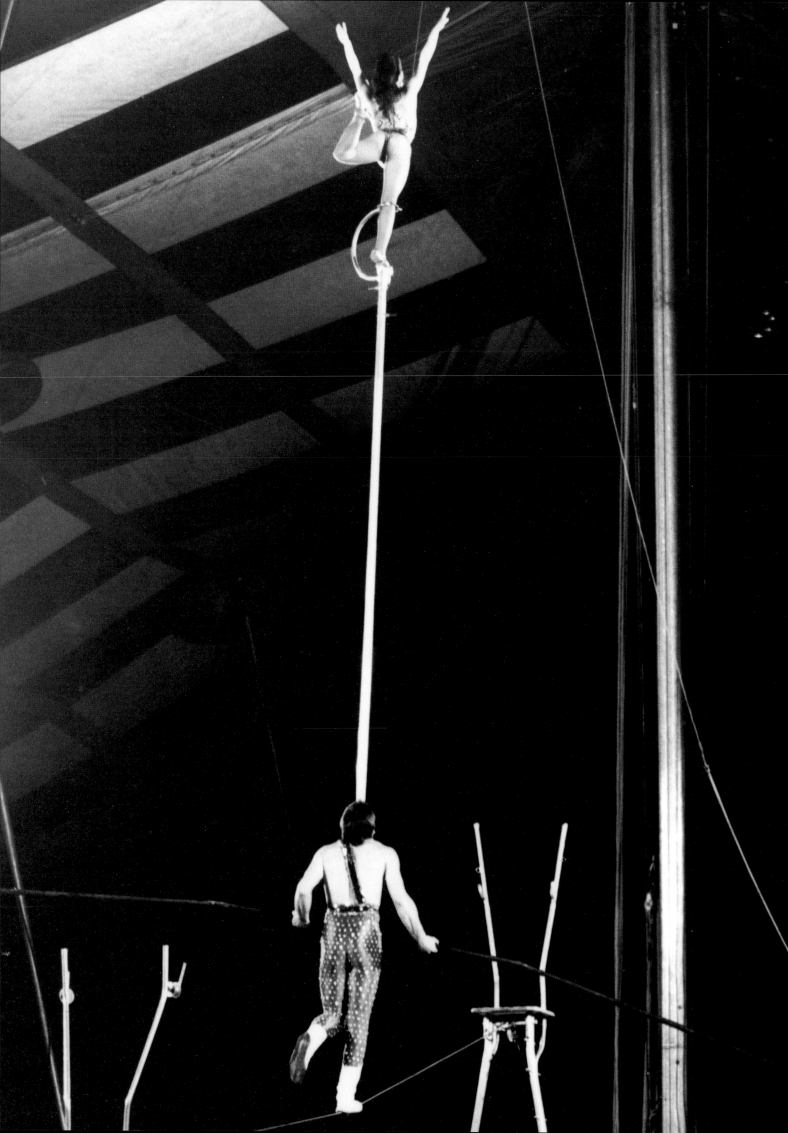

GREG PEASE

Clyde Beatty-Cole Brothers Circus

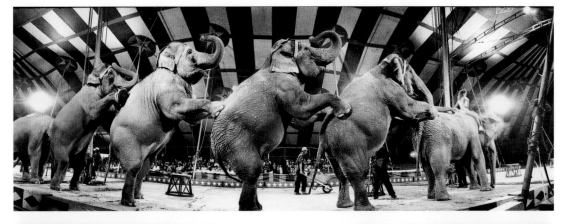

In the summer of 1996 I was contacted by a publisher working on an Americana book. They were asking photographers to capture an American experience. I thought of the obvious—apple pie, Little League baseball, '57 Chevys, cowboys and Indians. As my mind wandered, my wife called from the other room. "The circus is coming! It's going to be under the big top. The public is invited to watch the elephants raise the tent at dawn."

It was dark when I arrived at the parking lot off I-795, just north of Baltimore. In a distant field were about a dozen trucks. The sun began to rise, and so did the cacophonous noise of activity, as a steady stream of trailers, 18 wheelers, motor homes, and spectators' cars came over the horizon. An army of 100 men began to scurry about rolling out canvas, straightening lines, driving stakes. Within a few hours the big top was up and the show was ready to begin.

I squeezed my way through the sea of humanity that flowed in the mysterious sepia world under the tent. There were lions jumping through hoops in one ring, high-wire balancing acts in another, acrobats in a third. A procession of elephants and clowns paraded around the perimeter. Then came jugglers, trapeze artists, horses, and tigers. For the grand finale, a gigantic silver cannon blasts a human cannonball three stories up and nearly 200 feet across the tent. The applause was thunderous.

On the third day after the last show, I know my photo journey had only just begun, when the ringmaster walked over to me with a smile and handed me a piece of paper with the directions to the town where they were headed next. I packed up and followed this multicultural tribe of nomads south to Virginia. At the first light of dawn, I found myself in a tall grassy meadow surrounded by soft rolling hills. Another three days of three shows a day. Ah, life is a three-ring circus.

(OPPOSITE PAGE) HIGH-WIRE ACROBATS. ■ *(THIS PAGE)* THE PANORAMIC GRAND FINALE OF THE ELEPHANT ACT. ■ MAN SHOT FROM THE WORLD'S LARGEST CANNON.

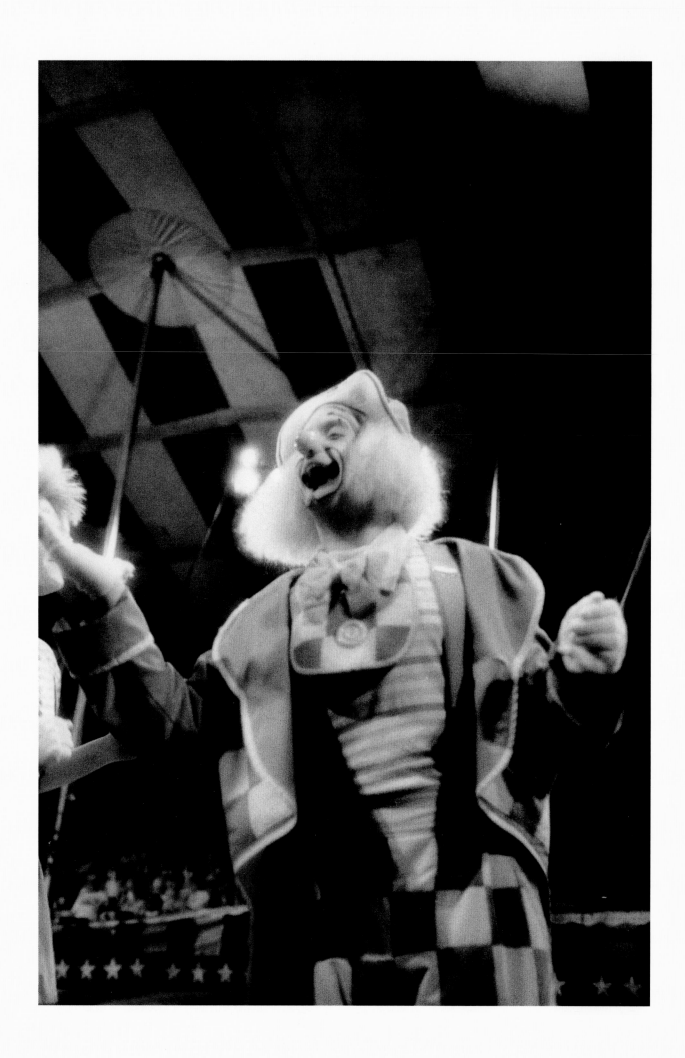

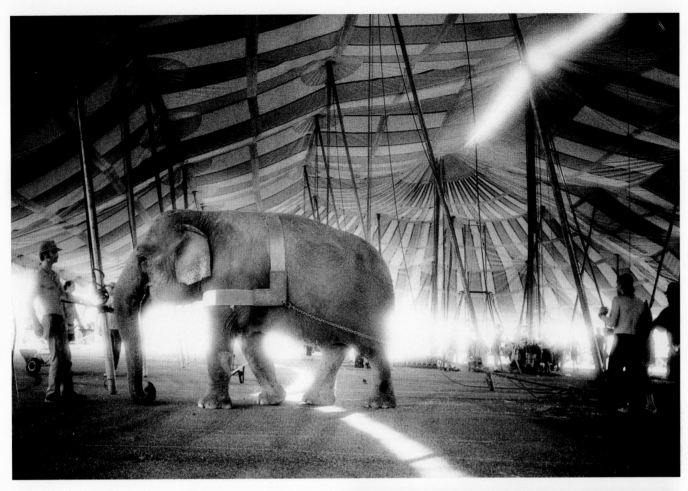

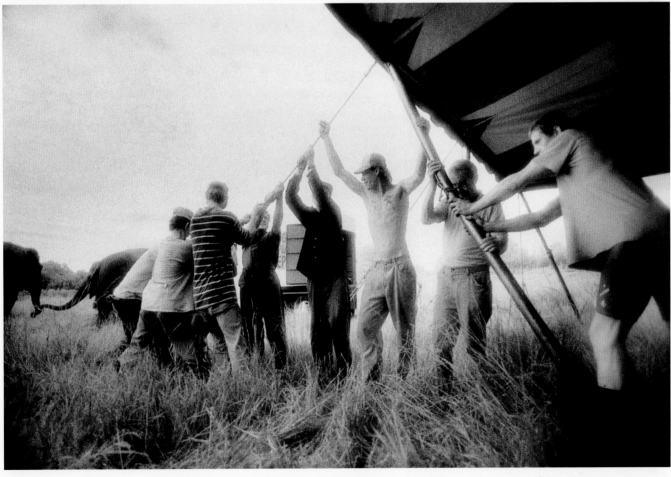

(OPPOSITE PAGE) CIRCUS CLOWN. ■ *(THIS PAGE)* ELEPHANTS RAISING THE BIG TOP. ■ ROUSTABOUTS SECURING TENT LINES WITH ELEPHANTS PLAYING IN THE BACKGROUND.

The High Life

Mark Peterson has been an avid chronicler of upper-crust social events for several years. He has photographed the very rich—both the old-money and the nouveaux variety—from Brooke Astor to Ivana Trump. Peterson has captured the rich at what they do best in public: attending charity events, garden parties, debutante balls, and elaborate masquerade parties; spending time at mahogany-paneled private clubs, where they smoke good cigars and drink vintage brandy; viewing the latest line of designer clothes for the coming season; shopping at chic stores; dining at the best restaurants; dancing in the best and most exclusive nightclubs; and watching their finely bred horses compete for oversized silver trophies.

Acutely aware of the public persona that many people wear at such public events, Peterson attempts to capture the moment when his subjects reveal their private selves. He works very close to people; he enters their space; he becomes part of the moment, allowing those who view his photographs to become immersed as well. *Representative: Saba Photo Agency*

(OPPOSITE PAGE) MARIA PATERNO CASTELLO DI SAN GIULIANO, INTERNATIONAL DEBUTANTE BALL, PLAZA HOTEL, NEW YORK CITY. ■ *(THIS PAGE)* CHARLOTTE ADELAIDE FORBES AND CATHERINE ISABELLE FORBES, INTERNATIONAL DEBUTANTE BALL, WALDORF ASTORIA HOTEL, NEW YORK CITY.

■ *(THIS PAGE)* INTERNATIONAL DEBUTANTE BALL, WALDORF ASTORIA HOTEL, NEW YORK CITY. ■ MISS STEPHANIE DIANE MARTIN DOES A "TEXAS DIP" CURTSEY, INTERNATIONAL DEBUTANTE BALL, PLAZA HOTEL, NEW YORK CITY. ■ HRH PRINCESS LAETITIA MURAT (FRANCE), INTERNATIONAL DEBUTANTE BALL, PLAZA HOTEL, NEW YORK CITY. ■ PIARIST DEBUTANTE

BALL TO BENEFIT AMERICAN AND HUNGARIAN PIARIST SCHOOLS AT THE PLAZA HOTEL, NEW YORK CITY. ■ INTERNATIONAL DEBUTANTE BALL, WALDORF ASTORIA HOTEL, NEW YORK CITY. ■ PIARIST DEBUTANTE BALL TO BENEFIT AMERICAN AND HUNGARIAN PIARIST SCHOOLS AT THE PLAZA HOTEL, NEW YORK CITY. ■ *(OPPOSITE PAGE)* INTERNATIONAL DEBUTANTE BALL, PLAZA HOTEL, NEW YORK CITY. ■ PIARIST DEBUTANTE BALL TO BENEFIT AMERICAN AND HUNGARIAN PIARIST SCHOOLS AT THE PLAZA HOTEL, NEW YORK CITY.

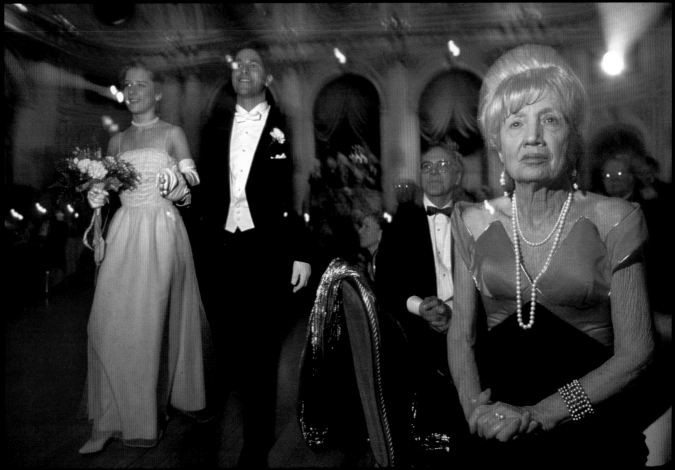

(*THIS PAGE*) NEW YEAR'S EVE AT THE RAINBOW ROOM, ROCKEFELLER CENTER, NEW YORK CITY. ■ NEW YORK BENEFIT FOR THE JAMES BEARD FOUNDATION, BRIDGEHAMPTON, LONG ISLAND. ■ VALET PARKING FOR CENTRAL PARK CONSERVATORY BENEFIT EVENT, NEW YORK CITY. ■ COCKTAIL PARTY AT FORBES GALLERY FOR DEBUTANTES ON THE NIGHT BEFORE

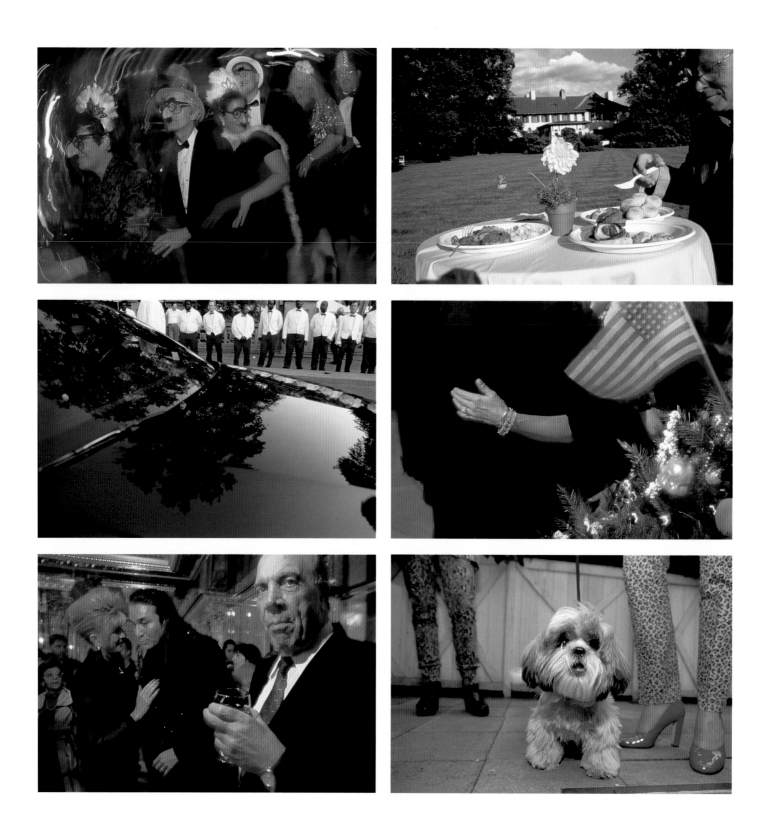

THEIR DEBUT AT THE INTERNATIONAL DEBUTANTE BALL. ■ IVANA TRUMP AT TRUMP TOWER RECEPTION, NEW YORK CITY. ■ PENTHOUSE PARTY TO BENEFIT THE HUMANE SOCIETY OF NEW YORK. ■ (*OPPOSITE PAGE*) MAID AT A PARTY GIVEN BY IVANA TRUMP AT TRUMP TOWER, NEW YORK CITY. ■ KATHY SPRINGHORN'S DOG HARRY AND HIS LIMOUSINE DRIVER ANDY.

(PREVIOUS SPREAD) MERCEDES-BENZ POLO CHALLENGE, HAMPTON POLO CLUB, BRIDGEHAMPTON, LONG ISLAND, NEW YORK. ■ (THIS PAGE) PLAYING CROQUET AT THE BREAKERS HOTEL, PALM BEACH, FLORIDA. ■ WORTH AVENUE SHOPPING DISTRICT, PALM BEACH, FLORIDA. ■ HOMES ALONG SOUTH COUNTY ROAD, PALM BEACH, FLORIDA. ■ THE BREAKERS, PALM BEACH, FLORIDA. ■ (OPPOSITE PAGE) WORTH AVENUE SHOPPING DISTRICT, PALM BEACH, FLORIDA. ■ WORTH AVENUE SHOPPING DISTRICT, PALM BEACH, FLORIDA.

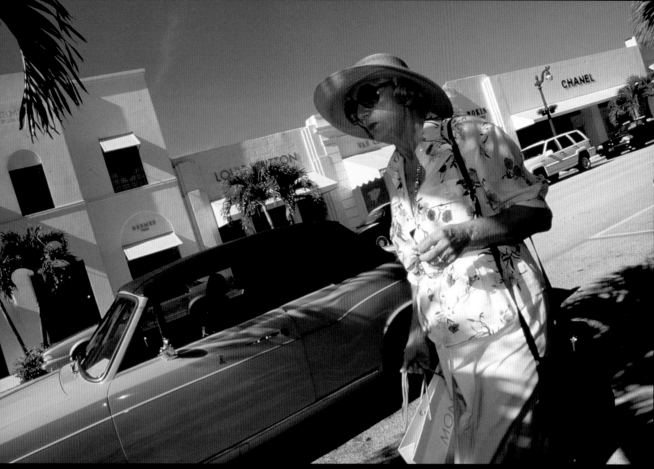

Joe Raedle
Guatemalan Farm Workers, Florida

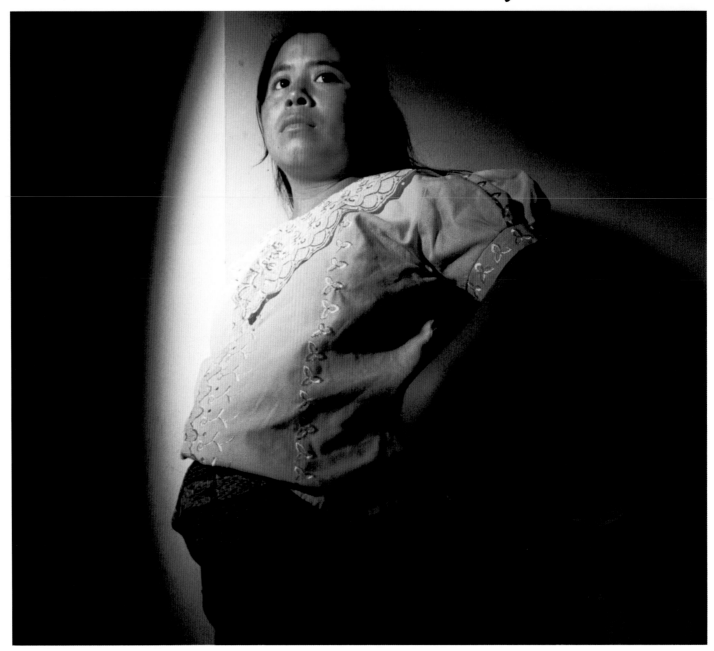

In the past three and a half years, at least 19 babies of Guatemalan farm workers in Palm Beach County, Florida, have been born with neural tube defects—a rate more than 40 times higher than the national average in the United States.

Field workers suspected that pesticide exposure had something to do with the troubling rate of birth defects. Raedle shot portraits of women in this community with the babies they gave birth to, hoping to show the human toll that these problems were taking on the community.

The photographs have produced tangible results: a group of health-care professionals and social workers have formed a task force to arrive at some solutions. Palm Beach County is expected to receive shipments of folic acid from the state for free distribution to women of child-bearing age, including the farm workers. Folic acid, a simple vitamin supplement, is known to reduce the incidence of severe birth defects. Lastly, the state's Department of Health has requested funds to set up a new statewide birth defect registry, so that researchers can accurately study and monitor such trends. *Publisher:* Sun-Sentinel, Florida

PETRONA PASQUAL DID NOT GET A MEDICAL CHECKUP DURING HER FIRST PREGNANCY UNTIL SHE WAS EIGHT MONTHS INTO HER TERM, A PRACTICE ALL TOO COMMON IN PALM BEACH COUNTY'S GUATEMALAN COMMUNITY. BY THE TIME DOCTORS FINISHED WITH WHAT SHOULD HAVE BEEN A ROUTINE EXAMINATION, THEY HAD DETERMINED THAT PASQUAL WAS AT HIGH RISK OF HAVING PROBLEMS WITH HER NEWBORN. SHE WAS LUCKY, AND GAVE BIRTH TO A HEALTHY EIGHT-POUND BOY. NOW PREGNANT WITH A SECOND CHILD, THE 24-YEAR-OLD MOTHER RECALLS THE FRIGHTENING EXPERIENCE OF THE FIRST TIME, AND BEGAN PRENATAL CARE EARLY.

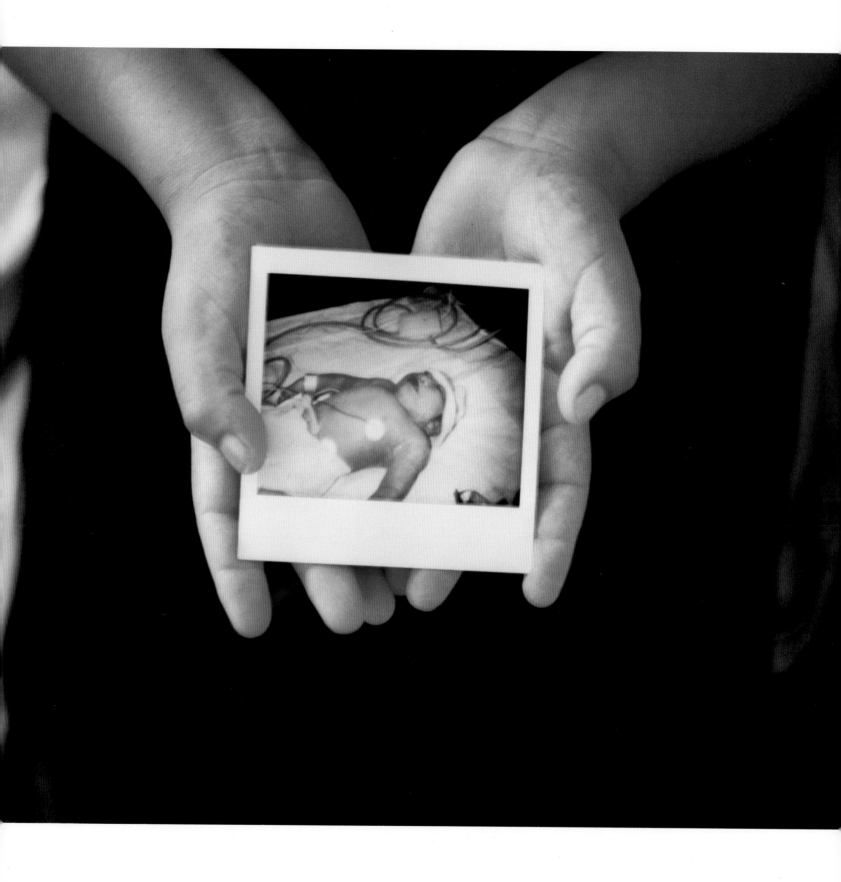

SHE COUNTED THE FINGERS AND THE TOES. ALL THERE. SHE CONSIDERED THE SIZE—PRETTY BIG AT EIGHT POUNDS. AND ROSA MIGUEL'S HEART SANK. THE DEFORMED HEAD CONFIRMED WHAT DOCTORS IN BOYNTON BEACH HAD TOLD MIGUEL THROUGH THE END OF HER PREGNANCY: HER NEWBORN DAUGHTER HAD NO BRAIN. FOR THE NEXT THREE HOURS MIGUEL FAWNED OVER THE CHILD, WHOM SHE HAD NAMED ANGELINA. THEN THE BABY STOPPED BREATHING, AND NURSES TOLD HER THE BABY WAS DEAD. "EVERYTHING WAS PERFECT. SHE JUST DIDN'T HAVE A BRAIN," MIGUEL SAID AS SHE LOOKED AT A POLAROID SNAPSHOT OF THE INFANT. ROSA MIGUEL HAD BEEN WORKING THE FIELDS SHORTLY BEFORE GIVING BIRTH TO THE BABY.

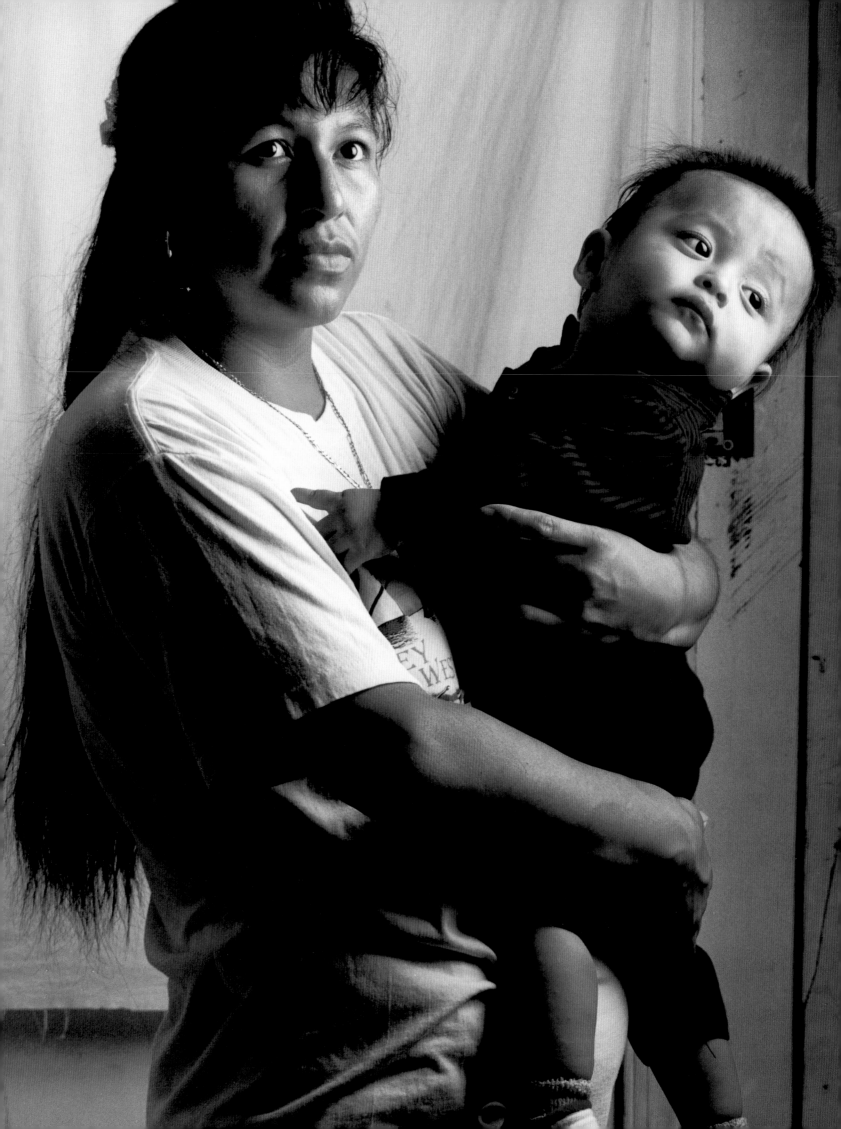

(OPPOSITE PAGE) EVERILDA VELASQUEZ HOLDS HER SON NELSON, BORN IN 1995. HE WAS DIAGNOSED AS HYDROCEPHALIC, SUFFERING FROM A NEURAL TUBE DEFECT IN WHICH FLUID BUILDS UP AND COMPRESSES THE BRAIN, DESTROYING BRAIN TISSUE AND CAUSING MENTAL RETARDATION. NELSON WILL UNDERGO SURGERY SOON TO IMPLANT A TUBE IN HIS HEAD TO DRAIN FLUIDS. EVERILDA HAS WORKED IN NURSERIES AND PRODUCE FARMS IN WESTERN PALM BEACH COUNTY SINCE ARRIVING FROM GUATEMALA FOUR YEARS AGO. SHE SAID SHE HAS SEEN CO-WORKERS VOMIT OR COMPLAIN OF HEADACHES THE MORNING AFTER THE FIELDS WERE SPRAYED WITH PESTICIDES AND FUNGICIDES. ■ (THIS PAGE) WITH LOVING CARE ANGELINA VINCENTE WASHES HER SON ON THE KITCHEN FLOOR, IN A SMALL BASIN. SHE PICKED TOMATOES IN THE FIELDS OF SOUTH FLORIDA UNTIL TWENTY DAYS BEFORE HER CHILD WAS BORN. HER SON, DANIEL VINCENTE, WASN'T SUPPOSED TO SURVIVE LONG AFTER HIS BIRTH IN APRIL OF 1995. THE DOCTORS EXPLAINED

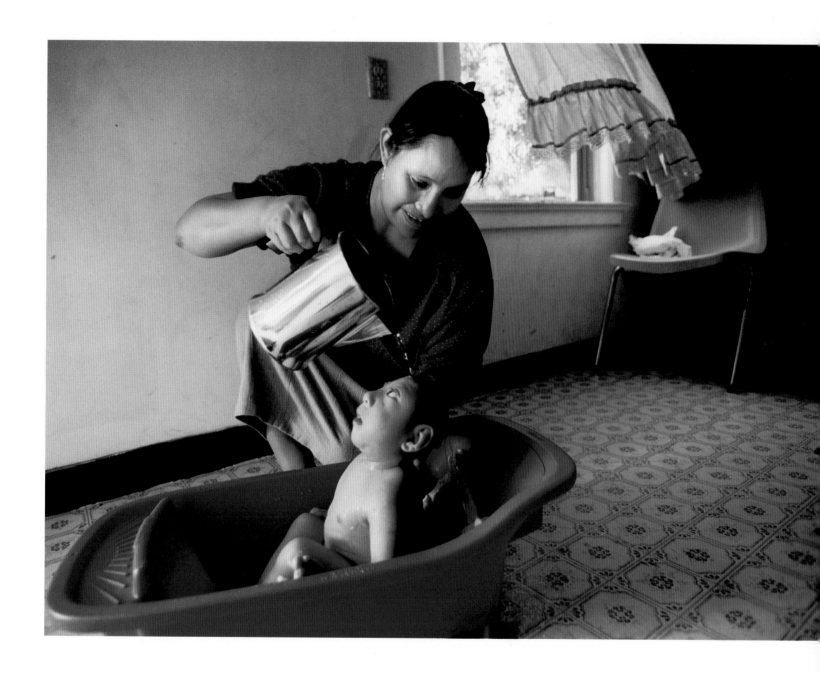

TO ANGELINA THAT THE BRAIN HAS TWO PARTS. HE ONLY HAD ONE GOOD HALF, AND THE BAD HALF WOULD HAVE TO BE REMOVED SIX DAYS AFTER HIS BIRTH. THE MEDICAL PAPERS LIST HIM AS AN ANENCEPHALIC INFANT WITH BRAINSTEM ACTIVITY. ■ (FOLLOWING SPREAD) IN A ONE-BEDROOM APARTMENT IN WEST PALM BEACH, SANDRA GALVEZ, 24, GENTLY CHANGED HER BABY'S DIAPER, CAREFUL NOT TO IRRITATE THE BRUISE ON HIS BUTTOCKS. SHE THEN PLACED THE BOY ON HIS STOMACH, THE ONLY POSITION THAT MADE HIM COMFORTABLE. GALVEZ, A FIELD WORKER, STILL WONDERS WHAT CAUSED HER BABY TO BE BORN WITH A HOLE IN THE SPINE. AFTER IMMIGRATING FROM GUATEMALA TWO YEARS AGO, SHE WORKED AT A FEW DIFFERENT NURSERIES UP UNTIL SHE WAS SIX MONTHS INTO HER PREGNANCY. IN THE PAST THREE AND A HALF YEARS AT LEAST 19 BABIES OF GUATEMALAN FARM WORKERS IN PALM BEACH COUNTY HAVE BEEN BORN WITH NEURAL TUBE DEFECTS. THAT RATE IS MORE THAN 40 TIMES HIGHER THAN THE U.S. AVERAGE.

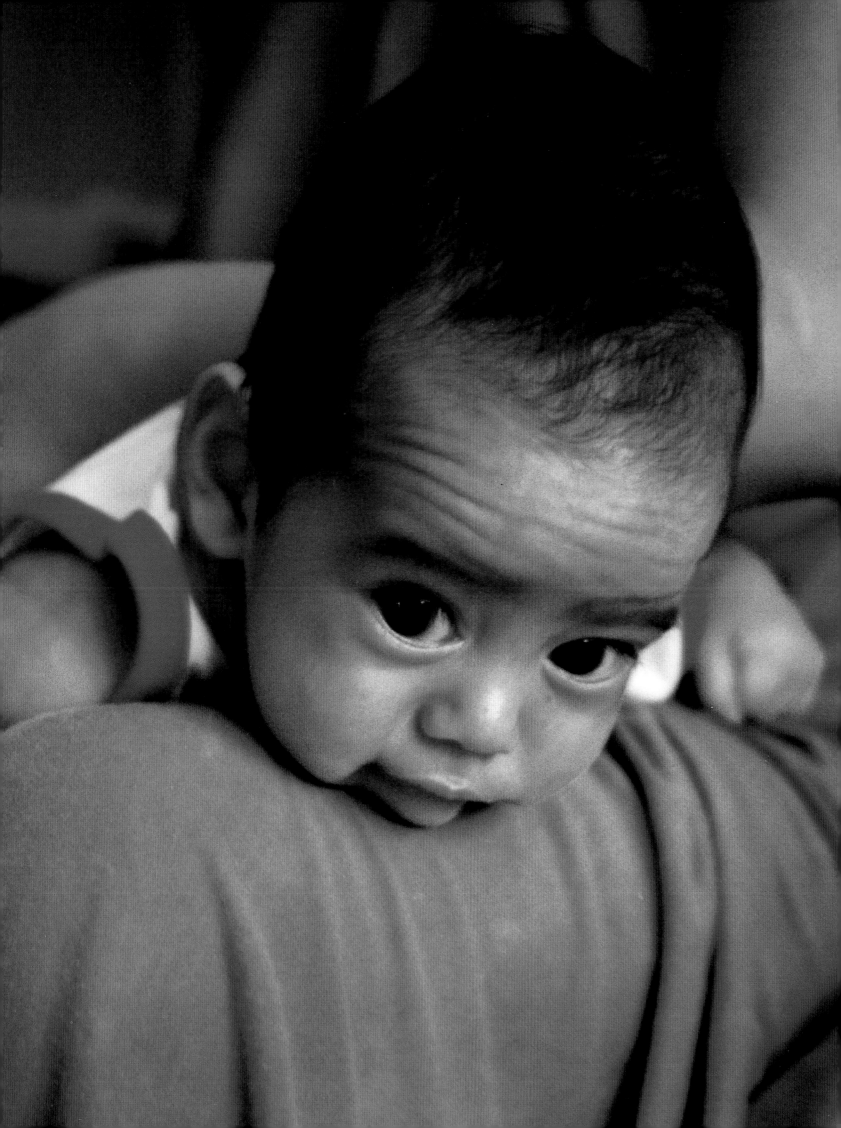

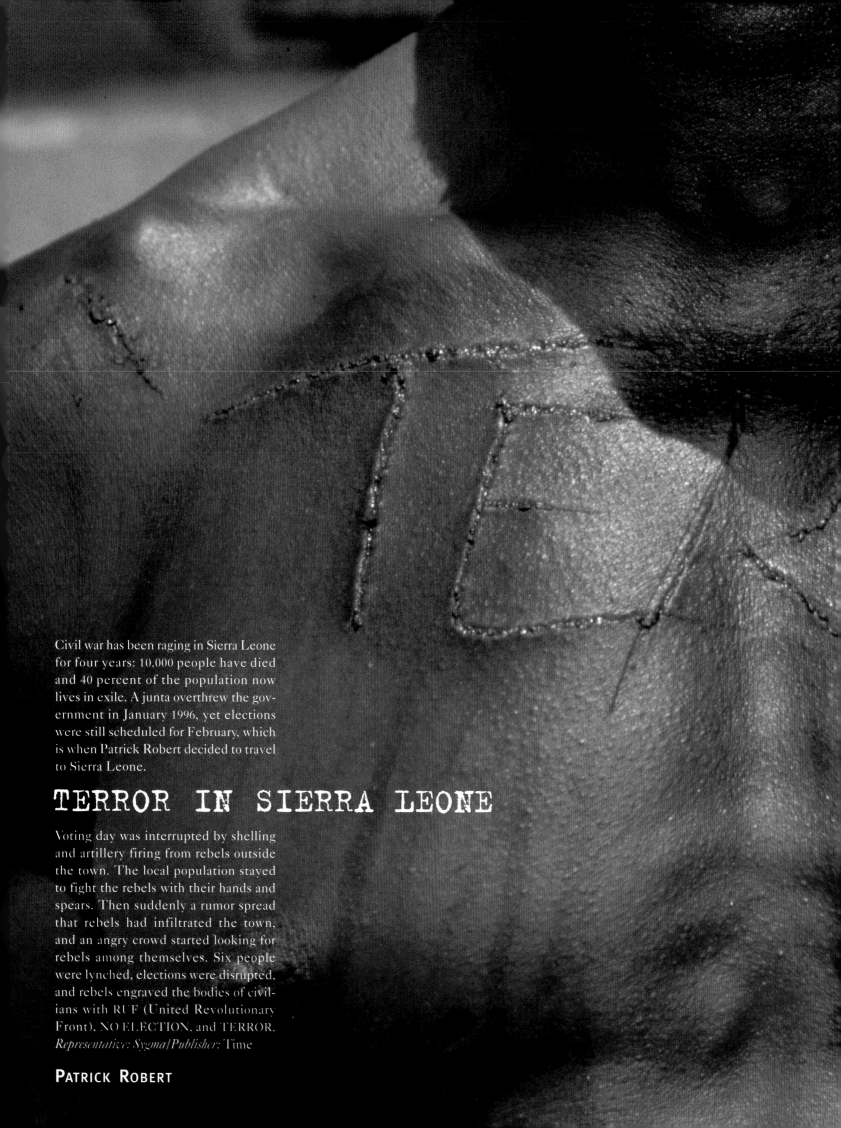

Civil war has been raging in Sierra Leone for four years: 10,000 people have died and 40 percent of the population now lives in exile. A junta overthrew the government in January 1996, yet elections were still scheduled for February, which is when Patrick Robert decided to travel to Sierra Leone.

TERROR IN SIERRA LEONE

Voting day was interrupted by shelling and artillery firing from rebels outside the town. The local population stayed to fight the rebels with their hands and spears. Then suddenly a rumor spread that rebels had infiltrated the town, and an angry crowd started looking for rebels among themselves. Six people were lynched, elections were disrupted, and rebels engraved the bodies of civilians with RUF (United Revolutionary Front), NO ELECTION, and TERROR. *Representative: Sygma/Publisher:* Time

PATRICK ROBERT

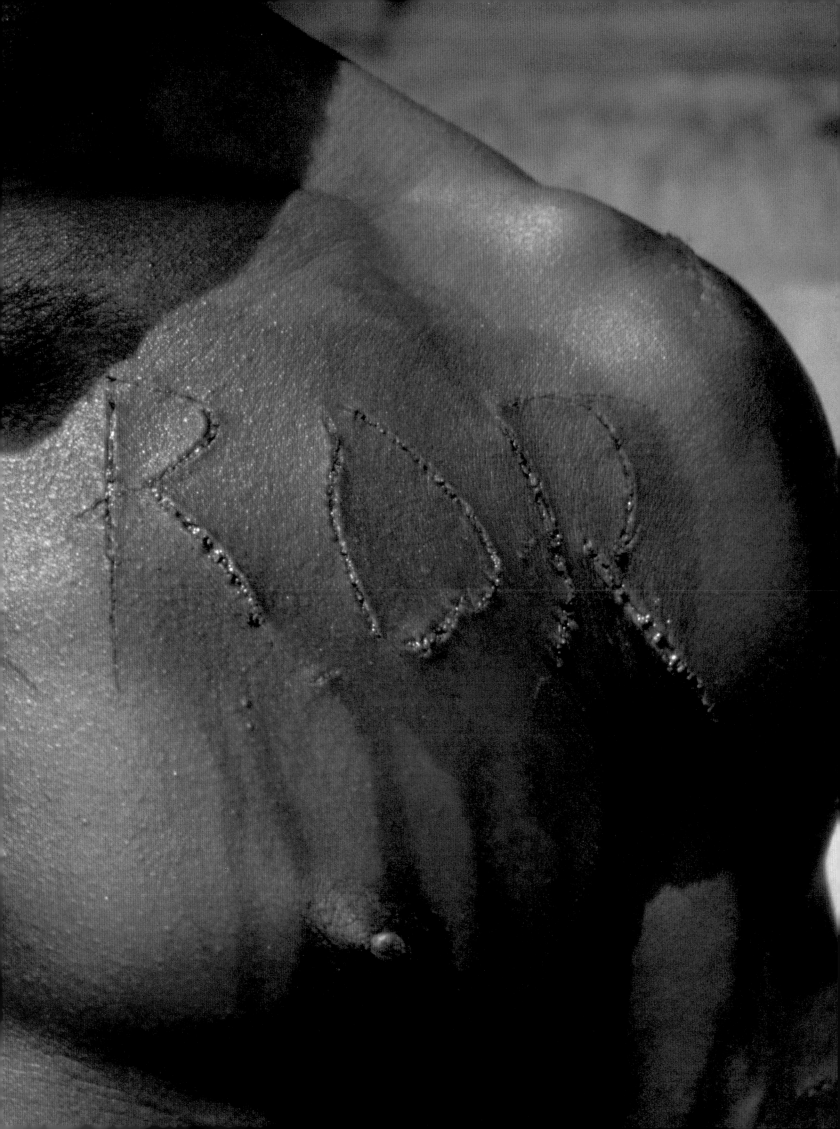

Joseph Rodriguez

Transylvania: The Land beyond the Forest

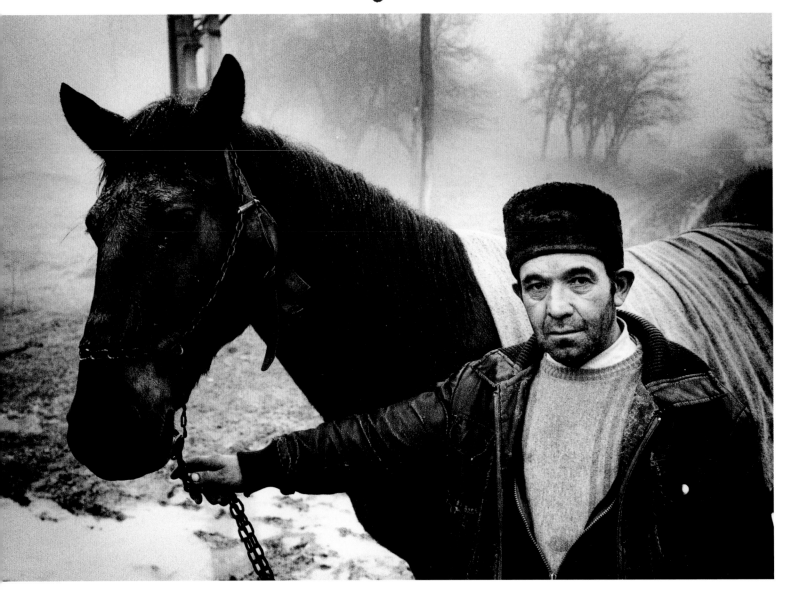

The end of Communist rule and the Ceaucescu reign in Romania has opened Transylvania to increased communication with the West and a greater tolerance for diversity within its borders.

Still, the history and relative isolation of Transylvania have created and reinforced deeply rooted cultural practices. In addition, the region has long been marked by competing religious beliefs, coupled with a rich tradition of local folklore, including the Dracula myth.

Life in the villages has remained relatively unchanged, with entire families working the land to sustain themselves and their communities. However, with the introduction of television, new expectations and ideals are formed among the rural population, and youth are drawn to cities such as Cluj and Tirgu Mures. There, unchecked and unregulated industrialization has led to unsafe working conditions and disturbing levels of pollution.

The Transylvania I photographed reflects a cultural tug-of-war between tradition and the life changes that the people of this region will inevitably face. *Agency: Black Star/Publication: ManadsJornalen, Stockholm*

(THIS PAGE) FARMER AND HIS HORSE, MARKOD, ROMANIA. ■ *(OPPOSITE PAGE)* TRADITIONAL HUNGARIAN WOMEN ON THE WAY TO CHURCH, MERA, ROMANIA. ■ GERGELY VIRÁG, 84 YEARS OLD, IS A WOODCUTTER WHO LIVES ALONE WITH NO PENSION. FELSÖLOK, ROMANIA. ■ GYPSY WOMAN IN FRONT OF HER HOUSE, BONTIDA, ROMANIA. ■ NINETY-FOUR-YEAR-OLD ESZTER SIKLODI IN HER WEDDING HAT, MARKOD, ROMANIA.

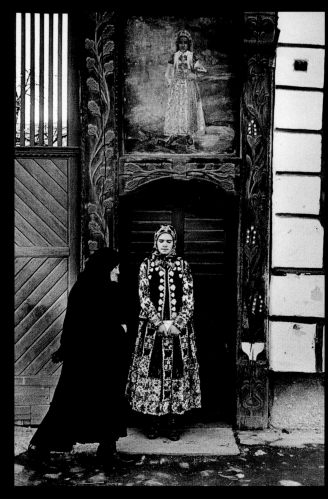
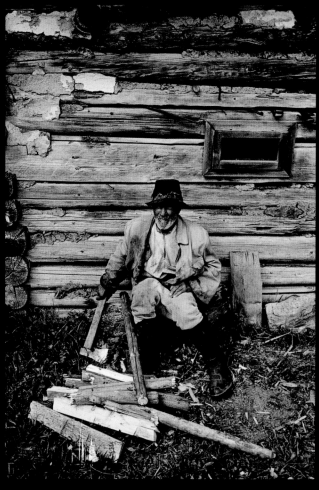
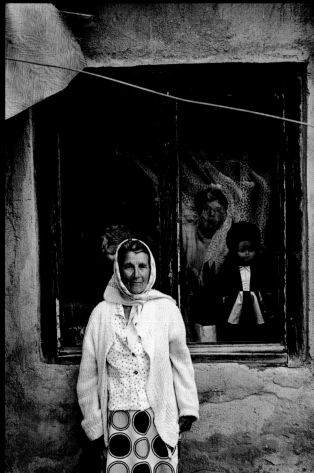
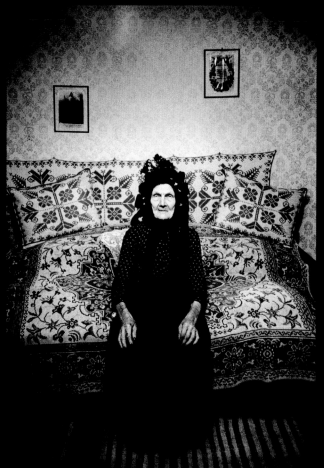

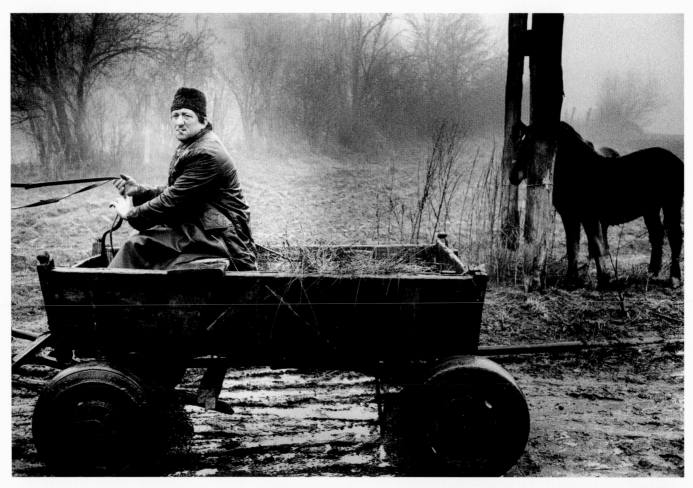

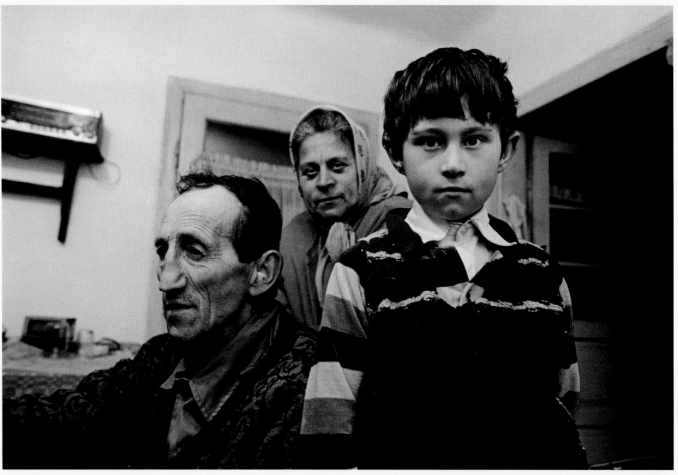

FARMER, MARKOD, ROMANIA. ■ KAROLY KACSO, HIS WIFE MAGDA, AND THEIR SON AT HOME, MARKOD, ROMANIA.

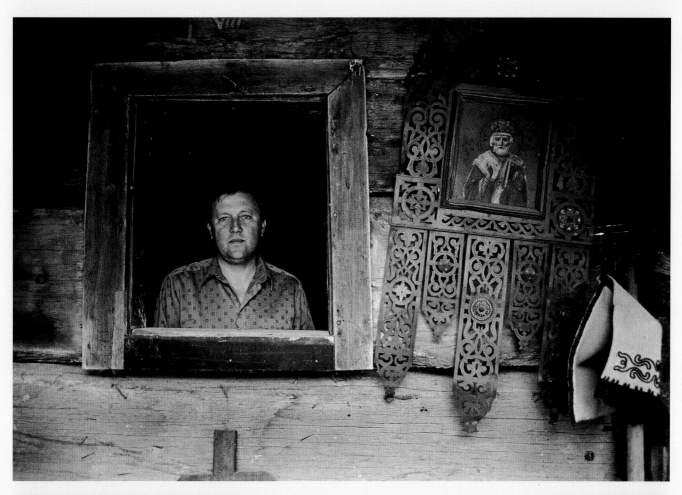

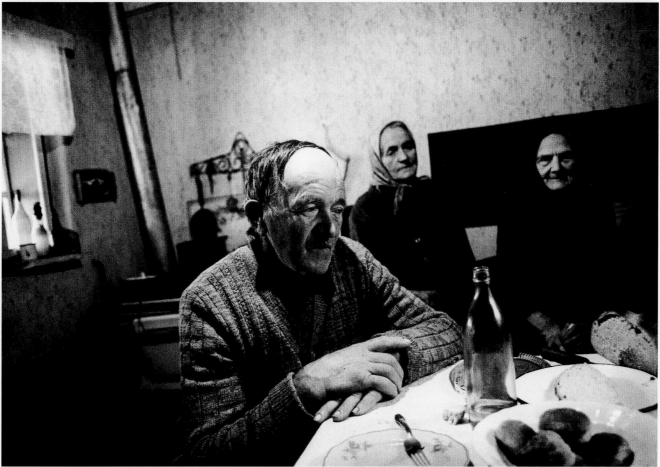

MAN IN HIS HOME, WHICH IS FILLED WITH ORTHODOX RELIGIOUS ART. ■ YANOS SIKLODI HAS BREAKFAST WITH HIS FAMILY, MARKOD, ROMANIA.

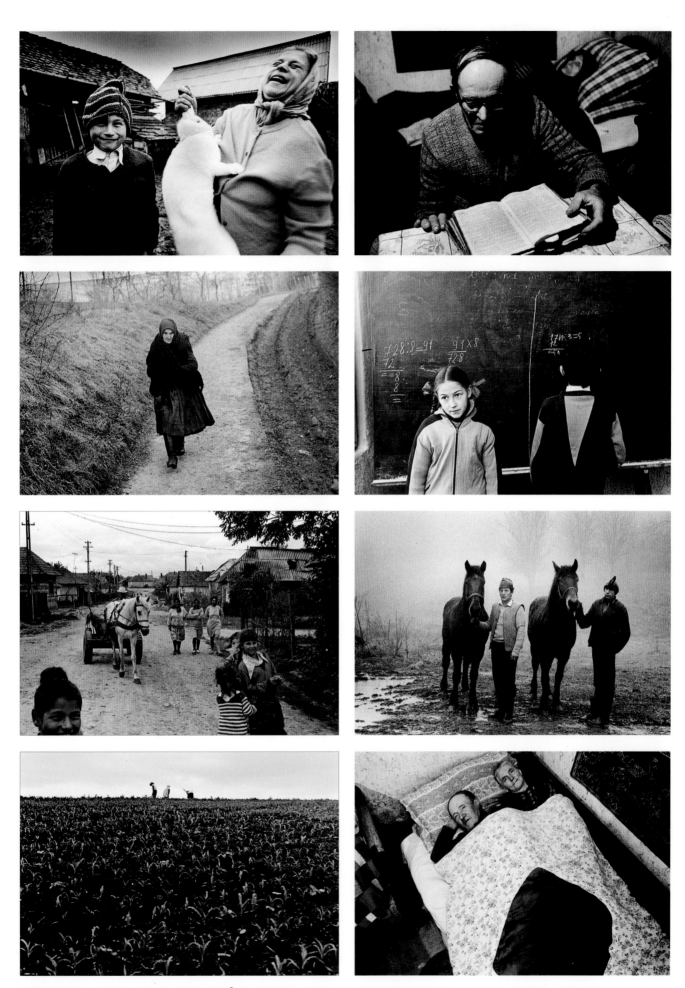

(OPPOSITE PAGE) **WOMAN WORKS THE FIELDS, FELSÖLOK, ROMANIA. ■** *(THIS PAGE)* **FAMILY WITH THEIR RABBIT, MARKOD, ROMANIA. ■ YANOS SIKLODI READS THE BIBLE TO HIS MOTHER, WHO LIES IN BED AFTER WORK. ■ WALKING HOME AFTER WORKING THE FIELDS. ■ SCHOOL IN MARKOD, ROMANIA. ■ GYPSY VILLAGE, BONTIDA, ROMANIA. ■ MARKOD, ROMANIA. ■ WORKING THE CROPS IN SPRING, PALATCA, ROMANIA. ■ YANOS SIKLODI AND HIS WIFE IN BED, MARKOD, ROMANIA.**

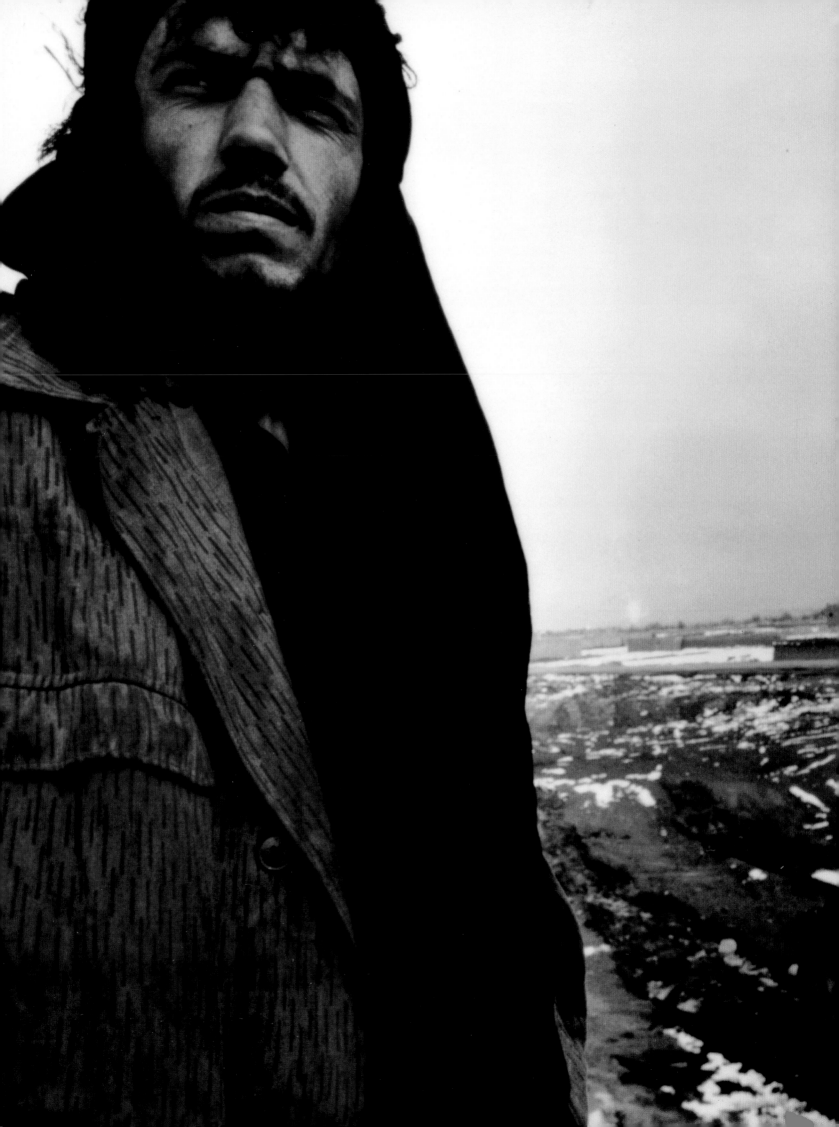

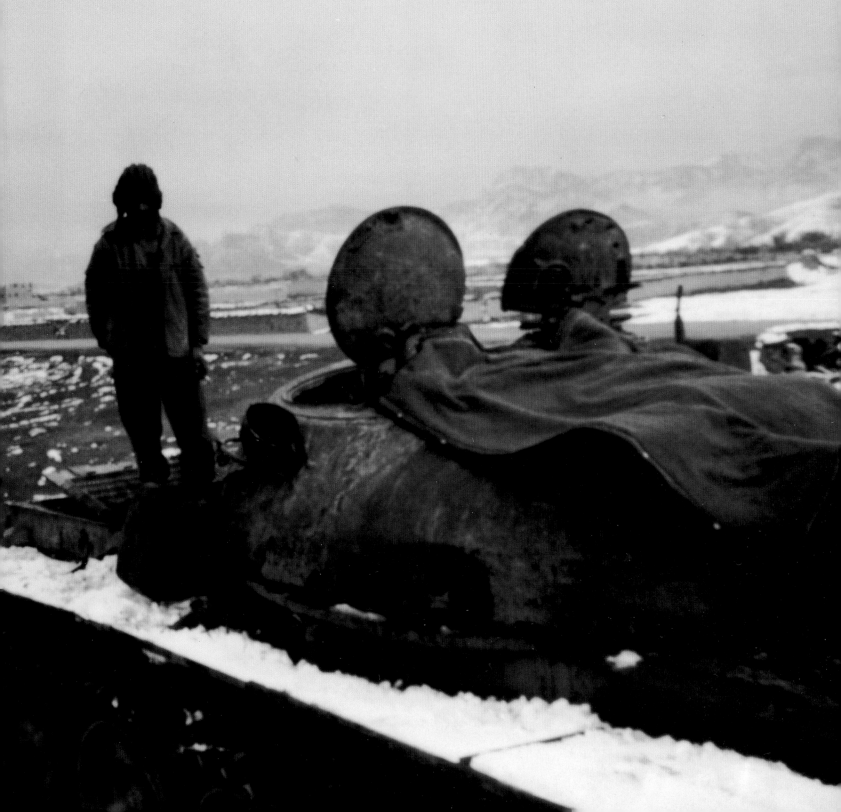

Life in the
Afghan War

Q. Sakamaki

REVIOUS SPREAD) MASOUD'S SOLDIERS WATCH OUT FOR INCOMING ROCKETS FROM THE TALIBAN AT THE FRONT LINE NEAR KABUL. ■ (THIS PAGE) ARTIFICIAL LEGS VIC
IMS OF THE AFGHAN WAR WHO ARE MAINLY CIVILIANS. THERE IS A SHORTAGE OF PROSTHETIC MATERIALS BECAUSE OF THE GREAT NUMBER OF LAND MINES AND BOMBS THA
HAVE GONE OFF IN AFGHANISTAN. ■ KANDAKH, A NINE-YEAR-OLD KABUL BOY, PLAYS WITH A BROKEN TOY GUN IN THE RUINS OF JADAYI MAIWAND, WHERE HE LIVES AND
WHERE ROCKETS FREQUENTLY HIT. ■ (OPPOSITE PAGE) FEMALE KABUL STUDENTS AND THEIR TEACHER IN THE WAR-TORN SCHOOL, BEFORE THE NEW TALIBAN RULER FORBIDS

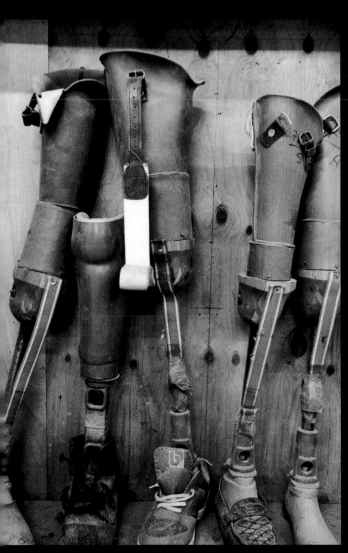

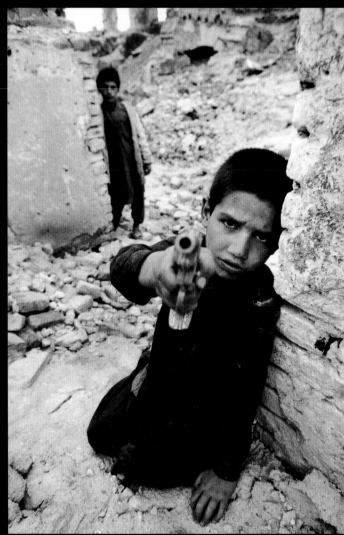

When I visited Kabul, Afghanistan, in the spring of 1996, what struck me was the destruction of the town by war, one of the longest-running wars, and a situation so miserable I couldn't imagine it was taking place in the twentieth century. It was worse than anything I had seen in Sarajevo or Beirut.

However, since the end of the Cold War, the Afghan war has been all but forgotten. Of course, when the Taliban took control of the capital in the fall of 1996, the world paid attention,

but that did not last for long.

"You guys just take pictures and nobody comes to help us!" shouted an old woman in a war-torn refugee building in Kabul when I tried to take her photograph. Maybe it's true. The agony of the Afghan people—trapped in a forgotten war—gets worse and worse, and I am just there as a photographer, to try to let the world outside know as much as possible about the inhuman situation in this land.

GIRLS TO ATTEND SCHOOL AND WOMEN TO TEACH. ■ THE FAMILY OF SALMA, A WIDOW, LIVING IN THE WAR-TORN REFUGEE BUILDING CALLED "OLD MICRORAYON" SURVIVE B
SELLING ANIMAL FECES FOR FERTILIZER. ■ KABUL CHILDREN ESCAPE FROM THE RAIN. ■ A FAMILY PASSES THROUGH THE PANJSER VALLEY, WHERE ONE OF COMMANDER
MASOUD'S STRONGHOLDS IS. ■ FOREIGN MONEY CHANGES HANDS IN KANDAHAR, SITE OF THE TALIBAN HEADQUARTERS. THE AFGHAN WAR HAS CREATED SKYROCKETING
ATION ■ A MAN WHO LOST AN ARM IN THE WAR SMILES AS ANOTHER AMPUTEE, A YOUNG BOY, GOES TO THE ICRC ORTHOPEDIC CENTER IN KABUL FOR REHABILITATIO

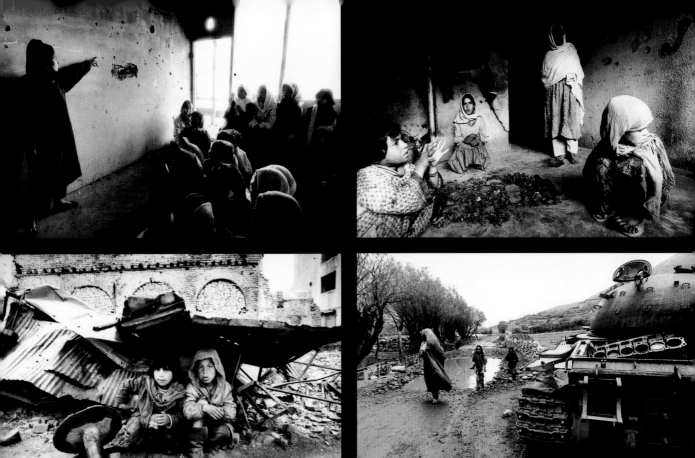
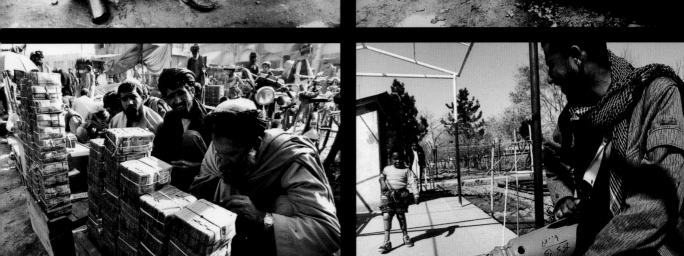

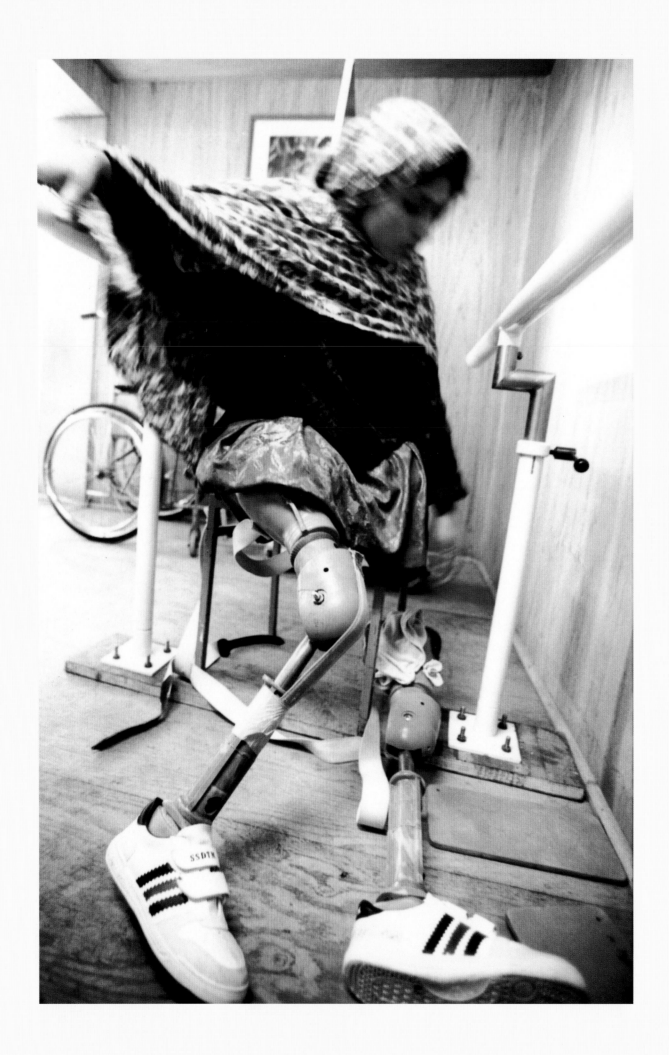

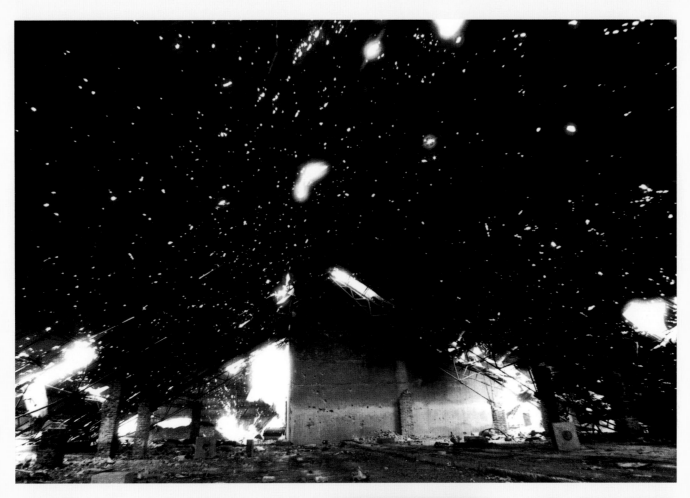

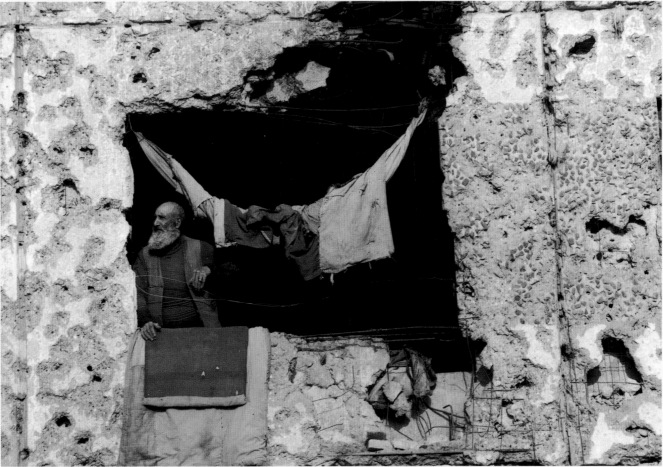

(*OPPOSITE PAGE*) ZAHRA, A 22-YEAR-OLD AFGHAN GIRL, LOST BOTH HER LEGS DUE TO A ROCKET. HERE SHE IS UNDERGOING REHABILITATION AT THE ICRC ORTHOPEDIC CENTER IN KABUL. ■ (*THIS PAGE*) THE ROOF OF THE FORMER ROYAL PALACE IN KABUL WAS DESTROYED BY WAR. IT HAS BEEN USED AS A MILITARY POST FOR SEVERAL WARRING FACTIONS, INCLUDING THE TALIBAN. ■ AN OLD MAN IN KABUL LOOKS OUT FROM HIS BUILDING DESTROYED IN THE WAR.

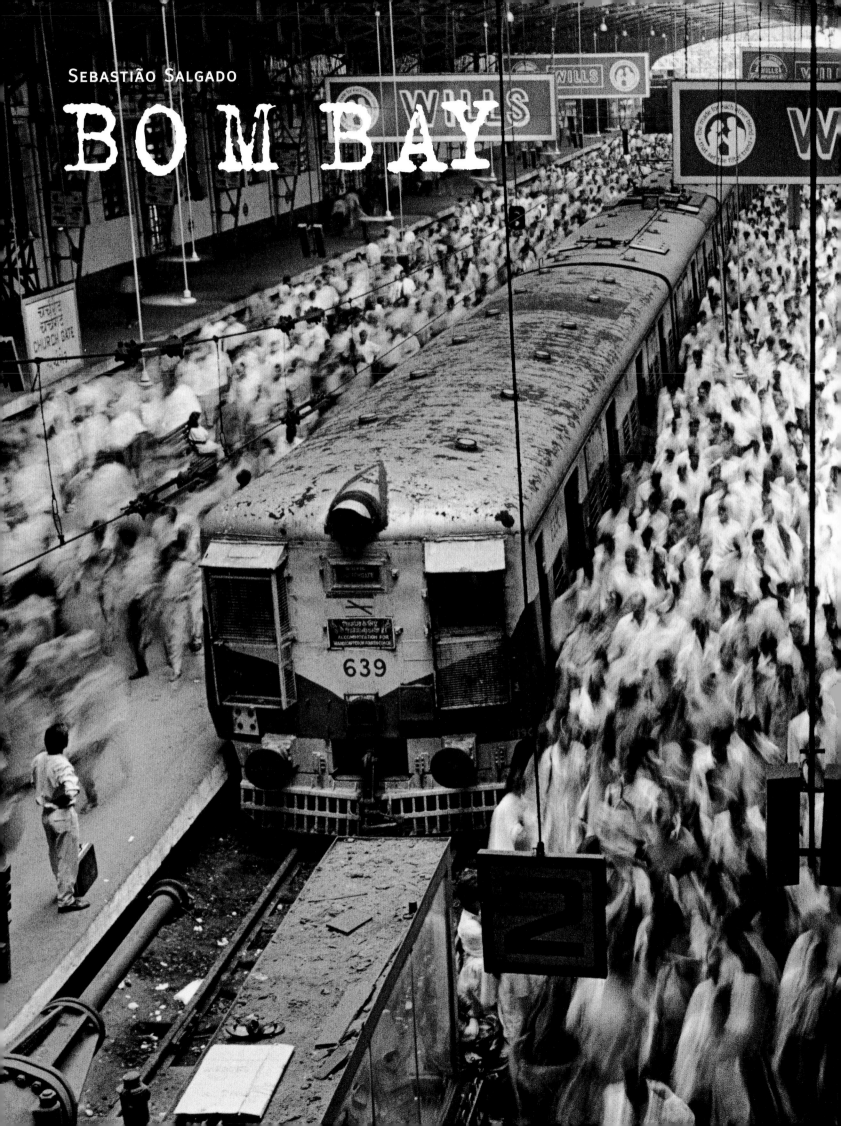

Sebastião Salgado

BOMBAY

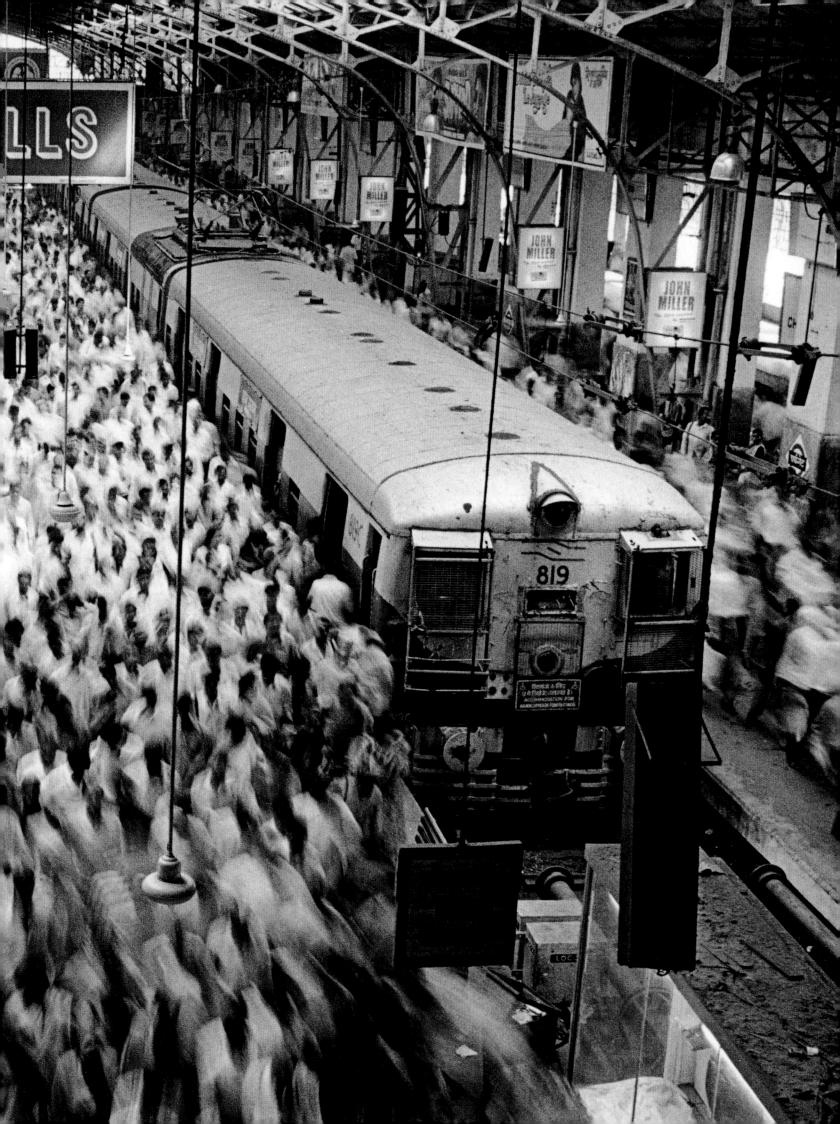

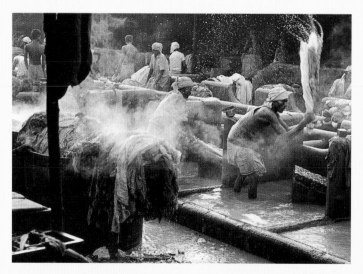

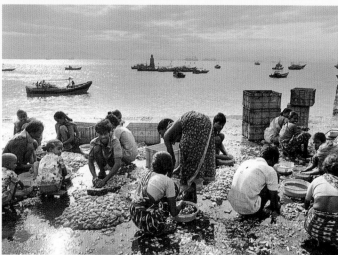

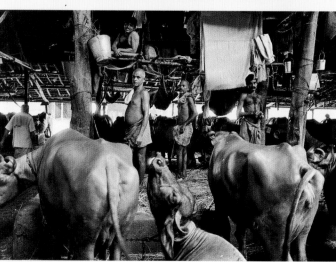

Photographer Sebastião Salgado is at work on a six-year project for *Rolling Stone* magazine, documenting the fate of the millions of people displaced worldwide by population growth, economic change, environmental degradation, and war. This series of photographs of Bombay forms part of the project.

In the text accompanying these images in the magazine, writer and film director Ismail Merchant wrote, "Bombay is a magnet to the millions of migrants who arrive in the city from every disadvantaged corner of India, with nothing more than dreams of a better future. For most the dream begins and ends in the misery and disease of Bombay's shantytowns, where survival is the only objective." As some of Salgado's photographs suggest, however, an expanding middle-class economy is helping to turn Bombay in to a city of hope. *Representative: Amazonas Images/Publisher:* Rolling Stone

A PIPELINE, BUILT TO BRING WATER TO THE WEALTHY NEIGHBORHOODS OF BOMBAY, RUNS DIRECTLY THROUGH MAHIM'S SHANTYTOWN, NEAR THE CITY'S AIRPORT. ROUGHLY HALF OF BOMBAY'S POPULATION—WHICH HAS BEEN ESTIMATED AT 15 MILLION—LIVE IN SHANTYTOWNS SUCH AS THIS ONE. ■ OVERUSE OF BOMBAY'S

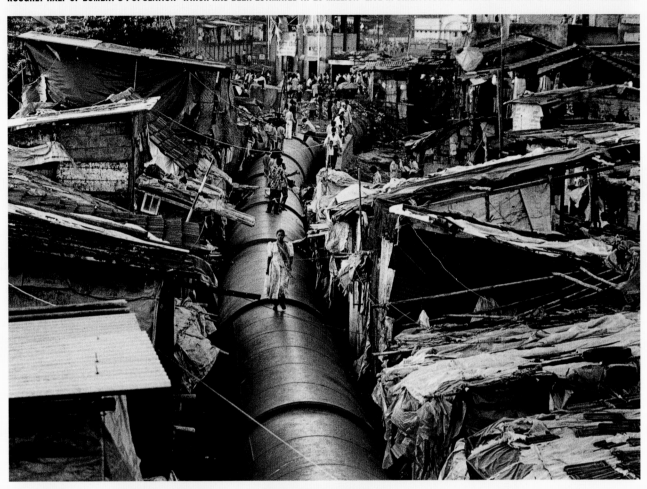

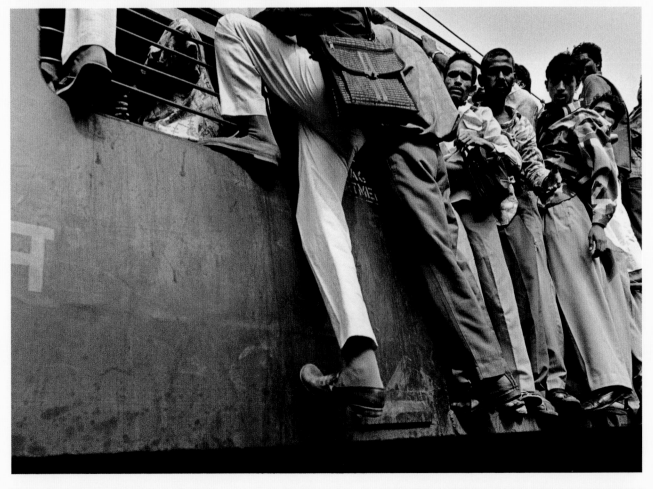

RAIL SYSTEM OFTEN FORCES RIDERS TO FIND SPACE ON THE OUTSIDE OF THE TRAINS. ■ *(FOLLOWING SPREAD)* BOMBAY'S SKYLINE LOOMS IN THE DISTANCE AS A HOMELESS MAN RESTS BESIDE THE CITY'S MARINE DRIVE. MANY OF THE POOR SLEEP HERE, WAITING FOR HE FOOD THAT IS DONATED BY THE AREA'S WEALTHY.

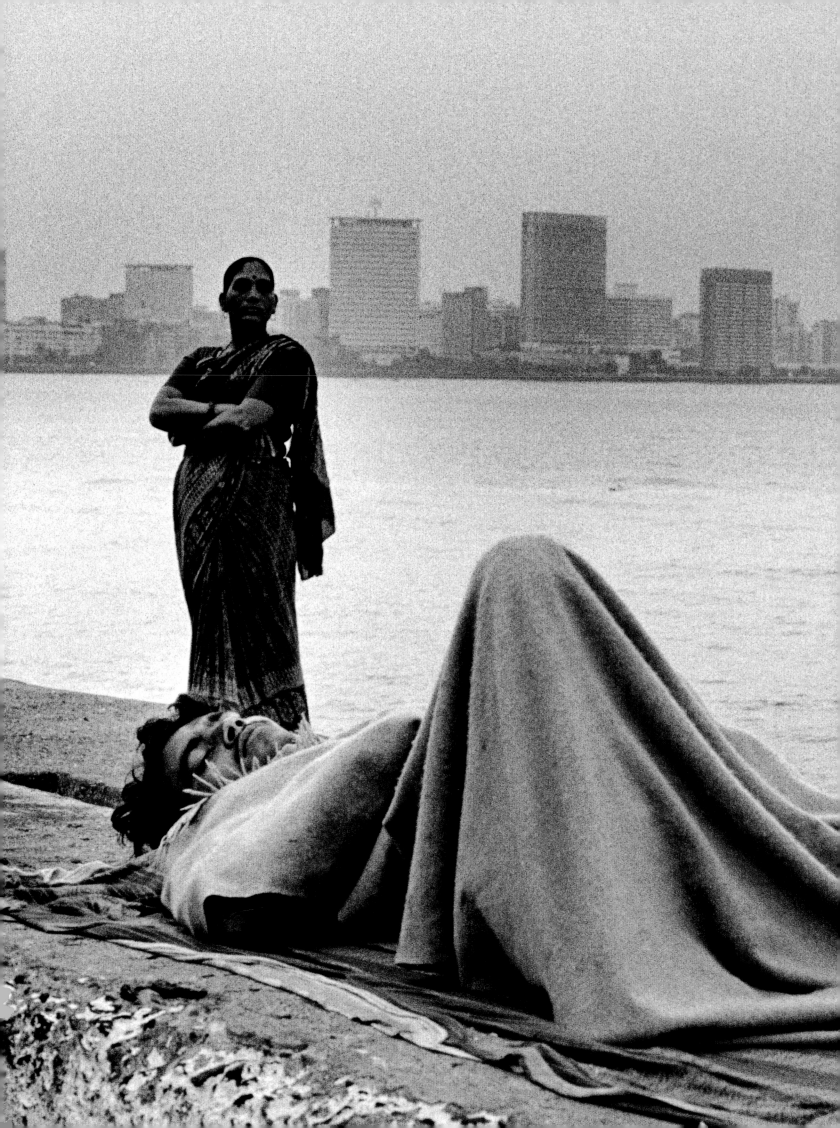

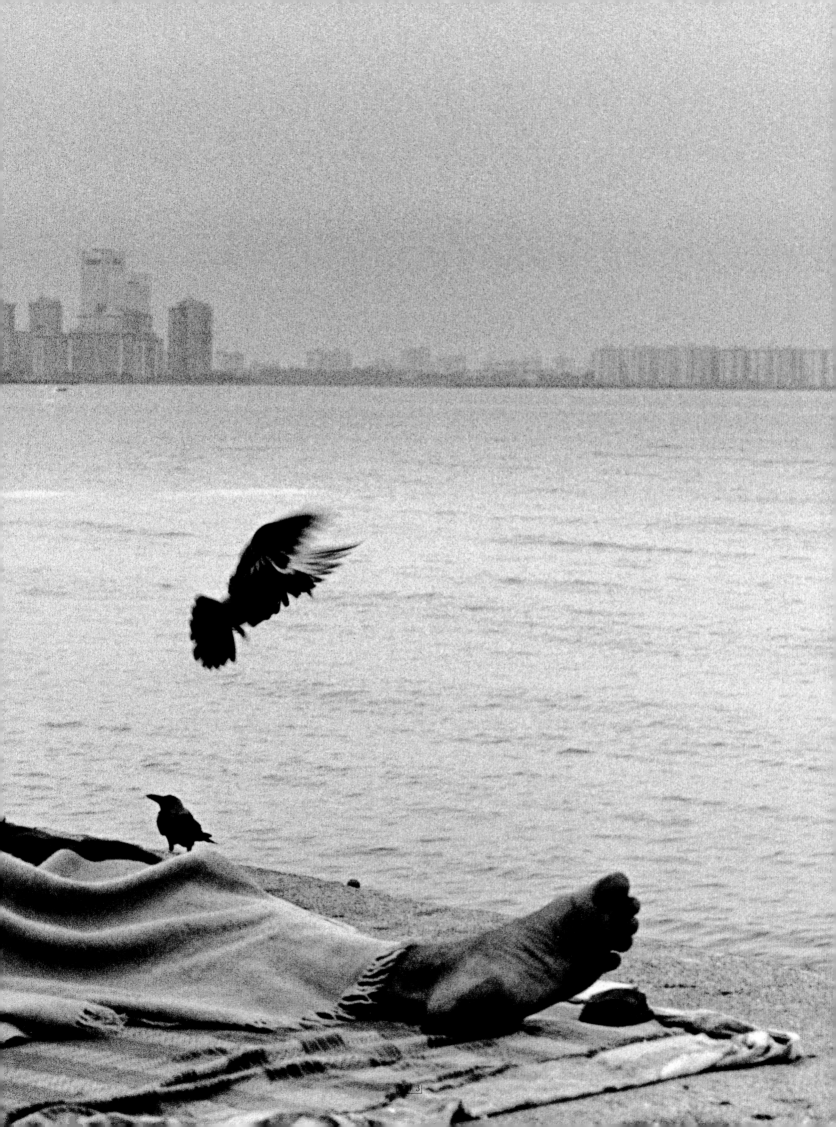

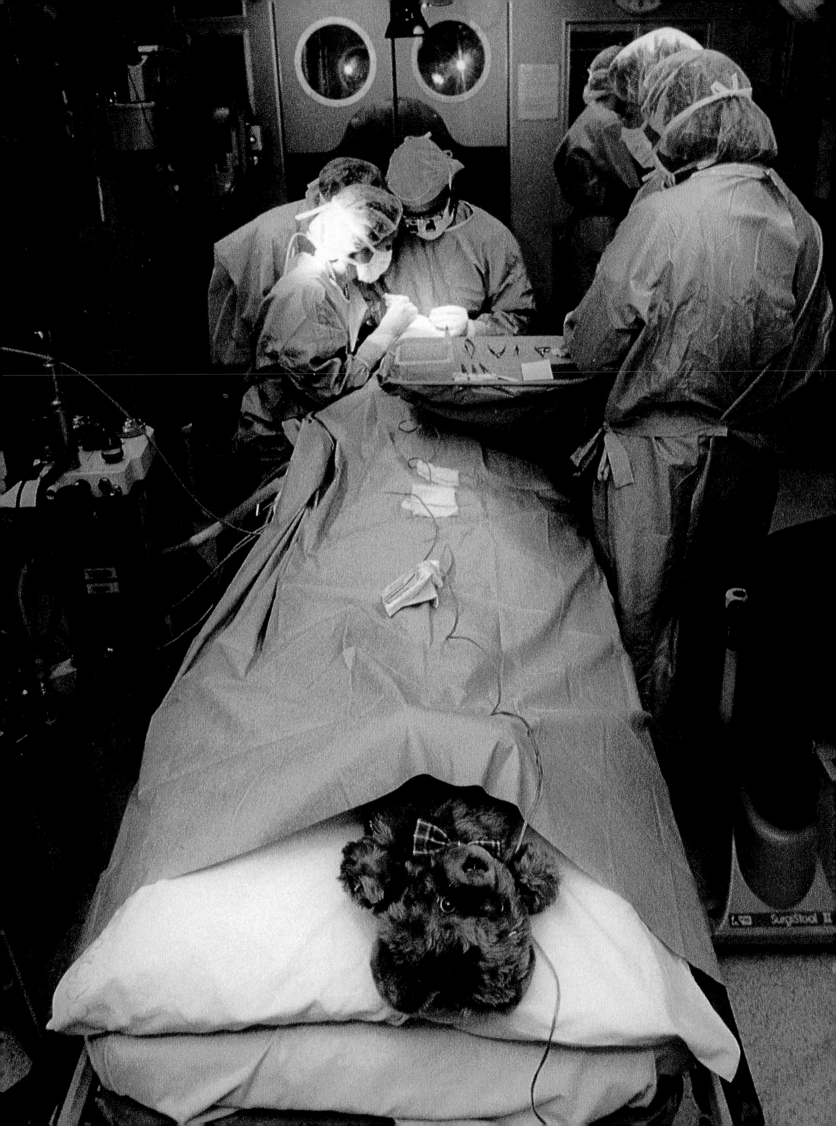

CHRIS SATTLBERGER

Project Orbis: Mobile Eye Hospital

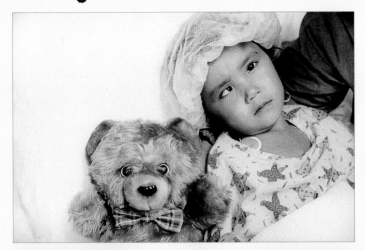
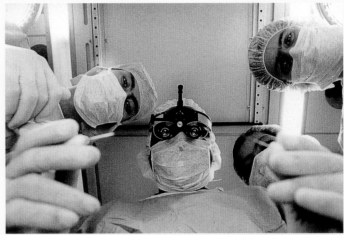
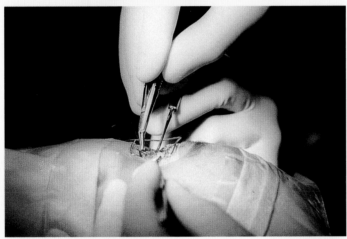
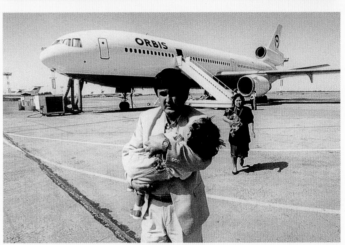
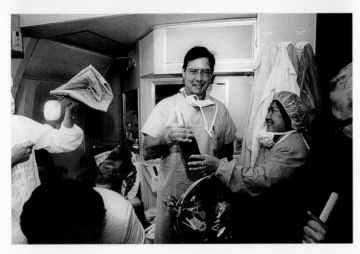
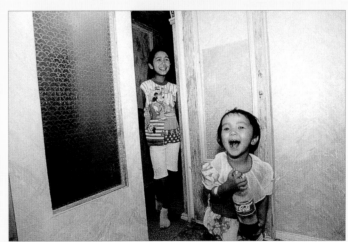

Project Orbis is a non-profit organization performing eye surgery and providing education worldwide. The organization owns a DC-10 aircraft that has been converted to a flying eye hospital. Patients are treated on the aircraft with the operations transmitted by closed-circuit television to a lecture room. The charity's mission is to instruct local doctors, as well as to heal.

In September 1996 I traveled to Kyghizstan in Central Asia to observe Project Orbis. I chose to follow one child though the entire process. Burlaim turned three on the day of her operation; she will retain eyesight in both eyes and be able to lead a normal life. *Representative: Regina M. Anzenberger/Publication:* Neue Zürcher Zeitung, *Zurich*

(OPPOSITE PAGE) DURING SURGERY THE TEDDY BEAR REMAINS WITH BURLAIM. ■ *(THIS PAGE)* BURLAIM WITH HER TEDDY BEAR IMMEDIATELY BEFORE SURGERY. ■ THE SURGEONS FROM BURLAIM'S POINT OF VIEW. ■ DR. SCOTT FOSTER WORKING ON ONE OF BURLAIM'S EYES. ■ AFTER SURGERY, HER FATHER CARRIES BURLAIM FROM THE PLANE. ■ THE GRATEFUL PARENTS PRESENT THE AMAZED SURGEON WITH A BOUQUET OF FLOWERS AND A BOTTLE OF RUSSIAN CHAMPAGNE. ■ PLAYING AT HOME A FEW DAYS AFTER THE OPERATION.

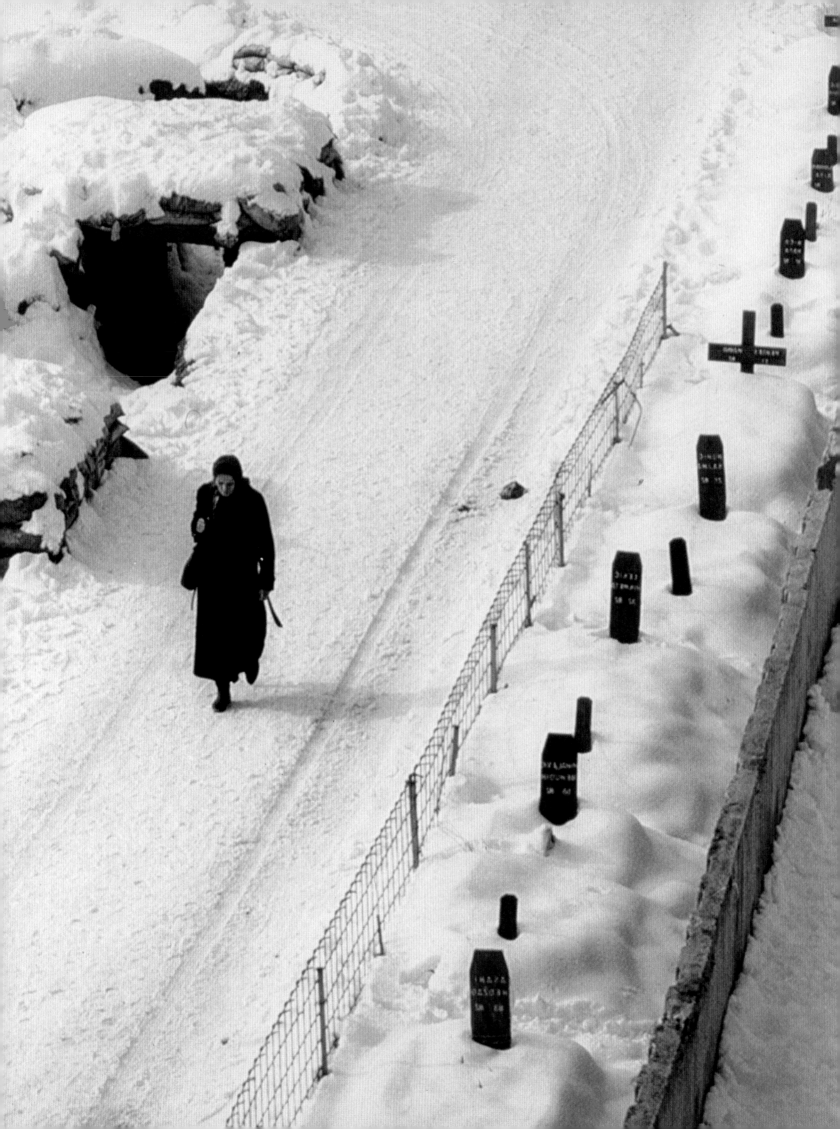

Bosnia, Perils of Peace

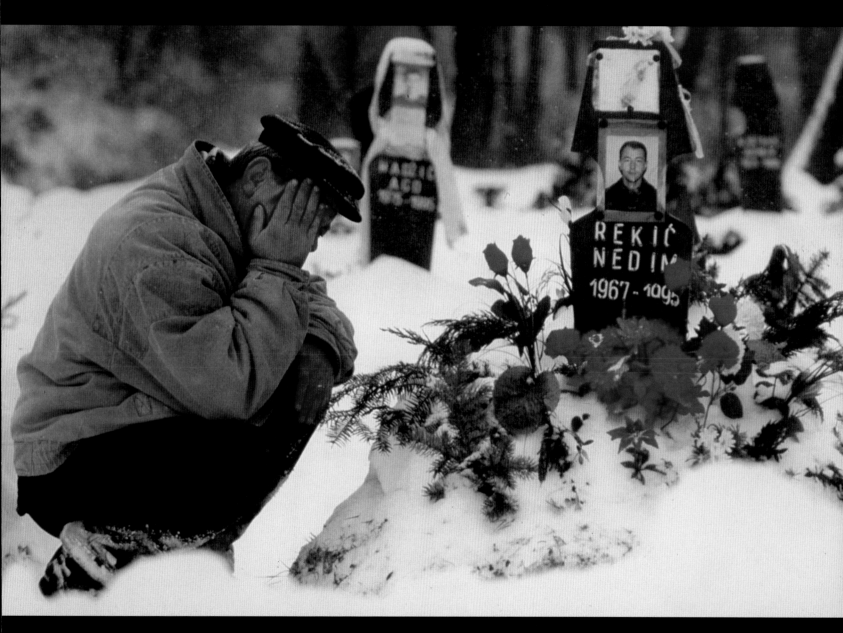

After a war that has killed more than 200,000 people, the survivors in Bosnia seek solace behind ethnic boundaries rather than trying to reunite the country.

The Dayton Peace Accord has put an end to the fighting for now, but there is still an air of fear and hatred between Muslims, Serbs, and Croats. Plans to unite key cities such as Sarajevo and Mostar have faltered, as have plans to allow civilians free movement between Serb-held territory and the rest of the country. The promise of a lasting peace is still a distant dream for the people of Bosnia. *Representative:* The Dallas Morning News

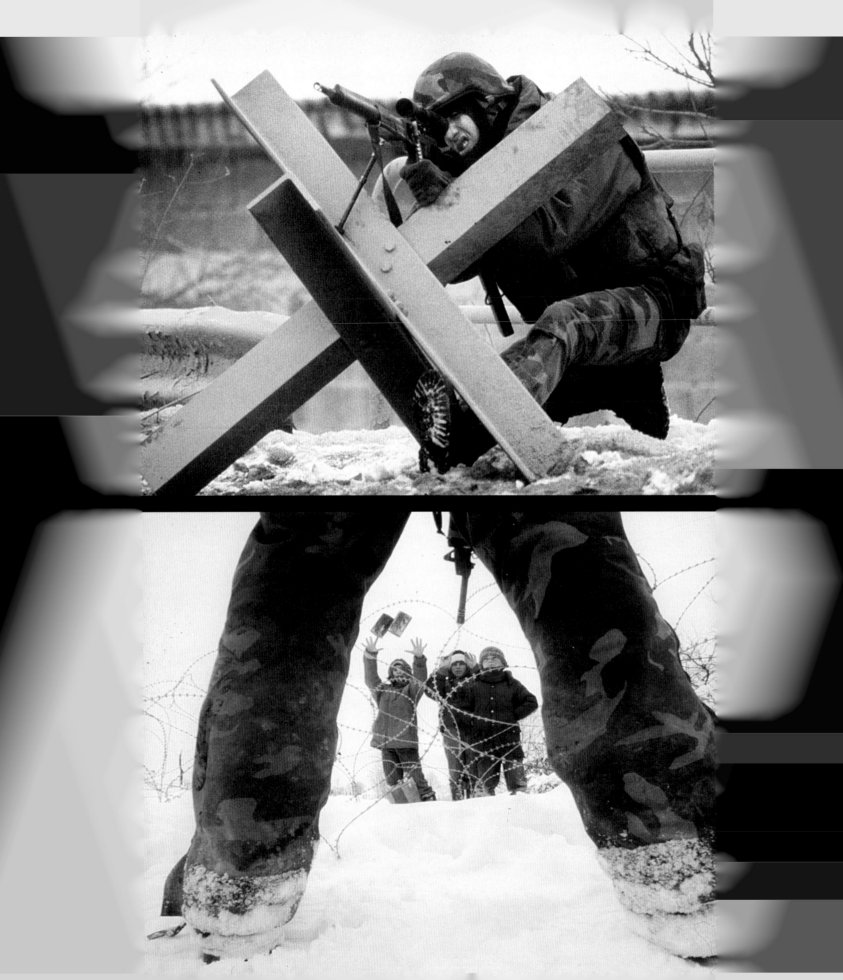

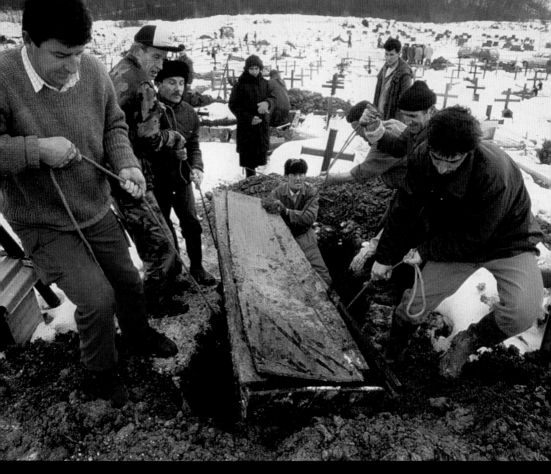

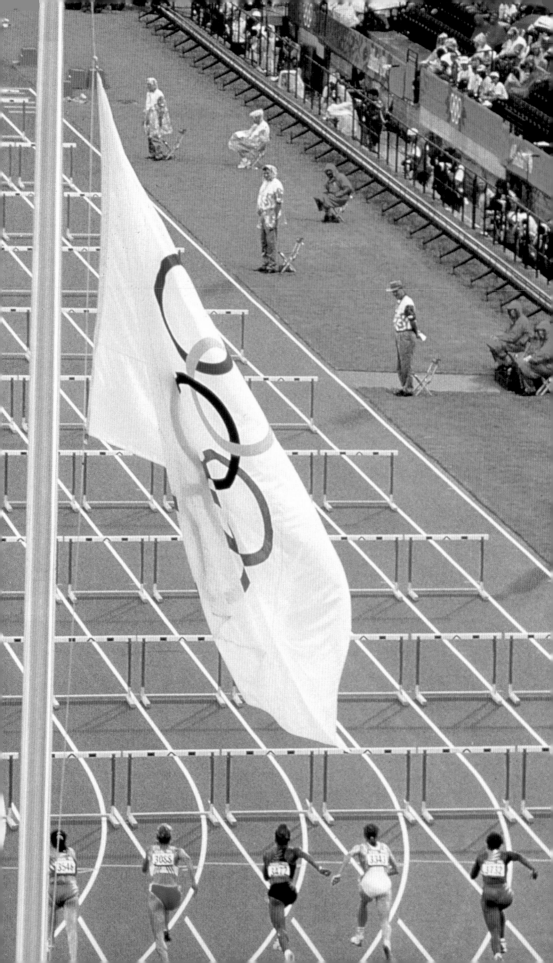

ERICH SCHLEGEL

1996
Olympic Games,
Atlanta, Georgia

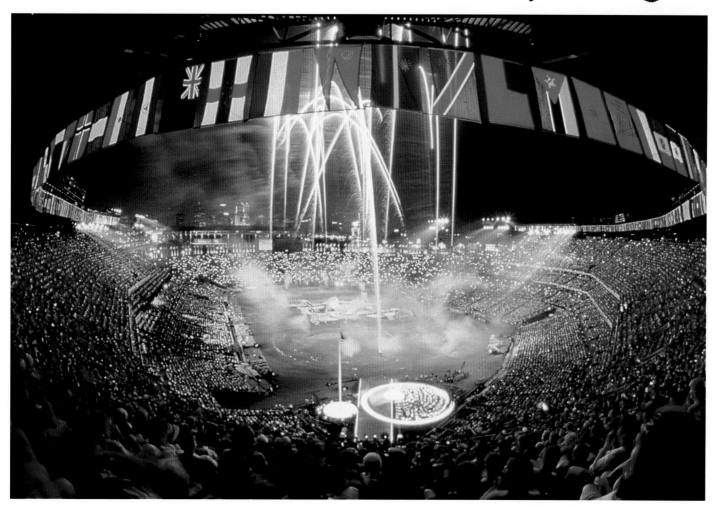

A week before the opening ceremonies of the 1996 Summer Olympics in Atlanta, I and two other staff photographers for the *Dallas Morning News* set up shop in the press center in downtown Atlanta. Our office included a Fuji C-41 processor and three scanning and transmitting stations, so that we could send images back to Dallas on a regular basis.

Up at the crack of dawn, we split up to cover different events, returning film to our office or to Kodak as we shot, transmitting images back to Dallas, and usually finishing our work at one or two in the morning, every night for two weeks.

These were my third Olympic Games, and each time I have felt like I participated in the Marathon.

(OPPOSITE PAGE) THE OLYMPIC FLAG FLIES AT HALF MAST AS THE WOMEN'S HEPTATHALON 100-METER HURDLES BEGIN, THE DAY AFTER A BOMB EXPLODED IN OLYMPIC PARK IN ATLANTA. ■ *(THIS PAGE)* THE FLAGS OF THE PARTICIPATING COUNTRIES ENCIRCLE CENTENNIAL OLYMPIC STADIUM DURING THE CLOSING CEREMONIES.

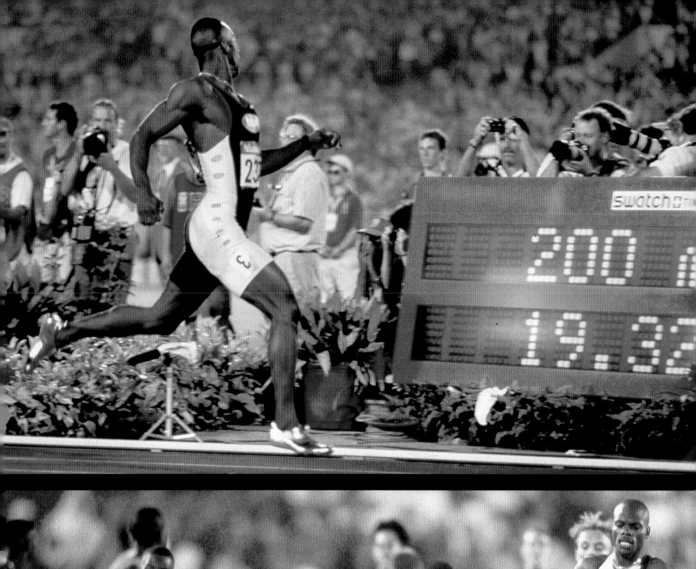

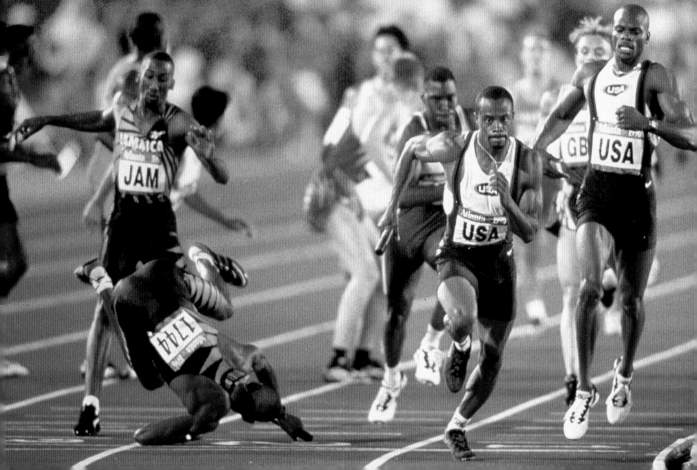

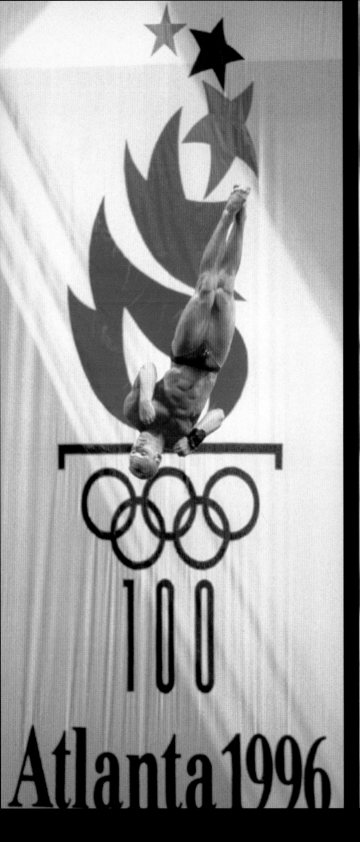

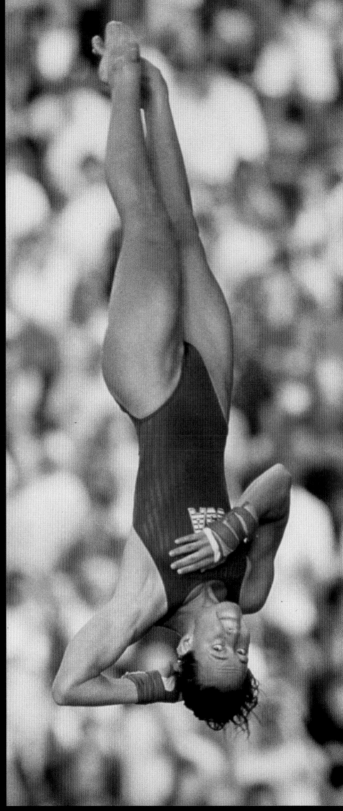

(OPPOSITE PAGE) MICHAEL JOHNSON GLANCES AT HIS WORLD-RECORD-BREAKING TIME IN THE 200-METER DASH. ■ IN THE MEN'S 4 X 400-METER RELAY, DEREK MILLS (USA) TAKES OFF AS JAMAICA'S GREG HAUGHTON TRIPS AND ROLLS. THE U.S. TEAM WON THE GOLD. ■ (THIS PAGE) IMRE LENGYEL OF HUNGARY COMPETES IN THE THREE-METER SPRINGBOARD. ■ AMERICAN BECKY RUEHL TWISTS IN THE 10-METER DIVING COMPETITION.

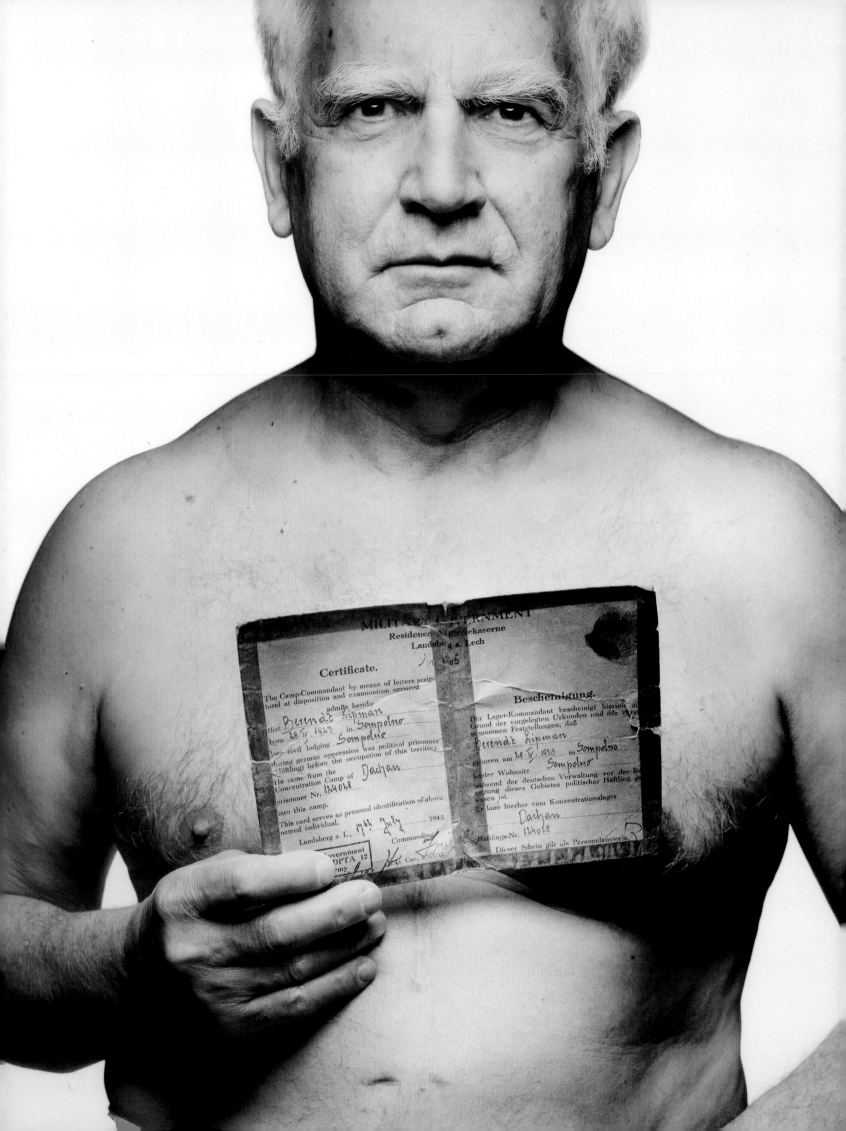

MARK SELIGER

When They Came to Take my Father —
Voices of the Holocaust

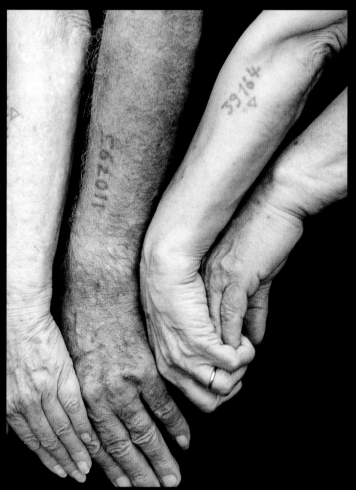
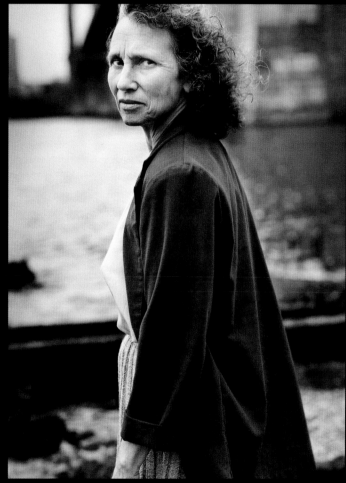

As a teenager, long before he became a successful celebrity photographer—and chief photographer for *Rolling Stone* and *US* magazine—Mark Seliger traveled with a Jewish youth group from his hometown of Houston, Texas, to Auschwitz, then to Romania and to Israel. The journey made a lasting impression on him, but it took nearly twenty years before he would photographically explore the feelings stirred in him by this experience.

The result is this series of stark black-and-white portraits of Holocaust survivors, in which Seliger sought to strip away some of the artifice of magazine editorial work and let the subjects' faces speak for themselves. In a recent interview he commented, "with celebrities, you can use props, sets, make-up, and hair stylists. . . . But then I realized that the face has a way of recording the pain, and I just tried to photograph the people as they were."

A group of stirring interviews by Leora Kahn and Rachel Hager accompanies Seliger's photographs in the 1996 book *When They Came to Take My Father* (Arcade Publishing). *Representative: Proof*

(OPPOSITE PAGE) LEE BERENDT, BORN APRIL 28, 1923, SOMPOLNO, POLAND. ■ *(THIS PAGE)* LIANE REIF-LEHRER, BORN NOVEMBER 14, 1934, VIENNA, AUSTRIA.

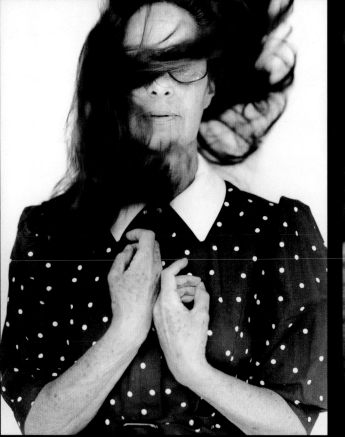
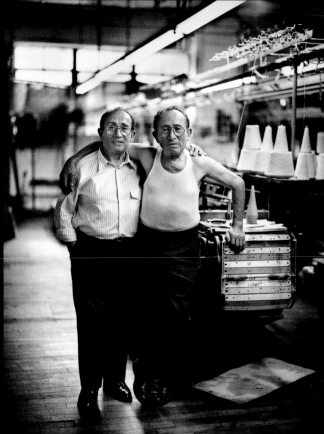

(THIS PAGE) ELIZABETH KOENIG, BORN VIENNA, AUSTRIA. ■ JACK TAVIN, BORN MAY 9, 1924, SLOMNIK, POLAND. ■ ERNST. W. MICHEL, BORN 1923 IN MANNHEIM, GERMANY. ■ WILLIAM DRUCKER, BORN APRIL 9, 1912, VIENNA, AUSTRIA. HERTA DRUCKER, BORN OCTOBER 7, 1923, VIENNA, AUSTRIA. ■ *(OPPOSITE PAGE)* ROBERT MELSON, BORN DECEMBER 27, 1937, WARSAW, POLAND.

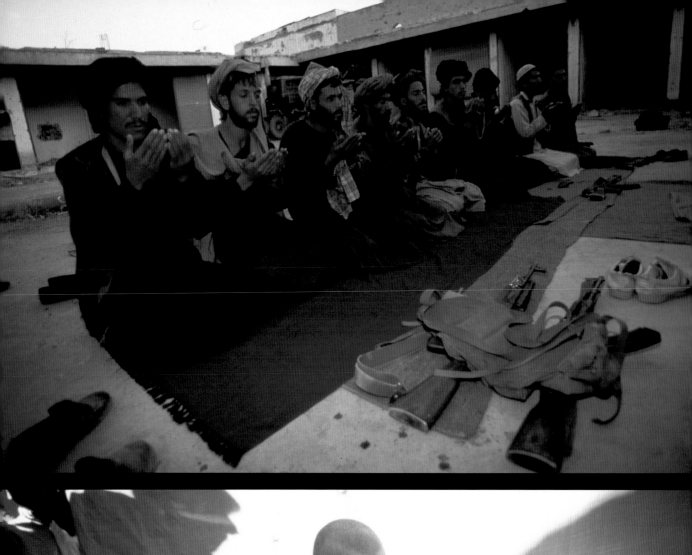
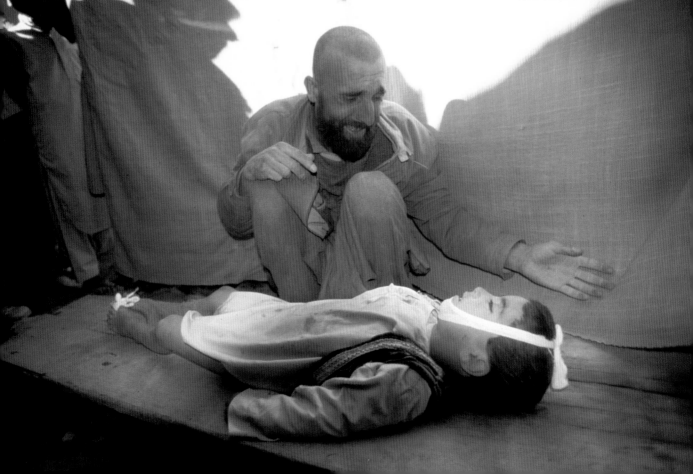

Kabul, Afghanistan,
after the Taliban Takeover

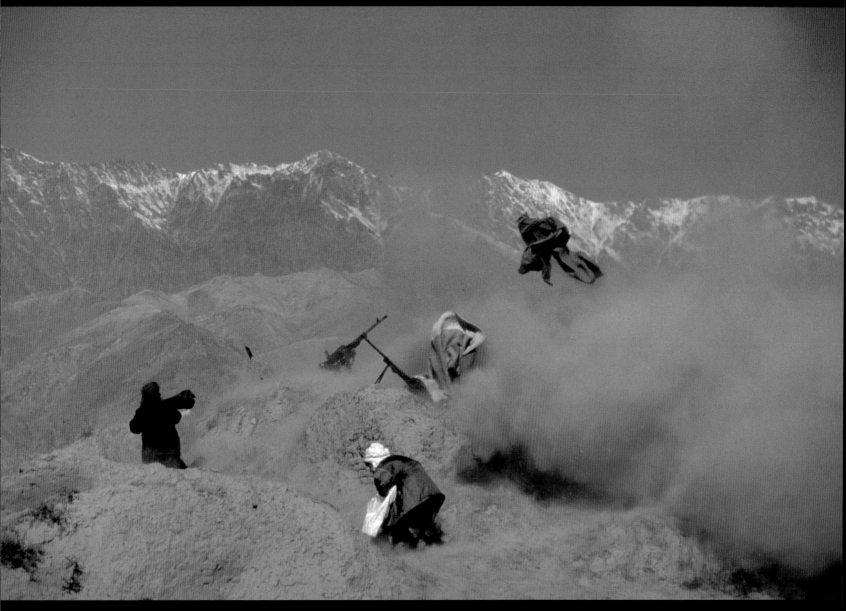

Two years after their formation, the Taliban, formerly a band of militant Islamic student vigilantes, captured Kabul, the capital city of Afghanistan. The government led by President Rabbani fell on September 27, 1996, with barely a shot fired.

Seventeen years of civil wars have destroyed large parts of the city and left more than 30,000 widows in Kabul alone. Once in power the Taliban began to enforce a strict brand of Islamic rule that bans women from working. This policy has left many hospitals and orphanages without staff, and has created great hardship for the widows. The new laws also require all women to cover their faces at all times, and girls are allowed to attend only Koranic schools.

In recent months, after Uimonen and other photojournalists left Kabul, the Taliban has also outlawed photography.
Agency: Sygma PhotoNews

(OPPOSITE PAGE) TALIBAN PRAY BEFORE DAWN. ■ UNCLE GRIEVES THE DEATH OF HIS SIX-YEAR-OLD NEPHEW, WHO, ALONG WITH HIS FATHER, WAS KILLED BY A BOMB DROPPED INTO THE SUBURBS OF KABUL BY GENERAL DOSTUM'S BOMBERS. ■ (THIS PAGE) THE TALIBAN FIRE ARTILLERY AT FORMER GOVERNMENT POSITIONS AT SALANG HIGHWAY, 15 KILOMETERS NORTH OF KABUL.

(THIS PAGE) LOCAL VILLAGERS FLEE THE FIGHTING JUST NORTH OF KABUL. ■ WIDOWS FLEE THEIR VILLAGE AFTER IT WAS BURNED BY THE TALIBAN FIGHTERS AS A WARNING AGAINST RESISTANCE. ■ ORPHANS AT DARYL YATAM ORPHANAGE, THE LARGEST ONE IN KABUL, WITH MORE THAN 500 CHILDREN. ■ WIDOWS LINE UP TO RECEIVE FOOD PRO-

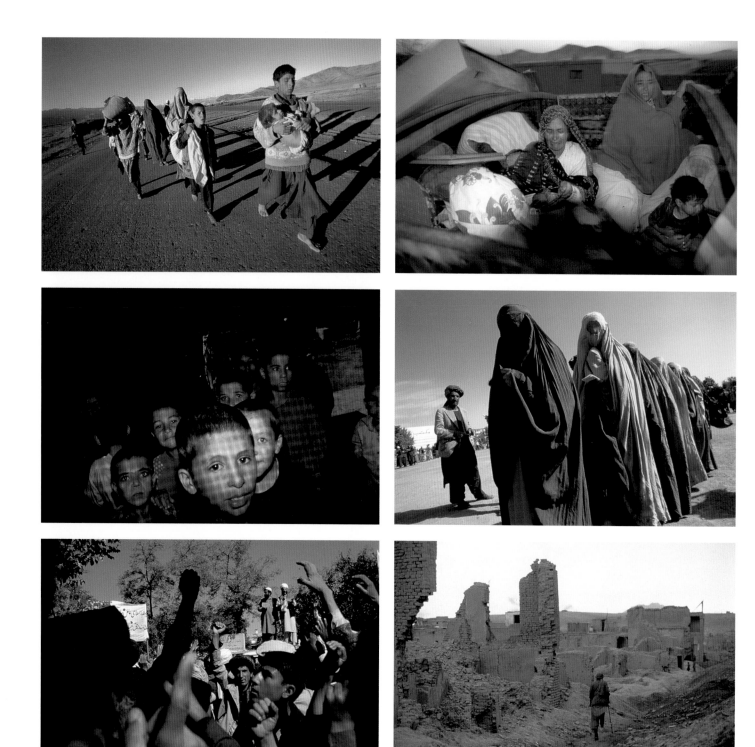

VIDED BY AID ORGANIZATIONS. ■ A CROWD GATHERS TO HEAR A MULLAH ORATION IN THE CENTER OF KABUL DURING A RALLY AGAINST IRAN'S INVOLVEMENT IN AFGHANISTAN'S INTERNAL AFFAIRS. ■ LAND-MINE VICTIM IN THE WAR-TORN RUINS OF WESTERN KABUL. ■ (OPPOSITE PAGE) AFTER BANNING WESTERN MUSIC, TV, AND ALCOHOL, THE TALIBAN SEIZED AND DESTROYED THE STOCK OF FILMS FROM A MOVIE THEATER. ■ MINE VICTIM LEARNING TO WALK WITH HER PROSTHESIS AT THE RED CROSS ORTHOPEDIC CENTER IN KABUL.

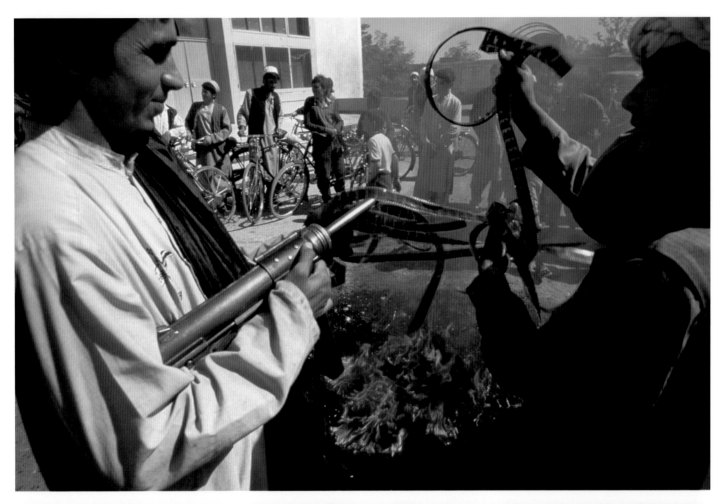

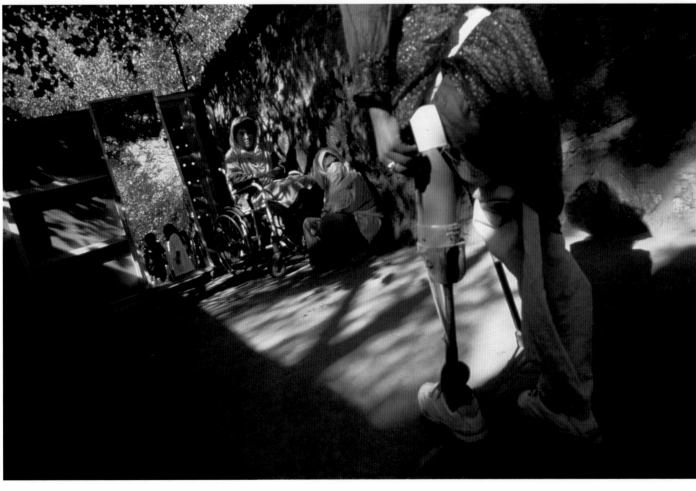

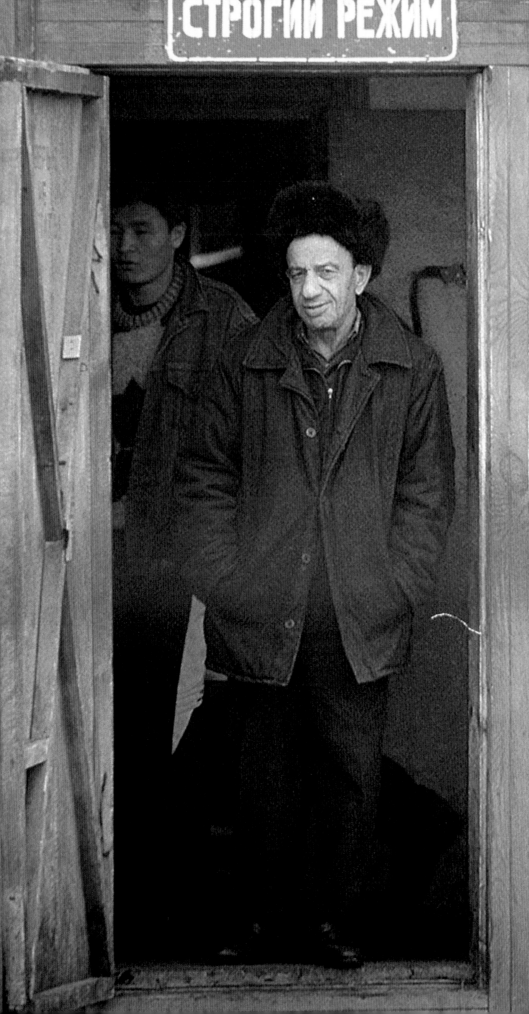

ALEXANDER ZEMLIANICHENKO

Russian Gulag for Foreigners

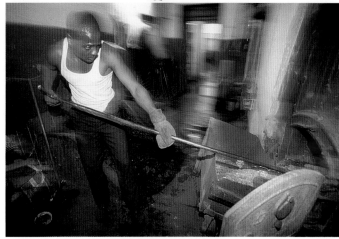

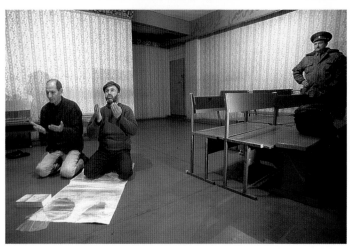

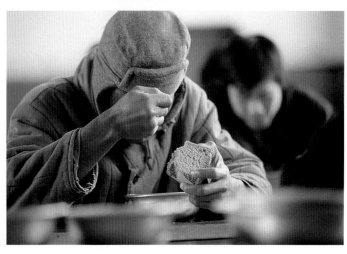

In the tiny village of Leplei, 350 miles east of Moscow on the windswept plains of central Russia, is a gulag formerly called Corrective Labor Colony No. 22. It is Russia's only facility for foreign prisoners, housing convicts from more than 30 nations, including some from Vietnam, Afghanistan, Korea, Iran, and China. Russia has gotten tough with offending foreigners in recent years and no longer sends them back to their homelands for punishment. It is cracking down particularly hard on drug smugglers. Most prisoners are tried and sentenced in Russian, which very few of them speak. *Representative: Associated Press*

STORY AND CAPTION TRANSLATIONS

KOMMENTARE UND LEGENDEN

COMMENTAIRES ET LÉGENDES

BIOGRAPHIES

JEFFREY AARONSON

GESICHTER DES WIDERSTANDS Im letzten Jahr bin ich dreimal zum «Dach der Welt» gereist, um den Geist und die Entschlossenheit des tibetanischen Volkes zu dokumentieren, das sich seinen Glauben und seine Identität bewahrt, trotz jahrelanger Unterdrückung durch die Chinesen. Da sich ihr geistiger Führer, der Dalai Lama, im Exil befindet, bleiben den Tibetanern ihr buddhistischer Glaube, ihre Familien, ihre Sprache, ihre Sitten und auch ihr Sinn für Humor als Rückhalt. Die chinesische Regierung behindert sie in der Ausübung ihrer Religion, in ihrer persönlichen Freiheit und mischt sich in die Ausbildung ein, doch in ihren Herzen und tiefster Seele sind die Tibetaner frei geblieben. *Agentur: Network Aspen/Publikation:* Vanity Fair

SEITEN 14-15: Lhasa, Tibet. Pilger wirken wie Zwerge neben der gigantischen Stupa am Eingang zu Lhasa, dahinter der Potalai.

SEITE 16: Eine Familie in traditionellen nomadischen Kleidern in einem kleinen Dorf im westlichen Tibet ausserhalb von Nagchu.

SEITE 17: Mönche beim Üben auf ihren Hörnern für eine religiöse Zeremonie im Jokhang-Tempel, dem heiligsten Tempel Tibets. ▪ Mönche schlagen traditionelle Trommeln bei einer seltenen religiösen Zeremonie im Jokhang-Tempel. ▪ Nonnen beim Gebet im Innenhof des Jokhang-Tempels. Hier versammeln sich Mönche und Nonnen aus ganz Tibet. ▪ Eine Frau mit ihrem Kind, in Lhasa. ▪ Ein Nomade auf der Strasse nach Nagchu. ▪ Pilger werfen sich auf der Strasse nach Lhasa nieder. ▪ Mönche beim gemeinsamen Gebet im Jokhang-Tempel. ▪ Pilger versetzen Gebetsmühlen in Umdrehungen.

SEITE 18: Mönche beim Falten eines heiligen Tuchs im Tsurphu-Kloster, dem Tempel der Karmapa. ▪ Im Tashilhunpo-Kloster nehmen ältere Mönche eine Gabe von einem tibetanischen Kind entgegen.

SEITE 19: Ein Mönch auf dem Dach des Jokhang-Tempels auf dem Weg zu seiner Zelle. ▪ Ein Mönch in einem Moment der Kontemplation auf dem Dach des Jokhang-Tempels.

LES VISAGES DE LA RÉSISTANCE L'année passée, je me suis rendu à trois reprises sur le «toit du monde» pour capturer l'esprit et la détermination du peuple tibétain, qui a su préserver, en dépit de l'oppression chinoise, ses croyances et son identité. Leur maître spirituel, le dalaï-lama, se trouvant en exil, les Tibétains doivent s'en remettre à leur foi dans le bouddhisme, à leur structure familiale, à leur langue, à leurs us et coutumes et à leur sens de l'humour pour supporter la terrible épreuve qui leur est imposée. Bien que le gouvernement chinois empêche la pratique de la religion, interfère dans l'éducation des jeunes et prive un peuple tout entier de ses libertés fondamentales, les Tibétains ont su rester libres dans leur cœur et au plus profond de leur âme. *Agent: Network Aspen/Editeur:* Vanity Fair

PAGES 14-15: Lhasa, Tibet. Les pèlerins ont l'air de nains à côté du gigantesque stûpa à l'entrée de Lhasa. Le Potalai se détache à l'arrière-plan.

PAGE 16: Famille de nomades en costumes traditionnels dans un petit village de l'ouest du Tibet, en dehors de Nagchu.

PAGE 17: Moines répétant en vue d'une cérémonie religieuse au temple de Jokhang, le plus sacré du Tibet. ▪ Moines jouant du tambour traditionnel à l'occasion d'une cérémonie religieuse rare au temple de Jokhang. ▪ Nonnes priant dans la cour intérieure du temple de Jokhang. C'est ici que se rassemblent des nonnes et des moines venus des quatre coins du Tibet. ▪ Femme et son enfant à Lhasa. ▪ Nomade sur la route de Nagchu. ▪ Pèlerins se prosternant sur la route de Lhasa. ▪ Moines priant dans le temple de Jokhang. ▪ Pèlerins faisant tourner des moulins à prières.

PAGE 18: Moines pliant un linge sacré au monastère Tsurphu, le temple de Karmapa. ▪ Moines acceptant l'offrande d'un petit enfant tibétain au monastère Tashilhunpo.

PAGE 19: Moine marchant le long du toit du temple de Jokhang pour rejoindre sa cellule. ▪ Moine en contemplation sur le toit du temple de Jokhang.

LUIGI BALDELLI

AFGHANISTAN IM ÜBERGANG Ich kam im Dezember 1995 in Kabul an, als die Stadt noch unter dem Beschuss der vor den Toren stehenden Taliban-Miliz lag. Man war bemüht, das Leben wie gewohnt weitergehen zu lassen: man ging zum Markt, auch wenn die Preise sehr hoch waren, die Frauen bewegten sich frei in der Stadt und versuchten, an Essen für ihre Familien zu kommen, und die Männer schwatzten in den Cafés oder suchten zusammen mit ihren Kindern Brennholz. Um 17.00 Uhr aber waren die Strassen verlassen, Kabul wurde zur Geisterstadt. Um 22.00 Uhr begann die Ausgangssperre, auf den Strassen waren nur noch Soldaten zu sehen. Die Nacht war erfüllt vom Lärm der Maschinengewehre und Explosionen.

Fotojournalismus bedeutet Unmittelbarkeit, aber ich achte darauf, dass meine Aufnahmen Dichte, Kraft und Gehalt haben, damit sie den Betrachter fesseln. Wir leben bekanntlich in einer Welt der Bilder, die von den Medien zu den verschiedensten Zwecken genutzt werden. Viele dieser Bilder besitzen aber keine eigene Kraft, keinen Charakter, und hinterlassen keinen bleibenden Eindruck. Photos und insbesondere der Photojournalismus müssen den Geist, müssen zum Nachdenken anregen. Der Photojournalist hat die grosse Chance, im Zentrum der Ereignisse zu sein. Doch er muss deshalb versuchen, anderen Menschen diese Ereignisse mit seinen Aufnahmen lebendig zu vermitteln. Photojournalismus legt Zeugnis ab von gesellschaftlichen Dimensionen. Es ist eine Herausforderung, sich nicht in die Falle locken zu lassen, also die Spontaneität des Gefühls nicht zu verlieren und die Authentizität des Ereignisses zu wahren. *Agentur: Contrasto/Saba Photo Agency*

SEITEN 20-21: Mudschahedin, Afghanistans Streitkräfte, Kabul.

SEITE 22: Freitagsgebet. Ein Mudschahed, Mitglied der afghanischen Streitkräfte.

SEITE 23: Freitagsgebet. ▪ Granatenopfer. ▪ Strassensperre für Wachposten an den Stadttoren. ▪ Schule für Waisenkinder. ▪ Beerdigungsfeier für ein Granatenopfer. ▪ Zwei Mudschahedin treffen sich in Kabul. ▪ Mudschahed an einem Check-point. Das Schild zeigt verschiedene Arten von Minen. ▪ Eine Moslemin beim Verlassen ihres Hauses in einem Vorort.

PAGES 24-25: Das zerstörte Stadtzentrum von Kabul.

L'AFGHANISTAN EN PÉRIODE DE TRANSITION C'est en décembre 1995 que je suis allé à Kaboul alors que la ville était toujours en proie à une pluie d'obus lancés par les Talibans stationnés en dehors de la ville. Les habitants essayaient de vivre leur vie comme si de rien n'était. les marchés fonctionnaient même si les prix étaient élevés; les femmes marchaient librement à travers la ville à la recherche de nourriture pour leurs familles pendant que les hommes se rencontraient dans les cafés pour discuter un peu ou cherchaient du bois pour faire du feu avec leurs enfants. Mais à 17h00 précises les rues étaient désertées et la ville devenait fantomatique. Le couvre-feu commençait à 22h00 précises et laissait place aux soldats. La nuit était remplie du vacarme que faisaient les mitraillettes et les explosions.

Le reportage-photo implique une rapidité de réaction, cependant j'essaye pour ma part d'imprégner mes photos de cohérence, de force et de sens afin de pouvoir capter l'attention du spectateur. Nous vivons dans un monde d'images, comme chacun sait, que les médias utilisent à diverses fins. Mais beaucoup de ces images ne possèdent pas de force et de caractère à elles propres, et ne laissent aucune empreinte durable. Les photographes et les reporters-photographes en particulier devraient encourager tout un chacun à la méditation et à la réflexion. Un reporter-photographe a la chance de se trouver plongé au cœur des événements et de l'actualité et c'est exactement pourquoi il se doit de les faire revivre pour les autres aussi. Le reportage-photo témoigne de la vie sociale. L'enjeu est de ne pas tomber dans le piège de la facilité, de ne pas perdre la spontanéité émotionnelle et l'authenticité du moment. *Agent: Contrasto/Saba Photo Agency*

PAGES 20-21: Moudjahidines, membres de l'armée afghane, Kaboul.

PAGE 22: La prière du vendredi. ▪ Un moudjahid, membre des forces armées afghanes.

PAGE 23: La prière du vendredi. ▪ Victime d'une grenade. ▪ Barrage d'un poste de garde aux portes de la ville. ▪ Ecole pour orphelins. ▪ Obsèques de la victime d'une grenade. ▪ Deux moudjahidines se rencontrant à Kaboul. ▪ Moudjahid à un poste de contrôle. Le panneau illustre différents types de mines.

PAGES 24-25: Le centre de Kaboul, dévasté par la guerre.

P. F. BENTLEY

BOB DOLE: HINTER DEN SCHLAGZEILEN Elf Monate lang begleitete ich Senator Bob Dole auf einer Reise, die im Januar 1996 ihren Anfang nahm. Mr. Dole kandidierte gegen Bill Clinton für die Präsidentschaft der Vereinigten Staaten, und ich wollte aufzeichnen, was sich hinter den Kulissen abspielt, ausserhalb der offiziellen Phototermine der Kampagne.

Ich hatte zu allem Zutritt, keine Tür blieb mir verschlossen. Die einzige Bedingung war, dass ich von dem, was hinter den Türen gesprochen wurde, nichts weitergeben durfte.

Mr. Dole begann das Jahr als Führer der Mehrheit im Senat, am Ende des Jahres war er ohne Job, zum ersten Mal in seinem Leben im Alter von 73 Jahren. Das ist die Geschichte jenes Jahres. *Publikation:* Time.

SEITEN 26-27: Wahlkampf in Iowa. Dole wartet auf einem Stuhl in der Turnhalle von Ottrunwa, Iowa, während sein Auftritt angekündigt wird.

SEITE 28: Bus-Tour. Dole winkt potentiellen Wählern bei einer Bus-Tour durch New Jersey an einem sonnigen Tag.

SEITE 29: Budget-Probleme. Dole hört aufmerksam zu, während Senatoren, Kongressabgeordnete und Mitarbeiter eine Budget-Verhandlungsstrategie diskutieren. ■ Doles Seele. Porträt Doles am Pool in Tucson, Arizona. ■ Vor einem Auftritt in Bangor, Maine. Dole späht vorsichtig durch den Vorhang, um einen Blick auf sein Publikum zu werfen, bevor er auf die Bühne geht. ■ Dole und Leader. Dole vertraut seinem Hund Leader an, an welchem Tag er seinen Rücktritt aus dem Senat bekanntgeben wird. ■ Er geht. Dole, von Gefühlen überwältigt, nach einer bewegenden Ehrung durch Senator Connie Mack nach der Bekanntgabe seines Rücktritts aus dem Senat. ■ Die letzte Fahrt. Nach dem letzten Auftritt im Senat fahren der Senator und Mrs. Dole still zur Wahlkampfzentrale. ■ Parteikonvent. Dole bei der Prüfung seiner Ansprache, in der er die Nominierung annehmen wird, auf der Terrasse in La Jolla, Kalifornien, mit Blick aufs Meer. ■ Der lange Weg. Die Doles auf dem Weg zu ihrem Apartment nach seiner Rede zu Clintons Sieg in der Wahlnacht.

BOB DOLE: LES COULISSES DE LA POLITIQUE Au mois de janvier 1996, j'ai entrepris un voyage de onze mois sur les traces du sénateur Bob Dole, candidat à la présidence des Etats-Unis face à Bill Clinton. Mon objectif était de saisir sur le vif ce qui se passe dans les coulisses, au-delà des séances photo savamment orchestrées de la campagne.
J'ai pu assister à tout ce qui se passait, toutes les portes s'ouvraient devant moi. La seule condition était que je ne révèle rien de ce que j'avais pu entendre dans l'intimité de la campagne.
Bob Dole a débuté l'année comme leader de la majorité au Sénat. A la fin de cette même année, il n'avait plus de travail pour la première fois dans sa vie et ce, à l'âge de 73 ans. C'est l'histoire de cette année-là. *Editeur:* Time, *New York*
PAGES 26-27: Campagne électorale dans l'Iowa. Assis sur une chaise dans le gymnase d'Ottrunwa, Bob Dole écoute l'annonce de son discours dans le cadre d'un meeting.
PAGE 28: Tournée électorale en bus. Bob Dole saluant des électeurs potentiels lors d'une tournée électorale en bus dans le New Jersey par une belle journée ensoleillée.
PAGE 29: Contestations concernant le budget. Bob Dole écoutant attentivement les sénateurs, les membres du Congrès et leurs collaborateurs discuter du budget. ■ L'âme de Dole. Portrait du sénateur assis au bord d'une piscine à Tucson, Arizona. ■ Avant un meeting à Bangor, dans le Maine. Bob Dole jetant un coup d'œil derrière le rideau pour voir le public avant de s'avancer sur la scène. ■ Dole et Leader. Dole confiant à son chien Leader le jour où il entend se retirer du Sénat. ■ Il se retire. Bob Dole, profondément ému après l'hommage vibrant que lui a rendu le sénateur Connie Mack suite à sa décision de se retirer du Sénat. ■ Le dernier trajet. Après sa dernière apparition au Sénat, le sénateur Dole et sa femme roulent doucement en direction des quartiers généraux de la campagne. ■ La convention. Bob Dole, sur une terrasse surplombant la mer à La Jolla, Californie, révisant son discours dans lequel il annonce qu'il accepte sa nomination. ■ La longue marche. Les Dole se retirant dans leur appartement après le discours de Bob Dole à l'occasion de la victoire de Clinton la nuit des élections.

DONNA BINDER
BRANDSTIFTUNG IN AFRO-AMERIKANISCHEN KIRCHEN Zwischen Januar und Juni 1996 gab es über 28 Kirchenbrände in den Südstaaten der USA. Die meisten der betroffenen Kirchen gehörten zu ländlichen, seit jeher schwarzen und multikulturellen Gemeinden.
In Alabama wurde der Brand in einer Kirche zwei Tage vor einem Gedenktag gelegt, der an die Selma-Demonstration erinnert, die wesentlich zur Durch setzung des allgemeinen Stimmrechts im Jahre 1965 beigetragen hat. Dreizehn Brände ereigneten sich im Januar kurz vor oder nach dem Martin-Luther-King-Jr.-Gedenktag. Es scheint, dass die meisten Brandstiftungen einen rassistischen Hintergrund haben, denn es wurden vor allem junge weisse Männer (von denen einige Ku-Klux-Klan-Krawatten trugen) in diesem Zusammenhang angeklagt. *Agentur: Impact Visuals*
SEITE 30-31: Nachdem ein Feuer die Little Zion Church in Boligee, Alabama, zerstört hat, werden die Gottesdienste im nahegelegenen Forkland abgehalten. ■ Trauung des Sohnes des Diakons der durch Feuer zerstörten Little Zion Church, Boligee, Alabama. Sie fand in einer benachbarten Kirche statt. ■ Untersuchung der Trümmer einer durch Brandstiftung zerstörten Kirche in South Carolina.
SEITE 32-33: Rose Johnson vom Center for Democratic Renewal und Ron Daniels vom Center for Constitutional Rights bei einer Versammlung in Washington, D.C. für die Pastoren der niedergebrannten Kirchen.

INCENDIES DANS DES ÉGLISES AFRO-AMÉRICAINES Entre janvier et juin 1996, plus de 28 églises ont brûlé aux Etats-Unis. La plupart d'entre elles appartenaient à des commu-

nautés rurales et multiculturelles, avec une population majoritairement noire.
En Alabama, des inconnus ont mis le feu à une église deux jours avant la commémoration de la manifestation de Selma, qui a largement contribué au droit de vote des Noirs en 1965 (Voting Rights Act). Treize incendies se sont déclarés en janvier, peu avant ou après la journée dédiée à Martin Luther King. Il apparaît que ces incendies reposent sur des actes racistes, la plupart des accusés étant des hommes de race blanche (dont certains arboraient les cravates du Ku Klux Klan). *Agent: Impact Visuals*
PAGE 30-31: Après l'incendie qui a ravagé la petite église de Sion (Little Zion Church) à Boligee, Alabama, les offices se tiennent dans le village voisin de Forkland. ■ Le mariage religieux du fils du diacre de la petite église de Sion à Boligee, Alabama, est célébré en pleine ville après que l'église a été ravagée par le feu. ■ Rose Johnson du Centre pour le Renouveau Démocratique (Center for Democratic Renewal) et Ron Daniels du Centre pour le Respect des Droits de la Constitution (Center for Constitutional Rights) à une rencontre organisée à Washington D.C. en faveur des pasteurs dont les Héglises ont brûlé.
PAGE 32-33: L'église baptiste de Rosemary (Rosemary Babtist Church), dans le comté de Barnwell County, Caroline du Sud, après un incendie.

JEAN-MARC BOUJU
RINDERZUCHT, SUDAN Für die Dinkas, den grössten Stamm im südlichen Sudan, ist eine Rinderherde nicht nur eine Nahrungsquelle, sondern auch ihr ganzer Stolz und Ausdruck ihres Wohlstands. Der Stamm hütet die Rinder von der Morgen- bis zur Abenddämmerung, führt sie zum Trinken, verbrennt Mist, um die Moskitos zu verjagen, säubert das Fell der Tiere mit Asche, um Zecken abzuhalten und legt sich schliesslich mit den Herden schlafen, um sie gegen Raubtiere zu schützen.
Unverheiratete Männer des Dinka-Stammes veranstalten einmal pro Jahr einen Wettstreit, falls genügend Milch vorhanden ist: dabei geht es darum, drei Monate lang möglichst viel Milch zu trinken, um möglichst dick zu werden. Auf diese Weise wollen sie die Frauen beeindrucken, indem sie demonstrieren, dass die Herde ihrer Familie gross genug ist, um zusätzliche Milch zu liefern.
Aufgrund des Bürgerkrieges im Sudan wurden die Herden jedoch dezimiert, und der Wettstreit findet in den meisten Dinka-Gebieten kaum noch statt. *Agentur: Associated Press*
SEITE 32: Ein Mädchen vom Stamm der Dinka beim Melken einer Kuh im Camp in der Nähe von Thiet, Sudan. Milch ist eines der Hauptnahrungsmittel der Dinka.
SEITE 33: Mayok Mayen, 25, richtet sich mit Hilfe eines Stocks wieder auf. Bei einem Wettbewerb in Piyiir, Sudan, bei dem es um die Wahl des fettesten männlichen Dinkas geht, war er auf die Knie gefallen. Die Dinkas glauben, dass Dickleibigkeit ein Zeichen von Reichtum ist und anziehend auf Frauen wirkt. ■ Tierarzt George Were, mit Streifen, nimmt einer Kuh in einem Rinder-Camp in Thiet, Sudan, Blut ab.

L'ÉLEVAGE DU BÉTAIL AU SOUDAN
Pour les Dinkas, la principale tribu qui peuple le sud du Soudan, un troupeau de bétail ne constitue pas seulement un moyen de subsistance, il est aussi l'expression de leur richesse et fait toute leur fierté. Les membres de la tribu gardent le bétail de l'aurore au crépuscule, le conduisent aux points d'eau, brûlent le fumier pour chasser les moustiques, nettoient le poil des animaux avec des cendres pour décourager les tiques et dorment auprès des bêtes pour les protéger des prédateurs.
Les hommes célibataires de la tribu organisent une fois par an une compétition, mais uniquement lorsque le lait «coule en abondance». En effet, pendant trois mois, il s'agit de boire du lait pour devenir aussi gros que possible et impressionner ainsi les femmes, en leur prouvant que le cheptel familial est assez important pour donner beaucoup de lait.
La guerre civile du Soudan ayant décimé les troupeaux, cette compétition est devenue rare dans le pays. *Agent: Associated Press*
PAGE 32: Fillette de la tribu des Dinkas en train de traire une vache dans un pré près de Thiet, au Soudan. Le lait est le principal aliment des Dinkas.
PAGE 33: Mayok Mayen, 25 ans, se redresse en s'aidant de sa canne. Il était tombé à genoux lors d'un concours à Piyiir, au Soudan, à l'occasion de l'élection du plus gros Dinka. Pour les Dinkas, être gros est un signe de richesse et un atout pour séduire les femmes. ■ Le vétérinaire George Were prenant le sang d'une vache dans un camp de bétail à Thiet, au Soudan.

BESCHNEIDUNG VON FRAUEN Die Weltgesundheitsbehörde schätzt, dass bis zu 120 Millionen heute lebender Frauen in mindestens drei Dutzend Ländern beschnitten worden sind. Gemäss UNICEF sind die meisten Mädchen zwi-schen vier und zehn Jahre alt, wenn dieser Ritus vollzogen wird. Die sechs Jahre alte Hudan Mohammed

Ali ist keine Ausnahme. Mit Hilfe von Hudans Grossmutter und Schwester bemüht sich eine Gudniin, eine traditionelle Beschneiderin, die Genitalien des sich windenden und schreienden Mädchens zu beschneiden. Zuvor hatte Hudan um diese Prozedur gebeten, um es den anderen Mädchen gleichzutun und von der Gesellschaft akzeptiert zu werden. In den Ländern Afrikas, des Mittleren Ostens und Südostasiens, wo diese Prozedur noch üblich ist, gelten Frauen, die nicht beschnitten wurden, als weniger begehrenswert: Eine beschnittene Jungfrau bringt einen höheren Brautpreis oder eine grössere Mitgift. Diese Prozedur, die in den westlichen Ländern als Verstümmelung, Kindesmissbrauch und Verletzung der Menschenrechte gilt, führt jedoch oft zu Infektionen, schweren Geburten und sogar zum Tod. *Agentur: Associated Press*

SEITE 34: Halimo Mohamoud Obahleh, eine Beschneiderin, begleitet eine noch gähnende Hudan Mohammed Ali. Sie wird an diesem frühen Morgen Hudan in ihrem Haus in Hargeisa, Somalia, beschneiden. Hudans Grossmutter ist links zu sehen. ■ Hudan Mohammed Ali, sechs Jahre alt, schreit vor Schmerzen während der Beschneidung in Hargeisa, Somalia. Ihre 18jährige Schwester Farhyia Mohammed Ali hält sie fest. ■ Verwandte von Hudan Mohammed Ali kommen zusammen, um Hudan nach Vollendung der Beschneidung zu sehen. ■ Zwei Mädchen aus der Nachbarschaft, angezogen von Hudans Schreien, versuchen durch die Tür des Hauses einen Blick zu erhaschen.

SEITE 35: Beschneiderin Halimo Mohamoud Obahleh beim Waschen ihrer Hände nach der Beschneidung. Links Hudans Grossmutter, Fatuma Ismail Mohamoud, die bei der Operation assistierte. ■ Hudan mit zusammengebundenen Beinen nach der Beschneidung in Hargeisa, Somalia. Sie wird mindestens eine Woche lang so liegen bleiben und nur klebrigen Reis zu essen bekommen, damit sie nicht uriniert.

L'EXCISION DES FEMMES L'Organisation mondiale de la santé estime que quelque 120 millions de femmes vivant dans une quarantaine de pays ont été excisées. Selon l'UNICEF, la plupart des fillettes ont entre quatre et dix ans lorsqu'elles subissent ce rite ancestral. Agée de six ans, le petite Hudan Mohammed Ali ne fait pas figure d'exception. Assistée par la grand-mère et la sœur d'Hudan, une *gudniin*, femme pratiquant l'ablation rituelle, s'efforce de couper tant bien que mal les parties génitales de Hudan qui crie et se tortille sous la douleur.

A l'origine, c'est Hudan elle-même qui a demandé à être excisée pour faire comme les autres et être acceptée par la société. En Afrique, au Moyen-Orient et dans le Sud-Est asiatique, régions où cette pratique demeure courante, les femmes non excisées sont considérées comme moins désirables: la dot d'une vierge excisée est, par exemple, beaucoup plus élevée. Assimilée à une mutilation dans les pays occidentaux, à une violation des droits de l'homme et à un abus des enfants, cette pratique entraîne souvent des infections, des complications à la naissance d'un enfant et, parfois, la mort. *Agent: Associated Press*

PAGE 34: Halimo Mohamoud Obahleh accompagnant la petite Hudan Mohammed Ali encore tout ensommeillée dans sa maison à Hargeisa, Somalie, pour procéder à son excision. La grand-mère de Hudan se tient à gauche. ■ Hudan Mohammed Ali, six ans, crie de douleur pendant l'excision à Hargeisa, Somalie. Sa sœur de 18 ans, Farhyia Mohammed Ali, la tient pour qu'elle ne bouge pas. ■ Les parents de Hudan Mohammed Ali se rassemblent pour voir Hudan après son excision. ■ Deux fillettes du voisinage, intriguées par les cris de Hudan, tentent de regarder à l'intérieur de la maison.

PAGE 35: Halimo Mohamoud Obahleh se lavant les mains après l'excision. A gauche, la grand-mère de Hudan, Fatuma Ismail Mohamoud, qui assistait à l'opération. ■ Hudan, les jambes liées, après son excision à Hargeisa, en Somalie. Elle devra garder cette position pendant au moins une semaine et ne recevra, pour toute nourriture, que du riz gluant pour qu'elle n'urine pas.

DAVID BURNETT

EINEN TRAUM VOR AUGEN: TRAINING FÜR DIE OLYMPIADE 1996 In den 12 Monaten vor der Olympiade in Atlanta photographierte David Burnett zahlreiche Veranstaltungen, an denen sich Olympia-Hoffnungen zu bewähren hatten. Dabei ging es ihm um die emotionale Anspannung bei diesen Vorbereitungswettkämpfen für die Spiele.

Sein Photo-Essay wurde in einer Olympia-Sonderausgabe der Zeitschrift *Time* zusammen mit Zitaten ehemaliger Olympia-Sieger veröffentlicht. *Agent: Contact Press Images/Publikation: Time, Sonderausgabe Sommer 1996, New York*

SEITEN 36-37: Colorado Springs, Olympisches Festival von Colorado. Ein Team von Radrennfahrern bereitet sich auf des Rennen im Velodrome vor.

SEITE 38: Philadelphia, Pennsylvania: Die 'Penn-Spiele'. Der amerikanische Rekordhalter Lawrence Johnson überspringt 19 Feet und gewinnt damit den Stabhochsprung. ■ Colorado Springs, olympisches Festival von Colorado. Gewichtsheberin der Schwergewichtsklasse bei der Vorbereitung.

SEITE 39: Phoenix, Arizona: Ein Schwimmkampf. Ein einsamer Freestyle-Schwimmer auf seiner Bahn im Pool. ■ Philadelphia, Pennsylvania: Penn-Staffelläufe. Die Übergabe der Staffel beim 4x100m-Staffellauf der Männer.

SEITE 40: Philadelphia, Pennsylvania: Penn-Staffelläufe. Der Staffel-Hürdenlauf der Männer.

SEITE 41: Ft. Lauderdale, Florida. Internationaler Tauchwettbewerb. Der Taucher Dean Panaro taucht vom Fünfmeter-Sprungbrett aus. ■ Atlanta, Georgia, Olympische Spiele. Photographen und Läuferinnen vor dem Start zur 4x400m-Staffel der Frauen. ■ Ft. Lauderdale, Florida. Internationale Tauch-wettbewerbe. Männlicher Taucher zieht beim Verlassen des 10m-Sprungbretts die Beine an. ■ Phoenix, Arizona: Ein Schwimm-Wettbewerb. Das Freestyle-Schwimmen der Männer. ■ Ft. Lauderdale, Florida. Internationaler Tauchwettbewerb: Männlicher Taucher beim Sprung vom 10m-Brett. ■ Colorado Springs, Colorado: Olympisches Festival. Das Hammerwerfen der Männer.

A LA POURSUITE DU RÊVE: LES JEUX OLYMPIQUES DE 1996 Durant les 12 mois précédant les Jeux olympiques d'Atlanta, David Burnett a suivi la préparation des athlètes désireux de participer à cet événement. Son objectif était de transmettre la tension émotionnelle des sportifs lors de ces épreuves décisives.

Son essai photographique, complété par des citations d'anciens médaillés des Jeux, a été publié dans une édition spéciale du magazine *Time. Agent: Contact Press Images/Publication: Time, édition spéciale été 1996, New York*

PAGES 36-37: Colorado Springs, festival olympique du Colorado. Equipe de cyclistes se préparant à la course dans le vélodrome.

PAGE 38: Philadelphia, Pennsylvania: les 'Jeux Penn'. L'Américain Lawrence Johnson, détenteur du record, saute 19 pieds, remportant ainsi l'épreuve du saut à la perche. ■ Colorado Springs, festival olympique du Colorado. Haltérophile de la catégorie poids-lourds lors de la préparation. ■

PAGE 39: Phoenix, Arizona: épreuve de nage libre. Nageur seul dans son couloir. ■ Philadelphia, Pennsylvanie: relais 4x100m hommes. Le passage du témoin.

PAGE 40: Philadelphia, Pennsylvanie: relais. Course de haies hommes.

PAGE 41: Ft. Lauderdale, Floride. Concours international de plongée. Dean Panaro plongeant du tremplin des cinq mètres. ■ Atlanta, Géorgie, Jeux olympiques. Photographes et athlètes avant le départ d'une course de relais 4x400m femmes. ■ Ft. Lauderdale, Floride. Concours international de plongée. Plongeur repliant ses jambes en sautant du tremplin des 10m. ■ Phoenix, Arizona: épreuve de nage libre hommes. ■ Ft. Lauderdale, Floride. Concours international de plongée: homme plongeant du tremplin des 10m. ■ Colorado Springs, Colorado: festival olympique. Epreuve de lancer du marteau hommes.

DAVID BUTOW

TAGE UND NÄCHTE AM HOLLYWOOD BOULEVARD Der Hollywood Boulevard ist nach wie vor eine der grössten Touristenattraktionen in Los Angeles. Touristen aus aller Welt kommen in Bussen zum Mann's Chinese Theatre, um sich die Hand- und Fussabdrücke von Filmstars der Gegenwart und Vergangenheit anzusehen. Besucher beim Absuchen des "Walk of Fame" nach den Namen ihrer Lieblingsschauspieler oder Prominenter.

Andere suchen diese Strassen auf, um hier zu leben, zu arbeiten, zu betteln oder nur herumzuhängen. Ihre Träume sind einfacher: ein guter Job, eine nette Wohnung, ein Partner, mit dem man diese Dinge teilen kann. Eine andere Gruppe – Strassenartisten aller Art – sind hier in der Hoffnung, ihren grossen Durchbruch im Show-Geschäft zu schaffen. Für die meisten von ihnen sind die Chancen gleich gross wie die eines Touristen aus Des Moines, zu einem Lunch mit Mel Gibson zu kommen. Der Glanz Hollywoods ist heute so zweidimensional wie ein Plakat von Marylin Monroe. *Agentur: Saba Photo Agency*

SEITEN 42-43: Ein schäbiger Chevrolet aus den fünfziger Jahren – das Ende des kalifornischen Traums?

SEITE 44: Billboard-Werbung "Angeline", eine lebende Person, deren Beruf es zu sein scheint, ihre Cartoon-ähnliche Erscheinung zur Schau zu stellen. ■ Ein professioneller Imitator von Michael Jackson tanzt für Trinkgeld. ■ Ein Fahrer wartet neben seiner geparkten Limousine auf einen Kunden – daneben ein Wandbild von Charlie Chaplin. ■ Touristen werfen Schatten auf die Abdrücke bei Mann's Chinese Theater.

■ Touristen vor Mann's Chinese Theater bei dem Versuch, wie James Deans zu posieren. ■ Arbeiter auf dem Nachhauseweg. Sie sitzen oberhalb eines Plakates, das für eine Verfilmung von *Gullivers Reisen* wirbt.

SEITE 45: Arnold Schwarzenegger und seine Frau Maria Shriver sprechen mit Fernsehleuten vor der Premiere eines Films. ■ Die Menge versucht, einen Blick auf die Prominenten zu werfen, die zur Schwarzenegger-Premiere ein-treffen.

SEITE 45: Diese beiden jungen Männer führten zwei Mädchen in einen Club aus und mussten dann feststellen, dass sich die beiden mehr für einander inte-ressieren. ■ Viele Teenager kommen an Freitag- und Samstagabenden auf den Boulevard, in der Hoffnung, einen Partner fürs Herz zu finden.

SEITE 46-47: Der Hollywood Boulevard als Schaufenster der Massenkultur: Fast Food, Rock and Roll und Show-Geschäft. ■ Eine Frau beim Anzünden einer Zigarette in einer fast leeren Bar. ■ Wenn man keine Arbeit und keine Unterstützung von der Familie hat, ist das Auto manchmal die beste Unterkunft für die Nacht. ■ Oft führt die verzweifelte Lage der Obdachlosen zu Ärger mit der Polizei. ■ Hispanische Backfische gehen mit kleinen, piepsenden Geräten und in aufreizender Kleidung auf die Strasse, um die Aufmerksamkeit der jungen Männer auf sich zu ziehen. ■ Drogenmissbrauch ist in dieser Gegend keine Seltenheit. Hier spritzt ein Mann sein-er Freundin Rauschgift.

LES NUITS ET LES JOURNÉES DE HOLLYWOOD BOULEVARD Hollywood Boulevard reste l'une des attractions touristiques les plus prisées de Los Angeles. Des bus entiers de touristes venus du monde entier se dirigent en masse au Mann's Chinese Theatre pour aller contempler les empreintes que des stars du cinéma, aussi bien du passé que du présent, ont faites de leurs mains et de leurs pieds. Ces visiteurs scrutent le trottoir appelé le "Walk of Fame" (le trottoir de la gloire), à la recherche du nom de leurs acteurs favoris ou d'une autre célébrité et d'un peu de glamour ambiant.

D'autres viennent dans ces rues pour y vivre, y travailler, y mendier ou simplement pour y flâner sans but précis. Leurs rêves sont plus modestes: avoir un bon travail, un appartement sympathique et un partenaire avec qui partager ces choses. Un autre groupe de personnes, les artistes de rue de tous genres, sont ici parce qu'ils espèrent faire une carrière dans le showbiz. Pour la plupart d'entre eux, c'est mission impossible; comme si un touriste venu de sa campagne natale voulait aller déjeuner avec Mel Gibson! Le glamour ambiant du Hollywood de nos jours est aussi ambigu qu'un poster de Marylin Monroe. *Agent: Saba Photo Agency*

PAGES 42-43: Une Chevrolet des années 50 qui a perdu de son éclat - est-ce la fin du rêve californien?

PAGE 44: Panneau publicitaire «Angeline», une personne en chair et en os dont la pro-fession semble se résumer à montrer sa ressemblance avec un personnage de dessin animé. ■ Imitateur professionnel de Michael Jackson dansant pour gagner de l'argent. ■ Chauffeur attendant le client à côté de son véhicule près d'une peinture murale de Charlie Chaplin. ■ Touristes projetant des ombres sur des empreintes au Mann's Chinese Theater. ■ Touristes devant le Mann's Chinese Theater prenant des poses à la James Dean. ■ Travailleurs rentrant chez eux. Ils sont assis au-dessus d'une affiche promotionnelle pour un film basé sur *Les voyages de Gulliver*.

PAGE 45: Arnold Schwarzenegger et sa femme Maria Shriver parlant avec des gens de la télévision avant la première d'un film. ■ La foule essayant d'apercevoir les célébrités se rendant à la première du film de Schwarzenegger.

PAGE 45: Ces deux jeunes hommes ont invité leur compagne dans un club et cons-tatent, dépités, que les deux filles s'intéressent plus l'une à l'autre qu'à eux. ■ De nom-breux adolescents arpentent le boulevard les vendredi et samedi soir dans l'espoir de rencontrer l'âme sœur.

PAGE 46-47: Le Hollywood Boulevard, vitrine de la culture de masse: fast-food, rock'n roll et showbiz. ■ Femme allumant une cigarette dans un bar presque vide. ■ Lorsque l'on n'a pas de travail et aucun soutien familial, la voiture est parfois le meilleur endroit où passer la nuit. ■ Souvent, les sans-abri s'attirent des ennuis avec la police en raison de leur situation désespérée. ■ Adolescentes hispaniques se baladant en tenue légère avec des bips pour attirer l'attention des garçons. ■ Communauté touchée par la drogue. Un homme injecte de la drogue à son amie.

WILLIAM CAMPBELL

INDIAN SUMMER Im Sommer des Jahres 1996 verbrachte der Photograph William Campbell sieben Wochen mit 40 Teenagern und einer Gruppe von Beratern vom Stamm der Sioux vom Chayenne River. Es handelte sich um ein "Healthy Nations"-Projekt, Wolakota Yukini Wicoti, ein Zeltlager, dessen Ziel es war, Geist und Kultur des Lakota-Volkes aufleben zu lassen.

Das Camp wurde von und für die Ureinwohner Amerikas organisiert, und zwar mit Unterstützung von Menschen aus der Region. Viele der Lakota-Teenager waren Kinder aus Alkoholikerfamilien, aus Foster-Familien oder aus Gangs, die sich in den Reservaten bilden. Es ging darum, den Teufelskreis von Missbrauch und Hoffnungslosigkeit zu durchbrechen, indem man ihnen zeigte, wie ihre Vorfahren gelebt haben – die Jugendlichen schliefen wie sie in Wigwams, ritten auf Pferden und lernten ihre ehemals verbotene Sprache, ihre Lieder und Bräuche. *Publikation:* Time, *New York*

SEITEN 48-49: Der Tag geht friedlich zu Ende für die Kinder der Seventh Generation im Healthy Nations Camp in Blackfoot, Süddakota. Hier lernen die Camper, dass ein jeder es in der Hand hat, was die Zukunft dem Stamm bringen wird. Die Traditionen müssen gepflegt, die Erde geachtet werden, nicht nur zum eigenen Wohl, sondern dem der kommenden sieben Generationen.

SEITE 50: Jugendliche der Lakota bauen ihr eigenes Tipi auf. ■ Chad White Face, elf Jahre, schützt sich mit warmen Decken gegen die Kälte bei Tagesanbruch.

SEITE 51: Die Kinder der Sioux im Healthy Nations Camp im Indianerreservat Cheyenne River lernen, ihre Tipis, in denen sie den Sommer über wohnen werden, auf traditionelle Weise zu errichten. ■ Alana Marshall, 20 Jahre, mit ihrem Pferd Coda. ■ Logan Stengal, 16 Jahre, zielt mit Pfeil und Bogen. ■ Leslie Horn, 15 Jahre, sitzt zum ersten Mal auf einem Pferd. Das ohne Arme auf die Welt gekommene Mädchen aus dem Camp benutzt spezielle, um die Schultern gelegte Zügel und seine Schenkel, um das Pferd zu lenken. ■ Die Adlerfeder-Zeremonie bei einem Pow-Wow, dem die Kinder im Sommer beiwohnten. ■ Alana Marshall lernt, Büffelleder auf traditionelle Weise zu verarbeiten. Die Camper erfahren, wie es die Vorväter anstellten, alle Teile des Bisons zu verwenden. ■ Ein Ältester der Healthy Nations mit Salbei und einem Grasbüschel, wie sie einst bei Büffeljagd-Zeremonien verwendet wurden. ■ David Rocky Mountain, 13 Jahre, wacht über das Healthy Nations Camp.

L'ÉTÉ INDIEN Durant l'été 1996, le photographe William Campbell a passé sept semaines avec 40 adolescents et un groupe de conseillers de la tribu des Sioux de la rivière Cheyenne. Dans le cadre d'un projet consacré au bien-être des populations de la nation et intitulé Wolakota Yukini Wicoti, un camp a été mis sur pied pour faire revivre l'esprit et la culture de la tribu lakota.

Le camp a été organisé pour et par les premiers habitants de l'Amérique avec l'appui de la population locale. De nombreux adolescents lakotas viennent de familles d'al-cooliques ou adoptives ou encore de gangs, qui se sont constitués dans les réserves. Il s'agissait de briser ce cercle vicieux fait d'abus et de dé-sespoir, en montrant aux jeunes comment leurs ancêtres vivaient autrefois. Les adolescents ont dormi dans des tipis, sont montés à cheval et ont découvert leur langue, autrefois interdite, leurs chants et leurs tradi-tions. *Publication:* Time, *New York*

PAGES 48-49: Voici une paisible journée qui se termine pour les enfants de la Seventh Generation du Healthy Nations Camp de Blackfoot, Dakota du Sud. On apprend aux campeurs qu'ils détiennent la clé du futur de leur tribu. Ils doivent respecter les tradi-tions et la terre, pas seulement pour leur salut mais aussi pour celui des sept généra-tions à venir.

PAGE 50: Les adolescents lakotas montent leur propre tipi. ■ Chad White Face, 11 ans, s'emmitoufle pour se protéger contre le froid du petit matin.

PAGE 51: Des enfants sioux du Healthy Nations Camp dans la réserve indienne de Cheyenne River apprennent à monter les tipis dans lesquels ils passeront tout l'été. ■ Alana Marshall, 20 ans, avec le cheval qu'elle a adopté, Coda. ■ Logan Stengal, 16 ans, pointe un arc et une flèche. ■ Leslie Horn, 15 ans, apprend à monter à cheval pour la première fois. Leslie est une campeuse qui est née sans bras. Elle utilise des rênes spéciales enroulées autour des épaules pour contrôler le cheval et ses jambes pour le guider. ■ Un bouquet de plumes d'aigle utilisé durant un rassemblement indien auquel ont participé les enfants cet été. ■ Alana Marshall apprend comment travailler la peau de bison. On enseigne aux campeurs comment utiliser chacune des parties du bison comme le faisaient leurs ancêtres. ■ Un des anciens du Healthy Nations Camp tient dans sa main de la sauge et une poignée de glycérie utilisées lors des rituels célébrés après avoir abattu un buffle. ■ David Rocky Mountain, 13 ans, regarde par-dessus le Healthy Nations Campage

GIGI COHEN

HONGKONGS GRENZE ZU CHINA Am 30. Juni 1997 um Mitternacht wird Grossbritannien Hongkong offiziell an China zurückgegeben haben. Die 43km lange Grenze, die zwei sehr unterschiedliche Ideologien trennt – Osten und Westen, Kapitalismus und Kommunismus –, wird sich zweifellos verändern.

Gegenwärtig bewacht die Royal Hong Kong Border Police die Grenze zusammen mit den britischen Gurkha-Truppen aus Nepal. Ihre Hauptaufgabe be-steht im Aufgreifen von illegalen Einwanderern und in deren Rückführung nach China. Die Polizei befürchtet, dass die Menschen in China glauben, nach der Übergabe frei nach Hongkong einwandern zu dürfen. Tatsache ist aber, dass die Grenze bestehen bleibt, und dass die meisten nach wie vor eine Sondergenehmigung für die Einreise benötigen. Tausende von Geschäftsleuten und Touristen dürfen die Grenze täglich passieren. Eine Tages-Arbeitserlaubnis wird auch denjenigen Chinesen erteilt, die nachweisbar Ackerland an der Grenze besessen haben.

Auf der chinesischen Seite spiegelt die Special Economic Zone die kapitalisti-schen Ambitionen Hongkongs wider. Die Skyline verändert sich ständig, neue Fabriken werden gebaut, und Bettler säumen die Strassen. "Windows on the World", Chinas erste grosse Touristen-Attraktion, befindet sich an der Grenze. Sie zeigt Nachbildungen von Monumenten, z.B. von der London Bridge, den ägyptischen Pyramiden und der Freiheitsstatue. China hat die Welt zu sich geholt, als wolle es seinen Bürgern sagen, dass sie ihr Land nicht zu verlassen brauchen. *Agentur: Network Photographers, Ltd./Saba Photo Agency*

PAGE 52: Illegale Immigrantin mit ihrem Neugeborenen in einem Spital in Hongkong. Sie erwartet ihre Rückführung nach China.

PAGE 53: Ein behinderter, illegaler Immigrant wird von dem Polizisten auf den Lastwagen gewiesen, dessen Ziel China ist. ∎ Ein illegaler Immigrant, der von der Polizei beim Versuch, heimlich die Grenze zurück nach China zu überqueren, festgenommen wurde. ∎ Illegaler Immigrant bei der Befragung. Er wurde an der Grenze wegen Waffenbesitzes festgenommen. ∎ Illegaler Immigrant in Ausschaffungszelle. Er wurde bei dem Versuch, die Grenze zurück nach China heimlich zu überqueren, festgenommen. ∎ Die 26jährige Wang Xiao Mei in ihrem Wohnheim nach ihrem Arbeitstag in einer Handtaschenfabrik. ∎ Grenzübergangsstelle.

PAGE 54: Die Grenzpolizei Hongkongs patrouilliert an der Grenze zwischen Hongkong und China.

PAGE 55: Ein junger Student beim Passieren der Grenze nach Hongkong am Grenzübergang der Lo Fo-Brücke.

HONGKONG OU LE SPECTRE DE LA CHINE Le 30 juin 1997 à minuit, la Grande-Bretagne rendra officiellement Hongkong à la Chine. La frontière de quelque 40 kilomètres qui sépare ces deux bastions aux idéologies diamétralement opposées – l'Est contre l'Ouest, le capitalisme contre le communisme – va sans doute beaucoup changer.

Actuellement, la Royal Hong Kong Border Police, épaulée par les troupes britan-niques Gurkha du Népal, surveille la frontière. Leur tâche principale consiste à arrêter les immigrés illégaux et à les rapatrier en Chine. La police craint que les Chinois pensent qu'ils pourront aller librement à Hongkong, une fois que l'île aura changé de mains. Dans la réalité, les frontières demeurent infranchissables à moins d'être en possession d'une autorisation spéciale.

Pourtant, des milliers d'hommes d'affaires et de touristes sont habilités à franchir la frontière au quotidien. Des permis de travail d'un jour sont également délivrés aux Chinois qui possèdent des terres à la frontière.

Du côté chinois, la zone économique reflète les ambitions capitalistes de Hongkong. Le paysage change en permanence de visage, les fabriques se multiplient, et les men-diants prennent les rues d'assaut. «Windows of the World», la première attraction pour touristes made in China se trouve à la frontière et présente des reproductions de mon-uments comme le London Bridge, les pyramides d'Egypte ou la statue de la Liberté. La Chine a fait entrer le monde à l'intérieur de ses frontières pour montrer à ses habi-tants qu'il n'est pas nécessaire de quitter le pays. *Agent: Network Photographers, Ltd./Saba Photo Agency*

PAGE 52: Immigrée illégale et son bébé dans un hôpital de Hongkong. La jeune femme sera refoulée en Chine.

PAGE 53: Policier conduisant un immigré illégal handicapé vers un camion qui le ramèn-era en Chine. ∎ Immigré illégal arrêté par la police alors qu'il tentait de passer la fron-tière pour rentrer en Chine. ∎ Immigré illégal lors d'un interrogatoire. L'homme a été arrêté à la frontière pour trafic d'armes. ∎ Immigré illégal en garde à vue. L'homme a été arrêté par la police alors qu'il tentait de passer la frontière pour rentrer en Chine. ∎ Wang Xiao Mei, 26 ans, dans son home après une journée de travail dans une fabrique de sacs à main. ∎ Poste-frontière.

PAGE 54: La police des frontières de Hongkong patrouillant le long de la frontière d'une quarantaine de kilomètres entre Hongkong et la Chine.

PAGE 55: Jeune étudiant passant la frontière de Hongkong au poste du pont Lo Fo.

C. TAYLOR CROTHERS

HELL WEEK Während der Aufnahmewoche der Studentenverbindungen an den amerikanischen Universitäten kommen manche Studenten spät oder überhaupt nicht zu den Vorlesungen. Stattdessen versuchen sie, die Aufnahmebedingungen zu bestehen. Sie marschieren schweigend zu geheimen Treffen. Sie lernen das griechi-sche Alphabet rückwärts aufsagen. Sie tauchen in Mülltonnen von Shopping-Centern auf, mit verbundenen Augen und wie die Natur sie schuf. Sie sehnen sich danach, dazu zu gehören.

Die Schindereien, die zur Aufnahme gehören, ereignen sich auf fast jedem Campus jeweils im Herbst, und jeden Herbst geht irgendwo etwas schief, es kommt zu ern-sthaften Verletzungen, manche mit tödlichem Ausgang. Die Krankenstationen auf dem Campus und die Notärzte verfluchen die Jahreszeit, in der nackte Verbindungskandidaten gefesselt an Bäumen stehen, in Kofferräumen von Autos eingeschlossen sind, in Flüsse geworfen oder durch brennendes Benzin gejagt wer-den.

Einige der Kandidaten geben während der sogenannten *Hell Week* auf, andere beschliessen, sich ihre Freunde nicht zu erkaufen. Viele von denen, die bleiben, glauben ihr Leben lang an die mystischen Bindungen der Brüderschaft. «Die Schindereien sind sehr aufschlussreich, was die men sch-liche Natur angeht», erzählte mir ein Leiter der Aufnahmeprozedur: «Die nettesten, höflichsten Leute und eifrigsten Kirchgänger erweisen sich als gemein und böse – und grausam, wenn man ihnen ein bisschen Macht gibt.» *Publikation:* The New York Times Magazine Textauszug aus einem begleitenden Artikel von Anne Matthews

PAGE 56: Geheimsitzung. Ein Student, der einer Verbindung beitreten möchte, wartet in einem Raum bei Kerzenlicht, um – wie er glaubt – mit einem geheimen Verbindungssymbol gebrandmarkt zu werden.

PAGE 57: «Big night» In einem spartanischen «Party-Raum» im Keller werden Bewerber offiziell in die Verbindung aufgenommen. Sie zerdrücken Bierdosen an ihrer Stirn, werfen Bier gegen die Decke und rutschen die Treppen auf Strömen von Bier hinunter. Viele Bewerber enden knöcheltief in Bier. ∎ Anstehen. Zehn Wochen vor der Aufnahme in die Studentenschaften beginnt das Training für die 'Hell Week'. Jeder Bewerber erhält eine Nummer, einen Spitznamen und ein einziges T-Shirt, das er während der ganzen Zeit tragen muss - ohne es zu waschen. ∎ Mit verbundenen Augen und vollgespuckten T-Shirts werden die Überlebenden mit Melasse über-gossen und dann fortgeführt. Geschützt vor den Blicken anderer, urinierten Verbindungsstudenten sorgfältig auf jeden neuen Bruder. ∎ Köstlichkeiten. Den Kopf mit einem Kissen verdeckt, die Armbeugen nach 30-minütigem Sitzen noch immer voller Peanut-Butter und Traubengelee, wartet ein Kandidat, bis die Reihe an ihm ist. Zwei Scheiben Weissbrot machen die Runde unter den Kandidaten: jeder wischt seine schweissnassen Unterarme an dem Brot ab, und danach essen alle davon. ∎ Ausdauer. Im Dunkeln, ausserhalb des Campus, halten sich die ihres Schlafes beraubten Bewerber an den Händen fest, während ihre zukünftigen Brüder ver-suchen, die Menschenkette zu durchbrechen. ∎ Kameradschaft. Mehlbedeckt und zu betrunken, um sich auf den Beinen zu halten, lassen die Bewerber der Verbindung eine letzte Tortur über sich ergehen. Ein Bewerber fehlt: da er sich nicht übergeben konnte, hatte er eine akute Alkoholvergiftung und musste sofort in die Notaufnahme des Spitals, wo man ihm den Magen auspumpte.

LA DURE LOI DU BIZUTAGE Durant la semaine d'essai précédant l'entrée dans une con-frérie d'étudiants américains, la plupart des nouveaux étudiants arrivent très en retard aux cours magistraux ou ne les suivent pas du tout. En lieu et place, ils préfèrent s'en-traîner aux épreuves traditionnelles du bizutage. Ils se rendent d'un pas lent à des ren-contres secrètes, apprennent par cœur l'alphabet grec à l'envers ou se promènent tout nus, les yeux bandés, dans des centres commerciaux. Ils font tout et n'importe quoi pour décrocher leur ticket d'entrée avant convoite.

Le bizutage a lieu en automne sur presque chaque campus et, chaque année, on assiste à de nouveaux incidents: des jeunes se blessent, parfois mortellement. Les infirmeries et les urgences maudissent cette période de l'année, où l'on peut voir des candidats nus comme des vers attachés aux arbres, enfermés dans des coffres de voiture, jetés dans des rivières ou prenant leurs jambes à leur cou devant la menace d'être brûlés...

Durant la *Hell Week* (semaine infernale), certains étudiants baissent les bras, refusant d'acheter ainsi leurs amis. Les «survivants» croient une vie entière aux liens mystiques et sacrés de la fraternité. Le bizutage est très révélateur de la nature humaine. Un recteur m'a raconté que «les gens les plus croyants, les plus polis et les plus aimables deviennent très vite des brutes méchantes, impitoyables et extrêmement cruelles dès

qu'on leur donne le goût du pouvoir.» *Publisher:* The New York Times Magazine
Extrait de l'article d'Anne Matthews accompagnant les photos

SEITE 56: Séance de spiritisme. Dans une pièce éclairée aux bougies, un étudiant tente d'entrer en communication avec les esprits pour être stigmatisé par un symbole de fraternité secret.

SEITE 57: «Big night». Dans un endroit spartiate aménagé dans une cave, les nouveaux membres font acte d'allégeance en écrasant des canettes de bière sur leur front, en jetant de la bière au plafond et en glissant dans les escaliers dans des flots de bière. La plupart de ces convives finissent la soirée en pataugeant dans la bière jusqu'aux chevilles. ▪ En ligne. L'entraînement pour la «Semaine infernale» commence deux mois et demi avant le bizutage. Chaque candidat reçoit un numéro, un surnom et un seul tee-shirt qu'il doit porter tout le temps, avec interdiction de le laver. ▪ Les yeux bandés, dans un tee-shirt couvert de vomissures, les survivants sont arrosés de mélasse et emmenés. Protégés du regard des autres, les meneurs de la cérémonie urinent avec soin sur chaque nouveau frère. ▪ Délicatesses. La tête dans un coussin, les aisselles encore pleines de beurre de cacahuète et de gelée de raisin, un candidat attend son tour. Deux tranches de pain font le tour des candidats: chacun doit frotter le pain sous ses aisselles trempées de sueur, puis tous les bizuths sont sommés d'en manger un bout. ▪ Endurance. Dans l'obscurité, hors du campus, les bizuths tirés de leur sommeil se tiennent par la main, tandis que leurs futurs frères tentent de briser cette chaîne humaine. «Il est de notre devoir d'infliger la souffrance», explique un étudiant de seconde année. ▪ Camaraderie. Couverts de farine et trop ivres pour tenir sur leurs jambes, les bizuths subissent une dernière épreuve. Un candidat est absent: incapable de vomir, intoxiqué par l'alcool, il a dû être transporté d'urgence à l'hôpital pour un lavage d'estomac.

D. NORMAN DIAZ

HAUSSCHLACHTUNGEN Jahrhunderte lang haben sich die Menschen selbst mit Fleisch versorgt, ohne Hightech-Geräte, Tiefkühlung, Hormone oder mechanische Werkzeuge. Diese Art der Nahrungsbeschaffung bedeutet weniger Verschwendung von Ressourcen, glücklichere und gesündere Tiere und Menschen und, wenn man daran gewöhnt ist, auch besser schmeckendes Fleisch.

Diese Aufnahmen sollen zeigen, wie selbst grossgezogene Nutztiere geschlachtet werden, ein Handwerk, das bald verloren gehen wird.

Die meisten Amerikaner machen sich überhaupt keinen Begriff mehr von der Verbindung zwischen Schweinen und Kühen auf dem Bauernhof und dem Braten, den sie im Supermarkt nebenan kaufen. Mit Hausschlachtungen sind nur noch die älteren Generationen vertraut oder Immigranten aus jüngerer Zeit, die noch das Können und die Motivation zu diesem langwierigen Prozess besitzen. In einigen wenigen Gemeinden ist das Schlachten noch immer ein Ereignis für Menschen jeden Alters.

SEITE 58: Totes Schwein mit durchschnittener Kehle.

SEITE 59: Das Schwein wird abgeschabt, um Haare zu entfernen. ▪ Häutung und Säuberung des toten Schweins. ▪ Entfernen der Eingeweide und Organe. ▪ Beim Plaudern, während das Fleisch kocht. ▪ Zerlegen des Tiers. ▪ Beim Kochen und Plaudern in der Küche.

ABATTAGE À LA FERME Durant des siècles, l'homme s'est approvisionné en viande sans recourir à des installations high-tech, à la réfrigération, aux hormones ou encore à des outils mécaniques. Grâce aux méthodes traditionnelles, moins de ressources sont gaspillées, les animaux et les hommes sont plus heureux et en meilleure santé, et une fois qu'on s'y est habitué, le goût de la viande gagne en saveur.

L'objectif de ces photographies est d'illustrer comment des animaux élevés à la ferme sont abattus, une tradition qui se perd de plus en plus.

La plupart des Américains ne font aucun lien entre les cochons et les vaches élevés à la ferme et le rôti qu'ils achètent dans le supermarché du coin. Seules les anciennes générations ou les nouveaux immigrants s'occupent encore d'abattre les animaux, car ils détiennent, au-delà de leur motivation personnelle, le savoir-faire nécessaire. Dans certaines communes, l'abattage constitue encore un événement pour la population, tous âges confondus.

PAGE 58: Cochon égorgé.

PAGE 59: Drayage. ▪ Nettoyage de la carcasse. ▪ Ablation des intestins et des organes. ▪ Bavardage pendant que la viande rôtit. ▪ Dépeçage. ▪ Bavardage dans la cuisine.

THOMAS ERNSTING

BERBER IN FRANKFURT Mitten in der City von Frankfurt, in Sichtweite der Bankhochhäuser, lebt seit 1988 eine Gruppe von Berbern. Neben der Untermainbrücke haben sie um eine Parkbank am Mainufer eine kleine Holzhütte gebaut, für die es sogar mit der Stadtverwaltung einen Duldungsvertrag gibt. Dort - und unter dem Brückenbogen - leben sie das ganze Jahr hindurch in einer mehr oder weniger festgefügten Hierarchie, in der jeder seine Aufgaben hat wie Betteln, Einkaufen, Kochen oder Abwaschen. Im Winter finden sich dort aufgrund der Kälte immer mehr Obdachlose ein, die dann von der Gruppe aufgenommen oder fortgeschickt werden. Im Sommer, sobald es warm wird, bleiben nur wenige dort, die meisten gehen weg, um dann an den ersten kalten Novembertagen teilweise wieder zurückzukehren.

Sie betteln abends oder nachts an angestammten Plätzen im Frankfurter Rotlichtmilieu, an die sich kein anderer Bettler setzen darf, und bekommen im Winter in wenigen Stunden mehrere hundert Mark, im Sommer jedoch meist nur 50-100 DM pro Sitzung. Not leidet keiner von ihnen, da sie ausser dem erbettelten Geld noch Sozialhilfe bekommen. Das Geld kommt grossteils in einen gemeinsamen Topf, aus dem das Essen, Trinken, Tabak und sonstiges bezahlt wird.

Die Bretterbude von etwa 10 Quadratmetern, in der sich oft ebensoviele Personen drängeln, hat Stromanschluss und daher Kühlschrank, Heizofen, Farbfernseher und Videorecorder. Drei bis vier Berber schlafen in der Hütte, die anderen auf Matratzen unter der Brücke, auch in den eisigen Winternächten.

Und eines Tages waren sie alle weg, und die Hütte wurde abgerissen. Nur noch die Parkbank, mit der alles angefangen hat, stand für müde Spaziergänger dort.

SEITE 60: Weihnachten steht vor der Tür, und es ist schon seit einigen Jahren Tradition in der Hütte, dass dort ein buntgeschmückter Weihnachtsbaum aufgestellt wird. Viele Passanten schenken in dieser Zeit den Obdachlosen Geld oder Schnaps, Lebensmittel oder Kleidung. ▪ Karl-Heinz und Manfred auf der Untermainbrücke. Auf dem Weg zum Betteln zünden sie sich eine Zigarette gegen die Kälte an. Neben dieser Brücke, in unmittelbarer Nachbarschaft zu den Banken, haben sie sich um eine Parkbank eine Bretterbude gebaut. ▪ Wenn es warm genug ist, sitzen die Berber, wie sich die Obdachlosen selbst mit einigem Stolz nennen, den ganzen Tag unter der Brücke, wo sie sich um eine Feuerstelle Sofas und Sessel zusammengestellt haben. ▪ Jeder Berber der Gruppe hat eine Aufgabe. An diesem Abend muss Rolli das Geschirr spülen. Da es dazu in der Hütte zu eng ist, geht er unter einen Brückenbogen. Rolli ist als einziger der Erbauer der Bretterbude noch in der Gruppe. ▪ Hans hatte vor wenigen Monaten seine Arbeit verloren und lebt seitdem auf der Strasse. An diesem Tag hatte er 4,000 DM Arbeitslosengeld bekommen, die ihm sofort gestohlen wurden, da er in der Frankfurter Rauschgiftszene mit dem Gald prahlte. ▪ Eugen hat als einziger in der Gruppe ständig eine Freundin - Michaela -, und als Chef der Berber steht ihm ein kleiner abgetrennter Raum in zu dem er mit seiner Freundin schläft. ▪ Rolli schläft auch tagsüber mit seinem Hund in Decken eingewickelt in der Hütte. ▪ Die meisten Obdachlosen dieser Gruppe müssen auch im Winter aus Platzgründen ungeschützt unter der Brücke schlafen.

SEITE 61: Die Parkbank, mit der alles angefangen hatte, stand nur noch für müde Spaziergänger dort.

COMMUNAUTÉ DE SANS-ABRI, FRANCFORT, ALLEGEMAGNE En 1988, un groupe de sans-abri s'était installé au cœur de Francfort, à une centaine de mètres des gratte-ciel occupés par les grandes banques de la place. Sur la berge du Main, ils avaient construit à côté d'un pont, avec l'autorisation officielle de la municipalité, une petite baraque de bois autour d'un banc. Ils ne possédaient toutefois pas de copie de ce document, les autorités craignant qu'ils utilisent le cachet officiel pour falsifier des papiers.

Tout au long de l'année, les sans-abri vivaient tantôt dans leur baraque tantôt sous le pont. Ils avaient établi une sorte de hiérarchie qui régissait la vie de la communauté. Chacun avait une tâche bien précise: mendier, faire les commissions ou la vaisselle, cuisiner, etc. En hiver, la rigueur du froid incitait d'autres sans-abri à les rejoindre, qui étaient acceptés ou rejetés selon les cas. Dès le retour des beaux jours, certains sans-abri quittaient cet endroit pour y retourner en novembre. Selon la saison, quatre à douze personnes résidaient sur les rives du Main.

Le soir venu, les sans-abri partaient mendier dans le quartier chaud de Francfort, à des endroits bien précis, leur chasse gardée en quelque sorte. En hiver, ils se faisaient plusieurs centaines de marks en quelques heures tandis qu'en été, une soirée leur rapportait entre 50 et 100 marks. La générosité des passants suivait le rythme des saisons. Aucun d'entre eux n'était vraiment dans le besoin, car ils recevaient de l'argent des services sociaux. La plupart de cet argent allait dans une bourse commune avec laquelle ils payaient la nourriture, les boissons, le tabac, etc.

Habité par une dizaine de personnes, leur cabanon était équipé d'un réfrigérateur,

d'un poêle, d'une TV couleur et d'un magnétoscope. Eugen, le chef du groupe, vivait avec son amie dans une petite pièce séparée. Son rang lui donnait droit à une TV couleur et à un magnétoscope personnels. Trois à quatre sans-abri dormaient dans le cabanon, les autres passaient la nuit sous le pont et ce, par n'importe quel temps.

Et un jour, ils ont tous disparu. Le cabanon a été détruit. Seul le banc où tout a commencé est encore là...

PAGE 60: A l'approche de Noël. La petite communauté de sans-abri avait pour habitude de décorer un sapin de Noël dans le cabanon. A cette époque de l'année, beaucoup de personnes donnent de l'argent, des spiritueux, de la nourriture ou des vêtements aux sans-abri. ■ Karl-Heinz et Manfred sur un pont enjambant le Main. Sur le chemin pour aller mendier, ils s'allument une cigarette pour oublier le froid. A côté de ce pont, non loin des banques, ils avaient construit un cabanon autour d'un banc. ■ Quand il faisait assez chaud, les sans-abri (qui se nommaient fièrement les «Berbères») passaient leurs journées sous le pont où ils avaient installé des fauteuils et des chaises autour d'un foyer. ■ Chacun dans le groupe avait une tâche précise. Ce soir-là, Rolli devait faire la vaisselle. Le cabanon étant trop exigu, il décida d'accomplir sa tâche sous le pont. Parmi les sans-abri qui avaient construit le cabanon, Rolli était le dernier à faire encore partie du groupe. ■ Quelques mois auparavant, Hans avait perdu son travail et depuis il était à la rue. Ce jour-là, il avait reçu DM 4'000 du chômage, somme qui lui avait aussitôt été dérobée tandis qu'il faisait le fier avec son argent dans le quartier des toxicos. ■ Eugen était le seul membre du groupe à avoir une relation suivie. Il partageait la petite pièce qui lui était réservée dans le cabanon avec son amie Michaela. En tant que chef du groupe, il disposait de sa propre TV couleur et d'un magnétoscope. ■ Rolli et son chien enroulés dans des couvertures. ■ La plupart des sans-abri dormaient sous le pont, même en hiver.

PAGE 61: Le banc où tout a commencé. Aujourd'hui, seuls les promeneurs fatigués s'y arrêtent encore pour se reposer.

DAVID EULITT

DIE VERGESSENEN SPIELE Alle vier Jahre treffen sich hier die besten Athleten der Nation zu internatioanlen Wettkämpfen – Gelegenheit, ihr Können zu zeigen und Belohnung für Jahre des Trainings in Anonymität. Für die behinderten Athleten, die an den 10. Paralympics in Atlanta, Georgia, teilnahmen, fand die Veranstaltung nicht gerade im Rampenlicht der Weltöffentlichkeit statt. Zwei Wochen nach Beendigung der Olympischen Spiele in Atlanta wurden die Paralympics mit sehr viel weniger Fanfaren eröffnet. Die Eröffnungs- und die Abschlusszeremonien waren zwar ausverkauft, aber zu den Wettkämpfen selbst kamen nur wenige Tausend Zuschauer, während sich hier nur ein paar Wochen zuvor 80000 versammelt hatten.

Bei den Paralympics werden die Athleten nach der Art ihrer Behinderung eingestuft: Amputierte, Athleten in Rollstühlen, die Blinden und die mit zerebraler Lähmung. Nach den Wettkämpfen werden die Athleten einer Doping-Kontrolle unterzogen, genau wie die Teilnehmer der Olympiade.

Die wenigen Zuschauer wurden Zeugen erstaunlicher Leistungen. 255 Weltrekorde wurden an den 10 Wettkampftagen gebrochen. Die 3211 Athleten haben bewiesen, dass die olympische Idee der besten Amateur-Wettkämpfe tatsächlich in Atlanta verwirklicht wurde, allerdings zwei Wochen nachdem die meisten Zuschauer gegangen waren. *Publikation:* The Topeka Capital-Journal, *Kansas*

SEITE 62: Der US Radrennfahrer Dory Selinger in der Stone Mountain-Rennbahn auf dem Weg zu einem neuen Weltrekord der Behinderten-Radrennfahrer bei der Paralympiade in Atlanta. Selinger fährt mit einer Beinprothese.

SEITE 63: Der chinesische Hochspringer Bin Hou übersprang kopfvoran die 1,92 Meter-Latte im Olympia-Stadion, ein neuer Weltrekord in der Klasse der behinderten F42-44 Hochspringer.

SEITE 64: James Hall, Tischtennisspieler aus San Bernardino, Kalifornien, Mitglied des US-Teams, das bei der Eröffnungszeremonie der Paralympics in Atlanta von 65'000 Fans im Olympia-Stadion bejubelt wurde. ■ Robert Figl aus Deutschland bekommt nach dem 400-Meter-Rollstuhlrennen einen Schuss kaltes Wasser ins Gesicht. Die Hitze und Feuchtigkeit machte den Teilnehmern zu schaffen, speziell jenen, die das Klima nicht gewöhnt sind.

SEITE 65: Regio Colton, links, mit seiner Frau Lotti, rechts, die ihm zum Sieg des US-Basketball-Männer-Teams über die Niederlande bei den Paralympics gra-tuliert. ■ Du Kim aus Korea auf der Ziellinie im Regen reagiert auf seine neue Weltbestzeit von 1:00.25 im 400m-Lauf der Kategorie T34-35 der zerebral Gelähmten im Olympia-Stadion.

LES JEUX OUBLIÉS Tous les quatre ans, quelques-uns des meilleurs athlètes des USA se retrouvent lors d'une compétition. Un moment privilégié où ils pourront exhiber ce pour quoi ils se sont entraînés pendant tant d'années dans l'anonymat le plus total et

récolter enfin les fruits de leur dur labeur. Les athlètes handicapés participant aux Xème Jeux paralympiques d'Atlanta ont commencé la compétition 15 jours après les Jeux olympiques, bien loin des projecteurs médiatiques et avec beaucoup moins de fanfares. Les cérémonies d'ouverture et de clôture affichaient certes complet, mais les gradins n'étaient occupés que par quelques petits milliers de spectateurs alors qu'il y en avait 80 000 quelques jours avant.

Les athlètes sont classés selon l'origine et le degré de leur handicap. On retrouve des personnes amputées, en chaise roulante, des aveugles et d'autres atteintes de lésions cérébrales. Ces athlètes sont soumis à des tests antidopage après leurs performances tout comme les athlètes nonhandicapés.

Le modeste public des Paralympiques a vécu des instants inoubliables. 255 records mondiaux ont été battus en l'espace de 10 jours de compétition. Les 3211 athlètes ont prouvé que l'idéal olympique, celui du meilleur amateur, a bel et bien été célébré à Atlanta, mais deux semaines après le départ du public. *Editeur:* The Topeka Capital-Journal, *Kansas.*

PAGE 62: Le coureur cycliste américain Dory Selinger sur la piste du vélodrome de Stone Mountain, sur le point de battre un nouveau record lors des Jeux paralympiques d'Atlanta. Selinger pédale avec une prothèse.

PAGE 63: Le Chinois Bin Hou franchit, la tête en avant, la barre placée à 1,92m dans le stade olympique et bat un nouveau record dans la catégorie F42-44 du saut en hauteur pour les handicapés.

PAGE 64: James Hall, joueur de ping-pong de San Bernardino, Californie, et membre de l'équipe américaine, acclamé par 65'000 fans dans le stade olympique lors de la céré-monie d'ouverture des Jeux paralympiques. ■ Le visage de l'Allemand Robert Figl est aspergé d'eau fraîche après le 400m en fauteuil roulant. Les participants souffraient de la chaleur et de l'humidité, en particulier ceux qui n'étaient pas habitués au climat.

PAGE 65: Regio Colton, à gauche, reçoit un baiser de sa femme Lottie, à droite, pour le féliciter après que l'équipe nord-américaine masculine de basket-ball a battu celle des Pays-Bas aux Paralympiques d'Atlanta. ■ Le Coréen Du Kim, franchissant la ligne d'arrivée sous la pluie, manifeste sa joie après avoir battu le record mondial du 400 mètres masculin avec 1:00.25, dans la catégorie T34-35 des athlètes atteints de lésions cérébrales.

NAJLAH FEANNY

ARBEIT IN KETTEN Sheriff Joe Arpaio aus Maricopa County betrachtet sich als Verfechter der Gleichberechtigung, wie er es gerne nennt. Weibliche Sträflinge Zwangsarbeit in Ketten verrichten zu lassen war für ihn eine logische Konsequenz und Teil seines einzigartigen Wiedereingliederungs-Programms.

In Gruppen von fünf aneinandergekettet, arbeiten die Frauen acht Stunden pro Tag und sechs Tage in der Woche, unter dem wachsamen Auge eines Aufsehers und einer Gruppe bewaffneter Hilfssheriffs. Die Vergehen der Frauen rangieren von Diebstahl und Prostitution bis zu Drogenbesitz und bewaffnetem Raubüberfall.

Arpaios Strategie besteht darin, den Verurteilten, die Mühe mit dem System hatten, die Möglichkeit zu geben, sich durch Arbeit einen normalen Gefängnisaufenthalt zu verdienen, statt für lange Zeit in Sonderzellen zu verschwinden. *Agentur: Saba Photo Agency*

SEITE 66: Jeden Morgen bei Sonnenaufgang werden Insassen des Zuchthauses aneinandergekettet zur Arbeit an den verschiedenen Einsatzorten in der Stadt gebracht. Transportiert werden sie in einem Bus, auf dessen Seiten die Aufschrift «Sheriff's Chain Gang» prangt.

SEITE 67: In Ketten, mit Vorhängeschlössern gesichert, reinigen Sträflinge die Strassen.

SEITE 68: Die Frauen bewegen sich bei der Arbeit «wie ein Mann» und lernen, aneinander-gekettet zurechtzukommen.

SEITE 69: Von ihren Zellen machen sich die Insassen in Sträflingskolonnen auf den Weg zur Arbeit. ■ Zusammenarbeit ist für die Frauen wichtig, um zurechtzukommen. ■ Es ist ganz klar, mit welchem Bus die Frauen zur Arbeit gebracht werden. ■ Die Arbeit in der Sträflingskolonne hindert eine Insassin nicht daran, auf ihr Äusseres zu achten. Hier wirft eine Insassin einen prüfenden Blick in den Spiegel, bevor sie sich zur Arbeit aufmacht. ■ Die Sträflingskolonne steht stramm und erwartet die Arbeitsanweisungen für den Tag. ■ Ein Hilfssheriff bewacht die Sträflingskolonne.

TRAVAILLER À LA CHAINE Le shérif Joe Arpaio du comté de Maricopa se veut geôlier parti-san de l'égalité des chances, comme il aime le préciser. Créer le premier service de travaux forcés de femmes enchaînées était une étape logique dans son projet unique de réhabilitation.

Enchaînées les unes aux autres en groupe de cinq, les femmes incarcérées travaillent

durement huit heures par jour et six jours par semaine, sous l'œil attentif du délégué du shérif et d'un petit groupe de gardes armés. Leurs délits vont du vol simple à la prostitution en passant par la détention de stupéfiants et le vol à main armée.

La stratégie d'Arpaio consiste à proposer un moyen aux femmes condamnées à la prison et qui ont eu des problèmes avec le système, de se sortir d'une incarcération à long terme afin de pouvoir réintégrer la population normale de la prison. *Agent: Saba Photo Agency*

PAGE 66: Tous les matins au lever du soleil, les prisonnières enchaînées accomplissant des travaux forcés sont transportées de la prison vers divers chantiers autour de la ville. Elles sont emmenées dans un bus qui porte sur le côté l'inscription: "Sheriff's Chain Gang" (Les prisonnières enchaînées du shérif).

PAGE 67: Des chaînes et des cadenas sont enroulés autour de leurs chevilles, enchaînant ainsi les prisonnières les unes aux autres lorsqu'elles nettoient la ville.

PAGE 68: Les femmes se déplacent à l'unisson sur leur lieu de travail, habituées à travailler tout en étant attachées les unes aux autres.

PAGE 69: Les prisonnières sortent de leur cellule pour aller accomplir leur tâche. ■ La coopération entre les femmes est essentielle pour qu'elles puissent se mouvoir sans problème. ■ On ne rate pas le bus qui amène les femmes à leur lieu de travail.

COLIN FINLAY

KAIRO: KINDERARBEIT Zehn Prozent der arbeitenden Bevölkerung Kairos ist jünger als 14 Jahre. Einige dieser Arbeiter sind gerade erst vier Jahre alt. Überarbeitet und ihrer Kindheit beraubt, kämpfen sie gegen ein System, das ihre Ausbeutung nicht nur akzeptiert, sondern sogar fördert. *Agentur: Saba Photo Agency/Publikation:* American Photo, *Campus Edition*

SEITE 70: Beim Heben eines schweren Sackes mit Schmutz und Steinen.

SEITE 71: Jungen beim Transportieren von Schlamm.

SEITE 72: Diese «Schlamm-Jungs» machen Ziegelsteine.

SEITE 73: Beim Entfernen von Steinen vom Förderband. ■ Ein Junge mit seiner Schüssel voll Lehm. ■ Ein Junge beim Glaserhitzen. ■ Beim Einsammeln getrockneter Vasen aus dem Brennofen. ■ Beim Anfertigen von Toilettenschüsseln. ■ Beim Abwischen des Schweisses von seiner Stirn.

LE CAIRE: LE TRAVAIL DES ENFANTS Dix pour cent de la population active du Caire est composée de jeunes de moins de 14 ans. Certains d'entre eux n'ont que quatre ans. Usés par le travail, privés de leur enfance, ils luttent contre un système qui non seulement accepte leur exploitation, mais l'encourage. *Agent: Saba Photo Agency/Publication:* American Photo, *Campus Edition*

PAGE 70: Sac rempli de déchets et de pierres.

PAGE 71: Garçons transportant un lourd chargement de boue.

PAGE 72: Garçons fabriquant des briques.

PAGE 73: Pierres retirées du convoyeur. ■ Garçon saisissant sa cuvette remplie de boue. ■ Garçon chauffant du verre. ■ Une fois secs, les vases sont retirés du four. ■ Aménagement de latrines. ■ Homme essuyant la sueur de son front.

STANLEY GREENE

WAS GESCHAH MIT FRED CUNY? Fred Cuny war ein Alleingänger, ein Texaner, der scheinbar unlösbare Probleme bei Kriegs- und Hungerkatastrophen in aller Welt in den Griff bekam, sei es in Biafra oder in Bosnien. Er hatte den Nerv und das Know-How, kurdische Guerrilla-Führer bei der Irak-Krise mit Hubschraubern der US-Armee ausfliegen zu lassen. Der Journalist Scott Anderson, der für das *New York Times Magazine* schreibt, bezeichnet Cuny als einen Mann, «der mit einer Kombination von humanitärer Hilfe, Diplomatie, Militäroperationen und Intelligenz arbeitet.»

Im März 1995 machte sich Cuny zusammen mit zwei Ärzten vom russischen Roten Kreuz, einem russischen Dolmetscher und einem lokalen Fahrer auf den Weg ins Herz von Tschedschenien während des blutigen Unabhängigkeits-kriegs dieser russischen Republik. Man hat die Gruppe angeblich zuletzt in Samashki, einer kleinen ländlichen Stadt in Westtschedschenien gesehen, aber sie ist nie zurückgekehrt. Es gab Gerüchte, dass die Russen sie loswerden wollten. Andere behaupten, dass tschedschenische Rebellen sie als Bedrohung betrachtet und deshalb umgebracht hätten. Ein Jahr später machte sich Anderson auf die Spur von Cuny, wobei er sich auf die umfangreiche aber ergebnislose Suche der US-Regierung und des Geheimdienstes stützte. Der Photograph Stanley Green reiste mit Anderson und machte eine Reihe von Aufnahmen, die sehr starke Momente bei den Bemühungen um die Aufdeckung des geheimnisvollen Verschwindens Fred Cunys zeigen. *Agentur: Agence Vu/Publikation: The New York Times Magazine*

SEITE 74: Witwen in der tschedschenischen Stadt Samashki erkennen Cuny auf dem Bild. Sie sagen, er sei bei einem russischen Angriff im vergangenen April dort gewesen. Wer hatte mehr Grund, ihn zu töten, die tschedschenischen Rebellen oder die russische Armee?

SEITE 75: Die Strasse nach Samashki könnte die Strasse des Todes für den «grossen Freund des tschedschenischen Volkes gewesen sein.»

SEITE 76: Tschedschenische Guerrilla-Führer wie Omar Hadji, ganz oben, und Mitglieder von Dzhokhar Dudayews Verhandlungsteam, oben, könnten etwas über den Tod Cunys wissen. ■ Ein Photo von Cuny, das von einem Suchtrupp verteilt wurde, befindet sich noch unter der gläsernen Schreibtischplatte eines Krankenhausverwalters in Samashki.

SEITE 77: An dieser Strasse sind angeblich viele Leute verschwunden. Sie wird zur Hälfte von den Russen und zur Hälfte von den Tschedschenen kontrolliert. ■ Der Markt in der tschedschenischen Hauptstadt Grozny, die zum Schlachtfeld wurde. Ein tschedschenischer Rebell behauptete zu wissen, was mit Cuny geschehen ist.

QU'EST-IL ARRIVÉ À FRED CUNY? Fred Cuny était une personne indépendante oeuvrant pour l'aide humanitaire, un Texan qui a su négocier des solutions à des situations qui semblaient pourtant sans issue dans divers coins de la planète ravagés par la guerre et la famine, du Biafra à la Bosnie. Il a su commander des hélicoptères de l'armée américaine pour transporter des leaders kurdes de la guérilla au-delà des frontières lors de la crise irakienne. Le journaliste du *New York Times Magazine* Scott Anderson décrit Cuny comme «un homme travaillant dans la zone grise entre l'aide humanitaire, la diplomatie, les opérations militaires et les services secrets».

Au mois de mars 1995, Cuny, accompagné de deux médecins russes de la Croix Rouge, un interprète russe et d'un chauffeur de la région, se sont mis en route pour le centre de la Tchétchénie alors ravagée par la guerre d'indépendance. On les aurait vus pour la dernière fois à Samashki, une petite ville de campagne située à l'Est de la Tchétchénie, mais ils ne seraient jamais revenus et on n'aurait plus jamais entendu parler d'eux. Selon certaines rumeurs les Russes auraient voulu les éliminer, tout comme les Tchétchènes qui les auraient assassinés parce qu'ils auraient représenté un danger potentiel pour eux. Un an après, Anderson s'est mis à la recherche de Cuny. Il a repris une enquête menée à grande échelle par le gouvernement américain et les service secrets mais qui n'a pas abouti. Le photographe Stanley Greene a voyagé avec Anderson et a fixé sur pellicules les moments forts et intenses de cette quête visant à élucider la mystérieuse disparition de Fred Cuny. *Représentation: Agence Vu/Editeur: The New York Times Magazine*

PAGE 74: Des veuves de la ville tchétchène de Samashki reconnaissent la photo de Cuny et disent qu'il était là en avril dernier lors d'une attaque des Russes. A qui sa mort bénéficierait-elle le plus, aux rebelles tchétchènes ou à l'armée russe?

PAGE 75: La route de Samashki a peut-être été le chemin de croix de «ce grand ami du peuple tchétchène» qu'était Cuny.

PAGE 76: Des chefs de la guérilla tchétchène tels que Omar Hadji, en haut, et des membres de la délégation de négociation de Dzhokhar Dudayev, en bas, étaient probablement au courant de la mort de Cuny. ■ Une photo de Cuny distribuée par une équipe de recherche se trouve toujours sur le bureau du directeur de l'hôpital de Samashki.

PAGE 77: On sait que de nombreuses personnes ont disparu sur cette route contrôlée en partie par les Russes et par les Tchétchènes. ■ Le marché central de Grozny, la capitale de la Tchétchénie transformée en champ de bataille. Un rebelle tchéchène prétend savoir ce qui est arrivé à Cuny.

DAVID GUTTENFELDER

RUANDISCHE BOXER Jean-Marie Ugiramahoro behauptet, das Boxen habe ihn und seine boxenden Kameraden am Leben gehalten. Ugiramahoro, ehemaliger ruandischer Landesmeister im Boxen, gründete den Box-Club im Mugunga-Flüchtlingslager in Goma, Zaire. «Das Training am Morgen macht uns stark», sagt Ugiramahoro. «Und wenn der Hunger sich meldet, trainieren wir einfach wieder und vergessen ihn.»

Als 1994 Tausende Hutus über die Grenze nach Zaire flüchteten, waren Ugiramahoro und seine beiden jüngeren Brüder Teil des Exodus, ausgerüstet mit Boxhandschuhen, einem Springseil und zwei Hanteln. In einer Halle aus Plastikplanen, mit denen die UNO sie versorgt hatte, wurde der Club auf nacktem Boden mit Sisal-Tauen und 30 Zuschauerbänken aus Holz eingerichtet. Der Eintritt kostete 1,000 Zaire pro Person - ungefähr 4 US Cent – für einen ganzen Nachmittag. *Agentur: Associated Press*

SEITEN 78-79: Flüchtlinge, die Mitglieder des Mugunga-Box-Clubs sind, kämpfen im

Schatten des Mugunga-Flüchtlingslagers in Goma, Zaire.

SEITE 80: Der frühere ruandische Boxmeister Jean-Marie Ugiramahoro, 26, beim Seilspringen, während andere Flüchtlinge Schattenboxen betreiben. ■ Augustin Habimana, unten rechts, während des Boxtrainings. Er kann den Schlag gegen Esidras Dusengimana nicht platzieren.

SEITE 81: Eine kleines Flüchtlingskind späht durch ein Loch der von der UNO gespendeten Plastikplane, die den Mugunga Box-Club umgibt. Jean-Marie Ugiramahoro, der Organisator des Flüchtlings-Box-Clubs, behauptet, der Sport hielte die Boxer am Leben. «Als wir vor eineinhalb Jahren ins Lager kamen und hier die Cholera grassierte, hat uns wahrscheinlich unsere physische und psychische Stärke am Leben gehalten», sagt er.

BOXEURS RWANDAIS Jean-Marie Ugiramahoro affirme que la boxe a permis à ses amis boxeurs ainsi qu'à lui-même de survivre. Ancien champion de boxe rwandais, Ugiramahoro a créé un club de boxe dans le camp de réfugiés Mugunga à Goma, au Zaïre. «L'entraînement du matin nous rend plus forts», déclare Ugiramahoro. «Et lorsque nous commençons à avoir faim, nous conti-nuons de nous entraîner et n'y pensons plus.»

En 1996, lorsque des milliers de Hutus franchirent la frontière du Zaïre, Ugiramahoro et ses deux frères cadets faisaient partie de l'exode, emportant avec eux des gants de boxe, une corde à sauter et deux haltères. C'est dans un local fait de bâches en plastique fournies par l'ONU que le club est reconstitué à même le sol, avec des cordes de sisal et 30 bancs en bois pour les spectateurs. L'entrée coûte 1000 zaïres par personne – environ 4 cent US – pour une après-midi entière de boxe. *Agent: Associated Press*

PAGES 78-79: Réfugiés membres du club de boxe de Mugunga participant à un combat à l'ombre du camp de réfugiés de Mugunga à Goma, Zaïre.

PAGE 80: L'ex-champion de boxe rwandais Jean-Marie Ugiramahoro, 26 ans, sautant à la corde pendant que d'autres réfugiés s'entraînent. ■ Augustin Habimana, en bas à droite, lors d'un entraînement de boxe. Il ne parvient pas à placer son coup contre Esidras Dusengimana.

PAGE 81: Petit enfant regardant par un trou dans la bâche qui entoure le club de boxe de Mugunga et mise à disposition par l'ONU. Jean-Marie Ugiramahoro, l'organisateur du club de boxe des réfugiés, affirme que la boxe les maintient en vie. «Lorsque nous sommes arrivés ici il y a un an et demi et que le choléra faisait des ravages, c'est sans doute grâce à notre résistance physique et psychique que nous avons survécu», déclare-t-il.

HAZEL HANKIN

MUHAMMAD ALI IN HAVANNA, KUBA Das Ende der sowjetischen Subventionen und das strenge U.S.-Embargo haben zu bedrohlichen Engpässen in der medizinischen Versorgung Kubas geführt. Im Januar 1996 wurden dem Roten Kreuz Kubas vom Disarm Education Fund (DEF), einer humanitäten Hilfsorgani-sation aus New York, Medikamente und andere Hilfsgüter im Wert von einer halben Million Dollar übergeben. Es war die grösste Lieferung, die von der US Regierung je bewilligt wurde und die erste von weiteren Lieferungen, die innerhalb von zwei Jahren erfolgen sollen.

Muhammad Ali begleitete die DEF-Delegation auf einer fünftägigen Tour durch Havanna. Dank seiner Anwesenheit erfuhr die Welt von dieser grossen humanitären Hilfsaktion und der verzweifelten Lage Kubas, während die US Medien diese Mission völlig ignorierten.

In Havanna wurde Ali von Teofilo Stevenson, dem grossen kubanischen Boxer und dreimaligen Olympia-Sieger im Schwergewicht, begleitet. Überall strömten Menschenmengen zusammen, um die beiden Boxer zu begrüssen und der DEF für ihre Hilfe zu danken. Fidel Castro empfing die Gruppe im Präsidentenpalast von Havanna.

SEITE 82: Muhammad Ali schaut Kindern im Boxring einer Sporthalle in Havanna zu.

SEITE 83: Fidel Castro mit Muhammad Ali im Präsidentenpalast von Havanna.

SEITE 84: Muhammad Ali begrüsst Fans in Havanna bei einem Besuch der Stadt. ■ Muhammad Ali bei einem Sparring mit einem jungen Boxer in einer Boxhalle in Havanna.

SEITE 85: Fildel Castro scherzt mit Muhammad Ali im Präsendentenpalast von Havanna. ■ Schulkinder begrüssen Muhammad Ali und seine Delegation mit einem Lied.

SEITE 86: Muhammad Ali mit dem kubanischen Box-Meister Teófilo Stevenson. ■ Boxnachwuchs in einer Boxhalle in Havanna während Alis Besuch. ■ Eine begeisterte Menge versammelt sich um Alis Bus bei seinem Besuch in Havanna. ■ Ali begrüsst

eine Lehrerin einer Grundschule in Havanna. ■ Muhammad Ali und seine Frau Lonnie beim Besuch einer Klinik in Havanna. ■ Ali begrüsst einen Patienten in einem Kinderspital. Bei ihm sind Bob Schwartz vom Disarm Education Fund und der Arzt des Jungen.

SEITE 87: Muhammad Ali betrachtet das Leben auf den Strassen Havannas bei einer Fahrt durch die Stadt.

MUHAMMAD ALI À LA HAVANE, CUBA La fin des subventions soviétiques et l'embargo américain ont eu des conséquences dramatiques sur l'approvisionnement en médica-ments de Cuba. En janvier 1996, le Disarm Education Fund (DEF), une organisation d'aide humanitaire new-yorkaise, a remis à la Croix-Rouge des médicaments et des biens de première nécessité d'une valeur d'un demi million de dollars. Cette livraison est la plus importante jamais autorisée par le gouvernement américain jusqu'à présent. D'autres livraisons devraient suivre au cours des deux prochaines années.

Durant cinq jours, Muhammad Ali a accompagné la délégation DEF à la Havane. Sa présence a attiré l'attention de l'opinion internationale sur cette grande action human-itaire et la situation critique de Cuba, tandis que les médias américains n'ont soufflé mot de cette mission. A La Havane, Muhammad Ali était accompagné du grand boxeur cubain Teófilo Stevenson, triple champion olympique des super-lourds. Partout, la foule accourait pour saluer les deux boxeurs et remercier le DEF de son aide. Fidel Castro a reçu la délégation dans le palais présidentiel de La Havane. *Agent: Impact Visuals*

PAGE 82: Muhammad Ali regardant des enfants boxer sur le ring d'un gymnase de La Havane, Cuba.

PAGE 83: Fidel Castro et Muhammad Ali dans le palais présidentiel de La Havane.

PAGE 84: Muhammad Ali saluant ses fans lors d'une visite à La Havane. ■ Muhammad Ali avec un jeune boxeur dans un gymnase de La Havane.

PAGE 85: Fidel Castro plaisantant avec Muhammad Ali dans le palais présidentiel de La Havane. ■ Enfants d'une école primaire accueillant Muhammad Ali et sa délégation avec une chanson.

PAGE 86: Muhammad Ali avec le champion de boxe cubain Teófilo Stevenson. ■ Futurs boxeurs dans un gymnase de La Havane durant la visite de Muhammad Ali. ■ La foule, enthousiaste, rassemblée autour du bus transportant Muhammad Ali lors de sa visite de La Havane. ■ Ali saluant une institutrice dans une école primaire à La Havane. ■ Muhammad Ali et sa femme Lonnie lors d'une visite dans une clinique de La Havane. ■ Muhammad Ali saluant un enfant dans un hôpital pédiatrique. Il est accompagné de Bob Schwartz du Disarm Education Fund et du médecin de l'enfant.

PAGE 87: Muhammad Ali regardant le spectacle des rues de La Havane lors de sa visite.

ANDREW HOLBROOKE

THE MARCHING SEASON Fanatische Protestanten in Nordirland bestehen mit Leidenschaft auf der sogenannten "Marching Season". Dabei handelt es sich um Märsche mit Pfeiffen, Trommeln und Flaggen durch überwiegend katholi-sche Gegenden. Sie feiern den Sieg des Protestanten Wilhelm von Oranien über König James in der Schlacht von Boyne im Jahre 1690. Ihr Triumpfmarsch verletzt die katholische Minderheit des Landes tief.

Im Juli 1996 stoppte die Polizei Männer des Oranien-Ordens auf ihrem Weg zurück nach Portadown, der durch eine katholische Gegend führte. Es kam zu heftigen Protesten auf Seiten der Marschierer, und die Spannungen eskalierten derart, dass die Polizei nachgab und sie schliesslich weitergehen liess.

Die katholischen Nationalisten, die sich von der Polizei im Stich gelassen fühlten, randalierten daraufhin ihrerseits. Mit über 1000 Zusammenstössen in der Region in nur einer Woche waren das die schwersten Unruhen in Nordirland seit 20 Jahren.

Solange die Gewalt zwischen den Konfessionen die Menschen in Nordirland auf-frisst, der Hass von Generation zu Generation weitergegeben wird und zehnjährige Kinder in den Strassen mit Flaschen, Steinen und Benzinbomben kämpfen, nehmen die Unruhen, wie man sie nennt, kein Ende.

SEITEN 88-89: Aufständische Protestanten im Sandy-Row-Distrikt von Belfast, Nordirland.

SEITE 90: Loyalisten demonstrieren ihre pro-britischen Gefühle.

SEITE 91: Protestanten, entschlossen, ihren Marsch fortzusetzen, passieren eine bren-nende Barrikade, die von prostestantischen Randalierern im Sandy-Row-Distrikt von Belfast errichtet wurde.

SEITE 92: Ein Katholik gibt seiner Wut über den Marsch der Protestanten Ausdruck, während britische Soldaten das Gebiet gegen randallierende Prostestanten abschir-men. ■ Kinder bei einem Aufruhr im Norden von Belfast.

SEITE 93: Protestantische Randalierer im Sandy-Row-Distrikt von Belfast. ■ In Portadown wurde die Entscheidung der Regierung, die Protestanten durch katholische Wohngebiete marschieren zu lassen, als Verrat empfunden, was zu erheblichen Protesten führte. ■ Die Falls Road im Westen von Belfast, einer katholischen Gegend. ■ Begräbnis für einen nationalistischen Randalierer, der von einem Polizeifahrzeug während einer Strassenschlacht in Londonderry überfahren wurde.

LA SAISON DE LA MARCHE Les loyalistes protestants mettent un point d'honneur à perpétuer la tradition de ce qu'ils appellent la «saison de la marche». A l'occasion de cette marche ressentie comme une provocation par la minorité catholique, ils font résonner fifres et tambours et lancent leurs bannières lorsqu'ils traversent les régions catholiques du pays. Ils célèbrent ainsi la victoire de Guillaume III d'Orange, un protestant, sur le roi Jacques II à Boyne en 1690.

En juillet 1996, la police arrêta la marche des membres de l'ordre d'Orange pour les empêcher de passer par un «fief» catholique avant de rejoindre la ville de Portadown. Les loyalistes protestants provoquèrent des émeutes et, sous la tension grandissante, les policiers baissèrent les bras, les laissant poursuivre leur marche.

Les nationalistes catholiques se sentant trahis par la police provoquèrent à leur tour des émeutes en guise de rétorsion. Avec plus de 1000 incidents dans la région en l'espace d'une semaine, la violence n'avait jamais atteint un tel paro-xysme en Irlande du Nord depuis 20 ans.

Tandis que la violence sectaire continue à faire des ravages en Irlande du Nord, tandis que la haine se transmet de génération en génération, tandis que des garçons de dix ans descendent dans les rues armés de bouteilles, de pierres et de cocktails Molotov, les troubles, doux euphémisme, ne sont pas prêts de toucher à leur fin.

PAGES 88-89: Les émeutiers loyalistes du quartier de Sandy Row à Belfast, Irlande du Nord.

PAGE 90: Les loyalistes témoignant de leurs sentiments probritanniques. ■ Falls Road, Belfast ouest, un quartier catholique.

PAGE 91: Des hommes de l'ordre d'Orange, déterminés à poursuivre leur marche, passent à travers des barricades en feu érigées par les émeutiers protestants dans le quartier de Sandy Row, Belfast.

PAGE 92: Un catholique affichant sa colère à la vue des soldats britanniques bouclant les environs de Portadown avant le défilé des protestants. ■ Enfants nationalistes participant aux émeutes au nord de Belfast.

PAGE 93: Emeutiers royalistes dans le quartier de Sandy Row, Belfast. ■ A Portadown, la décision du gouvernement d'autoriser le défilé des protestants dans la région a été ressentie comme une trahison par les catholiques et elle a provoqué une émeute. ■ Quartier de Falls Road à l'ouest de Belfast, «fief» catholique. ■ Obsèques d'un nationaliste tué par un véhicule de la police durant les émeutes de Londonderry.

ED KASHI

HINTER GITTERN ALT WERDEN Die Gefängnisse in den USA sind hoffnungslos überfüllt, und es stellt sich ein kostspieliges neues Problem: die älteren Insassen. In den letzten vier Jahren ist ihre Anzahl um über 50% gestiegen, d.h. heute sind über 20000 der Insassen amerikanischer Gefängnisse über 55 Jahre alt.

Die Gefängnisverwaltungen mussten für die langfristige medizinische Versorgung der Alten sorgen, für neue Diäten und sogar für Einrichtungen, die für gehbehinderte bzw. an den Rollstuhl gefesselte Insassen geeignet sind.

Diese Geschichte zeigt die Auswirkungen des Alterns in US-Gefängnissen am Beispiel eines 60-Betten-Pflegeheims, das einem Spital in der Nähe von Huntsville, Texas, angeschlossen ist. Von den 2000 Insassen des Gefängnisses sind ca. 100 betagt. Alle männlichen Insassen sind des Mordes oder der Körperverletzung angeklagt.

SEITE 94: Ein Insasse in Handschellen als Geriatrie-Patient im Gefängnishospital bei einer Nieren-Dialyse.

SEITE 95: Herman Jundt, der seit Jahrzehnten immer wieder im Gefängnis sass, hat wiederholt Kinder belästigt. Da er zu Schwachsinn und gewalttätigen Ausbrüchen neigt, befindet er sich in Einzelhaft. ■ Geriatrische Insassen treffen nur im Gefängnishof mit den anderen Insassen zusammen. ■ Johnson Frank ist seit über 30 Jahren inhaftiert und isst in einer Isolationszelle. Diese Zellen sind für gewalttätige und schwierige Insassen bestimmt. ■ Der Dienstplan des geria-trischen Krankensaals. ■ Insassen im geriatrischen Krankensaal fallen über eine der drei täglichen Mahlzeiten her, die gemeinsam eingenommen werden. ■ Robert Daniel, 68, der sich von einer Prostata-Operation erholt, wechselt die Windel in seiner Kabine. Im geriatrischen Krankensaal gibt es wenig Privatsphäre.

SEITE 96: Thomas Clinton Stodghill, 65, zeigt eine der vielen Narben, die sich im

Laufe eines kriminellen Lebens und im Gefängnis zugezogen hat. ■ Einegeriatrischer Insasse, der an Alzheimer leidet, hält bei der Toilette seiner Zelle inne.

SEITE 97: Ein blinder geriatrischer Insasse hört sich in einer der Kabinen, die im geriatrischen Krankensaal als Zelle dienen, Geschichten auf Tonband an. ■ Richard Young, 80 Jahre alt, erliegt im Gefängnishospital einem Krebsleiden.

VIEILLIR DERRIÈRE LES BARREAUX Déjà dramatiquement surpeuplées, les prisons américaines sont confrontées à un nouveau problème qui leur coûte cher: les prisonniers âgés. Au cours des quatre dernières années, leur nombre a augmenté de plus de 50%, ce qui signifie que plus de 20'000 prisonniers incarcérés dans les prisons d'Etat ou fédérales ont plus de 55 ans.

Les administrations carcérales ont dû mettre en place un système de prévoyance médicale à long terme pour ces prisonniers, prévoir de nouveaux régimes alimentaires et des installations spéciales pour les prisonniers handicapés ou cloués dans un fauteuil roulant.

Cette histoire illustre les répercussions liées au fait de vieillir dans les prisons américaines à l'exemple d'une unité gériatrique de 60 lits rattachée à un hôpital près de Huntsville, au Texas. Sur les 2000 prisonniers du pénitencier attenant, une centaine sont des personnes âgées. Tous ces hommes ont été inculpés pour meurtre ou coups et blessures.

PAGE 94: Détenu menotté sous hémodialyse dans l'unité gériatrique de la prison.

PAGE 95: Incarcéré à plusieurs reprises durant des années, Herman Jundt a régulièrement molesté des enfants. Souffrant de crises de démence et d'accès de violence, il a été placé en isolement cellulaire. ■ Incarcéré depuis 30 ans, Johnson Frank est en détention cellulaire. Ce mode de détention est réservé aux prisonniers violents et difficiles. ■ Les prisonniers de l'unité gériatrique rencontrent les autres détenus uniquement dans la cour de la prison. ■ Tableau de service de l'unité gériatrique. ■ Les détenus de l'unité gériatrique se jettant sur l'un des trois repas quotidiens pris en commun. ■ Agé de 68 ans, Robert Daniel, qui se rétablit d'une opération de la prostate, change ses langes dans son alcôve. Les prisonniers de l'unité gériatrique souffrent du manque d'intimité.

PAGE 96: Thomas Clinton Stodghill, 65 ans, exhibant l'une de ses nombreuses cicatrices, qui témoignent de son long passé de criminel et de détenu. ■ Prisonnier de l'unité gériatrique atteint de la maladie d'Alzheimer marquant un temps d'arrêt près des toilettes de sa cellule.

PAGE 97: Prisonnier écoutant des histoires sur un magnétophone dans l'une des alcôves de l'unité gériatrique qui font office de cellule. ■ Richard Young, 80 ans, mourant d'un cancer dans la prison de l'hôpital.

SYRIEN: HINTER DER MASKE Syrien, das im Westen lange als terroristischer Staat unter der Herrschaft eines gewissenlosen Diktators galt, ist heute eines der komplexesten und politisch lebendigsten Länder des Mittleren Ostens, das bei der Erhaltung des Friedens und des Gleichgewichts der Macht in der Region eine zentrale Rolle spielt.

Der Photo-Essay zeigt Aspekte des Lebens in Syrien, die der übrigen Welt grössten-teils verschlossen bleiben. Obgleich das Land nach der 25jährigen ei-sernen Herrschaft des Präsidenten Hafez Al-Assad noch die Narben der regionalen Konflikte der jüngeren Zeit trägt, sind doch auch Spuren der alten Zivilisation sichtbar geblieben. *Publikation:* National Geographic, *Washington, D.C.*

SEITEN 98-99: Beim Haupteingang zu den Ruinen von Palmyra wartet ein junger Kameltreiber auf Touristen. Er vertreibt sich dabei die Zeit mit seinem Walkman.

SEITE 100: Eine Familie hinter ihrem Fenster im Jaramanah-Lager für palästinensische Flüchtlinge. In Syrien befinden sich insgesamt 20000 palästinensische Flüchtlinge.

SEITE 101: Ein kurdischer Weizenträger, *Atal* genannt, krümmt sich unter der Last der guten Weizenernte in der Nähe von Qamishli. ■ Eine Drusen-Familie ruft die Nachrichten der Woche über das Tal der Golan Höhen, einer verminten Zone, die israelisch besetzten Majdal Shams von syrischem Gebiet trennt. ■ Eine Gruppe von traditionellen Moslemfrauen geniesst die sommerliche Brandung an einem Strand in der Nähe von Latakia an der Mittelmeerküste. ■ Frauen bei einer Ruhepause während der Weizenernte in der Nähe von Apamea, einer griechischen Stadt, deren Hauptstrasse auf einer Strecke von 1,6km von 13m hohen korinthischen Säulen gesäumt wird. ■ Eine beduinische Familie weidet ihre Herde jedes Frühjahr auf den abgeernteten Weizenfeldern im Al-Ghab-Tal, dem Brotkorb Syriens. ■ Eine Weizenstadt erhebt sich aus der syrischen Wüste in der Nähe von Qamishli, wo die Kornsäcke auf die Verteilung warten. Syrien importiert trotz seiner Überschüsse landwirtschaftliche Produkte.

LA SYRIE: DERRIÈRE LE MASQUE Longtemps considérée par l'Occident comme un Etat

terroriste sous la férule d'un dictateur impitoyable, la Syrie est aujourd'hui l'un des pays du Moyen-Orient les plus complexes et les plus dynamiques sur le plan politique et joue un rôle prépondérant pour le maintien de la paix et l'équilibre du pouvoir dans cette région.

Cet essai photographique illustre des aspects de la vie en Syrie jusqu'alors méconnus. Même si le pays porte encore les cicatrices des conflits régionaux qui l'ont secoué sous le régime du président Hafez al-Assad mené d'une poigne de fer durant 25 ans, les traces de l'ancienne civilisation sont toujours présentes. *Edituer:* National Geographic, *Washington, D.C.*

PAGES 98-99: Posté à l'entrée principale des ruines de Palmyre, un jeune chamelier attend la venue des touristes en écoutant de la musique sur son baladeur.

PAGE 100: Famille palestinienne regardant par la fenêtre dans le camp de réfugiés de Jaramanah. 20'000 Palestiniens vivent en Syrie.

PAGE 101: Un porteur de blé kurde, ou *atal*, croulant sous le poids de la récolte dans les environs de Qamishli. ▪ Famille druze criant les nouvelles de la semaine au-dessus du plateau du Golan, une zone minée séparant Majdal Shams, occupé par Israël, du territoire syrien. ▪ Femmes musulmanes s'ébattant dans les vagues sur une plage située dans les environs de Lattaquié, sur la Méditerranée. ▪ Femmes faisant une pause durant la récolte de blé dans les environs d'Apamée, ville de l'Orient antique et patrie de Posidonios. La grand-rue d'Apamée, qui fait 1,6 km, est bordée de colonnes corinthiennes d'une hauteur de 13 m. ▪ Famille de Bédouins faisant paître chaque printemps après la récolte son bétail dans les champs de blé de la vallée d'Al Ghab, la corbeille à pain de la Syrie. ▪ Ville de blé s'élevant au milieu du désert de Syrie dans les environs de Qamishli, où les sacs de blé attendent d'être distribués. Malgré ses surplus, la Syrie importe des produits agricoles.

YUNGHI KIM

DER TÖDLICHE WEG NACH HAUSE: HUTUS KEHREN NACH RUANDA ZURÜCK Im November 1996 nahm die tödlichste Flüchtlingskrise unserer Zeit ein abruptes Ende, als Hunderttausende ruandischer Hutus das benachbarte Zaire verliessen, um in ihre Heimat zurückzukehren. Es war eine Rückkehr nach zweijähriger Flucht vor Völkermord, dem eine halbe Million Menschen in Ruanda zum Opfer fielen. Eine weitere halbe Million war in den Flüchtlingslagern an Cholera gestorben.

Im Herbst 1996 gab es wochenlange, schwere Kämpfe zwischen den zairischen Rebellen und den Regierungssoldaten. Die Hilfswerke zogen ihre Mitarbeiter aus den Flüchtlingslagern in Goma, Zaire, ab, u.a. auch aus Mugunga, dem grössten Flüchtlingslager der Welt. Angesichts der wachsenden Gefahr einer neuen Cholera-Epidemie, zogen die USA die Entsendung von Truppen in Betracht.

Plötzlich setzten sich dann die Flüchtlinge aus dem Mugunga-Lager zu jedermanns Überraschung in Bewegung. Innerhalb von vier Tagen waren 600000 Flüchtlinge nach Ruanda zurückgekehrt, und nach zweijähriger Trennung waren zahlreiche Familien wieder vereinigt. *Agentur: Contact Press Images*

SEITEN 102-103: Einwohner von Goma, Zaire, wegen des Bürgerkrieges von der Umwelt abgeschlossen und ohne Nahrungsmittel, laufen verzweifelt hinter einem Lastwagen des World Food Program her, der die letzten Vorräte verteilt.

SEITE 104: Nachdem sie zwei Jahre lang Krankheit, Hunger und Krieg im Mugunga-Flüchtlingslager ertragen haben, verlassen Hunderttausende von Ruandern am 15. November 1996 plötzlich Mugunga und machen sich auf den langen Heimweg, nachdem Kämpfe zwischen zairischen Rebellen und Soldaten der alten Hutu-Regierung das Lager bedroht hatten.

SEITE 105: Der Körper eines Soldaten liegt auf der Strasse im Mugunga-Lager. Frühere Hutu-Regierungssoldaten im Lager ermordeten auch Flüchtliche, um sie daran zu hindern, in das von Tutsis kontrollierte Ruanda zurückzukehren.

SEITE 106: Die Taschen der Einwohner, die aus Goma, Zaire, vor den Kämpfen geflohen waren, werden bei ihrer Rückkehr von einem Soldaten der zairischen Rebellen untersucht. Wegen der heftigen Kämpfe in der Gegend von Goma war es sicherer, im Boot statt über Land zurückzukehren. ▪ Im Central Hospital von Goma gab es keine Schmerzmittel für die Verwundeten. Das Bein dieses Mannes musste amputiert werden, nachdem er bei der Übernahme der Rebellen verwundet worden war. ▪ Kämpfe um Lebensmittel ereignen sich täglich in Goma, wo Wachposten versuchten, die Menschenmenge daran zu hindern, das Lager mit den Hilfsgütern zu stürmen. Die Kämpfe in der Gegend hatten den Hilfsorganisationen den Zugang unmöglich gemacht, und es waren kaum noch Nahrungsmittel vorhanden. ▪ Nach wochenlangen Kämpfen in und um die Stadt herum war das Goma, das die Rebellen erobert hatten, nur noch eine Ruinenstadt – die Läden waren geplündert worden, und der Abfall brannte auf den Strassen.

SEITE 107: Im Mugunga-Lager spielt ein Mann auf einer Gitarre, die er in einem verlassenen Lastwagen gefunden hatte. Die Soldaten des alten Hutu-Regimes, die angesichts der sich nähernden zairischen Rebellen hastig in die Berge geflüchtet waren, hatten den Lastwagen zurückgelassen. ▪ In einem Übergangslager, das die UN in der Nähe von Kigali in Ruanda errichtet hatten, versuchen Tausende von Ruandern, einen Platz auf den Lastwagen zu erobern, die sie ihre Heimat in entlegeneren Gebieten Ruandas bringen sollen. ▪ Der Weg der Flüchtlinge zurück nach Hause durch die ruandischen Berge. Viele marschieren wochenlang lieber am Abend und in der Nacht, um der brennenden Sonne zu entgehen. ▪ Nach einem zweiwöchigen Fussmarsch aus dem Flüchtlingslager Yolanda umarmt die nach Rhuengeri, Ruanda, zurückgekehrte Mugeni ihre Schwiegermutter, Angeline Iradukunda.

LA ROUTE DE LA MORT POUR LES HUTUS RENTRANT AU RWANDA En novembre 1996, la crise des réfugiés la plus sordide de notre temps a pris une fin abrupte, lorsque des centaines de milliers de réfugiés rwandais ont quitté le Zaïre pour rentrer dans leur pays. Ce retour a eu lieu deux ans après l'exode massif de la population hutue suite au génocide qui a coûté la vie à un demi-million d'êtres humains au Rwanda. Un autre demi-million a péri dans les camps de réfugiés, emporté par une épidémie de choléra.

En automne 1996, des conflits sanglants ont opposé pendant des semaines les troupes rebelles kabilistes aux soldats de la garde présidentielle zaïroise. Les organisations humanitaires ont rappelé leurs collaborateurs qui travaillaient dans les camps de réfugiés à Goma, au Zaïre, et à Mugunga, le plus grand camp de réfugiés du monde. Au vu du danger croissant d'une nouvelle épidémie de choléra, les Etats-Unis envisagent l'envoi de troupes spéciales.

Soudain, à l'étonnement général, les réfugiés du camp de Mugunga se sont mis en marche. En l'espace de quatre jours, 600'000 réfugiés sont rentrés au Rwanda, et après une séparation de deux ans, de nombreuses familles sont à nouveau réunies. *Agent: Contact Press Images*

PAGES 102-103: Coupés du monde et privés de nourriture en raison de la guerre civile, des habitants désespérés de Goma, Zaïre, suivent un camion du World Food Program, qui distribue ses dernières provisions.

PAGE 104: Le 15 novembre 1996, après avoir enduré pendant deux ans la maladie, la faim et la guerre dans le camp de Mugunga, des milliers de réfugiés rwandais quittent tout à coup le camp pour une longue marche vers le Rwanda, sous la menace de combats opposant les rebelles zaïrois aux soldats de l'ancien régime hutu.

PAGE 105: La cadavre d'un soldat sur la route du camp de Mugunga. Dans le camp, d'anciens soldats du régime hutu ont massacré des réfugiés pour les empêcher de rejoindre le Rwanda, contrôlé par les Tutsis.

PAGE 106: Rebelle zaïrois fouillant les sacs des habitants regagnant Goma, Zaïre, qui avaient fui les combats. En raison de la violence du conflit, il était plus sûr de retourner à Goma en bateau plutôt qu'à pied. ▪ L'hôpital central de Goma ne disposait pas d'analgésiques pour calmer la douleur des patients. Cet homme a été blessé lors de l'offensive des rebelles, et sa jambe a dû être amputée. ▪ Chaque jour, les gens devaient se battre pour obtenir de la nourriture à Goma, où des gardes essayaient de contrôler la population qui voulait piller un dépôt de marchandises. En raison des combats qui faisaient rage dans la région, les organisations humanitaires n'avaient pas pu acheminer des biens de première nécessité. ▪ Après des semaines de combat dans et autour de Goma, la ville, aux mains des rebelles, n'était plus que ruines – les magasins avaient été pillés, et les déchets brûlaient dans les rues.

PAGE 107: Homme jouant de la guitare dans le camp de Mugunga. Il a trouvé cet instrument dans un camion abandonné par les soldats de l'ancien régime hutu, qui avaient fui dans les montagnes à l'approche des rebelles zaïrois. ▪ Dans un camp de transfert des Nations unies situé à proximité de Kigali, des milliers de Rwandais luttent pour trouver une place dans un camion qui les ramènera dans des régions reculées du pays. ▪ Retour des réfugiés à travers les montagnes rwandaises. Beaucoup ont préféré marcher de nuit pour éviter le soleil de plomb. ▪ Après une marche de deux semaines depuis le camp de réfugiés, Yolanda Mugeni de retour à Rhuengeri, Rwanda, étreignant sa belle-mère Angeline Iradukunda.

ZIV KOREN

STRIPPERINNEN AUS RUSSLAND Jessica und Lolita (ihre Bühnennamen) sind letztes Jahr nach Israel eingewandert, so wie fast 700000 weitere Russen seit der Liberalisierung in den Ländern der ehemaligen Sowjetunion. Jessica ist 19, Lolita 23 Jahre alt.

Die Massenimmigration führte zu Arbeitslosigkeit unter den Russen, was zur Folge hatte, dass viele junge Frauen, wie auch diese beiden, ihren Lebensunterhalt als Stripperinnen verdienen. Dadurch wurde in Israel eine Art von

Unterhaltungsindustrie ins Leben gerufen, die es zuvor nicht gegeben hatte und die ausschliesslich von den Russen kontrolliert wird. *Agent: Sygma/Publikation:* Yedioth Ahronoth

LES EFFEUILLEUSES DE RUSSIE Jessica et Lolita – leur nom d'artiste – ont émigré l'année dernière en Israël, à l'instar de quelque 7000 Russes depuis la libéralisation des pays de l'ex-Union soviétique. Jessica a 19 ans et Lolita en a 23.
Cette immigration massive, à l'origine d'un important chômage parmi les Russes, a conduit de nombreuses jeunes femmes comme Jessica et Lolita à ga-gner leur vie comme strip-teaseuses. Une industrie du sexe et du divertissement jusqu'alors inconnue en Israël est ainsi née dans ce pays. Cette industrie est entièrement entre les mains des Russes. *Agent: Sygma/Editeur:* Yedioth Ahronoth

DIE ERMORDUNG RABINS – EIN JAHR DANACH Ein Jahr nach der Ermordung des israelischen Ministerpräsidenten Yitzhak Rabin versammeln sich Menschen am Ort des Verbrechens, um eine Kerze anzuzünden. *Agent: Sygma/Publikation:* Yedioth Ahronoth

L'ASSASSINAT DE YITZHAK RABIN, UN AN APRÈS Un an après l'assassinat du Premier ministre israélien Yitzhak Rabin, la foule s'est rassemblée sur le lieu du crime pour allumer une bougie. *Agent: Sygma/Editeur:* Yedioth Ahronoth

ANTONIN KRATOCHVIL

DAS FEST VON ST. LAZARUS Jeders Jahr, kurz vor Weihnachten, pilgern Wallfahrer zum Fest des St. Lazarus in eine kleine Stadt ausserhalb Havannas.
Auf ihren Bäuchen kriechend, Felsblöcke an die Körper geschnallt, legen diese Männer grosse Distanzen zurück, in der Hoffnung, dass ihre Opfer und Qualen ihnen den Segen des heiligen St. Lazarus (Patron der Aussätzigen) bringen wird. Die Männer kommen aus kleinen Dörfern und kriechen mit ihren Lasten in eine Kirche, wo sie als Belohnung für die Qualen, die sie auf sich genommen haben, Heilung für ein krankes Familienmitglied oder einen kranken Freund erflehen. *Agent: Saba Photo Agency*
SEITEN 116-117: Die Kirche St. Lazarus in Rincon, Kuba.
SEITE 118: Eine Frau kriecht zur Kirche, daneben eine Statue des Heiligen Lazarus. ▪ Am Altar von St. Lazarus beten Pilger. ▪ Pilger mit Opfergaben für die Kirche St. Lazarus. ▪ Ein Pilger kriecht zur Kirche St. Lazarus. ▪ Pilger kriechen zur Kirche St. Lazarus.
SEITE 119: Auf den Stufen der Kirche bricht ein Pilger zusammen.

LA FÊTE DE SAINT-LAZARE Chaque année, peu avant Noël, des pèlerins se rendent à la fête de Saint-Lazare dans une petite ville aux abords de La Havane.
Des hommes, rampant à plat ventre et portant des blocs de roche sanglés à même le corps, parcourent de grandes distances dans l'espoir que leur sacrifice et leur douleur leur apporteront la bénédiction de Saint-Lazare. Partis de petits villages, ces pèlerins rampent avec leur fardeau júsque dans une église où ils demandent dans leurs prières qu'un membre de leur famille ou un ami proche soit délivré de sa maladie en échange de leur souffrance. *Agent: Saba Photo Agency*
PAGES 116-117: L'église de St.Lazare à Rincon, Cuba.
PAGE 118: Une femme rampe en direction de l'église à côté de la statue de St-Lazare. ▪ Des pèlerins prient à l'autel de St-Lazare. ▪ Des pèlerins font des offrandes à l'église de St-Lazare. ▪ Un pèlerin rampe en direction de l'église de St-Lazare. ▪ Des pèlerins rampant en direction de l'église de St-Lazare.
PAGE 119: Un pèlerin défaille sur les marches menant à l'église.

EIN PAAR GUTE MÄNNER: WEISSE RASSISTEN IM MILITÄR Anfang 1996 untersuchte die Zeitschrift *Esquire* die Story des gemeinen Soldaten Jim Burmeister und seiner Kameraden in Fort Bragg, North Carolina, die in ihren Baracken stolz das Hakenkreuz zeigen und an die Überlegenheit der weissen Rasse glauben. Die Armee hat diese Aktivität offenbar seit Jahren toleriert, bis eines Tages ein farbiges Paar in der Gegend ermordet aufgefunden wurde und Burmeister und einer seiner Kameraden, Malcolm Wright, die Hauptverdächtigen waren.
Der Mord führte zu unbequemen Fragen. «Was muss geschehen, damit man aus der Armee entlassen wird?» fragte *Esquire*. Wenn er homosexuell gewesen wäre, hätte man Burmeister sofort rausgeschmissen. Aber die politischen Extremisten profitieren von der Haltung des Militärs, keine Fragen zu stellen.
Der Photograph Antonin Kratochvil dokumentierte die Geschichte für die Zeitschrift. Alle in den Aufnahmen gezeigten Soldaten waren bei Erscheinen des Artikels aus der Armee entlassen worden, und zwar, wie *Espquire* berichtete, vor allem weil sie sich hatten photographieren lassen und nicht unbedingt wegen ihrer Aktivitäten als Skinheads. *Agent: Saba Photo Agency/Publikation:* Esquire
SEITEN 120-121: Bierabend von Neonazis in Fort Bragg, North Carolina.
SEITE 122: Bierabend von Neonazis in Fort Bragg, North Carolina.
SEITE 123: Bierabend von Neonazis in Fort Bragg, North Carolina. ▪ Jacken mit Nazi-Emblemen bei einem Bierabend in Fort Bragg. ▪ Bierabend von Neonazis in Fort Bragg, North Carolina. ▪ In der Kaserne von Fort Bragg grüsst ein Neonazi.

QUELQUES HOMMES DE BIEN: L'HÉGÉMONIE DE LA RACE BLANCHE DANS L'ARMÉE Au début de l'année 1996, le magazine *Esquire* a fait une enquête sur l'appointé Jim Burmeister et ses camarades de Fort Bragg, Caroline du Nord, qui montrent fièrement leur collection de croix gammées dans leurs baraquements et qui célèbrent l'hégémonie de la race blanche. L'armée a semble-t-il toléré cette activité des années durant, jusqu'au jour où un couple noir a été assassiné dans la région et que Burmeister et un de ses camarades, Malcolm Wright soient devenus les principaux suspects.
Cet assassinat soulève des questions vraiment alarmantes: *Esquire* s'interroge: «Mais que faut-il bien faire pour être expulsé de l'armée? Si Burmeister avait été homosexuel, il aurait été renvoyé immédiatement, et les vrais bénéficiaires de cette philosophie militaire du 'Ne pose pas de questions, ne dis rien' sont les extrémistes politiques.»
Le photographe Antonin Kratochvil a couvert cette histoire pour le magazine. Selon *Esquire*, tous les soldats soumis à l'enquête réalisée pour l'article, ont été «évincés» par l'armée principalement pour avoir été photographiés et pas nécessairement pour leur passé de skinhead. *Agent: Saba Photo Agency/ Publi-cation:* Esquire
PAGES 120-121: Soirée néonazie arrosée de bière à Fort Bragg, Caroline du Nord.
PAGE 122: Soirée néonazie arrosée de bière à Fort Bragg, Caroline du Nord.
PAGE 123: Soirée néonazie arrosée de bière à Fort Bragg, Caroline du Nord. ▪ Des vestes aux emblèmes nazis lors d'une soirée arrosée de bière à Fort Bragg. ▪ Soirée néonazie arrosée de bière à Fort Bragg, Caroline du Nord. ▪ Un partisan néonazi salue dans les quartiers de Fort Bragg.

REGIS LEFEBURE

ALCATRAZ Um Alcatraz ranken viele Geschichten. Im Bürgerkrieg war es Festung und Militärgefängnis, und in den 70er Jahren wurde es 19 Monate lang von amerikanischen Indianern besetzt in einem symbolischen Kampf für ihre Rechte. Die bekanntesten Geschichten nahmen 1934 ihren Anfang, als J. Edgar Hoover Alcatraz zum sichersten Gefängnis der USA machte. Ich hatte die Insel seit 1989 photographiert, als Edgar Rich vom *Smithsonian* Magazin vorschlug, die Geschichte über das frühere Staatsgefängnis mit Photos der berüchtigsten Insassen auszuschmücken. *Publikation:* Smithsonian
SEITE 124: Frank Morris zwischen den Brüdern Clarence und John Anglin. Sie hatten ihren Ausbruch sechs Monate lang vorbereitet. Sie machten Gipsabgüsse von ihren Köpfen, gruben sich mit Hilfe von Löffeln durch Wände und kletterten in diesem Korridor an Rohren hoch bis zu einer Lüftungsöffnung im Dach. Man nimmt an, dass alle ertrunken sind.
SEITE 125: Al Capone lächelt beim Kartenspiel im Zug während des ersten Gefangenentransports nach Alcatraz im Jahre 1934. Capone fungierte in Alcatraz als Hauswart: er hatte die Böden im Haupttrakt, Broadway genannt, zu reinigen. ▪ Alvin «Creepy» Karpis war der erste, den Präsident Hoover zum Staatsfeind Nr. 1 erklärte; er verbrachte 20 Jahre auf Alcatraz. ▪ George «Machine Gun» Kelley war bei allen Insassen sehr beliebt, galt vielen aber als nicht besonders intelligent. ▪ Robert Stroud, der «Flieger von Alcatraz»—gerissen, verschlagen, ein selbsternannter Pädophiler, der stets über Transplant-ationsschmerzen klagte und sieben Jahre isoliert in einer umgebauten Hospitalzelle verbrachte.

ALCATRAZ On ne compte plus les histoires au sujet d'Alcatraz, tant elles sont nombreuses. Forteresse datant de la Guerre civile qui a par la suite servi de prison militaire, elle fut assiégée en 1970 par des Indiens dont le geste symbolisait un combat pour le respect de leurs droits. L'histoire la plus connue débute en 1934, lorsque J.Edgar Hoover fait d'Alcatraz la meilleure prison des Etats-Unis. J'ai photographié cette île depuis 1989 quand Edgar Rich du magazine *Smithsonian* suggéra de prendre des photos des détenus les plus notoires d'Alcatraz pour illustrer un article sur cette ancienne prison fédérale. *Editeur:* Smithsonian
PAGE 124: Frank Morris flanqué de ses frères Clarence et John Anglin. Ils avaient élaboré un plan d'évasion pendant six mois: après avoir fait des moulages en plâtre de leurs têtes,

ils ont creusé des passages à travers les murs avec des cuillères, puis ils ont grimpé le long de la canalisation dans ce corridor jusqu'à une ouverture qui permettait d'accéder au toit. On suppose qu'ils sont tous morts noyés.

PAGE 125: Al Capone joue aux cartes et sourit alors qu'il se trouve dans le premier convoi de prisonniers en route pour Alcatraz en 1934. Al Capone était le «concierge» d'Alcatraz, il nettoyait les sols du bloc principal appelé «Broadway». ▪ Alvin «Creepy» Karpis était l'ennemi publique numéro 1 du président Hoover en personne. Il a passé 20 ans à la prison d'Alcatraz. ▪ George «Machine Gun» (mitraillette) Kelley était apprécié par la plupart des personnes à la prison, même si beaucoup d'entre elles pensaient qu'il n'était pas très futé. ▪ Robert Stroud, «l'homme-oiseau d'Alcatraz». Malicieux, l'esprit tordu et pédophile auto-proclamé, il a passé sept années d'isolement total dans une cellule d'hôpital modifiée, se plaignant de douleurs dues selon lui à une transplantation.

ROGER LEMOYNE

RUANDA: DER LANGE WEG ZURÜCK Bilder der Rückführung der ruandischen Hutu-Flüchtlinge aus Mugunga und anderen Flüchtlingslagern in Zaire – eine der längsten Völkerwanderungen der Geschichte. *Agent: Gamma-Liaison/Editeur: UNICEF*

SEITEN 126-127: Mutter und Kind.

SEITE 128: UNHCR-Busse. ▪ Fussabdrücke. ▪ Kekse. ▪ Feuer zum Kochen. ▪ Lastwagen in der Nähe von Ruhengeri. ▪ Auszug aus Mugunga.

SEITE 129: Die Zurückgelassenen. ▪ Verzweifeltes Kind in Mugunga.

RWANDA: LE LONG CHEMIN DU RETOUR Ces images illustrent le rapatriement des réfugiés hutus de Mugunga et d'autres camps de réfugiés au Zaïre – un des exodes les plus longs de l'histoire. *Agent: Gamma-Liaison/Editeur: UNICEF*

PAGES 126-127: Mère et son enfant.

PAGE 128: Bus du HCR. ▪ Empreintes de pas. ▪ Biscuits. ▪ Feux pour la préparation des repas. ▪ Camion dans les environs de Ruhengeri. ▪ Départ de Mugunga.

PAGE 129: Ceux qui sont restés. ▪ Enfant désespéré à Mugunga.

MARK LEONG

DAS ZURÜCKGELASSENE CHINA Im Jahre 1923 verliess mein Grossvater Fong Quong Zon das Dorf Soon Wall im Süden Chinas, um sein Glück in den USA zu suchen. Siebenundsechzig Jahre später kehrte ich in dieses Dorf in der Provinz Toisan im Herzen des Guangdong-Flussdeltas zurück. Obwohl unsere Familie seit drei Generationen in den USA lebte, wurde ich wie ein heimgekehrter Bruder aufgenommen. Fast jeder in Soon Wall hiess Fong. Ich musste nur sagen, «Ich bin der Enkel von Fong Quong Zon», und alle Türen standen mir offen.

Bei einem zweiten Besuch, den ich vor nicht langer Zeit unternahm, war ich überrascht, viele dieser Türen verschlossen und verriegelt vorzufinden. Das ehemals blühende Dorf war zu einem verfallenen Ort mit leeren Häusern und bröckelnden Mauern geworden, in dem nur noch einige ältere Leute und Kinder lebten. Die Bevölkerung, die sich seit ihrem Höchststand von 700 in den 30er Jahren nach und nach dezimiert hatte, war in den letzten fünf Jahren von 350 auf 120 geschrumpft.

Wo waren sie alle geblieben? Ein Cousin führte mich an den leeren Häusern vorbei und sagte 'San Francisco, Houston, Connecticut', während er auf die stillen Türen deutete.

In diesem Jahrhundert sind so viele Chinesen aus Dörfern wie Soon Wall in der Provinz Toisan nach Amerika ausgewandert, dass ihre Anzahl mittlerweile grösser ist als die Millionenbevölkerung dieser Provinz. Auf einer grossen Tafel in der Hauptstadt der Provinz stand einmal «Heimat der Übersee-Chinesen», bis auch diese Tafel verwitterte. *Agentur: Matrix/Publikation: The New York Times-Magazin*

SEITEN 130-131: Das Dorf Soon Wall liegt am Delta des Pearl Rivers in der südchinesischen Provinz Guangdong. Hügel und Felder trennen es von anderen Dörfern. Heute sind die 300 Jahre alten Bauernhäuser des Dorfes leer.

SEITE 132: Soon Wall bietet wenig Zerstreuung, deshalb verbringen die Dorfbewohner den Nachmittag damit, die Strasse zu beobachten. Junge Leute, die es nicht schaffen, nach Amerika auszuwandern, suchen sich Arbeit in den boomenden Städten Chinas, nicht nur um Geld zu verdienen, sondern auch, um der Langeweile zu entkommen.

SEITE 133: Verwandte aus Übersee helfen mit englischen Adress-Etiketten, die Korrespondenz zu erleichtern. ▪ Wände voller Schnappschüsse von Verwandten im Westen sind in Soon Wall und anderen Dörfern der Provinz keine Seltenheit. ▪ Der siebzigjährige Fong Ny Zong führt den einzigen Laden in Soon Wall, nachdem der Mangel an Kundschaft zwei andere Läden zum Schliessen veranlasste. In seinem Laden befindet sich einer der wenigen Eisschränke im Dorf; andere moderne

Errungenschaften wie Telephon, fliessendes Wasser und Autos sind nach wie vor eine Rarität. ▪ Die Schriftzeichen für «Soon Wall» bedeuten «sanfter Frieden». ▪ In Soon Wall wohnen fast nur noch alte Leute und Kinder, weil die meisten jungen Leute das Dorf verlassen haben, um in den Vereinigten Staaten oder einer der boomenden Städte Chinas zu arbeiten. ▪ Schnappschüsse von Elaine Fong und ihrer Familie, die in San Francisco lebt, an der Küchenwand ihrer Mutter in Soon Wall. Elaine (in der Mitte mit ihrem Mann) hat gerade die amerikanische Staatsbürgerschaft erhalten und hofft, dass sie ihre Mutter im nächsten Jahr zu sich holen kann.

SEITE 134: Die wenigen jungen Männer, die im Dorf geblieben sind, finden Arbeit auf Baustellen in nahegelegenen Städten. Hier beträgt der durchschnittliche Monatslohn US$ 25.00, während man in Fabriken in Städten wie Guangzhou und Shenzhen $45.00 pro Monat verdient. ▪ Am Totengedenktag besuchen die Einwohner von Soon Wall die Grabstellen ihrer Familenangehörigen in den umliegenden Hügeln. Zum Ritual gehören die Darbietung von gebratener Ente, Reiswein, hartgekochten Eiern, Zuckerrohr und Reiskuchen. Zu diesem Fest Ende März und Anfang April kehren auch die Fortgezogenen in ihr Dorf zurück. ▪ Diese Kuh wurde zum Pflügen gekauft, und zwar mit Geld, das ein in den vierziger Jahren ausgewanderter Verwandter, der jetzt ein Restaurant in Chicago besitzt, geschickt hatte. ▪ Mit Weihrauch wird den Vorfahren mitgeteilt, dass ihre Abkömmlinge aus dem Ausland zurückgekehrt sind, um ihre Familie zu besuchen. ▪ Ein Kind und seine Grossmutter bleiben in Soon Wall. Sie warten darauf, dass der Vater reich wird und sie in die grosse Stadt holt.

SEITE 135: 1934 liess sich mein Grossvater in Chicago nieder und schickte nach meiner Grossmutter. Da er noch nicht amerikanischer Staatsbürger war, gab sie einem Mann aus einem nahegelegenen Dorf, der die notwendigen Papiere besass, Geld dafür, dass sie als seine Tochter mit ihm reisen durfte. Sie hatte einen Zettel mit Einzelheiten über ihr angebliches Zuhause bei sich, den sie für das Gespräch mit den Einwanderungsbehörden auswendig lernte. ▪ Das Haus meines Urgrossvaters steht seit den 40er Jahren leer. Damals ist der Rest der Familie aus China geflohen, um dem kommunistischen Regime zu entkommen.

LA CHINE DES SOUVENIRS En 1923, mon grand-père Fong Quong Zon a quitté le village de Soon Wall situé au sud de la Chine pour tenter sa chance aux Etats-Unis. Soixante-sept ans plus tard, j'ai décidé de retourner dans ce hameau du comté de Toisan, au cœur du delta de la rivière des Perles, dans la province de Quangdong. Bien que ma famille soit installée aux Etats-Unis depuis trois générations, les habitants du village m'ont accueilli comme un frère. Il faut dire qu'à Soon Wall, presque tout le monde s'appelle Fong. Il me suffisait donc de dire «je suis le petit-fils de Fong Quong Zon» pour que les portes s'ouvrent aussitôt.

Pourtant, lors de ma deuxième visite, j'ai été surpris de voir bon nombre de ces portes fermées. Autrefois très animé, Soon Wall offrait le triste spectacle d'un village aux maisons abandonnées et aux murs en ruine, peuplé uniquement de vieillards et d'enfants. Depuis 1930, date à laquelle le village comptait 700 habitants, la population a régulièrement diminué, passant de 350 à 120 personnes durant les cinq dernières années.

Où étaient-ils tous passés? Un cousin me guida dans le dédale des maisons vides, récitant une litanie de villes américaines – San Francisco, Houston, Connecticut – au fur et à mesure que nous passions devant les portes closes.

Le nombre de personnes ayant quitté au cours de ce siècle des villages comme Soon Wall pour émigrer aux Etats-Unis est si élevé qu'il dépasse aujourd'hui celui de la population de Toisan, qui compte un million d'habitants.

Un panneau du comté affichait autrefois «Patrie des Chinois d'outre-mer» avant qu'il ne devienne, lui aussi, décrépi. *Agent: Matrix/Editeur: The New York Times Magazine*

PAGES 130-131: Dans la province de Guangdong, au sud de la Chine, se trouve le village isolé de Soon Wall, dans le delta de la rivière des Perles. Les collines et les champs le séparent des autres villages. Aujourd'hui, 300 fermes du village sont abandonnées.

PAGE 132: Les distractions à Soon Wall sont rares. Pour cette raison, les villageois passent leurs après-midi à observer la rue. Les jeunes qui n'ont pas la possibilité de se rendre aux Etats-Unis s'installent dans les grands centres urbains de la Chine, à la fois pour chercher du travail et à échapper à l'ennui.

PAGE 133: Des parents vivant à l'étranger fournissent des étiquettes d'adresses en anglais pour faciliter la correspondance. ▪ A Soon Wall et dans les autres villages de la province, les habitants ont pour habitude de recouvrir les murs de leur maison avec des photos de parents vivant en Occident. ▪ Le septuagénaire Fong Ny Zong tient le

dernier magasin de Soon Wall après que les deux autres commerces du village ont dû fermer boutique en raison du manque de clientèle. Son magasin est équipé de l'un des rares frigidaires du village. D'autres commodités, comme le téléphone, l'eau courante et les voitures, sont un luxe à Soon Wall. ■ Les caractères de «Soon Wall» signifient «douce paix». ■ Seuls des personnes âgées et des enfants habitent encore à Soon Wall, la plupart des jeunes ayant quitté le village pour aller travailler aux Etats-Unis ou dans les villes en plein essor de la Chine. ■ Des photos d'Elaine Fong et de sa famille, qui vit à San Francisco, ornent les murs de la cuisine de sa mère. Elaine (au milieu avec son mari) vient d'obtenir la nationalité américaine et espère pouvoir faire entrer sa mère aux Etats-Unis l'année prochaine.

PAGE 134: Les quelques jeunes hommes restés au village trouvent du travail sur les chantiers en construction des villes avoisinantes. Dans la région, le salaire moyen d'un travailleur s'élève à US$ 25.–, tandis que dans les fabriques de Guangzhou et de Shenzhen, les ouvriers gagnent US$ 45.– par mois. ■ A l'occasion de la journée des Morts, les habitants de Soon Wall se rendent sur les tombes de leurs parents dans les collines avoisinantes. Les offrandes de canard rôti, de saké, d'œufs durs, de canne à sucre et de gâteaux de riz font partie du rituel. Les anciens habitants du village retournent à Soon Wall pour ces cérémonies qui ont lieu fin mars et début avril. ■ Cette vache a été achetée pour labourer les champs. Un parent qui a émigré à Chicago dans les années 40 et qui possède aujourd'hui un restaurant a financé son achat. ■ Des villageois (à gauche) regardent des cousins venus de Chicago (à droite) faire une offrande extravagante, un cochon rôti, sur les tombes de leurs aïeux, situées dans les collines des environs de Soon Wall. Une partie de la viande est déposée sur les tombes, et le reste est réparti entre les habitants du village. ■ En brûlant de l'encens, les anciens habitants du village qui ont émigré aux Etats-Unis font savoir à leurs ancêtres qu'ils sont revenus de l'étranger pour rendre visite à leur famille. ■ Enfant et sa grand-mère restés au village de Soon Wall. Ils attendent que le père de famille fasse fortune pour le rejoindre dans la grande ville.

PAGE 135 : En 1934, mon grand-père est parti pour Chicago. Comme il ne possédait pas encore la nationalité américaine, ma grand-mère a payé un homme d'un village voisin pour qu'il lui délivre des papiers stipulant qu'elle était sa fille et qu'elle avait l'autorisation de voyager avec lui. Elle portait sur elle un papier avec tous les détails de son domicile supposé, dont elle a appris le contenu par cœur pour passer l'entretien avec les autorités d'immigration américaines. ■ La maison de mon arrière-grand-père est abandonnée depuis les années 40. A cette époque, le reste de la famille a fui la Chine pour échapper au régime communiste.

JACK LUEDERS-BOOTH

FAMILIEN, DIE VON DER MÜLLKIPPE VON TIJUANA LEBEN. Eine Reihe, die zwischen 1991 und 1997 entstanden ist.
Ich photographiere seit 1991 auf den Müllhalden und in den barrios von Tijuana, Mexiko, jeweils mehrere Wochen im Jahr. Ich beabsichtige, die Arbeit fortzusetzen und noch 1997 wiederzukommen.
Durch das Vertrauen, das ich habe gewinnen können, bekam ich tiefen Einblick in das Leben dieser Gemeinschaft, die nicht nur den meisten Amerikanern, sondern auch den meisten Mexikanern unbekannt ist. Es sind sehr einfallsreiche Menschen, die sich geschickt durch den Müll wühlen und gegen Pfand einlösbare Dosen und Flaschen, reparierbare Möbel und Spielsachen und (manchmal) auch Essbares finden. Angesichts wirtschaftlichen und medizinischen Notstands ist ihr Sinn für klare Ziele, Spiritualität, Familie und Grosszügigkeit stark ausgeprägt. Ich war überrascht, als ich feststellte, dass sie ein bestimmtes Gebiet der Müllhalde aus eigenem Antrieb den Älteren und Behinderten überlassen haben, wo diese ohne Konkurrenz von den Tüchtigeren nach Brauchbarem suchen können. Immer wieder beeindruckt haben mich die vielen Beispiele der Selbstlosigkeit, des Gemeinschaftssinnes und der Zuversicht dieser Menschen, für die Kindersterblichkeit, Unterernährung, chronische Krankheiten, schlechte Behausung und Bekleidung alltäglich sind. Viele von ihnen beginnen nun, mit meinen Aufnahmen ihrer Familie ein Photoalbum anzulegen. Ich fühle mich geehrt.

LES DÉCHARGES DE TIJUANA. Série de photographies prises entre 1991 et 1997.
J'ai eu l'occasion de photographier les décharges et les bidonvilles de Tijuana, Mexique, au cours de séjours de plusieurs semaines faits chaque année depuis 1991. J'ai l'intention de continuer mon entreprise et d'y retourner à la fin de l'année 1997. Grâce à la confiance que l'on m'a accordée, j'ai pu accéder à l'intérieur de la communauté de façon tout à fait privilégiée, puisque celle-ci reste en effet inconnue de la plupart des Américains, mais aussi de la plupart des Mexicains. Les membres de cette communauté sont ingénieux; ils fouillent dans les tas d'ordures de manière habile à la recherche de boîtes de conserves et de bouteilles qui sont encore bonnes à vendre, de meubles qui peuvent être restaurés, jouets pour leurs enfants que l'on peut encore réparer, et quelquefois de la nourriture encore comestible pour eux-mêmes. Ils sont confrontés à une situation économique désastreuse et à un système médical catastrophique, mais ils ont développé un sens aigu pour la finalité, la spiritualité, la famille et la générosité. J'étais très étonné de voir que les membres de cette communauté avaient volontairement délimité un secteur de la décharge réservé aux plus vieux et aux plus faibles d'entre eux pour que ceux-ci puissent tranquillement se servir dans les poubelles sans devoir rivaliser avec ceux qui sont en meilleure santé. J'observe quantité d'autres exemples du profond altruisme dont ils font preuve, de l'esprit de communauté et de leur optimisme, ce qui m'impressionne beaucoup. Surtout parce que la mortalité infantile, la malnutrition, les maladies chroniques, les logements et les habits d'infortune sont leur lot quotidien. Beaucoup d'entre eux utilisent mes photos pour commencer leur album de famille, ce qui m'honore beaucoup.

NORMAN MAUSKOPF

A TIME NOT HERE Der aus Brooklyn, New York, stammende Photograph Norman Mauskopf lebt heute in Santa Fe, New Mexico. 1992 reiste er zum ersten Mal nach Mississippi. Er wollte ursprünglich etwas für einen Zeitschriftenartikel über Country-Blues-Musiker und ihre Musik machen, und er fuhr nach Oxford und dann nach Clarksdale und Städte der Umgebung, die einst Synonym für Delta Blues waren.
Bald aber packte ihn der Rhythmus des täglichen Lebens in Mississippi derart, dass er sich stattdessen mit ausgiebig abgelegenen Kirchen, den Gottesdiensten und der Gospel-Musik befasste. Nach drei Jahren und einigen hundert Metern Film hatte er ein umfassendes Porträt dieses religiösen und kulturellen Lebens im ländlichen Mississippi beisammen. Eine umfangreiche Auswahl der Bilder wurde mit einem bemerkenswerten Text von Randal Kennan in dem preisgekrönten Buch *A Time Not Here* (Twin Palms/Twelve Trees Press) veröffentlicht.

A TIME NOT HERE Originaire de Brooklyn, New York, le photographe Norman Mauskopf vit actuellement à Santa Fé, au Nouveau-Mexique. Il a entrepris une série de voyages dans le Mississippi où il est parti pour la première fois en 1992. Il est allé là-bas avec la ferme intention d'écrire un article sur le country blues et ses musiciens, c'est pourquoi il est parti à Oxford, en passant par Clarksdale et les villes environnantes: des endroits qui jadis étaient synonymes de delta blues.
Tout de suite attiré par les rythmes ambiants qui bercent le quotidien du Mississippi, il a commencé à faire des prises de vue d'églises peu connues, de l'intérieur et de l'extérieur, ainsi que d'offices religieux et de chanteurs de gospel. Trois ans et quelques centaines de films plus tard, il possédait un portrait très complet de cet aspect de la vie religieuse et culturelle de la campagne du Mississippi. Un grand nombre de photos accompagnées de textes expressionnistes écrits par Randal Kennan ont été publiés dans l'ouvrage primé *A Time Not Here* (Twin Palms/Twelve Trees Press).

STEVE MCCURRY

FISCHER, SRI LANKA Wie seltsame Reiher sehen diese Männer aus, die, in ihre traditionellen Sarams gekleidet, auf Holzstangen hocken, um hier an der Südküste Sri Lankas zu fischen. Vor nicht allzulanger Zeit sah es ganz so aus, als würde dieser Inselstaat am wirtschaftlichen Boom Asiens teilhaben können, aber 13 Jahre Unfrieden und ethnische Konflikte haben die Entwicklung gelähmt, so dass viele Menschen auf Sri Lanka noch heute mit den Methoden ihrer Vorfahren das Land bestellen oder fischen. *Agentur: Magnum Photos, Inc./Publikation:* National Geographic, *Washington, D.C.*

PÊCHEURS, SRI LANKA Tels d'étranges hérons juchés sur de longues perches en bois, ces hommes vêtus de leur traditionnel *saram* pêchent dans les eaux de la côte sud du Sri Lanka. Il n'y a pas si longtemps, tout laissait croire que l'île allait participer au boom économique de l'Asie, mais 13 ans de troubles et de conflits ethniques ont paralysé le développement. Aujourd'hui, une grande partie de la population continue à pêcher et à travailler la terre avec des méthodes ancestrales. *Agent: Magnum Photos, Inc./Editeur:* National Geographic, *Washington, D.C.*

JOHN MOORE

DER KLEINE LAMA Der vierjährige Trulku-la ist in vieler Hinsicht wie jeder andere Junge seines Alters. Er ist verspielt – glücklich über eine Fahrt in einem roten Wagen –, aber auch wild, und er bringt es durchaus fertig, seinem Kindermädchen beim

Anziehen ein Spielzeug an den Kopf zu werfen. Aber da enden auch schon die meisten Gemeinsamkeiten Trulku-las mit anderen Jungen. Die tibetanischen Buddhisten sehen in ihm Deshung Rinpoche IV, die Reinkarnation eines hohen Lama, der 1987 in Seattle, Washington, starb.

Deshung Rinpoche III verkündete seinen Schülern vor seinem Tod, dass er in der Gegend von Seattle wiedergeboren werden würde. Als Sonam Wangdu in dieser Stadt geboren, wurde der Junge in Trulku-la umbenannt, was auf Tibetanisch «Reinkarnation» bedeutet. Im Alter von zwei Jahren wurde er in einer Zeremonie, der 4000 Menschen beiwohnten, formell gekrönt. Unter der Obhut von 38 Mönchen eines Klosters in Katmandu, Nepal, wird er sich eingehend mit verschiedenen Wissensgebieten befassen, mit Medizin, der tibetani-schen Sprache und dem Buddhismus. Später wird er dem Kloster einmal vorstehen. *Agentur: The Associated Press*

SEITE 154: Sonam Wagdu, der jetzt Trulku-la heisst, wird weitergezogen, während andere junge Mönche des Klosters Tharlam in Katmandu, Nepal, zuschauen.

SEITE 155: Trulku-la ruht neben einer Buddha-Statue im Kloster Tharlam in Katmandu. ■ Trulku-la haut seinem Kindermädchen ein Spielzeug auf den Kopf, während sie ihn ankleidet.

LE PETIT LAMA Trulku-la a quatre ans et ressemble, à bien des égards, aux autres enfants de son âge. Ce petit garçon espiègle – ravi de faire un tour dans sa voiture rouge – s'amuse à cogner sur la tête de sa nourrice avec un jouet lorsqu'elle l'habille. Mais c'est ici que s'arrête la comparaison avec les autres enfants. Les bouddhistes tibétains voient en lui Deshung Rinpoche IV, la réincarnation d'un grand lama décédé en 1987 à Seattle, Washington.

Peu avant sa mort, Deshung Rinpoche III a annoncé à ses disciples qu'il se réincarnerait dans la région de Seattle. Et c'est précisément dans cette ville qu'est né le petit Sonam Wangdu, rebaptisé par la suite Truklu-la, ce qui signifie «réincarnation» en tibétain. À l'âge de deux ans, il a été intronisé officiellement lors d'une cérémonie à laquelle assistaient 4000 personnes. Aujourd'hui, 38 moines lui enseignent des matières très diverses qui vont de la médecine à la langue tibétaine en passant par le bouddhisme dans un monastère de Katmandou au Népal, qu'il dirigera à la fin de sa formation. *Agent: The Associated Press*

PAGE 154: Sonam Wagdu, rebaptisé Truklu-la, est tiré en avant, tandis que d'autres jeunes moines du monastère de Tharlam à Katmandou, Népal, le regardent.

PAGE 155: Truklu-la se reposant près d'une statue de Bouddha dans le monastère de Tharlam à Katmandou. ■ Truklu-la tapant sur la tête de sa nourrice avec un jouet pendant qu'elle l'habille.

VIVIAN MOOS

DER MISS-WORLD-FAT-WETTBEWERB «Man sollte stolz auf seine Pfunde sein» war das Motto am Sonntag, 19. März, in Couvour, einem kleinen italienischen Dorf bei Turin. Vierundzwanzig Männer und fünf Frauen aus Italien, Deutschland und den USA bewarben sich um die Titel des Mister bzw. der Miss World Fat. Zusammen brachten sie 4044 kg auf die Waage, was einem Durchschnittsgewicht von 130,4 kg entspricht.

Im Jahre 1948 hatte Giovanni Genovesio, der stattliche Besitzer der Locanda La Posta, einem Lokal, das seit 1720 existiert und für gutes Essen bekannt ist, einige seiner korpulenten Freunde um sich versammelt, und gemeinsam beschlossen sie aufzuhören, sich für ihre Körperfülle zu entschuldigen. Der Wirt organisierte einen Wettbewerb, bei dem es darum ging, wer nach einem opulenten Mahl am meisten Gewicht zugelegt hatte. Daraus wurde ein äusserst erfolgreicher Anlass, und jedes Jahr strömten Leute von nah und fern herbei, um daran teilzuhaben. Von 1967 bis 1970 gewann Margherita Cauda, eine Frau aus Turin, dank ihrer unschlagbaren 229 kg den Titel viermal in Folge. Die Locanda La Posta wurde zum Treffpunkt für die Dicken, aber aus irgendeinem Grund hörte man 1971 mit dem Wettbewerb auf.

In diesem Jahr haben Antonella und Giovanni, Genovesios Enkelkinder, zusammen mit ihren Eltern, die weiterhin für den ausgezeichneten kulinarischen Ruf des Gasthauses sorgen, den Brauch wieder aufleben lassen.

Zum ersten Mal gewann eine Teilnehmerin aus den USA: die 41jährige Nancy Esposito aus Queens, New York, wurde mit 161 kg zur Miss World Fat 1996 gekürt. Sie schlug Angela Masini, eine italienische Film- und TV-Schauspielerin aus Alessandria, die Miss Fat Italiens aus dem Jahre 1995.

Rennar und Diane, ein Ehepaar aus den USA, das Mode für füllige Frauen entwirft, präsentierte eine elegante Modenschau. Zu diesem Zweck hatte man auf dem Dorfplatz einen Laufsteg errichtet, vor dem sich ein grosses Publikum jeden Alters und Geschlechts drängte. *Agentur: Saba Photo Agency*

SEITE 156: Wettbewerbsteilnehmer vor La Posta in Cavour, Italien. ■ Die Göttinnen veranstalten eine Wäsche-Modeschau im Café 44 in New York. ■ Nancy Esposito, Miss World Fat 1996. ■ Nancy beim Körpertraining im YMCA in Long Island, New York.

SEITE 157: Angela Masini, die italienische Miss Fat 1995, auf der Waage in Cavour.

SEITE 158: Nancy wird für eine Modeschau von Rennar, New Jersey, zurechtgemacht. ■ Nancy probiert in Rennar's Boutique Hosen an. ■ Nancy als Miss World Fat 1996. ■ Maria LaBanca und Angela Masini im Sportclub von Palmira, Italien. ■ Die Göttinnen veranstalten eine Wäsche-Modeschau im Café 44 in New York. ■ Nancy beim Körpertraining im YMCA in Long Island, New York.

SEITE 159: Nancy beim Körpertraining im YMCA in Long Island, New York. ■ Erschöpft lässt sich Nancy ihre Füsse von Pat, Modell und Freundin, massieren.

L'ÉLECTION DE MISS WORLD FAT «Gros et fier de l'être», tel était le mot d'ordre en ce dimanche 19 mars dans le petit village de Cavour, situé près de Turin en Italie. Venus d'Italie, d'Allemagne et des Etats-Unis, vingt-quatre hommes et cinq femmes ont concouru pour les titres de Mister Fat et de Miss Fat. Ensemble, ils totalisaient un poids de 4'044 kilos, soit une moyenne de quelque 139 kilos chacun.

Flash-back. En 1948, Giovanni Genovesio, propriétaire bedonnant de la Locanda La Posta, une auberge fondée en 1720 et réputée pour son excellente cuisine, réunit quelques-uns de ses amis bien «enrobés» et leur déclara qu'il n'y avait aucune honte à être gros. Il organisa donc un concours afin de voir lequel d'entre eux engraisserait le plus au terme d'un repas gargantuesque. Cette ma-nifestation rencontra un tel succès que le nombre de participants venus des quatre coins du monde ne cessa de croître. Durant quatre années consécutives, soit de 1967 à 1970, Margherita Cauda, originaire de Turin, fut la championne incontestée avec un poids de 229 kilos. Bien que devenue célèbre en tant qu'auberge pour personnes obèses, la Locanda La Posta n'organisa plus ce concours à partir de 1971 et ce, pour une raison inconnue.

Grâce à Antonella et à Giovanni, petits-enfants de Genovesio, et à leurs parents, qui ont su perpétuer la tradition culinaire de l'auberge, le concours a de nouveau eu lieu cette année.

Pour la première fois, une Américaine y a pris part. Agée de 41 ans, Nancy Esposito de Queens, New York, a été élue Miss World Fat 1996 avec un poids de 161 kilos. Elle a devancé Angela Masini, une actrice italienne de cinéma et de télévision originaire d'Alexandrie, qui détient le titre de Miss Fat of Italy 1995.

Rennar et Diane, un couple de créateurs américains, ont organisé un élégant défilé de mode pour les femmes pesant plus de 90 kilos. C'est avec superbe qu'elles ont défilé sur un podium installé au centre du village où se tenait une foule nombreuse. *Agent: Saba Photo Agency*

PAGE 156: Participants au concours de La Posta à Cavour, Italie. ■ Les Déesses organisant un défilé de lingerie dans le Café 44 à New York. ■ Nancy Esposito, Miss World Fat 1996. ■ Nancy s'entraînant au YMCA à Long Island, New York.

PAGE 157: L'Italienne Angela Masini, Miss Fat 1995, sur le pèse-personnes à Cavour.

PAGE 158: Préparation de Nancy pour un défilé de mode de Rennar, New Jersey. ■ Nancy essayant des pantalons dans la boutique Rennar. ■ Nancy a gagné le titre de Miss World Fat 1996. ■ Maria LaBanca et Angela Masini dans le centre de remise en forme de Palmira, Italie. ■ Les Déesses organisant un défilé de lingerie dans le Café 44 à New York. ■ Nancy s'entraînant au YMCA à Long Island, New York.

PAGE 159: Nancy s'entraînant au YMCA à Long Island, New York. ■ Epuisée, Nancy se fait masser les pieds par son amie Pat, un mannequin.

JERRY NAUNHEIM, JR.

BOSNIENS KINDER Oft wird mir von anderen Photographen vorgeworfen, dass ich so viele Aufnahmen von Kindern mache. In den Augen eines «ernsthaften» Photojournalisten sind Kinder ein leichtes Sujet. Selbst ein Warenhaus-Photograph kann ein niedliches Photo von einem Baby machen. Sie nennen meine Aufnahmen «Jerrys Kids», und mir gefällt dieser Titel.

Das erste Bild dieser Serie zeigt ein kleines Mädchen, durch Stacheldraht gesehen, der die Luftwaffenbasis in Tuzla, Bosnien, umgibt. Hinter diesem Zaun befindet sich der wahrscheinlich sicherste Ort in ihrem Land – ein US Militär-Komplex mit einigen der besten Soldaten der Welt, alle eingeschworene Kämpfer für den Frieden. Das Mädchen jedoch bleibt in der Kälte, der Zaun sperrt sie aus – sie bleibt in Gefahr.

Sie teilt das Schicksal vieler anderer moslemischer Flüchtlinge: ihr Vater, ihre Grossväter, Onkel und älteren Brüder, die versuchten, sie zu schützen, wurden getötet. Vielleicht sind sie im Kampf gefallen, vielleicht aber wurden sie auch wie viele Tausend Männer und Knaben der Zivilbevölkerung in Lagern zusammengepfercht und hingerichtet.

Was kann ich aber über sie erzählen, was man nicht selbst mit eigenen Augen sieht? Meine Aufgabe als Photojournalist ist es, Ihnen, den Lesern, zu helfen, die Dinge zu sehen und zu fühlen, die ich gesehen und gefühlt habe – das Leben eines Kindes aus einer anderen Welt, dargestellt in einer 1/250stel Sekunde. *Publikation:* St. Louis Post Dispatch

SEITE 160: Ich hatte Soldaten eines Konvois durch die Strassen von Tuzla begleitet. Sie sollten Leute nach Waffen untersuchen und Propaganda verteilen. Es war einer der ersten Konvois in die Stadt. Beim Anblick der beiden Jungen, die ihn misstrauisch beobachteten, sprang der 31jährige Capt. Tracy Ludgood aus St. Louis mit seiner M-16 aus dem Fahrzeug. Die Jungen zögerten. Ist das ein guter oder ein schlechter Soldat? Die Entscheidung eines Erwachsenen. Innerhalb von Sekunden waren sie jedoch wieder Kinder, die herumrangelten und eine Schau abzogen.

SEITE 161: Als der erste amerikanische Panzer den Sava-Fluss nach Bosien überquerte, schien dieser Junge sich nicht bewusst zu sein, dass eine schwer bewaffnete fremde Macht in sein Land einmarschierte. Er stieg weiter den kleinen Hügel hinauf, um dann herunter zu rutschen. ■ Ein bosnisches Mädchen am Stacheldraht, der die US-Basis in Tuzla umgibt.

LES ENFANTS BOSNIAQUES Souvent, les autres photographes ne comprennent pas que je fasse tant de photos d'enfants. Aux yeux d'un photoreporter «sérieux», les enfants sont un sujet facile. Même un photographe de grand magasin peut faire de jolies photos de bébés. Ils appellent mes images «Jerry's Kids» – les gosses de Jerry –, un titre qui me plaît.

La première image de cette série montre une petite fille à travers les barbelés qui entourent la base aérienne de Tuzla, en Bosnie. Cet endroit est sans doute le lieu le plus sûr de son pays – un complexe militaire américain où se trouvent des soldats parmi les mieux entraînés du monde, tous de farouches gardiens de la paix. Mais la petite fille reste derrière la barrière, exposée au danger et dans le froid.

Elle partage le sort de nombreux réfugiés musulmans: son père, ses grands-parents, son oncle et ses frères aînés qui ont tenté de la protéger ont été tués. Peut-être sont-ils morts dans la bataille, à moins qu'ils n'aient été déportés et exécutés dans un camp comme des milliers d'hommes et de jeunes de la population civile.

Mais que dire de cette fillette quand on ne l'a pas vue de ses propres yeux? Mon devoir en tant que photoreporter est d'aider le public à voir et à sentir les choses que j'ai vues et ressenties – la vie d'un enfant d'un autre monde, représentée en un 250e de seconde. *Editeur:* St. Louis Post Dispatch

PAGE 160: J'avais accompagné un convoi de soldats à travers les rues de Tuzla. Ils devaient fouiller les gens pour voir s'ils portaient des armes et faire de la propagande. Ce fut l'un des premiers convois qui sillonna la ville. Comme deux garçons le regardaient d'un air méfiant, le capitaine Tracy Ludgood de Saint Louis, 31 ans, sauta du camion avec son M-16. Les deux jeunes gens hésitèrent un instant, se demandant si c'était un bon ou un mauvais soldat – une réaction d'adulte. Mais en l'espace de quelques secondes, les deux jeunes gens redevinrent des enfants, se bagarrant et faisant les pitres.

PAGE 161: Lorsque le premier char américain traversa le fleuve Sava, ce garçon bosniaque ne sembla pas réaliser qu'une puissance étrangère très bien armée entrait dans son pays. Il continua à grimper sur la colline pour se laisser glisser ensuite le long de la pente. ■ Fillette bosniaque près des barbelés entourant la base américaine de Tuzla.

WILL VAN OVERBEEK

BARTON SPRINGS Barton Springs, ein natürliches Schwimmbecken in der Stadt Austin, Texas, ist Gegenstand einer Umweltdiskussion in der Region. Die einen wollen die Bodenschichten erhalten, die die Grundwasserquelle speisen, aber die wirtschaftliche Entwicklung und die damit verbundene Bautätigkeit sind eine Gefahr für diese empfindlichen Bodenschichten.

Während der ökologische Kampf im Gange ist, habe ich mich dafür interessiert, wie der Ort heute genutzt wird: hier spielen Kinder und Teenager – sie geniessen das klare, kühle Wasser unter der heissen Sonne von Texas.

BARTON SPRINGS Barton Springs, un bassin naturel situé dans la ville de Austin, Texas, suscite maintes controverses dans la région. Les écologistes veulent à tout prix préserver l'aquifère qui alimente les sources, un terrain menacé par le développement économique et les nouvelles constructions.

Tandis que la bataille écologique faisait rage, je me suis intéressé à l'utilisation que l'on fait de cet endroit: des enfants et des adolescents y jouent, appréciant la fraîcheur de l'eau sous le soleil de plomb du Texas.

GREG PEASE

CLYDE BEATTY-COLE BROTHERS CIRCUS Im Sommer 1996 nahm mich ein Verleger unter Vertrag, der ein Buch mit Amerikana plante. Die Photographen sollten etwas aus dem amerikanischen Leben festhalten. Ich dachte zunächst an den obligaten Apple Pie, Baseball, 57er Chevrolets, Cowboys und Indianer. Ich hing gerade meinen Gedanken nach, als meine Frau aus dem Nebenzimmer rief: «Der Zirkus kommt, mit grossem Zelt! Alle sind eingeladen, morgen früh den Elefanten beim Aufrichten des Zelts zuzusehen».

Es war noch dunkel, als ich auf dem grossen Parkplatz im Norden Baltimores anlangte. Auf einem Abschnitt in der Ferne standen ein Dutzend Lastwagen. Die Sonne ging auf, und es erhob sich der Lärm erwachender Aktivitäten, als ein stetiger Strom von neunachsigen Sattelschleppern, Wohnmobilen und Autos von Schaulustigen am Horizont auftauchte. Ein geschäftiges hundertköpfiges Heer begann, Zeltplanen auszurollen, Taue zu zurren und Pfähle einzurammen. Nach wenigen Stunden stand das grosse Zelt, die Vorstellung konnte beginnen. Ich arbeitete mich durch die Menschenmassen, die in die geheimnisvolle, sepiabraune Welt unter dem Zeltdach strömten. In der ersten Manege gab es durch Reifen springende Löwen, in der zweiten Hochseilakte, in der dritten Akrobaten. Ein Zug von Elefanten und Clowns marschierte rundherum. Es folgten Jongleure, Trapezkünstler, Pferde und Tiger. Zum grossen Finale schoss eine gewaltige silberne Kanone eine menschliche Kugel drei Stock-werke hoch und 60 m weit durch das Zelt. Es gab donnernden Applaus.

Am dritten Tag, nach der letzten Vorstellung, wurde mir klar, dass dies erst der Anfang meiner Reportage war: der Zirkusdirektor kam lächelnd auf mich zu und drückte mir einen Zettel mit der Wegbeschreibung zum nächsten Veranstaltungsort in die Hand. Ich packte meine Sachen und folgte der Vielvölkerkarawane südwärts nach Virginia. Beim ersten Tageslicht fand ich mich auf einer grossen Wiese mit hohem Gras wieder, die von sanften Hügeln umgeben war. Noch einmal drei Tage mit täglich drei Vorstellungen. Ach, das Leben ist ein Zirkus mit drei Manegen.

SEITE 164: Hochseilakt.

SEITE 165: Das grosse Finale der Elefantennummer im Panorama. ■ Der Mann, der aus Welt grösster Kanone abgeschossen wird.

SEITE 166: Zirkusclown.

SEITE 167: Elefanten beim Aufrichten des grossen Zelts. Die Handlanger beim Sichern der Taue, im Hintergrund spielende Elefanten.

LE CIRQUE CLYDE BEATTY - COLE BROTHERS Je fus contacté en été 1996 par un éditeur travaillant sur un ouvrage concernant les faits, lieux et personnages historiques symbolisant les Etats-Unis. On demandait aux photographes de faire un cliché représentatif de l'Amérique. J'ai tout de suite pensé à l'incontournable tourte aux pommes, au baseball, aux '57 Chevys, aux cowboys et aux indiens. Alors que j'étais perdu dans mes pensées, ma femme qui se trouvait dans l'autre pièce me dit: «Le cirque va venir prochainement! Ça se passera sous le grand chapiteau. Le public est invité à voir les éléphants dresser le grand chapiteau à l'aube.»

Il faisait déjà noir lorsque je suis arrivé au parking proche de l'autoroute I-795 situé au nord de Baltimore. Plus loin, il y avait une dixaine de camions. Le soleil commençait à se lever et les bruits cacophoniques du va-et-vient continu s'élevaient dans le lointain avec le flot incessant de camions, de semi-remorques, de mobiles homes et de voitures de spectateurs. Une troupe de 100 hommes commencèrent à s'activer, déroulant la toile du chapiteau, dressant les cordages, enfonçant des attaches. En quelques heures, le grand chapiteau fut monté et le spectacle put commencer.

Je me frayai un chemin à travers le flot de gens qui se pressait à l'intérieur du chapiteau et de son monde de sépia. Il y avait une piste avec des lions passant à travers un cerceau, une autre avec des numéros de funambules sur la corde raide et des acrobates sur une autre piste. Un cortège d'éléphants et de clowns paradaient dans les parages. Ensuite vinrent des jongleurs, des trapézistes, des chevaux et des tigres. Pour la grande finale, un gigantesque canon en argent propulsa un boulet humain à une hauteur de trois étages et presqu'à 200 pieds à travers le chapiteau. Il y eut alors un tonnerre d'applaudissements.

Trois jours après la dernière représentation, je sus que mon excursion photographique ne faisait que commencer lorsque 'Monsieur Loyal' vint à ma rencontre avec un sourire aux lèvres et me remit un papier avec la direction à prendre pour se rendre dans la ville où le cirque se produirait ensuite. Je pliai bagages et je suivis cette tribu de nomades jusqu'en Virginie. Aux premières lueurs de l'aube, je me retrouvai dans une grande prairie verdoyante entourée de petites collines. Il y eut trois autres jours de shows avec trois représentations par jour. Ah oui, la vie se résume à un cirque à trois pistes.

MARK PETERSON

DAS LEBEN DER REICHEN Mark Peterson ist seit Jahren ein passionierter Chronist des Lebens der gehobenen Gesellschaft. Er hat die Reichsten der Reichen photographiert – alten Geldadel wie Neureiche – von Brooke Astor bis Ivana Trump.

Peterson hat die Reichen bei öffentlichen Auftritten photographiert, die ihnen besonders liegen: bei Wohltätigkeitsanlässen, Garten-Partys, Debütantinnen-Bällen und aufwendigen Maskenbällen; oder in ihren Mahagony-getäferten Privat-Clubs, wo sie teure Zigarren und alten Cognac geniessen; beim Begutachten der neusten Kollektion der Modeschöpfer für die kommende Saison; beim Einkaufen in chicen Läden; beim Diner in den besten Restaurants; beim Tanzen in den besten und exklusivsten Nachtclubs und als Zuschauer beim Wettkampf ihrer edlen Rösser um überdimensionierte Silberpokale.

Peterson kennt das Gesicht, das jeder einzelne von ihnen bei öffentlichen Anlässen präsentiert, und er versucht, den Moment zu erwischen, in dem seine Sujets ihr privates Gesicht zeigen. Er arbeitet sehr nah bei den Leuten; er mischt sich in ihre Kreise; er wird Teil des Augenblicks und lässt die Betrachter seiner Bilder ebenfalls teilhaben. *Agentur: Saba Photo Agency*

LA VIE DES RICHES Depuis des années, Mark Peterson est un chroniqueur passionné de la jet-set. De la vieille noblesse fortunée aux nouveaux riches, de Brooke Astor à Ivana Trump, il a photographié les plus riches parmi les riches.

Peterson a immortalisé les nantis de ce monde à l'occasion de leurs apparitions publiques les plus glorieuses: galas de bienfaisance, bals des débutants ou bals masqués en grande pompe; dans leurs clubs privés lambrissés d'acajou, fumant cigares de luxe et dégustant cognacs et fines; en train d'assister aux défilés de mode des grands couturiers ou de faire des achats dans les boutiques les plus chics, dégustant

des dîners fins dans les meilleurs restaurants, dansant et s'amusant dans les boîtes de nuit les plus huppées ou encore assistant aux courses de leurs chevaux racés couronnées de trophées en argent surdimensionnés.

Peterson connaît le visage que chacun d'entre eux arbore lors de manifestations officielles, et il s'attache à capturer l'instant où le masque tombe. Il travaille très près des gens; il se mêle à leurs cercles et fait corps avec l'instant, permettant à ceux qui regardent ses photos de faire de même. *Agent: Saba Photo Agency*

JOE RAEDLE

FLORIDA: LANDARBEITER AUS GUATELMALA In den letzten dreieinhalb Jahren wurden in Palm Beach County, Florida, mindestens 19 Babys von Landarbeitern mit Wirbelkanal-Anomalien geboren – dieser Prozentsatz ist vierzig mal höher als der nationale Durchschnitt in den Vereinigten Staaten.

Es wird vermutet, dass der Umgang mit Pestiziden etwas mit dieser Besorgnis erregenden Quote von Geburtsfehlern zu tun hat. Raedle porträtierte Frauen der Landarbeiter mit ihren Babys, um zu zeigen, was die Zahlen in der Realität für die Menschen hier bedeuten.

Die Aufnahmen haben konkret etwas bewirkt: einige medizinische Fachleute und Sozialarbeiter haben eine Taskforce gebildet, die Lösungen des Problems erarbeiten soll. Palm Beach County wird vom Staat Folsäure-Lieferungen erhalten, die kostenlos an Frauen im gebärfähigen Alter, einschliesslich der Landarbeiterinnen, abgegeben werden sollen. Folsäure, ein einfacher Vitaminzusatz, reduziert nachweisbar das Risiko von schweren Geburtsfehlern. Ausserdem hat das Gesundheits-Departement des Staates finanzielle Mittel gefordert, um eine neue landesweite Statistik über Geburtsfehler erstellen zu können, so dass die Entwicklung untersucht und beeinflusst werden kann.

SEITE 179: Sie zählte die Finger und Zehen. Alles da. Sie betrachtete die Grösse – ziemlich gross für siebeneinhalb Pfund. Und Rosa Miguels Herz sank. Der deformierte Kopf bestätigte, was die Ärzte in Boynton Beach ihr am Ende der Schwangerschaft gesagt hatten: ihre neugeborene Tochter hatte kein Gehirn. Während der nächsten 3 Stunden liebkoste sie ihr Kind, das sie Angelina genannt hatte. Dann hörte das Baby auf zu atmen, und die Krankenschwestern sagten ihr, dass es tot sei. «Alles war perfekt, sie hatte einfach nur kein Gehirn», sagt Rosa Miguel beim Betrachten der Polaroid-Aufnahme des Babys. Rosa Miguel hatte noch bis kurz vor der Geburt des Kindes auf dem Feld gearbeitet.

SEITE 180: Everilda Velasquez hält ihren 1995 geborenen Sohn Nelson im Arm. Man hatte einen Wasserkopf festgestellt, dessen Ursache gemäss Diagnose eine Abflussbehinderung der Gehirn-Rückenmarks-Flüssigkeit ist, was zu geistiger Behinderung führt. Nelson wird operiert werden, wobei eine Röhre zur Ableitung der Flüssigkeit in seinen Kopf eingepflanzt wird. Everilda hatte nach ihrer Einreise aus Guatemala vor vier Jahren in Kindertagesstätten und in landwirtschaftlichen Betrieben in Western Palm Beach County gearbeitet. Ihre Arbeitskollegen hatten sich morgens oft übergeben oder über Kopfschmerzen geklagt, nachdem die Felder mit Pestiziden und Fungiziden besprayt worden waren.

SEITE 181: Mit liebevoller Fürsorge wäscht Angelina Vincente ihren Sohn in einem kleinem Bottich auf dem Küchenboden. Sie hat auf den Feldern von South Florida als Tomatenpflückerin bis 20 Tage vor der Geburt ihres Kindes gearbeitet. Man hatte ihrem im April 1995 geborenen Sohn, Daniel Vincente, keine grossen Überlebenschancen gegeben. Die Ärtze erklärten Angelina, dass ihr Kind nur eine gesunde Gehirnhälfte habe, die kranke Hälfte würde innerhalb von sechs Tagen nach der Geburt entfernt werden müssen. In den medizini-schen Unterlagen wird er als anenzephalisches Kind mit Hirnstammaktivität geführt.

SEITEN 182-183 In einer Zweizimmerwohnung in West Palm Beach wechselte Sandra Galvez, 24, die Windel ihres Babys sehr behutsam, weil er Prellungen am Gesäss hat. Dann legte sie den Jungen auf den Bauch, die einzige Position, die für ihn angenehm ist. Sandra Galvez, eine Feldarbeiterin, fragt sich noch immer, was dazu geführt haben mag, dass ihr Kind mit einem Loch im Rückgrat geboren wurde. Nach der Immigration aus Guatemala vor zwei Jahren hat sie bis zum sechsten Monat ihrer Schwangerschaft in verschiedenen Kinderkrippen gearbeitet. In den letzten dreieinhalb Jahren wurden wenigstens 19 Babies von guatemalischen Feldarbeitern in Palm Beach County mit Wirbelkanal-Anomalien geboren. Dieser Prozentsatz ist vierzigmal höher als der Durchschnitt in den USA. *Publikation:* Sun-Sentinel, *Florida*

DES OUVRIERS AGRICOLES GUATÉMALTÈQUES, FLORIDE Ces trois dernières années, au moins 19 bébés issus de familles d'ouvriers agricoles guatémaltèques du comté de Palm Beach, Floride, sont nés avec des troubles neurologiques, ce qui représente un taux de plus de 40 fois plus élevé que la moyenne nationale.

Les ouvriers agricoles sont d'avis que le nombre inquiétant de nouveaux-nés souffrant de troubles est dû aux pesticides auxquels ils sont exposés. Raedle a pris des photos des femmes de cette communauté tenant leur bébé afin de montrer aux hommes que la communauté est affectée par ce problème.

De solides résultats ont pu être obtenus grâce à ces photos: un groupe d'experts médicaux et d'assistants sociaux ont formé une unité d'action spéciale chargée de trouver des solutions. Des doses d'acide folique vont être envoyées par bateau au comté de Palm Beach afin d'être distribuées gratuitement aux femmes en âge de procréer ainsi qu'à tous les autres ouvriers agricoles. L'acide folique est tout simplement un complément de vitamine connu pour réduire les troubles graves pouvant survenir à la naissance. En outre, le département d'Etat de la santé a demandé des fonds afin de mettre en place un registre répertoriant les nouveaux-nés souffrant de troubles et ce au niveau de tout l'Etat. Ce registre permettra aux chercheurs de faire une étude très précise et de contrôler ce genre de tendance.

PAGE 178: Lors de sa première grossesse, Petrona Pasqual a passé son premier contrôle médical au 8ᵉ mois seulement. Son cas ne fait malheureusement pas figure d'exception parmi la population guatémaltèque du comté de Palm Beach. L'examen médical, qui n'aurait dû être qu'un contrôle de routine, révéla qu'il y avait des risques élevés que son enfant souffre de troubles graves. Petrona a eu de la chance et a mis au monde un garçon sain de trois kilos et demi. Aujourd'hui, cette jeune femme de 24 ans est enceinte de son deuxième enfant et, forte de sa première expérience douloureuse, elle a fait suivre sa grossesse dès le début.

PAGE 179: Elle compta les doigts et les doigts de pied. Rien ne manquait. Elle observa la taille, plutôt grande pour un bébé de quatre kilos. Et soudain, le cœur de Rosa Miguel se brisa. La tête déformée de son enfant confirma le diagnostic qu'avaient prononcé

les médecins de Boynton Beach au terme de sa grossesse: sa fille n'avait pas de cerveau. Durant les trois heures qui suivirent la naissance, elle berça sa petite fille qu'elle avait baptisée Angelina. Puis, le bébé cessa de respirer, et les infirmières lui apprirent qu'il était mort. «Tout était parfait, la seule chose qui lui manquait, c'était un cerveau», dit Rosa Miguel en regardant un Polaroid de son bébé. Peu avant la naissance, Rosa Miguel travaillait encore aux champs.

PAGE 180: Everilda Velasquez tient dans ses bras son fils Nelson né en 1995. Les médecins avaient diagnostiqué une hydrocéphalie, soit un excès de liquide céphalorachidien dans les cavités du cerveau provoquant des troubles mentaux. Nelson va subir une opération qui consistera à introduire un drain dans sa tête pour évacuer l'excès de liquide. Depuis son arrivée du Guatemala il y a quatre ans, Everilda a travaillé dans des crèches et des exploitations agricoles dans le comté de Palm Beach Ouest. Ses collègues de travail vomissaient souvent le matin ou se plaignaient de maux de tête lorsque les champs étaient arrosés de pesticides et de fongicides.

PAGE 181: Angelina Vincente lavant avec un soin attentionné son fils dans une bassine posée sur le sol de la cuisine. Vingt jours avant la naissance de son fils, elle travaillait encore dans les champs à la récolte des tomates dans le sud de la Floride. Les chances de survie de son fils Daniel né en avril 1995 étaient minces. Les médecins lui expliquèrent que seule une partie du cerveau de son fils était saine. Six jours après la naissance, les médecins procédèrent à l'ablation de l'hémisphère atteint. Le dossier médical répertorie ce cas comme une anencéphalie.

PAGES 182-183: Dans un deux-pièces de Palm Beach Ouest, Sandra Galvez lange avec précaution son bébé, dont le derrière est couvert d'hématomes. Puis la jeune femme de 24 ans le couche sur le ventre, la seule position qu'il supporte. Sandra Galvez, qui travaille dans les champs, se demande encore pourquoi la colonne vertébrale de son enfant est endommagée. Après son départ du Guatemala il y a deux ans, elle a travaillé jusqu'au sixième mois de sa grossesse dans des crèches. Au cours des trois dernières années, au moins 19 bébés nés de mères guatémaltèques travaillant dans les champs du comté de Palm Beach sont venus au monde avec des anomalies du tube neural. Aux Etats-Unis, le pourcentage de ces anomalies est quarante fois plus élevé que la moyenne.

Publication: Sun-Sentinel, *Florida*

PATRICK ROBERT

TERROR IN SIERRA LEONE Seit vier Jahren tobt der Bürgerkrieg in Sierra Leone: 10'000 Menschen kamen ums Leben, und 40% der Bevölkerung leben jetzt im Exil. Im Januar 1996 stürzte eine Junta die Regierung, doch es wurden für Februar Wahlen angesetzt, der Grund für Patrick Roberts Entschluss, nach Sierra Leone zu reisen.

Der Wahltag wurde durch Granaten und Atilleriefeuer der Rebellen ausserhalb der Stadt unterbrochen. Die Bevölkerung blieb, um die Rebellen mit Händen und Speeren abzuwehren. Dann wurden plötzlich Gerüchte laut, dass die Rebellen die Stadt infiltriert hätten, und die wütende Menge begann, in den eigenen Reihen nach Rebellen zu suchen. Sechs Menschen wurden gelyncht, die Wahlen wurden unterbrochen, und Rebellen ritzten die Worte RUF (United Revolutionary Front), NO ELECTION (keine Wahlen) und TERROR in die Körper von Zivilisten. *Agentur: Sygma/ Publikation:* Time, *New York*

TERREUR EN SIERRA LEONE Depuis quatre ans, la Sierra Leone est dévastée par une guerre civile qui a déjà fait 10'000 morts et poussé 40% de la population à quitter le pays. En janvier 1996, le gouvernement a été renversé par une junte, tandis que des élections étaient prévues au mois de février, événement qui décida Patrick Robert à se rendre en Sierra Leone.

Des rebelles postés en dehors de la ville ont interrompu les élections avec des grenades et des tirs d'artillerie. La population est restée sur place pour les combattre avec des lances pour seule arme. Puis la rumeur s'est soudain répandue que des rebelles s'étaient introduits en ville, et la foule en colère s'est mise à chercher des traîtres parmi les siens. Six hommes ont été lynchés, les élections, interrompues, et les rebelles ont marqué les mots RUF (United Revolutionary Front), NO ELECTION (pas d'élections) et TERROR (terreur) sur les corps des civils. *Agent: Sygma/Editeur:* Time magazine, *New York*

JOSEPH RODRIGUEZ

SIEBENBÜRGEN: DAS LAND HINTER DEN WÄLDERN Das Ende der kommunisti-schen Herrschaft und des Ceaucesu-Regimes in Rumänien hat zu einer Öffnung Siebenbürgens gegenüber dem Westen und zu grösserer Toleranz gegenüber den verschiedenen Bevölkerungsgruppen innerhalb seiner Grenzen geführt.

Die Geschichte und Isolation Siebenbürgens haben jedoch eine besondere, tief verankerte Kultur geschaffen und gefördert. Was die Religion angeht, so gibt es viele

rivalisierende Glaubensbekenntnisse, verbunden mit einer reichen Tradition lokaler Folklore, wozu auch der Drakula-Mythos gehört.

Das Leben in den Dörfern ist ziemlich unverändert geblieben, noch immer leben ganze Familien und Gemeinden vom Ertrag ihrer Felder. Mit dem Aufkommen des Fernsehens wurden bei der ländlichen Bevölkerung jedoch neue Erwartungen und Wünsche geweckt, und die jungen Leute zieht es in die Städte, z.B. nach Cluj oder Tirgu Mures. Dort hat die unkontrollierte Industrialisierung zu unsicheren Arbeitsbedingungen und besorgniserregender Umweltverschmutzung geführt.

Das Siebenbürgen, das ich photographiert habe, reflektiert den kulturellen Bruch zwischen der Tradition und den neuen Lebensbedingungen, denen die Menschen dieser Region unweigerlich ausgesetzt sein werden. *Agentur: Black Star/Publikation:* Manads Jornalen, *Stockholm*

SEITE 186: Bauer und sein Pferd, Markod, Rumänien.

SEITE 187: Ungarische Frauen in Tracht auf dem Weg zur Kirche in Mera, Rumänien. ■ Gergely Virág, 84 Jahre alt, ist Holzfäller und lebt allein ohne Rente. Felsölok, Rumänien. ■ Zigeunerin vor ihrem Haus in Bontida, Rumänien. ■ Die 29jährige Eszter Siklodi mit ihrem Brauthut, Markod, Rumänien.

SEITE 188: Bauern, Markod, Rumänien. ■ Karoly Kacso, seine Frau Magda und ihr Sohn, zu Hause in Markod, Rumänien.

SEITE 189: Mann bei sich zu Hause, umgeben von orthodoxen religiösen Kunstgegenständen. ■ Yanos Siklodi beim Frühstück mit seiner Familie, Markod, Rumänien.

SEITE 190: Eine Frau bei der Feldarbeit, Felsölok, Rumänien.

SEITE 191: Familie mit ihrem Kaninchen, Markod, Rumänien. ■ Yanos Siklodi liest seiner Mutter, die sich auf dem Bett von der Arbeit ausruht, aus der Bibel vor. ■ Auf dem Heimweg nach der Feldarbeit. ■ Schule in Markod, Rumänien. ■ Zigeunerdorf, Bontida, Rumänien. ■ Markod, Rumänien. ■ Arbeit auf dem Feld im Frühling, Palatca, Rumänien. ■ Yanos Siklodi und seine Frau im Bett, Markod, Rumänien.

LA TRANSYLVANIE: LE PAYS AU-DELÀ DES FORÊTS La fin du communisme et du régime de Ceaucescu en Roumanie a permis à la Transylvanie de s'ouvrir vers l'Occident et a contribué à une plus grande tolérance entre ses différentes po-pulations.

L'histoire et l'isolement relatif de la Transylvanie ont favorisé des us et coutumes profondément ancrés dans la culture. De plus, la région a pendant longtemps été marquée par la rivalité de différentes croyances religieuses auxquelles se mêle un riche folklore local, dont le célèbre mythe de Dracula.

La vie dans les villages n'a pas vraiment changé. Des familles et des communes entières continuent à vivre du produit de leurs champs. L'arrivée de la télévision a éveillé de nouvelles attentes auprès de la population rurale, et de nombreux jeunes sont attirés par des villes comme Cluj-Napoca et Tîrgu Mures. Là, une industrialisation sauvage a conduit à des conditions de travail précaires et à une pollution inquiétante.

La Transylvanie que j'ai photographiée reflète la révolution culturelle entre les traditions et les nouvelles conditions de vie. Une révolution à laquelle les gens de cette région seront inévitablement confrontés. *Agence: Black Star/Publication:* Manads Jornalen, *Stockholm*

PAGE 186: Paysan avec son cheval, Markod, Roumanie.

PAGE 187: Femmes hongroises en costumes traditionnels se rendant à l'église de Mera, Roumanie. ■ Agé de 84 ans, Gergely Virág, bûcheron, vit seul et ne touche aucune rente. Felsölok, Roumanie. ■ Femme tzigane devant sa maison à Bontida, Roumanie. ■ Eszter Siklodi, 29 ans, avec son chapeau de mariée, Markod, Roumanie.

PAGE 188: Paysans, Markod, Roumanie. ■ Karoly Kacso, sa femme Magda et leur fils, chez eux à Markod, Roumanie.

PAGE 189: Homme dans son logis, entouré d'objets pieux orthodoxes. ■ Yanos Siklodi en train de prendre le petit-déjeuner avec sa famille, Markod, Roumanie.

PAGE 190: Femme travaillant aux champs, Felsölok, Roumanie.

PAGE 191: Famille avec son lapin, Markod, Roumanie. ■ Yanos Siklodi lisant un passage de la Bible à sa mère qui se repose dans son lit après le travail. ■ En rentrant des champs. ■ Ecole à Markod, Roumanie. ■ Village tzigane, Bontida, Roumanie. ■ Markod, Roumanie. ■ Travail dans les champs au printemps, Palatca, Roumanie. ■ Yanos Siklodi et sa femme au lit, Markod, Roumanie.

Q. SAKAMAKI

AFGHANISTAN Als ich im Frühjahr 1996 die afghanische Hauptstadt Kabul besuchte, war ich erschüttert: die Stadt ist vom Krieg, einem der längsten, fast völlig zerstört, und es herrscht dort ein solches Elend, wie ich es im 20. Jahrhundert nicht für möglich

gehalten hätte. Es war schlimmer als alles, was ich zuvor in Sarajevo oder Beirut gesehen hatte.

Allerdings ist der Afghanistan-Konflikt seit dem Ende des Kalten Krieges fast vergessen. Natürlich merkte die Öffentlichkeit wieder auf, als die Taliban-Miliz im Frühjahr 1996 die Hauptstadt einnahm, aber das Interesse schwand bald darauf wieder.

«Ihr macht bloss Photos und keiner hilft uns!» rief eine alte Frau in einer zerbombten Flüchtlingsunterkunft, als ich sie aufnehmen wollte. Vielleicht hat sie recht. Die Todesqualen des afghanischen Volkes, verstrickt in einen vergessenen Krieg, werden schlimmer und schlimmer. Ich bin dort nur ein Photograph, der versucht, der Aussenwelt soviel wie möglich über die unmenschlichen Zustände in diesem Lande nahezubringen.

SEITEN 192-193: Soldaten Massuds an der Front vor Kabul erwarten die Raketen der Taliban.

SEITE 194: Beinprothesen für die Opfer des Afghanistan-Kriegs, meist Zivilisten. Wegen der grossen Zahl von Landminen und explodierenden Blindgängern herrscht in Afghanistan Mangel an Prothesen. ■ Kandakh, ein neunjähriger Junge aus Kabul, spielt mit einer kaputten Spielzeugwaffe in den Ruinen von Jadayi Maiwand – dort lebt er, dort schlagen immer wieder Raketen ein.

SEITE 195: Schülerinnen aus Kabul und eine Lehrkraft im kriegszerstörten Schulgebäude, vor dem Erlass des Arbeits- und Schulverbots für Frauen und Mädchen durch den neuen Taliban-Machthaber. ■ Die Familie der Witwe Salma ist in einer kriegszerstörten Flüchtlingsunterkunft untergebracht und lebt vom Verkauf von Tierfäkalien. ■ Kinder aus Kabul suchen Zuflucht vor dem Regen. ■ Eine Familie passiert das Panjsher-Tal, einen der Stützpunkte des Militärchefs Massud. ■ Ausländisches Geld wechselt den Besitzer in Kandahar, wo sich das Hauptquartier der Taliban befindet. Der Krieg in Afghanistan heizt die Inflation immer weiter an. ■ Ein Mann, der im Krieg ein Bein verloren hat, lächelt, als ein Junge, ebenfalls ein Amputierter, in die Orthopädie des Roten Kreuzes in Kabul zur Rehabilitation kommt.

SEITE 196: Zahra, eine 22jährige afghanische Frau, verlor bei einem Raketen angriff beide Beide. Hier ist sie in der Orthopädie des Roten Kreuzes in Kabul zur Rehabilitation.

SEITE 197: Das Dach des früheren Königspalastes in Kabul ist vom Krieg zerstört. Das Gebäude diente bereits mehreren Kriegsparteien, auch den Taliban, als Militärstützpunkt. ■ Ein alter Mann blickt aus seinem kriegszerstörten Haus in Kabul.

VIVRE PENDANT LA GUERRE EN AFGHANISTAN Lorsque je visitai Kaboul, Afghanistan, au printemps de l'année 1996, je fus stupéfait, d'une part, par la ville détruite par une des guerres les plus longues qu'il y ait jamais eues, et, d'autre part, par une situation des plus déplorables. Il est d'ailleurs difficile de s'imaginer qu'une telle misère puisse exister au XXème siècle. En effet, j'avais connu l'horreur à Sarajevo et à Beyrouth, mais ce n'était rien comparé à la situation qui régnait à Kaboul.

Mais depuis la fin de la guerre froide, la guerre en Afghanistan a cessé de défrayer la chronique. Et c'est seulement lorsque les Talibans ont pris possession de la capitale à la fin de l'année 1996, que le monde s'est à nouveau intéressé à cette guerre, mais cet intérêt s'est vite estompé.

Alors que je voulais prendre une photo d'une vieille femme qui se trouvait dans un centre de réfugiés détruit par la guerre à Kaboul, celle-ci me lança à la figure: «Vous autres à l'étranger, vous êtes uniquement là pour prendre des photos, mais personne ne vient nous aider!». Il y a peut-être un fond de vérité dans cette déclaration. L'agonie du peuple afghan pris au piège dans une guerre d'ores et déjà oubliée devient de pire en pire, alors que moi, je ne suis qu'un simple photographe qui s'efforce de faire connaître au monde entier les conditions inhumaines qui règnent dans ce pays.

PAGES 192-193: Les soldats de Masoud sont à l'affût des roquettes lancées par les Talibans sur la ligne de front située près de Kaboul.

PAGE 194: Des prothèses pour les victimes afghanes qui sont pour la plupart des civils. Il n'y a pas assez de matériel prothétique parce qu'il y a eu énormément de mines et de bombes qui ont explosé en Afghanistan. ■ Kandakh est un garçon de neuf ans originaire de Kaboul. Il joue avec un fusil factice cassé dans les ruines de la ville de Jadayi Maiwand où il vit, et sur laquelle tombent fréquemment des bombes.

PAGE 195: Des étudiantes de Kaboul et leur professeur dans une école bombardée avant que les Talibans au pouvoir n'interdisent aux filles d'aller à l'école et aux femmes d'enseigner. ■ La famille de Salma, une veuve, vit dans le centre de réfugiés appelé 'le vieux Microrayon' et survit grâce aux excréments d'animaux qu'elle vend

comme engrais. ■ Des enfants de Kaboul courent pour échapper à la pluie. ■ Une famille traversant la vallée Panjser sous l'emprise du commandant Masoud. ■ Des devises étrangères passent de main en main à Kandahar, la ville dans laquelle les Talibans ont pris leurs quartiers. Depuis le début de la guerre en Afghanistan, les bombardements sont incessants. ■ Un homme ayant perdu un bras sourit à un jeune garçon, amputé lui aussi. Il va au centre de réadaptation orthopédique du CIRC de Kaboul.

PAGE 196: Zahra est une jeune femme de vingt-deux ans qui a perdu ses jambes lors de l'explosion d'une roquette. Elle est en traitement au centre de réadaptation orthopédique du CIRC de Kaboul.

PAGE 197: Le toit de l'ancien palais royal de Kabul fut détruit par la guerre. Celui-ci a été utilisé par différentes factions en guerre ainsi que par les Talibans qui s'en servaient comme poste militaire.

SEBASTIÃO SALGADO

BOMBAY Der Photograph Sebastião Salgado arbeitet an einem Sechsjahresprojekt für die Zeitschrift *Rolling Stone*. Sein Thema ist das Schicksal von Millionen Menschen, die wegen Überbevölkerung, wirtschaftlicher Veränderungen, Verwüstung des Landes oder Krieg ihre Heimat verlassen müssen. Diese Reihe von Aufnahmen aus Bombay ist Teil des Projekts.

Im Begleittext für *Rolling Stone* schreibt der Autor und Filmregisseur Ismail Merchant: «Bombay zieht Millionen von Migranten magnetisch an; sie kommen aus allen benachteiligten Ecken Indiens, mit nichts als ihren Träumen von einer besseren Zukunft. Für die meisten beginnt und endet der Traum im Elend und Schmutz der Slums von Bombay, wo es nur noch ums Überleben geht.» Wie einige Bilder Salgados jedoch zeigen, trägt eine wachsende Anzahl mittelständischer Betriebe dazu bei, aus Bombay eine Stadt der Hoffnung zu machen. *Agentur: Amazonas Images/Publikation:* Rolling Stone

SEITE 200: Die Mahalaxmi-Wäscherei beschäftigt ca. 6000 Männer als Wäscher, die sieben Tage in der Woche arbeiten und zwischen US$ 45 und US$ 65 pro Monat verdienen. ■ Obwohl es einige Computer in Bombay gibt, arbeiten die meisten Büros noch auf Papier, von dem die berüchtigte Bürokratie des Landes Tonnen verschlingt. ■ Arbeiter am Sassoon Dock, einem der grössten Fischereihäfen Bombays, füllen Körbe mit kleinen Fischen. ■ Bombays Milchwirtschaft beschränkt sich grösstenteils auf die Produktion von Büffelmilch. Da die Arbeiter aus der selben Region Indiens zugewandert sind, leben und arbeiten sie hier zusammen.

SEITE 201: Eine Pipeline, die gebaut wurde, um die reichen Gebiete Bombays mit Wasser zu versorgen, führt direkt durch die Mahim-Slums in der Nähe des Flughafens von Bombay. Ungefähr die Hälfte der Bevölkerung Bombays – die auf 15 Millionen geschätzt wird – lebt in Slums wie diesem. ■ Oft zwingt die Überlastung der Züge Bombays Reisende, ausserhalb der Wagons einen Platz zu finden.

SEITEN 202-203: Ein obdachloser Mann am Marine Drive von Bombay - in der Ferne die Skyline von Bombay. Viele der Armen schlafen hier und warten auf das Essen, das ihnen die Reichen dieses Viertels spenden.

BOMBAY Le photographe Sebastião Salgado travaille depuis six ans sur un projet pour le magazine *Rolling Stone*, dans lequel il retrace le sort de millions de personnes qui ont dû émigrer dans le monde entier à la suite de la croissance démographique, de bouleversements économiques, d'une dégradation de l'environnement ou d'une guerre. Cette série de photos de Bombay fait partie du projet.

Dans le texte qui accompagne ces images, Ismail Merchant, écrivain et cinéaste, note: «Bombay exerce une véritable force d'attraction sur les millions de migrants qui viennent des régions les plus démunies de l'Inde avec, pour tout bagage, le rêve d'un avenir meilleur. Mais pour la plupart d'entre eux, le rêve commence et se termine dans la misère et la gangrène des bidonvilles de Bombay, où survivre est le seul objectif.» Certaines photos de Salgado suggèrent toutefois que l'expansion économique de la classe moyenne contribuera à faire de Bombay une ville d'espoir. *Agent: Amazonas Images/Editeur:* Rolling Stone

PAGE 200: La blanchisserie Mahalaxmi occupe 6000 employés, qui travaillent 7 jours sur 7 et gagnent entre US$ 45.– et US$ 65.– par mois. ■ Bien que certains bureaux soient équipés d'ordinateurs à Bombay, la plupart utilisent uniquement du papier, en particulier la bureaucratie, très dense, qui engloutit des tonnes de papier. ■ Travailleurs remplissant des paniers de petits poissons sur le Sassoon Dock, l'un des plus grands ports de pêche de Bombay. ■ L'industrie laitière de Bombay est essentiellement axée sur la production de lait de buffle. Originaires de la même région de l'Inde, ces hommes travaillent et vivent au même endroit.

PAGE 201: Pipeline construit pour l'approvisionnement en eau des quartiers riches de Bombay. Il passe directement au travers des bidonvilles de Mahim, à proximité de l'aéroport de Bombay. Environ la moitié de la population de Bombay, estimée à 15 millions d'habitants, vit dans les bidonvilles comme celui-ci. ■ Souvent, les trains de Bombay sont à ce point bondés que les voyageurs doivent se trouver une place à l'extérieur des wagons.

PAGES 202-203: Sans-abri sur la Marine Drive de Bombay. Au loin, la ville se détache de l'horizon. Beaucoup de pauvres dorment ici et attendent que les gens aisés du quartier leur donnent de la nourriture.

CHRIS SATTLBERGER

DAS ORBIS-PROJEKT: EINE MOBILE AUGENKLINIK Hinter dem Orbis-Projekt steht eine Nonprofit-Organisation, die weltweit Augenoperationen durchführt und Augenärzte fortbildet. Die Organisation besitzt eine DC-10, die in eine fliegende Augenklinik umgebaut wurde. Die Patienten werden im Flugzeug behandelt, und in einem Vorlesungssaal können die Operationen auf dem Bildschirm verfolgt werden.

Im September 1996 reiste ich nach Kyghizstan in Zentralasien, um das Orbis-Projekt zu verfolgen. Ich beschloss, ein Kind durch den ganzen Prozess zu begleiten. Burlaim wurde am Tag ihrer Operation 3 Jahre alt; sie wird auf beiden Augen sehen und damit ein normales Leben führen können. *Agent: Regina M. Anzenberger/Publikation:* Neue Zürcher Zeitung, *Zürich*

SEITE 204: Nach der Operation trägt Burlaims Vater sie aus dem Flugzeug.

SEITE 205: Mit ihrem Teddy kurz vor der Operation. ■ Die operierenden Ärzte aus Burlaims Blickwinkel. ■ Dr. Scott Foster bei der Operation eines Auges von Burlaim. ■ Ihr Teddy bleibt während der Operation bei ihr. ■ Die dankbaren Eltern schenken dem erstaunten Arzt einen Strauss Blumen und eine Flasche russischen Champagner. ■ Einige Tage nach der Operation beim Spielen zu Hause.

LE PROJET ORBIS: UNE CLINIQUE OPTHALMOLOGIQUE ITINÉRANTE Une organisation à but non lucratif est à l'origine du projet Orbis. Spécialisée dans les opérations ophtalmologiques, elle assure la formation de médecins dans le monde entier. L'organisation dispose d'un DC-10, transformé en véritable clinique volante. Les patients sont traités dans l'avion, tandis que les opérations sont projetées sur un écran relié à une salle de conférences.

En septembre 1996, je me suis rendu à Kyghizstan en Asie centrale pour obser-ver les actions entreprises dans le cadre du projet Orbis. J'ai choisi de suivre le cas d'une petite fille, Burlaim, qui a eu trois ans le jour de son opération. Ses deux yeux ont été sauvés, et elle pourra mener une vie normale. *Agent: Regina M. Anzenberger/Publication:* Neue Zürcher Zeitung, *Zurich*

PAGE 204: Après l'opération, le père porte Burlaim en sortant de l'avion.

PAGE 205: Avec son ours en peluche peu avant l'opération. ■ Les chirurgiens dans l'angle de vue de Burlaim. ■ Le chirurgien Scott Foster opérant un œil de Burlaim. ■ Burlaim a pu garder son ours en peluche auprès d'elle durant l'opération. ■ Les parents offrent un bouquet de fleurs et une bouteille de champagne russe pour remercier le médecin, surpris par ce geste. ■ Quelques jours après l'opération, Burlaim en train de jouer.

ERICH SCHLEGEL

BOSNIEN, DIE GEFAHREN DES FRIEDENS Nach einem Krieg, in dem 200000 Menschen ihr Leben liessen, suchen die Überlebenden Trost innerhalb ethni-scher Grenzen, statt zu versuchen, das Land wieder zu vereinigen.

Das Friedensabkommen von Dayton hat den Kämpfen vorläufig ein Ende gesetzt, aber zwischen den Muslims, Serben und Kroaten herrscht eine Atmosphäre von Angst und Hass. Die Pläne, wichtige Städte wie Sarajevo und Mostar wieder zu vereinigen, sind fehlgeschlagen, ebenso wie die Pläne des freien Verkehrs von Zivilisten zwischen den serbisch kontrollierten Gebieten und dem Rest des Landes. Noch immer ist für die Menschen in Bosnien ein anhaltender Friede ein Traum in weiter Ferne. *Publikation:* The Dallas Morning News

SEITE 206: Gräber von Moslems säumen den Weg dieses Wohnblocks an der Front in Sarajevo.

SEITE 207: Kemal Rekic weint am Grab seines Sohnes, der bei einem serbischen Raketenangriff getötet wurde.

SEITE 208: Ein französischer Scharfschütze hat eine Wohnung im Visier, in der sich ein mutmasslicher Heckenschütze befindet. ■ Jungen aus einem nahegelegenen Dorf nennen US-Sergeant Brian Lince auf der Luftwaffenbasis in Tuzla ihr Alter.

SEITE 209: Serbische Flüchtlinge kehren in ihre Heimatstadt Mrkonjc Grad zurück, wo sie ihre Tiere nur noch tot vorfinden, umgebracht von Kroaten auf dem Rückzug. ■ Ein Sarg wird ausgegraben, um auf moslemischem Territorium wieder bestattet zu werden.

BOSNIE: LES PÉRILS DE LA PAIX Au terme d'une guerre qui a coûté la vie à plus de 200000 personnes, les survivants cherchent la consolation au sein de frontières ethniques plutôt que d'essayer de réunifier le pays.

Le traité de Dayton a mis un terme provisoire aux conflits, mais un climat de peur et de haine continue à régner entre Musulmans, Serbes et Croates. Les plans qui visaient à réunifier les grandes villes comme Sarajevo et Mostar ont échoué, tout comme ceux qui prévoyaient la libre circulation des civils entre les régions contrôlées par les Serbes et le reste du pays. La promesse d'une paix durable reste ainsi un rêve lointain pour la Bosnie et ses habitants. *Editeur:* The Dallas Morning News

PAGE 106: Tombes musulmanes jalonnent le chemin de cet immeuble le long de la ligne de front à Sarajevo.

PAGE 207: Kemal Rekic pleurant sur la tombe de son fils, tué par un mortier serbe.

PAGE 208: Tireur d'élite français prenant pour cible un appartement où est supposé se cacher un tireur isolé. ■ De jeunes hommes habitant un village des environs disent leur âge au sergent américain Brian Lince en poste à la base aérienne de Tuzla.

PAGE 209: Réfugiés serbes retournant dans leur ville natale de Mrkonjc Grad, où ils trouvent leurs animaux morts, abattus par les Croates lors de leur retrait. ■ Un cercueil est déterré pour être enterré à nouveau en territoire musulman.

OLYMPISCHE SPIELE 1996, ATLANTA, GEORGIA Eine Woche vor der Eröffnungszeremonie der Olympischen Sommerspiele 1996 in Atlanta installierte ich mich zusammen mit zwei anderen Photographen der *Dallas Morning News* im Pressezentrum von Atlanta. Unser Büro war mit einem Fuji C-41 Processor und 3 Scanner- und Übermittlungsstationen ausgestattet, so dass wir die Bilder sofort direkt nach Dallas schicken konnten.

Wir standen bei Tagesanbruch auf und teilten die verschiedenen Veranstaltungen unter uns auf; die Filme gaben wir laufend an unser Büro oder Kodak, und die Bilder wurden dann direkt nach Dallas überspielt. Zwei Wochen lang arbeiteten wir bis spät in die Nacht.

Das waren meine dritten Olympischen Spiele, und jedes Mal hatte ich das Gefühl, an einem Marathon teilzunehmen.

PAGE 210: Die olympische Flagge auf Halbmast beim Start zum 100-m-Hürdenlauf der Frauen. Am Tag zuvor war die Bombe auf dem olympischen Gelände hochgegangen.

PAGE 211: Die Flaggen der teilnehmenden Länder im Centennial-Olympiastadion während der Abschlusszeremonie.

PAGE 212: Michael Johnson wirft einen Blick auf seine Weltrekordzeit im 200-Meterlauf. ■ Bei der 4x400m-Staffel sprintet Derek Mills (USA) los, während Greg Haughton aus Jamaica stolpert und fällt. Das US-Team gewann Gold.

PAGE 213: Imre Lengyel aus Ungarn nimmt am Kunstspringen vom 3-Meter-Turm teil. ■ Die Amerikanerin Becky Ruehl beim Sprung vom 10-Meter-Brett.

LES JEUX OLYMPIQUES DE 1996 À ATLANTA, GEORGIE Une semaine avant la cérémonie d'ouverture des Jeux olympiques d'été à Atlanta, je m'installais en compagnie de deux autres photographes du *Dallas Morning News* dans le bureau de presse situé au centre d'Atlanta. Notre bureau comptait un processeur Fuji C-41 ainsi que trois scanners-émetteurs, ce qui nous permettait d'envoyer régulièrement des images à Dallas.

Au point du jour, nous nous séparions pour couvrir différents événements sportifs, renvoyer les films avec les photos que nous avions prises à notre bureau ou à Kodak et transmettre les images à Dallas. Nous finissions généralement notre travail à une heure ou deux heures du matin et ce, toutes les nuits pendant deux semaines.

C'était la troisième fois que je participais aux Jeux olympiques et chaque fois j'avais l'impression de courir moi-même un marathon!

PAGE 210: Le drapeau olympique à mi-hauteur du mât au départ du 100m haies des femmes. Le jour précédent, une bombe avait explosé dans le Parc olympique d'Atlanta.

PAGE 211: Les drapeaux des pays participant aux Jeux dans le stade olympique durant la cérémonie de clôture.

PAGE 212: Michael Johnson jettant un regard sur son record olympique du 200 mètres. ■ Relais 4x400m. Derek Mills (USA) se lançant dans son sprint tandis que le Jamaïcain Greg Haughton trébuche et tombe. Les Américains ont remporté l'or.

PAGE 213: Le Hongrois Imre Lengyel participant au plongeon des 3 mètres. ■ L'Américaine Becky Ruehl pivotant lors du plongeon des 10 mètres.

MARK SELIGER

WHEN THEY CAME TO TAKE MY FATHER: STIMMEN DES HOLOCAUST Als Jugendlicher,

lange bevor er zum erfolgreichen Photographen von Berühmtheiten wurde und zum Hauptphotographen der Magazine *Rolling Stone* und *US* reiste Mark Seliger mit einer jüdischen Jugendgruppe aus seiner Heimatstadt Houston (Texas) nach Auschwitz, anschliessend nach Rumänien und Israel. Die Reise hinterliess unauslöschliche Eindrücke, aber es dauerte fast zwanzig Jahre, bis er die durch diese Erfahrung ausgelösten Gefühle photographisch verarbeiten konnte.

Das Ergebnis ist diese Serie kontrastreicher Schwarzweissporträts von Überlebenden des Holocaust. Seliger war hier bestrebt, ganz auf das Raffinement der Reportagephotographie für Magazine zu verzichten und die Gesichter für sich sprechen zu lassen. Vor kurzem äusserte er dazu in einem Interview: «Bei Berühmtheiten kann man auf Requisiten, Bühnenaufbauten, Schminke und Hair-Stylisten zurückgreifen. Dann aber wurde mir klar, dass sich das Leid bei jedem auf eigene Weise ins Antlitz eingräbt, und so versuchte ich, die Menschen so zu photographieren, wie sie eben sind.»

Eine Reihe bewegender Gespräche, die Leora Kahn und Rachel Hager mit Überlebenden führten, begleiten Seligers Photos in dem 1996 veröffentlichten Buch *When They Came to Take My Father* (Arcade Publishing). *Agentur: Proof*

SEITE 214: Lee Berendt, geb. in Sompolno, Polen, am 28. April 1923.

SEITE 215 (RIGHT): Liane Reif-Lehrer, geb. in Wien am 14. November 1934.

SEITE 216: Elizabeth Koenig, geb. in Wien. ■ Jack Travin, geb. in Slomnik, Polen, am 9. Mai 1924. ■ Ernst W. Michel, geb. 1923 in Mannheim. ■ William Drucker, geb. in Wien am 9. April 1912. ■ Herta Drucker, geb. in Wien am 7. Oktober 1923.

SEITE 217: Robert Melson, geb. in Warschau am 27. Dezember 1937.

WHEN THEY CAME TO TAKE MY FATHER Lorsqu'il était adolescent, bien avant qu'il devienne un photographe mondain de renom et le photographe en chef du magazine *Rolling Stone* et de *US*, Mark Seliger partit en voyage en compagnie d'un jeune groupe de juifs de sa ville natale de Houston, Texas, pour se rendre à Auschwitz, puis en Roumanie et en Israël. Ce voyage fit impression sur lui et le marqua profondément, mais il lui fallut presque vingt ans avant qu'il n'explore ce remous de sentiments qu'avait suscité cette expérience en lui à travers des photos.

Il en est résulté cette série de portraits noirs et blancs très sobres de rescapés de l'holocauste que Seliger a dépouillés de tout artifice pour laisser s'exprimer les visages d'eux-mêmes. Dans une récente interview, il fit la remarque suivante: «avec des célébrités, vous avez des béquilles, vous faites prendre des poses, vous disposez de maquillage et de coiffeurs stylistes…Mais j'ai réalisé que le visage a une façon toute particulière d'exprimer la souffrance et c'est pourquoi j'ai uniquement voulu photographier les gens tels qu'ils sont en réalité.»

Une série d'interviews passionnantes menées par Leora Kahn et Rachel Hager accompagne les photos de Seliger parues dans un ouvrage de 1996 intitulé *When They Came to Take My Father* (Arcade Publishing). *Agent: Proof*

PAGE 214: Lee Berendt, né le 28 avril 1923 à Sompolno, Pologne.

PAGE 215 (À DROITE): Liane Reif-Lehrer, née le 14 novembre 1934 à Vienne, Autriche.

PAGE 216: Elizabeth Koenig, née à Vienne, Autriche. ■ Jack Tavin, né le 9 mai 1924 à Slomnik, Pologne. ■ Ernst W. Michel, né en 1923 à Mannheim, Allemagne. ■ William Drucker, né le 9 avril 1912 à Vienne, Autriche. ■ Herta Drucker, née le 7 octobre 1923 à Vienne, Autriche.

PAGE 217: Robert Melson, né le 27 décembre 1937 à Varsovie, Pologne.

ILKKA UIMONEN

KABUL, NACH DER ÜBERNAHME DURCH DIE TALIBAN Zwei Jahre nach ihrer Gründung eroberten die Taliban, eine Miliz, bestehend aus einer Bande militanter islamischer Studenten, Kabul, die Hauptstadt Afghanistans. Die von Präsident Rabbani geführte Regierung wurde am 27. September 1996 gestürzt, wobei kaum ein Schuss fiel.

Siebzehn Jahre Bürgerkrieg haben grosse Teile der Stadt zerstört, und allein in Kabul gibt es 30000 Witwen.

Sobald die Taliban an der Macht waren, führten sie strenge islamische Gesetze ein, die u.a. den Frauen verbieten zu arbeiten. Diese Politik hat dazu geführt, dass viele Spitäler und Waisenhäuser kein Personal mehr haben, und andererseits hat sie die Witwen in noch grösseres Elend gestürzt. Die neuen Gesetze fordern auch, dass die Frauen immer verschleiert sind, und die Mädchen Koran-Schulen besuchen.

In den letzten Monaten, nach der Abreise von Uimonen und anderen Photojournalisten aus Kabul, haben die Taliban auch das Photographieren von Menschen verboten. *Agentur: Sygma PhotoNews*

SEITE 218: Taliban beim Gebet vorm Morgengrauen. ■ Der Onkel trauert um seinen sechs Jahre alten Neffen, der zusammen mit seinem Vater von einer Bombe getötet

wurde, die General Dostum auf die Vororte Kabuls abwerfen liess.

SEITE 219: Artilleriefeuer der Taliban auf frühere Regierungsstellungen an der Salang-Autostrasse, 15 km nördlich von Kabul.

SEITE 220: Dorfbewohner auf der Flucht vor den Gefechten, ein bisschen nördlich von Kabul. ▪ Witwen fliehen aus ihrem Dorf, das als Warnung vor Widerstand von Taliban-Kämpfern niedergebrannt wurde. ▪ Waisenkinder im Daryl-Yatam-Waisenhaus, mit über 500 Kindern das grösste in Kabul. ▪ Witwen stehen für Nahrungsmittel an, die von Hilfsorganisationen verteilt werden. ▪ Die Menge hat sich im Zentrum von Kabul versammelt, um die Ansprache eines Mullahs während einer Demonstration gegen Irans Einmischung in Afghanistans innere Angelegenheiten zu hören. ▪ Opfer einer Landmine in den Kriegsruinen im Westen Kabuls.

SEITE 221: Nachdem sie westliche Musik, Fernsehen und Alkohol verboten haben, zerstören die Taliban das Filmarchiv eines Lichtspielhauses. ▪ Im orthopädischen Zentrum des Roten Kreuzes in Kabul lernt ein Minenopfer, mit ihrer Prothese zu gehen.

KABOUL, APRÈS L'ARRIVÉE AU POUVOIR DES TALIBANS Deux ans après la fondation de leur mouvement, les Talibans, une ancienne milice formée d'étudiants militants islamistes, ont réussi à s'emparer de Kaboul, la capitale de l'Afghanistan. Le gouvernement dirigé par le président Rabbani est tombé le 27 septembre 1996, sans qu'un seul coup de feu ne soit échangé.

Dix-sept ans de guerre civile ont détruit des quartiers entiers et laissé plus de 30'000 veuves dans la seule ville de Kaboul.

Dès leur arrivée au pouvoir, les Talibans ont instauré des lois islamiques très strictes qui interdisent notamment aux femmes de travailler. Cette politique a eu pour conséquence de priver de nombreux hôpitaux et orphelinats de personnel et a plongé les veuves dans une misère plus grande encore. Les nouvelles lois imposent également le port du voile aux femmes, et les filles ne sont autorisées à fréquenter que des écoles coraniques.

Récemment, après le départ de Ilkka Uimonen et d'autres photoreporters de Kaboul, les Talibans ont également interdit de photographier les gens. *Agence: Sygma PhotoNews*

PAGE 218: Taliban priant avant l'aube. ▪ Oncle pleurant son neveu de six ans tué avec son père par une bombe larguée sur la banlieue de Kaboul par les soldats du général Dostum.

PAGE 219: Feux d'artillerie des Talibans sur d'anciennes positions du gouvernement le long de l'autoroute, à 15km au nord de Kaboul.

PAGE 220: Villageois fuyant les combats, au nord de Kaboul. ▪ Veuves fuyant le village mis à feu par les Talibans, un avertissement à la population qui serait tentée de résister. ▪ Des orphelins dans l'orphelinat de Daryl Yatam, le plus grand de Kaboul, qui compte plus de 500 enfants. ▪ Veuves attendant de recevoir de la nourriture distribuée par les organisations humanitaires. ▪ Rassemblement de la foule au centre de Kaboul pour écouter l'oraison d'un mollah durant la manifestation contre l'ingérence de l'Iran dans les affaires intéreures de l'Afghanistan. ▪ Victime d'une mine dans les ruines à l'ouest de Kaboul.

PAGE 221: Après avoir interdit l'alcool, la musique et la télévision occidentales, les Talibans détruisent les films d'un cinéma. ▪ Centre orthopédique de la Croix-Rouge à Kaboul. Victime des mines apprenant à marcher avec sa prothèse.

ALEXANDER ZEMLIANICHENKO

RUSSISCHER GULAG FÜR AUSLÄNDER In dem winzigen Dorf Leplei, ca. 550 km von Moskau entfernt in den windgepeischten Ebenen Zentralrusslands, befindet sich ein Gulag, der früher Arbeitsstrafkolonie Nr. 22 hiess. Es ist die einzige Einrichtung Russlands für ausländische Häftlinge, und es sind hier Verurteilte aus über 30 Nationen untergebracht, u.a. aus Vietnam, Afghanistan, Korea, dem Iran und China. Russland geht in den letzten Jahren hart mit straffälligen Ausländern um und schiebt sie nicht einfach mehr zur Bestrafung in ihr Heimatland ab. Besonders hart werden Drogenschmuggler bestraft. In den meisten Fällen erfolgten Gerichtsverhandlung und Urteilsspruch in russischer Sprache, die nur von sehr wenigen der Gefangenen verstanden wird. *Agentur: Associated Press*

SEITE 222: Der Gefangene Ivan Shimun aus Iran im Eingang einer Baracke der Arbeitsstrafkolonie # 22 in Leplei, einem ca. 600 km östlich von Moskau gelegenem Dorf. Shimun gehört zu den ältesten Insassen des Lagers - er hat hier wegen Taschendiebstals mit Unterbrechungen insgesamt 42 Jahre verbracht.

SEITE 223: Ausländische Insassen eines russischen Gefängnisses bei einem Gang auf dem Gelände des Gulags. ▪ John Pedro aus Angola beim Säubern eines Zentralheizungskessels. ▪ Zwei moslemische Gefangene aus dem Irak und dem Iran beten unter den Augen eines Wärters. ▪ Ein nicht identifizierter ausländi-scher Gefangener im Mantel beim Mittagessen im Gefängnis.

GOULAG RUSSE POUR ÉTANGERS A quelque 550 km de Moscou, dans le hameau de Leplei situé dans la plaine battue par les vents de la Russie centrale, se trouve un goulag, appelé autrefois Colonie de travail punitive n⁰ 22. C'est la seule prison de Russie où sont uniquement incarcérés des étrangers originaires de plus de 30 pays, dont le Viêt-nam, l'Afghanistan, la Corée, l'Iran et la Chine. Depuis quelques années, la Russie réserve un traitement particulièrement dur aux criminels étrangers et refuse de les expatrier dans leur pays pour qu'ils y accomplissent leur peine. Les sanctions infligées aux trafiquants de drogue sont exemplaires. La plupart des prisonniers sont jugés et condamnés en russe, une langue que peu d'entre eux comprennent. *Agent: Associated Press*

PAGE 222: Le prisonnier iranien Ivan Shimum à l'entrée d'une baraque dans la Colonie de travail punitive n⁰ 22 située dans le village de Leplei, à 600km à l'est de Moscou. Shimum fait partie des plus vieux prisonniers du camp – il a passé 42 ans de sa vie en prison pour vol à la tire répété.

PAGE 223: Détenus étrangers dans une prison russe lors d'une sortie sur le périmètre du goulag. ▪ L'Angolais John Pedro nettoyant l'installation du chauffage central de la prison. ▪ Deux prisonniers musulmans, un Irakien et un Iranien, priant sous les yeux d'un gardien. ▪ Un prisonnier étranger non identifié gardant son manteau pour manger.

JEFFREY AARONSON is an internationally recognized photojournalist whose assignments have taken him throughout Asia, the former Soviet Union, Europe, Africa, and Australia, as well as Mexico and the United States. He has worked on assignment for several leading publications, including *Time, Life, Newsweek, US News & World Report*, the *New York Times Magazine, Rolling Stone*, and *Vanity Fair*. Aaronson is based in Aspen, Colorado.

LUIGI BALDELLI began working with the Contrasto photo agency in Rome in 1987. Since then he has covered revolution in Romania, the Gulf War, and the Kurdish refugee crisis, among other stories. He is the author of a long reportage called "Travels to the End of the World," done in cooperation with *Il Corriere della Sera*, an Italian newspaper, and of a body of work on the people and cultures along the Silk Road. He lives in Rome.

P. F. BENTLEY grew up in Hawaii and specializes in covering U.S. and international politics. Bentley is known throughout the journalistic community for earning unprecedented access to presidential candidates and heads of state. He has covered every U.S. presidential campaign, and photographed every serious presidential contender, since 1980. His book *Clinton: Portrait of Victory* was a bestseller and received wide critical acclaim.

DONNA BINDER is a photojournalist based in New York City, and is a founding member of Impact Visuals documentary photo agency. Her work on socially significant issues has been published in magazines and journals including *Time, Mother Jones, Newsweek, Der Spiegel, George, Spin*, and *American Photographer*.

JEAN-MARC BOUJU was hired by the Associated Press in 1993 as a photographer in Nicaragua. In 1994 he transferred to Africa, where he covered Rwanda's genocide and war, earning a Pulitzer Prize in 1995. He is now based in Nairobi, Kenya, after spending two months covering the war in Liberia last year.

DAVID BURNETT launched his photographic career as an intern at *Time* magazine in 1967. From 1970 to 1972, he served as a staff photographer for *Life* magazine covering the Vietnam War. Along with Robert Pledge, he is a founder of the photo agency Contact Press Images. He has won numerous awards and has been widely published over his 25-year career. Burnett has also served as special photographer on several films, including *The Outsiders, The Babe, Scent of a Woman*, and *In the Name of the Father*.

DAVID BUTOW began his career in photography working for newspapers in the Los Angeles area, and turned to freelancing for magazines full-time in 1992. He is now a contract photographer with *U.S. News and World Report*, and is a member of the SABA photo agency. His photographs have appeared on the covers of *Newsweek, People, Harper's*, and *U.S. News and World Report*.

WILLIAM CAMPBELL has been a contract photographer for *Time* magazine for more than 20 years. Campbell has covered stories as diverse as famine in Ethiopia, death-row inmates, and the new country music of Nashville. He is currently collaborating with his wife, Maryanne Vollers, a former *Rolling Stone* editor, to produce multimedia, educational, and editorial projects such as "Indian Summer."

GIGI COHEN began photographing for *New York Newsday* in 1993, for whom she covered several assignments, including the first free elections in South Africa, in which Nelson Mandela was named president. For the past two years she has traveled to Hong Kong to photograph life leading up to the Chinese takeover in 1997. She is represented by the Network Photographers agency in London, and is based in Brooklyn, New York.

C. TAYLOR CROTHERS was invited to attend the eighth Eddie Addams Workshop after moving to New York in 1995, and then in 1996 published his first story in the *New York Times Magazine*. Last summer he was invited to travel the world with NBA *agent-provocateur* Dennis Rodman and his entourage, producing images of his off-season exploits for a book to be published early next year. Currently, Crothers is working on a project examining the presence of firearms in the everyday lives of Americans.

D. NORMAN DIAZ is a freelance photographer specializing in real people and rural images. His family owns a small farm in the High Desert of Southern California. The farm, known as Hill's Ranch, was homesteaded by his great grandfather Sherman Sperry Hill around 1900.

THOMAS ERNSTING covered his first photo assignments in 1987, and in 1988 won first prize in the World Press Photo awards for Daily Life Stories. Since 1989 he has worked for such magazines as *GEO, Stern*, and *Merian*; in 1990 he became a member of the Bilderberg collective. He is the recipient of four World Press Photo awards in total, in the Daily Life and Science and Technology categories.

NAJLAH FEANNY covers news and feature stories on assignment for major magazines including *Newsweek, Time, U.S. News and World Report, Fortune*, and *Der Spiegel*. Among other assignments, Feanny spent more than 100 days in 1996 covering the U.S. presidential campaign. Her coverage of stories from Hurricane Andrew to the World Trade Center bombing have appeared in several international magazines. She is a native of Kingston, Jamaica, and is represented by SABA in New York.

COLIN H. FINLAY was born in Edinburgh, Scotland, in 1964, and is now based in Santa Barbara, California. His first book, *The Unheard Voice*, is a collection of 65 black-and-white images made over a four-year period and covering nearly 20 countries. It focuses on the effects of war, violent conflict, poverty, and disease on children around the world. An exhibition of "The Unheard Voice" will be presented by the Santa Barbara Museum of Art in 1997 and will travel internationally.

STANLEY GREENE was born in New York in 1949. He spent his childhood and adolescence traveling across the United States with his parents, who belonged to a theatrical troupe. He was very much influenced by his father, who was a member of the Harlem Renaissance Movement—a group of writers, musicians, and actors who promoted black culture during the jazz and be-bop era in New York. In 1970 he met Eugene Smith and was offered a job working with Smith. After receiving a BFA and an MFA from the San Francisco Art Institute, Greene began working for publications such as *Newsweek, Time*, and *Rolling Stone*. Following an assignment to cover terrorist bombings in Paris for *Newsweek*, Greene settled in Paris and continues to live there now.

DAVID GUTTENFELDER has been an Associated Press photographer since 1996 and is currently based in Abijan, covering assignments in west Africa. Before coming to the Associated Press, Guttenfelder photographed for the *Iowa City Press*, the *New York Times*, and Sipa Press.

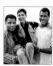

HAZEL HANKIN is a freelance documentary photographer and teacher from New York City. Her work has been widely exhibited, and is in the permanent collections of the Brooklyn Museum and the Houston Museum of Fine Arts. In 1995 she exhibited her work in a one-person show at the Cuban Union of Architects in Havana. She is currently an instructor of photography at the City College of New York.

ANDREW D. HOLBROOKE has photographed stories as diverse as homelessness in New York, refugees in Indo-China, Romania after the fall of Ceaucescu, the famine in Somalia, Ellis Island, and the economy in China. His work has appeared in numerous books and major magazines. He won a World Press Photo award and two NPPA/Picture of the Year awards for his work on New York's homeless. His work in Somalia won him the World Hunger Year's Best Photojournalism award.

ED KASHI'S published books are *The Protestants: No Surrender*, on the Loyalist community in Northern Ireland, and *When the Borders Bleed: The Struggle of the Kurds*. He has completed personal essays on the heroin problem in Poland, culture and nightlife in the re-unified Berlin, overpopulation in Cairo's City of the Dead, and the Christian pilgrimage site in Conyers, Georgia, among others. After years of focusing on the Middle East, Kashi is currently working on a long-term project exploring the trends of aging in America.

 YUNGHI KIM was born in South Korea and emigrated to the United States at the age of 10. She was a staff photographer at the *Boston Globe* for seven years, and before that she worked at the *Quincy Patriot Ledger* in Quincy, Massachusetts for four years. She is currently affiliated with Contact Press Images and is based in Washington, D.C. In 1994 she received the Overseas Press Club award for best foreign coverage for newspaper and wires for her work in South Africa and Rwanda.

 ZIV KOREN was born in Ramat-Gan, Israel, where he is still based. Following his military service, where he was a photographer for the Israeli Defense Forces, he became a staff photographer for *Yedioth Aharonoth*, the largest daily paper in Israel. Since 1995, he has been affiliated with the Sygma photo agency. His photographs have been published internationally.

ANTONIN KRATOCHVIL is a freelance photojournalist based in New York City. He was born in the Czech Republic and was educated in Holland. Kratochvil received the ICP Infinity Award in 1991 for Photojournalist of the Year. He has also received the Leica Medal of Excellence and a grant from the Mother Jones Fund, both in 1994. A monograph of 20 years of his photography is being published by the Monacelli Press in 1997.

REGIS LEFEBURE was born in the Washington, D.C., area, where he currently resides. Self-taught, he began his career in photography in 1991, and his award-winning work in editorial and advertising has been seen in *Time, Newsweek, Smithsonian, Forbes,* and *Audubon.*

ROGER LEMOYNE dabbled in filmmaking, music, advertising, and illustration before turning to photojournalism, which he calls "a crystalline medium, a distilled form of communication." For the last few years Lemoyne has photographed mostly in the world's "trouble spots," such as the former Yugoslavia, Afghanistan, Rwanda, and Zaire. Lemoyne is based in Montreal and is represented by Gamma-Liaison in New York.

 MARK LEONG was born in Sunnyvale, California. In 1989 he first visited China on a graduate traveling fellowship from Harvard University. Since then, he has spent much time there on a long-term project documenting life at a time of tremendous change. He has received grants from the NEA, the Lila Wallace/Reader's Digest Foundation, and the Ford Foundation.

JACK LUEDERS-BOOTH has been teaching photography in the Department of Visual Studies at Harvard University since 1970. He has done documentary photography projects on a wide range of subjects, including The Salvation Army, women prisoners, motorcycle culture, and, currently, families who live off the dumps in Tijuana, Mexico. His photographs have been exhibited throughout the United States and have appeared in several publications.

 NORMAN MAUSKOPF has recently published three books of his photography: *Dark Horses*, which documents the world of thoroughbred racing in the United States and Europe, *A Time Not Here*, and *Rodeo*, which looks at the lives of professional rodeo cowboys. All three books were published by Twin Palms/Twelvetrees Press. *A Time Not Here* has won two merit awards from the Art Directors Club of New York. *Rodeo* won a Best of Show citation from the Art Directors Club of Los Angeles. Mauskopf, whose work has been published and exhibited worldwide, is based in Santa Fe, New Mexico.

 STEVE MCCURRY entered rebel-controlled Afghanistan in 1979, just before the Russians invaded, and returned to Delhi to transmit pictures that were among the first to show the conflict there. His pictures in *Time* magazine won him the Overseas Press Club's Robert Capa Gold Medal for best photographic reporting from abroad. McCurry has covered international and civil conflicts including the Iran-Iraq war and strife in Beirut, the Philippines, and Croatia. He is a member of Magnum, and has published two books: *Monsoon* (1988), and *The Imperial Way* (1985), and is currently working on a book chronicling his experiences in Afghanistan.

JOHN MOORE joined the Associated Press in 1991 as a photographer in Nicaragua, after graduating from the University of Texas in 1990. Since 1991 Moore has photographed assignments for the AP in South Africa and is presently based in New Delhi.

VIVIAN MOOS'S work has appeared in several major international publications and exhibitions. She was one of three photographers for *Sister of the South* (Marval, 1995), a book depicting the daily struggle of women around the world. She won a first prize World Press Photo award, a Canon Photo Essayist award, and a Magazine Picture Story award from the National Press Photographers Association. In February 1996 her work was exhibited at the Centro de la Imagen in Mexico City.

 JERRY NAUNHEIM, JR., has worked as a photojournalist for the *St. Louis Post-Dispatch* since 1983, covering everything from sports to fashion to foreign conflicts. Naunheim has reported on apartheid in South Africa, the Missouri flood of 1993, and the Los Angeles earthquake of 1994. He has toured across Europe and Japan with the St. Louis Symphony. In January 1996 he returned to St. Louis after spending five weeks in Bosnia covering the landing of the American peacekeeping force.

 WILL VAN OVERBEEK studied photography at the University of Texas under Garry Winogrand. His first major project was a photo documentary book entitled *Aggies: Life in the Corps of Cadets at Texas A&M*, published in 1982. His photographs have appeared in numerous magzines, including *Texas Monthly, Smithsonian, Time,* and *Newsweek*. He is based in Austin, Texas.

 GREG PEASE, a photographer and co-principal with his wife Kelly in Greg Pease photography, a Baltimore-based studio, specializes in editorial, corporate, and industrial photography. Greg has been working as a commercial photographer since 1974. He has won numerous awards for his photographs. Greg is best known to the public for his maritime photographs. His book *Sailing with Pride* chronicles his 10 years of photographing Baltimore's tall ships *Pride of Baltimore* and *Pride of Baltimore II*.

MARK PETERSON started photographing for neighborhood and community papers in Minneapolis in the early 1980s. From 1985 to 1987 he served as Photo Bureau Chief for UPI in Minneapolis, and in 1987 he moved to New York, where he worked for Reuters until 1991. He began his work on "The High Life" in 1991 and is still at it. Peterson joined the Saba agency in 1993.

 JOE RAEDLE has been a staff photographer for the *Sun-Sentinel* newspaper in South Florida for the past nine years. While in college at the University of Miami, Raedle freelanced and interned for the *Miami News* and United Press International.

PATRICK ROBERT started as an assistant in fashion and advertising in 1979 and shot celebrity portraits and film sets in the 1980s, while also covering major conflicts in Africa, Asia, Eastern Europe, and the Middle East. He joined the Sygma agency in 1987. He has covered the conflict in Bosnia since 1991, suffering a head wound in Sarajevo along the way. Robert has been awarded numerous prizes for his work, including two World Press Photo awards, the Grand Prize from Care France for his coverage of Rwanda, and the Fuji Prize for his coverage of Liberia and Sierra Leone.

 JOSEPH RODRIGUEZ was born in New York in 1951. Rodriguez has published his photographs in several major publications worldwide, and has been awarded Pictures of the Year by the National Press Photographers and the University of Missouri in 1990 and 1992. A grant from the Alicia Patterson Foundation has subsidized his three-year project on Los Angeles gangs, which will be published as *East Side Stories* by powerHouse Books in 1997. His book *Spanish Harlem* was published in 1993 by the National Museum of American Art/Distributed Art Publishers.

Q. SAKAMAKI is a Japanese-born photojournalist who lives in New York and works for American, Japanese, and European magazines. His work has taken him throughout the world, most recently to the war in Afghanistan and to the Middle East. He is currently a member of the Grazia Neri agency in Italy.

SEBASTIÃO SALGADO is an award-winning photographer who is currently working on a project for *Rolling Stone* which will document the fate of displaced peoples worldwide. His photographs have been exhibited in major museums internationally, and have been published in several books, including *An Uncertain Grace* and *Workers: An Archaeology of the Industrial Age*. His most recent book is *Terra*, which was produced simultaneously in seven different languages.

CHRIS SATTLBERGER was born in Linz, Austria, and took up photography in the late 1970s. Several hundred of his photo essays have been published worldwide, in such publications as *Stern, GEO, Newsweek*, and others. His work has been internationally exhibited, and is in the permanent collections of the National Libraries of France and Australia.

ERICH SCHLEGEL joined the staff of the *Dallas Morning News* in 1988, and has covered two Winter Olympics, three Super Bowls, the 1996 Summer Olympics, and conflicts in Bosnia, Zaire, and Rwanda for the *News* since then, as well as stories in Cuba, Mexico, and elsewhere in Latin America. Schlegel was born in Monterrey, Mexico, and lived in Columbia, Panama, and Mexico City before moving to Brownsville, Texas at the age of nine.

MARK SELIGER is an editorial photographer who grew up in Amarillo, Texas, and currently lives and works in New York City. He is the chief photographer for *Rolling Stone, US* magazine, and *Men's Journal*. Seliger began shooting for *Rolling Stone* in 1987, and has shot more than 60 covers. His photographs have won numerous awards and have appeared in several books. He recently completed his two-year book project *When They Came to Take My Father*, featured in these pages. Some of the photographs were exhibited in 1996 at the Yancey Richardson Gallery and at Synagogue Space in New York City.

ILKKA UIMONEN was born in Rovaniemi, Finland, in 1966. He is presently based in New York City, and is a member of the Sygma agency. Her work has been published in *Time, Newsweek, People, Focus* (Germany), *Helsingin Sanomat* (Finland), and elsewhere.

ALEXANDER ZEMLIANICHENKO has traveled extensively throughout the former Soviet Union covering the struggles in the new republics for the Associated Press since 1990. His photographs of an attempted coup in the Soviet Union were part of an AP package that won the 1992 Pulitzer Prize.

INDEX

VERZEICHNIS

INDEX

PHOTOGRAPHERS

AGENCIES/REPRESENTATIVES

G R A P H I S B O O K S

BOOKS		ALL REGIONS
☐ APPLE DESIGN: THE WORK OF THE APPLE INDUSTRIAL DESIGN GROUP	US$	44.95
☐ FINE ART PHOTOGRAPHY 2	US$	85.95
☐ HUMAN CONDITION PHOTOJOURNALISM 97	US$	49.95
☐ GRAPHIS ADVERTISING 98	US$	69.95
☐ GRAPHIS AMATEUR PHOTOGRAPHY	US$	39.95
☐ GRAPHIS ANNUAL REPORTS 5	US$	69.95
☐ GRAPHIS BOOK DESIGN	US$	75.95
☐ GRAPHIS BOTTLE DESIGN	US$	39.95
☐ GRAPHIS BROCHURES 2	US$	75.00
☐ GRAPHIS DESIGN 98	US$	69.95
☐ GRAPHIS DIAGRAM 2	US$	69.95
☐ GRAPHIS LETTERHEAD 3	US$	75.00
☐ GRAPHIS LOGO 3	US$	49.95**
☐ GRAPHIS MUSIC CDS	US$	75.95
☐ GRAPHIS NEW MEDIA	US$	69.95
☐ GRAPHIS NUDES 2	US$	50.00
☐ GRAPHIS PACKAGING 7	US$	75.00
☐ GRAPHIS PHOTO 97	US$	69.95
☐ GRAPHIS POSTER 97	US$	69.95
☐ PASSION & LINE: PHOTOGRAPHS OF DANCERS BY HOWARD SCHATZ	US$	50.00

**SHIPPING IN USA: ADD $4 PER BOOK. SHIPPING OUTSIDE USA: ADD $10 PER BOOK.

NOTE! NY RESIDENTS ADD 8.25% SALES TAX

☐ CHECK ENCLOSED (PAYABLE TO GRAPHIS)

USE CREDIT CARDS TO PAY IN US DOLLARS.

☐ AMERICAN EXPRESS ☐ MASTERCARD ☐ VISA

CARD NO. EXP. DATE

CARDHOLDER NAME

SIGNATURE

(PLEASE PRINT)

NAME

TITLE

COMPANY

ADDRESS

CITY STATE/PROVINCE

ZIP CODE COUNTRY

SEND ORDER FORM AND MAKE CHECK PAYABLE TO:
GRAPHIS INC., 141 LEXINGTON AVENUE, NEW YORK NY 10016-8193

BOOKS	EUROPE/AFRICA MIDDLE EAST	GERMANY	U.K.
☐ GRAPHIS ADVERTISING 98	SFR. 123.–	DM 149,–	£ 59.95
☐ GRAPHIS ANNUAL REPORTS 5	SFR. 137.–	DM 149,–	£ 59.95
☐ GRAPHIS BOOK DESIGN	SFR. 137.–	DM 149,–	£ 59.95
☐ GRAPHIS BROCHURES 2	SFR. 137.–	DM 149,–	£ 59.95
☐ GRAPHIS DESIGN 98	SFR. 123.–	DM 149,–	£ 59.95
☐ GRAPHIS DIGITAL FONTS 1	SFR. 123.–	DM 149,–	£ 59.95
☐ GRAPHIS LETTERHEAD 3	SFR. 123.–	DM 149,–	£ 59.95
☐ GRAPHIS LOGO 3	SFR. 98.–	DM 112,–	£ 42.00
☐ GRAPHIS MUSIC CDS	SFR. 137.–	DM 149,–	£ 59.95
☐ GRAPHIS NEW MEDIA	SFR. 123.–	DM 149,–	£ 59.95
☐ GRAPHIS NUDES (PAPERBACK)	SFR. 59.–	DM 68,–	£ 38.00
☐ GRAPHIS PACKAGING 7	SFR. 137.–	DM 149,–	£ 59.95
☐ GRAPHIS PHOTO 97	SFR. 123.–	DM 149,–	£ 59.95
☐ GRAPHIS POSTER 97	SFR. 123.–	DM 149,–	£ 59.95
☐ GRAPHIS STUDENT DESIGN 97	SFR. 69.–	DM 88,–	£ 39.95
☐ HUMAN CONDITION PHOTOJOURNALISM 97	SFR. 69.–	DM 78,–	£ 42.00
☐ INFORMATION ARCHITECTS	SFR. 75.–	DM 98,–	£ 39.95
☐ WORLD TRADEMARKS	SFR. 385.–	DM 458,–	£ 198.00

(FOR ORDERS FROM EC COUNTRIES V.A.T. WILL BE CHARGED IN
ADDITION TO ABOVE BOOK PRICES)

FOR CREDIT CARD PAYMENT (ALL CARDS DEBITED IN SWISS FRANCS):

☐ AMERICAN EXPRESS ☐ DINER'S CLUB ☐ VISA/BARCLAYCARD/CARTE BLEUE

CARD NO. EXP. DATE

CARDHOLDER NAME

SIGNATURE

☐ BILL ME (ADDITIONAL MAILING COSTS WILL BE CHARGED)

(PLEASE PRINT)

LAST NAME FIRST NAME

TITLE

COMPANY

ADDRESS CITY

POSTAL CODE COUNTRY

SEND ORDER FORM AND MAKE CHECK PAYABLE TO: DESIGN BOOKS
INTERNATIONAL, DUFOURSTRASSE 107, CH-8008 ZURICH/SWITZERLAND

G R A P H I S C A L L F O R E N T R I E S

ENTRY INSTRUCTIONS *THE HUMAN CONDITION: PHOTOJOURNALISM 98* is the third in this exciting series. This annual takes an innovative approach to presenting the most significant events of the year as seen through the eyes of the photojournalists who witnessed them. Each photographer's work will be presented as an extended visual essay of two to six pages.

ELIGIBILITY All photojournalists may submit work produced from September, 1996 - September, 1997

WHAT TO SEND Please send a selection of photographs illustrating a specific subject along with captions and story. The photographs should be reproduction-quality transparencies, slides, or prints. Prints must be no larger than 8" x 10". Do not send originals or glass mount slides. By submitting the work, the sender grants Graphis permission to reproduce the material free of charge. *We regret that entries can not be returned.*

HOW TO PACKAGE YOUR ENTRY Please tape (do not glue) a copy of the completed entry form to the back of each piece. For transparencies and slides, clearly label each with the photographer's name and number. The photographer's name and contact information must be firmly affixed to each image.

ENTRY FEE US $15.00 per subject. Make checks payable to Graphis, Inc., New York. Enclose check and an additional copy of entry form with entry materials.

A confirmation of receipt will be sent to each entrant. All entrants will be notified whether or not their work has been accepted for publication shortly before the book comes off press. ☐ All entrants qualify for a 25% discount on the purchase price of the finished book. Entrants whose work is accepted for publication will receive a complimentary copy of the book and are be eligible for a 50% discount on additional copies.

MAIL ALL ENTRIES TO Graphis, Inc. TEL (212)532-9387

141 Lexington Avenue FAX (212)213-3229

New York, NY 10016-8193 **ENTRY DEADLINE: CALL FOR INFORMATION**

..

ENTRY FORM

.. ..
Photographer: Title of Project:
.. ..
Address:
.. ..
 Please give a brief descriptive caption for each image as well as a succinct
..
Telephone: Fax: (no longer than 250 words) narrative description of the project.
.. Use additional sheet if necessary.
Representative/Agent (if any):
.. ..
 Time Frame (month, year):
 ..
I hereby grant permission for the attached material to be published free of Location:

charge in Graphis books, any article in *Graphis Magazine*, or any advertise-

ment, brochure or other material produced for the purpose of promoting ..

Graphis publications. Signature: